W9-CGP-471

What Really Matters

John Pepper

What Really Matters
John Pepper

The Procter & Gamble Company
One Procter & Gamble Plaza
Cincinnati, Ohio 45202
USA

Colophon
Cover and book design by David Hess and Andy Ruttle, RDG.
Type set in Adobe Bodoni, Adobe Garamond, ITC Berkeley and ITC Galliard.
Text pages printed on Mohawk Satin 2.0. Cover printed on Utopia One Dull.
Pre-press, printing and binding by Berman Printing Co., Cincinnati, Ohio, USA.

ISBN: 0-938973-01-0
9 8 7 6 5 4 3 2 First Printing 2005

Printed and bound in the United States of America.

What Really Matters

Table of Contents

To Francie,

Who made it all possible.

Spring 2005

Preface

"Memory is less a neutral accident of the mind than a conscious work of interpretation, marked as much by deletion as by selection. How a community remembers the past is the single, most important element in determining its future."

— James Carrol
"Constantine's Sword"

I had several motivations for writing this book. I wanted to convey some of Procter & Gamble's history through stories — stories of people making choices and achieving success despite great challenges. I also wanted to thank those who have helped me become who I am today. In addition, this book is important to me, personally, because it represents an effort to help ensure that the values I believe in most continue to guide our decisions and our actions as a company. But, above all, I have tried to identify those learnings that I believe will be most helpful as you pursue the Purpose and growth of this Company, and fulfillment in your personal lives.

My intention is to share certain principles and learnings based on *what really matters* — on what, over the course of a career of almost 40 years, I have come to believe is most important to the development of our brands, to the growth of Procter & Gamble, and to our individual careers. This book isn't meant to be studied academically or read passively. I want to make a difference in your understanding of what leads to success, both personally and professionally. I hope to deepen your sense of pride in Procter & Gamble. And, I want to underscore the responsibility each of us has to help perpetuate the success and character of this great Company.

In no sense do these recollections attempt to provide a complete history of the events I describe. I have drawn on my own memory, my journal and the memories of others to the extent needed to identify the lessons embedded in those events. My view is only one view of what happened. In some cases it will be incomplete, and in others it could differ from the views of those involved.

＊-o-＊

This book is structured in three sections:

How we succeed at P&G. I start with the foundation of our success: serving consumers by creating and sustaining leadership brands. We look at key lessons in brand building, both good and bad. I establish how important it is to our

success that we *let the consumer decide* and we *go for the "big win."* This will provide the best orientation for what follows.

How we keep P&G in the lead. Here we will review the organizational qualities — the values, practices and relationships with people that have enabled Procter & Gamble to be not only a strong company, but also a vibrant *institution* and *community*. I explain why I believe being a community is P&G's greatest competitive advantage, and I discuss some of the challenges in retaining this advantage. This section also brings to life the fundamental truth that by *doing* good ... by doing what's right in supporting our communities ... we *gain* good in many ways.

How we live our lives. Here we get to what underpins everything else. We explore the value of the *passionate ownership* that P&G people bring to the business and the importance of building and taking advantage of our *diversity*. Then, in *Personal Model for Living*, I describe the life-goals I have pursued and the qualities of living and the values I have tried to embrace to achieve these goals. Finally, I share my conviction that when all is said and done, life at P&G and the success we personally achieve is a *family affair*.

While these sections are presented independently, I hope to demonstrate that they are each interconnected. I want to show, for example, how our appreciation of the opportunity to serve consumers – not abstractly, but personally and individually – becomes a source of our deeply felt conviction that a career at P&G is truly worthy of a lifetime of our best effort.

I want to show that our commitment to doing good in the community can also build the reputation of our brands and help attract and retain the very kind of men and women most able to make P&G a vibrant community, capable of sustaining leadership over time.

I want to show how our growing appreciation of the benefits of diversity has not only made us a bastion of talent not otherwise available, but has also supported P&G's global expansion and enabled us to better meet the needs of over five billion (extraordinarily diverse) consumers whose lives we can now touch.

I want to show how our individual (and certainly my own) actions and decisions have been informed and inspired by the values of the Company, but equally how it has been the decisions and actions of individuals, especially at testing moments of time, that have given shape to P&G's Values, lifting them from what can easily be paper-bound truisms to active guides for living.

I want to show that our deep and sincere interest not only in the men and women working at P&G, but in their families, has made a special contribution

to P&G itself being a community and to the feelings of loyalty and ownership that flow from this.

Finally, I hope to show that it is through the general consistency and mutual reinforcement of *all* these values that we gain our greatest strength as a company and as individuals.

If there's one overarching theme threaded throughout the book which ties the different segments together, it is this: Growth and leadership involve constant change and innovation … in how we understand consumer needs and how we meet them; in how we work with our customers and how we take costs out of our system; in how we develop the talent of our organization and how we support one another in our personal growth; in how we organize to manage an increasingly global business and how we support our communities … constant change and innovation in everything we do.

We should embrace change proactively as a natural process of renewal. We should pursue innovation enthusiastically, recognizing it is the lifeblood of progress and competitive advantage. And we should pursue both innovation and change with a constant commitment to not only remaining faithful to, but indeed better fulfilling our most fundamental Purpose and Values. This is true whether we are talking about the evolution and growth of brands, or an organization like Procter & Gamble, or each of us as individuals.

As we'll see later, we sum it up with the phrase: "Preserve the core; be prepared to change everything else." These are the two mandates that any lasting institution must meet. They are much easier to state than to achieve, but they are necessary and achievable with strong leadership and unwavering focus. Nothing confirms that more persuasively for me than the 165-plus-year history of Procter & Gamble, where I was privileged to work for almost 40 years; and the 300-plus-year history of my alma mater, Yale, where I work today.

In what follows, I will try to be very candid, calling out what has worked and what has not; what went well and what went badly, both for me, personally, and for the Company. In the process, I hope to share lessons that will help future P&G generations succeed and come to love and respect this great Company as much as I do. This, I believe, is *what really matters*.

Chapter 1
A Brief Personal History

"We know the end before we consider the beginning, and we can never
fully recapture what it was to know the beginning only."

— Veronica Wedgewood

Looking back now over almost 40 years, it's hard to know exactly how and
when I came to love and respect Procter & Gamble the way I do today. My
deep affection for P&G grew out of my contacts with its people, by observing
their character and their decisions, particularly when they were under pressure.

This book, written with as much insight and candor as I could muster,
is about my experiences with those people and the lessons I've learned
from them.

In a way, my relationship with P&G people began long before I joined the
Company, while I was attending Yale University on a Navy ROTC scholarship.
As advertising manager of the *Yale Daily News* in 1958, during my junior year,
I was selling space for the paper. My clients included on-campus recruiters,
which is how I met two men from P&G. They were alive with energy. You
could literally see the enthusiasm in their eyes and hear it in their voices. The
pride they felt in their company and the fun they appeared to be having in their
jobs were palpable. They talked about "brand management," the opportunity
to run your own business before you were 30.

Five years later, as I left the Navy, I decided to give business a try and
remembered those two P&G men. Business wasn't at all what I had in mind
while I was at Yale or during my Navy tour. I was set on going to law school.
In fact, I had been admitted to Harvard and had applied for a job on the *Boston
Globe* to help pay my way through. Law seemed like a natural for me. I took a
Military Justice correspondence course during the first two years of my naval
duty at sea, and I served on naval courts-martial boards my final year in the
Philadelphia Naval Shipyard. I liked a lot about law. The need for tightly drawn
research and stimulating, well-developed, intellectual debates appealed to me.

On the other hand, a career in business was an unknown. Although I had
gotten a taste of it while working on the *Yale Daily News*, several disquieting
issues about corporate life were in the air in the early 1960s. The dull, conformist
atmosphere portrayed in Sloan Wilson's *The Man in the Gray Flannel Suit* was
fresh in my mind. So was the regimented environment suggested by William
Whyte's *Organization Man* and David Reisman's *The Lonely Crowd*.

For a 21-year-old who found great solace in and confidence from pursuing academic studies, and who drew his greatest sense of accomplishment from the research and writing involved in a history major, I had to wonder what a career in business offered. Would it be intellectually challenging? All about making a buck? Dull, routine and a drive for conformity? And, more important, could I even succeed?

Despite these questions, and at the last minute of my Navy tour, I realized I wasn't quite ready to go back to the "stacks." Three years in the Navy led me to this decision. It was an exciting time. I loved being able to run a destroyer around the North Atlantic and Mediterranean all on my own in the dead of night. (My wife, Francie, still questions the Navy's wisdom for allowing me to do this.) Also, I was starting to feel confident as a leader: first as chief communications officer on the USS Blandy (DD943), and then as an engineering officer at the Philadelphia Naval Shipyard outfitting PT boats for Vietnam. And, of course, I liked the action. So before returning to school, I thought I'd take off one more year and try to run my own business.

Why Go Anywhere Else?

It was summer 1963, and I went to P&G's Philadelphia office for a screening interview. There I met Bob Dillard, the P&G sales manager in the Philadelphia area. I was amazed at how considerate he was — obviously a competent professional and so eager for me to learn about the Company. It was almost as if I were the only person he would interview that year.

Then came the interview panel in Cincinnati. Jim Cochran, head of the Commercial Production Department at the time, took the lead. He was friendly, direct and accessible. In the middle of the interview, Jim asked me a straightforward, disarmingly simple question: "Why do you want to be a brand manager?" I gave a careful, academic answer saying why I liked P&G and why, on the other hand, I had some questions.

At the time, I thought I'd delivered the perfect answer. I felt downright proud ... until I was about to leave Jim's office at the end of the interview. He put his hand on my shoulder and said something I'll never forget: "John, I think you might have a great career in this Company, but I have a piece of advice for you. The next time somebody asks you why you want to go into brand management, and trust me, everyone will, sound like you're more certain of your answer."

It was hard to believe. Here was a P&G manager training me during the interview process on how to handle the rest of the interviews. Whatever doubt I had about Procter & Gamble being the Company I wanted to join vanished

at that moment. Jim was right. The other two interviewers *did* ask me that same question. And I was ready to give a more direct answer.

Stu Shaw was the last member of my interview panel. He headed up the Advertising Department for a large number of P&G brands. An Englishman and proud of it, Stu's free spirit, creativity and energy filled the room. I felt certain that I'd like to work for this guy.

You can imagine my joy and sense of relief when, after about a 30-minute discussion, he told me he was pleased to offer me a position in P&G Advertising starting in September. I accepted immediately.

Stu paused, appeared surprised and asked if I wanted to think it over. Did I have any questions? I didn't. I came to Cincinnati knowing I wanted to work for P&G, and I was delighted to have the offer. Still, I sensed he had not had anyone accept a job quite this way before.

I found out why with his next question: "Don't you at least want to know what you'll be paid?" That, I had to acknowledge, was a question I should have asked. Frankly, I was sure it would top my $3,500 Navy salary. To my surprise, he wasn't certain and needed to check.

Stu must have been gone 15 minutes, but it seemed like an eternity. The thought crossed my mind that perhaps he was considering withdrawing the offer, because I hadn't shown the good sense to ask obvious and intelligent questions. Stu came back, of course, and informed me that my salary would be $7,000 a year, which seemed like all the money on earth. I returned home to Philadelphia a happy young man.

P&G had an almost mythical quality in those days that I didn't fully appreciate until I started working there. It was known to provide the finest marketing training in the world. Years later, I was telling Roy Kendall the story of how I joined the Company. A great leader of P&G's Canadian business, Roy was one of my important early role models. His reflection on why he joined P&G precisely described my own: "Working for P&G was like carrying a passport to success! Why would you go anywhere else?"

A Career Begins

In early September 1963, I arrived in Cincinnati at the old Union Terminal train station not knowing a soul, except for my interviewers. Then I discovered I had lost my wallet and had no money. What a way to begin! Certainly this was something I didn't want the Company to know, so I called my mother. As she had done every step of the way, she came to my rescue, wiring money to

the local Western Union office.

I sought advice on where to live and chose the L.B. Harrison Club. It was only 15 minutes from the office on a frequently scheduled bus line, and was it ever cheap, with the rent at $50 a month. My bedroom was roughly 8 by 10 feet, with paper-thin walls, a bathroom down the hall and the food OK. But for someone just coming out of the Navy it looked fine and, best of all, it was filled with other P&G recruits — six arrived the same week I did.

September 25, 1963, was my first day of work. I was assigned to a group with two brands: Cascade dishwashing detergent and Duz soap. Introduced in 1955, Cascade was still small but growing fast, with only 7 percent of U.S. homes owning a dishwasher. Duz soap had been the largest P&G laundry brand prior to the introduction of synthetic laundry detergents, led by Tide in the late 1940s.

I arrived that morning not knowing what to expect and with a head full of questions. P&G was a big company. Dozens of us sat in a tightly packed "bullpen" on the ninth floor of the General Office. Would I get lost? Would people even know I existed? What was the nature of the work? Would my work matter? I had loved school, but would I like this? Would the work here be challenging and intellectually exciting? What would the people be like? Would I make it? I didn't realize it then, but my love affair with Procter & Gamble had begun.

Ralph Browning, my first boss and a Frenchman who held a senior marketing position in our still-young French subsidiary, had come to Cincinnati for three years of training. He got me off to a wonderful start. He gave me counsel. And above all, he let me try things. I recall asking if I could take the lead role in preparing the budget proposal for the coming fiscal year, something typically done by a more senior assistant brand manager. Ralph's reply, "By all means, do it. Let me know how I can help." I had my first taste of the Company's commitment to training and to delegating responsibility. What's more, I had my first taste of the personal accountability that came with it.

Ralph's boss, Jack Clagett, was an associate brand promotion manager responsible for three brands. I'll never forget all he taught me; all he and his wife, Nancy, did for me. I had only a few new friends, and I hadn't met my future wife, Francie, yet. With my family hundreds of miles away, Jack and Nancy welcomed me into their home. They invited me for dinner not just once, but several times. They showed they cared. Yet Jack did something more: He conveyed confidence in me and he encouraged me. That mattered because, in some ways, I lacked the confidence you might have expected given my education and military experience.

From Pottsville to P&G

I was born in the town of Pottsville, Pennsylvania, which had a population of about 25,000, declining every year. It had seen its best days as the center of the now-burned-out anthracite coal region. My father, John, was a graduate of Georgetown, and his family had lived in Pottsville for many generations. My mother, Irma, came from a town in downstate Illinois. She attended Rosemont College in suburban Philadelphia, where she became friends with my father's sister. It was through her that my parents met and were married in 1937. I was born the following year.

Two years later, my sister, Elizabeth, was born. We were very close. Tragically, she died following a field hockey accident when she was just 32 years old. I think I've carried a latent feeling of guilt ever since, because I wasn't able to somehow prevent her death.

My childhood memories are hazy, but a few stand out. What I remember most is the interest my parents took, especially my mother, in teaching me to read. We were surrounded by all kinds of books. I can recall my mother reading to me day after day and night after night. I had a habit of smuggling a flashlight under my blankets and reading one Hardy Boys mystery after another.

As a child, teenager and young man, I was a bit of a loner with a handful of fairly close friends. I don't know why, exactly, but I had trouble making friends. It wasn't until high school, when I made the football and track teams, that I even tried to develop the modest athletic abilities I had. I loved books and was tantalized by them, but I also sought refuge in them, I'm sure, because academics was something I knew I could do well in.

As I grew up, I slowly became aware of problems within my family. I could see and sense the relationship deteriorating between my mother and father. I'm sure there were many reasons. Not even a child, in the words of Terry Tempest Williams, "ever knows the interior landscape of a marriage. It is one of the great secrets kept between couples." Nothing is more private. Nothing is more dependent on the words and gestures, spoken and unspoken, in the quietest moments. However what did become clear to me, sometimes painfully, is that from the earliest years of my childhood, my father, with my mother alongside him, fought the destructive consequences of his alcoholism.

But through it all, my parents created an environment that showed how much they valued education and cared about me. They led me to feel I could do just about anything. They took me down paths I never would have known. They sent me ("sent me" is the only way to put it; I didn't know where I was

going!) to camps in the Adirondacks in New York state and the White Mountains in New Hampshire. In the latter stages of this camping experience, I became a counselor, learning to lead in small ways.

After my sophomore year in the Philadelphia area, my parents concluded that it would be best if I went away to school for my junior and senior years, both to enhance my education and, I suspect, to live in a more settled environment. Their choice turned out to be a brilliant one: Portsmouth Priory (now Portsmouth Abbey), an English Benedictine school located on Narragansett Bay near Newport, Rhode Island. It was a life-changing move. It brought me into contact with some of the finest men I've ever known: Dom Bede Gorman and Dom Andrew Jenks. These were men who, in quiet but uncompromising ways, demanded high levels of scholarship, established high expectations of accomplishment and, particularly in the case of Father Andrew, showed they believed in me more than I believed in myself.

Who is wise enough to know the sources of our drives and ambitions, our hopes and fears; the roots of our insecurities and confidences? We know they are rooted in relationships and experiences that occur early in our childhoods. From a past too distant to recapture in memory, I was driven to excel. I was your basic overachiever, fueled by my love of learning. And to a degree I was driven, I'm sure, to overcome challenges I experienced in my family and insecurities I felt around others.

Still, by the end of my two years at Portsmouth, I was No. 1 in the class academically and had earned letters in football and track. I was proud and more confident than I had ever been before.

That confidence carried me through college and the Navy, but it was challenged and bolstered more in my first months at P&G than at any other time in my life.

Growing Loyal to P&G

From my earliest weeks with the Company, I was allowed to test my beliefs and ideas, even when they were off the wall. I experienced this first with Ed Artzt, Jack Clagett's boss. More than two decades later in 1990, Ed became CEO and chairman of the Company. I worked for him for about half of my P&G life. That was a piece of very good fortune. At that time, he had responsibility for the most important part of P&G's business, including its largest-selling brand, Tide.

Ed was a busy man and was known, appropriately, as a tough taskmaster. "You need to be really prepared," we young folks were told, "before you meet

this man." Well, I met him a lot. He never ceased to impress me with the time he took with me, often one-on-one, going over a piece of market research or a marketing plan to ferret out what we could learn to give our brand a bigger competitive edge or to build more business. Was Ed tough-minded and competitive? You bet! But did he want to teach a young person the business? Absolutely.

Ed did something else. He let me try things. Some worked and some didn't. It was wonderful. I experienced failures right at the beginning of my career and didn't get hurt. It became natural for me to think that success required reaching out, knowing that some things would be successful and some not, and learning from both.

This was particularly true during what came next. After being with P&G for about a year, I received the good news that I had made it to Sales Training. In those days it was your first milestone of success as a P&G marketer. About one-third of new hires didn't make it to this stage. I was assigned to a sales team in Nashville, where I lived for six months. I know now this was probably the single-most important six months in my career. I wouldn't have traded it for any other. Why? Because being there allowed me to see in a whole new light the quality of the people in the field and, by extension, the culture of Procter & Gamble.

I came to know a number of people who had been with the Company for what seemed like forever — 10 to 20 years!

- Jim McKeon, my district manager, who took me under his wing as if I'd be working for him for years.

- John Kimbrough, my unit manager in Nashville who, together with his wife, invited me to dinner many times at their home.

- Bill Prendergast, a bull of a man and a seasoned veteran from upstate Tennessee, who couldn't stand for a competitor to have a display in one of his stores, and had market shares to prove it.

- Tom Deal, whose commitment and ability to deliver excellence was a model for me to follow.

These men, all with their own personal responsibilities, reached out to support and train me with the same caring I had experienced in Cincinnati. They displayed that feeling of ownership and accountability I was coming to see as a priceless Company asset. Some of them told me how P&G had not only afforded them exciting careers, but had also helped their families when they needed it because of a health problem. I was discovering a whole new

dimension of how P&G kept its commitment to employees. I hadn't realized businesses did this kind of thing. I was impressed, but beyond that I was lifted. I was becoming more aware of why these folks felt such strong loyalty to this Company.

My six months in Nashville also brought my first, deeply felt appreciation of the importance of our customers. I found I enjoyed being with them and with the consumers I met in their stores. I liked the opportunity to develop ideas and to see what we could do, together, to build our businesses.

By the time I left, I had come to know Nashville and routes heading west to the Mississippi River like the back of my hand. I'd come to know and like customers in Waverly and Dixon, Tennessee. I'd become more comfortable with selling and with people in general. I was starting to enjoy being with people who were different from me. It was an eye-opening, exciting experience.

Having happily extended my sales training assignment two times, I came back to Cincinnati in spring 1965. In May, in one of those serendipitous events that forever changes your life for the better, I had my first date with my future wife, Francie Garber, at the Kentucky Derby. Two-and-a-half years later we were married. This was the toughest and most important selling job in my life. After that, I believed I could do anything. I thought my life couldn't go wrong. And in just a short time, I found I had not only married the woman of my dreams but had married into what became my second family.

Growing to Love P&G

If my marriage to Francie was the most important event of my adult life, and it surely was, then the next most important was our move to Rome in 1974, when I became general manager of P&G's Italian business. I was 36 and had been with P&G for 11 years. Francie was 34. We had three boys by then, ages 4, 3 and 8 months. (Happily, Susie was to arrive four years later.) I was working pretty much nonstop and, as Francie so appropriately and accurately reminds me, she was doing everything else.

I can still recall Bill Gurganus, then head of P&G International Operations, and a supportive mentor of mine, calling me to his office in December 1973 to ask if Francie and I would be willing to move to Europe the following June. Without even knowing the country he had in mind, I answered without a moment's hesitation, "We'll go."

"Don't you want to ask Francie? You have time to think it over."

"No, I don't need time. Francie's been waiting years for us to go abroad. I promised her when we got married we'd see the world, and she's been wondering what's taking so long."

In Italy, I was in charge of my own company. I was impressed by the distinctive insights provided by our Italian employees, and yet I was equally conscious of our common values. The ownership and the integrity they brought to their work were exactly what I had experienced in Cincinnati and Nashville. I learned to lead across functions. I was in unfamiliar territory and on my own. The telephone was often out of commission. Fax machines and e-mail didn't exist. Most decisions stopped with me. There could have been no better way to grow, which was especially important for me at that point in my life.

Our three years in Italy changed our lives forever: mine, Francie's and, while they didn't know it then, our children's. It was a glorious assignment in every way. We discovered the beauty of landscape and the wonder of art. History came alive. We discovered and were lifted by the warmth of the Italian people. Some of them became our very best friends. All that and more happened during our years in Italy.

It's remarkable to read a novel and find a character expressing, almost word for word, what you experienced earlier in your life. That happened to me with the stunning book *Crossing to Safety*, by Wallace Stegner. When I read the thoughts of a principal character, Larry Morgan, it seemed as if he'd discovered Italy just as I did: "In the past, I had periods when I learned and grew very fast ... but I never felt any such explosion of capacity and appreciation of things beautiful and artistic and human and personal as I felt in those three years in Italy."

<p style="text-align:center">>>-o-<<</p>

I must insert a disclaimer here. I would not want to give the impression that my early years at P&G were all sweetness and light. I experienced many frustrations. In the first few months I felt inundated with new information. At times during the first couple of years I wondered if I would make it. When they asked me to rewrite a memorandum for the fourth time, it was as if these folks had forgotten that I had gone through college. There were tests that didn't work and some proposals were rejected. On occasion, I wondered if it would even be possible to make a real difference in a company of this size.

Despite all that, I was becoming aware of what was special about the place: the quality of the people and their commitment to serving the consumer and to winning; the emphasis on making data-based decisions and on executing with excellence. In dealings with management, I saw evidence that the

aphorism "What's important is *what's* right, not *who's* right" was not mere rhetoric, but a deeply held conviction that people acted on. They spent a tremendous amount of time helping me learn. The nature of the work was exciting. It was varied, intellectually stimulating and demanding of my best efforts.

Looking back, I am struck by how modest my objectives were in those early years. Becoming a vice president of the Company, let alone a CEO, wasn't part of my thinking. I wanted to learn, to be the best at what I did and to go a step beyond. Somehow, from my earliest experiences at Procter & Gamble, I had developed the belief that working hard and applying what I'd learned through success and failure would serve me well. I certainly didn't think I "had it made." But this didn't worry me. I kept going, knowing I liked what I was doing more and more, and feeling ... hoping ... believing that good would come from my efforts and benefit my career.

Through it all, I was starting to see P&G as more than a business. It was an institution and a community dedicated to a noble purpose worthy of a lifetime of one's finest work. This perception was built layer-by-layer as I watched what Procter & Gamble people accomplished around the world, in good times and in bad. It was built as I saw the fruits of what we can do as a company through the eyes of customers who sell our brands, and the eyes of consumers who use them; through the eyes of fellow employees, and members of the governments who recognize and appreciate the support we provide. Yes, it has been my privilege to see through the eyes of others what a business, an institution, a community like ours can achieve, and it has been a wondrous sight. Yet, it is possible only by our rising to meet great challenges — challenges continuing into the future. It is possible only by our recognizing and acting on *what really matters*.

How We Succeed at P&G

This section begins with the *foundation* of our success: serving consumers by *creating and sustaining leadership brands*. We examine key lessons in brand-building, both good and bad.

Nothing matters more in creating and sustaining leadership brands than *letting the consumer decide*. We examine why people who care so much about serving the consumer sometimes fail to do so — and what we can do to avoid this shortcoming.

Achieving success requires *going for big wins*. We explore what it takes to accomplish them, while minimizing failure along the way.

Chapter 2
Creating Great Leadership Brands — and Keeping Them Young

"Experience has taught us it is not enough to invent a new product. The real payoff is to manage that brand with such loving care that it continues to thrive year after year in a changing marketplace.

"In marketing circles, it is popular to talk about the 'life cycle' of products. I am sometimes asked what is our theory on the life cycle of products, and my answer is very simple. We don't believe in it! I don't mean to say we haven't had brands die — we have — but in each case we failed to do our job."

— Ed Harness on
Principles of Marketing

As 1999 came to a close, Procter & Gamble was named "Marketer of the Century" by *Advertising Age*. When the magazine's reporter phoned to tell me the news, he asked a simple question: "What do you believe was the greatest contribution P&G made to marketing over the course of the century?"

My answer was simple, also: "The unrelenting emphasis we place on creating and sustaining great leadership brands." As we'll see, many factors underpin P&G's success, but without our leadership brands, we would not be a company at all. As we'll also see, creating and sustaining leadership brands has been no easy feat.

Many other companies, such as Coca-Cola, Johnson & Johnson, and General Electric, have created great brands that have stood the test of time. Still, I believe what sets P&G apart is our never-ending commitment to our brands as living, dynamic entities that we can and must keep strong and growing. More particularly, at the heart of P&G's success lie our focus on innovation to improve consumers' lives and our ability to communicate product benefits with relevance and conviction.

As I write this, P&G has 16 brands already generating sales of a billion or more dollars per year *(see page 24)*. A number of other brands, each producing annual sales over half-a-billion dollars each, are likely to join the billion-dollar club within the next few years. All in all, it is a record unmatched by any consumer goods company in the world.

Brand-Building Success Factors

Five factors explain Procter & Gamble's ability to create so many leadership brands and keep them young year after year, decade after decade. It's only when all of these factors are present — not three or four, but *all* of them — that we sustain and improve our record of creating and building leadership brands.

1. A Passion for Providing New Benefits to Consumers

This passion is driven by two motivations: to improve the lives of consumers through our brands; and to know, based on 167 years of history, that doing this is the foundation of our ability to lead and to grow. Perhaps more than any other company, P&G operates with the mindset that *its role in the world* and *the key to its growth* lie in creating brands that provide new benefits and in establishing whole new businesses capable of growing over time. That is what disposable diapers and fabric softeners did when we introduced them years ago. It is what Actonel and Swiffer are doing today. We take many actions, follow many techniques, and adopt many organization designs that matter a great deal in achieving our goal. Yet, to keep P&G brands growing, I cannot overemphasize how important the starting point is: the passionate commitment to provide new benefits to consumers.

This commitment to provide benefits never available before and to build businesses that didn't exist before is not the province of any one person or position. This commitment must exist at every level right up to the CEO. Examples can be found in each business, across all generations and areas of the world:

- A.G. Lafley has reinforced our focus on the 'consumer is boss' and on consumers' experiences with our brands as P&G's moments of truth.

- Vic Mills and Bob Duncan (among others) worked in their laboratories for years convinced they could create a more convenient way for parents to diaper their babies and care for babies' skin.

- Haile Mehansho worked for more than a decade on the micro-nutrient combination of iron, iodine and vitamin A in our NutriStar drink product, believing — *knowing* — it could make a life-changing contribution to the growth and health of children and their mothers.

- P&G people around the world are working to get PUR water purification products to consumers knowing we can improve — indeed *save* — the lives of millions of people and create a whole new business in the process.

- Customer Business Development's women and men are building new businesses for P&G by taking our brands to consumers in the most remote areas of the world.

Procter & Gamble's Unparalleled Brand-Building Record

In 1879, Ivory became the first mild, personal cleansing product sold broadly at an affordable price.

P&G introduced a healthier cooking product with Crisco in 1911, and the first broadly available non-soap shampoo with Drene in 1934.

Tide was the first heavy-duty synthetic laundry detergent — truly a "washday miracle" when it launched in 1946.

P&G introduced fluoride toothpaste with Crest in 1955, the first economically priced disposable diaper with Pampers in 1961, and a revolutionary anti-dandruff hair care

product with Head & Shoulders in the same year.

P&G revolutionized the disposable paper category with improved Charmin toilet tissue in 1960 and Bounty towels in 1965.

P&G transformed the hair-care category with the introduction of two-in-one shampoo and conditioner technology in Pert Plus in 1986, followed by Pantene, which became the No. 1-selling hair care product in the world.

Pringles in 1968, Bounce fabric softener and Dawn in 1972, Always in 1983, Actonel in 1998, Swiffer in 1999 and ThermaCare in 2002 have been a few of the other category-creating, category changing brands that Procter & Gamble has introduced.

2. A Commitment to Thoroughly and Intimately Understand Consumer Needs

Procter & Gamble was the first company to conduct broad-based, reliable consumer research. It started in 1924 as market researchers fanned across the United States, calling on consumers in their homes.

Our commitment to effective consumer research has been a rich tradition ever since. Still, we have sometimes failed to honor it, perhaps through undue focus on speed or a cavalier assumption that we know more than consumers, and our business has suffered predictably.

You might think we would have it all figured out by now, having pursued research as a discipline for almost eight decades. We don't, and we never will. It has only been in the past couple of years, for example, that we have found it's more accurate to predict purchase intent when consumers compare products side-by-side in the market packaging with the prices indicated, than it is when they compare products in unmarked packages without pricing.

We continue to find ways to improve how we conduct research. About half of P&G's consumer research is now done over the Internet. We use "virtual" test markets to save time and money. Further improvements in the speed and effectiveness of our research will be limited only by our imagination and diligence.

Linking winning innovation to genuine consumer needs is also a function of how we organize and work together. Sharing ideas among our people in products research, technology development and marketing is especially important.

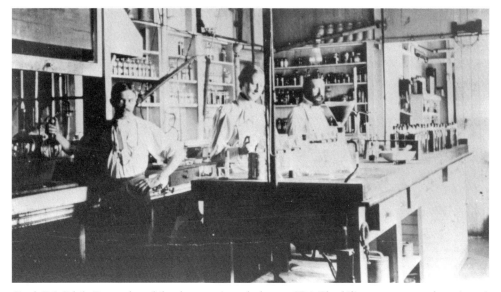

Early P&G lab. Research and development is at the heart of P&G's ability to create new brands and consumer benefits.

Early market research

I have particularly noticed how crucial it is that we observe consumers as they live. What inconveniences do they face? What cries out for a solution? What can they afford? Intimacy with the consumer is critical if we are to define the true consumer need we can fill. Bob Dirksing, one of our great product innovators, expressed this as having empathy with the consumer. That's why, for example, he tested a new spray cleaner package with people who have arthritis. Years later, he still recalled one consumer's poignant comment: "You know, no one ever cared about us before."

As you'll see repeatedly in this book, caring about the consumer is all-important. Caring leads us to identify the detail of a product's design that can add 10 points to its acceptance. Caring leads us to do that extra-small-scale test in the Middle East, which might show that a diaper design well-accepted in Western Europe does not effectively meet consumer needs in Saudi Arabia.

3. An Ability to Turn Consumer Understanding Into Winning Strategies and Business Models

What constitutes a winning strategy and business model will vary by brand and by category. Moreover, as former P&G Executive Vice President Wolfgang Berndt has said, even on a given brand they "will be emergent and subject to evolution depending on new consumer needs and preferences, as well as on new technologies that are capable of delivering against new performance or preference vectors." Still, a winning brand strategy and business model are invariably built on the following three elements:

1. *Technical benefits and product and package attributes providing consumers with superior performance that addresses a very important need.* For Tide, this is superior cleaning of soiled fabrics; for Always, a clean, dry feeling of protection; for Bounty, faster, more complete absorption of spills; for Dawn, superior removal of grease.

2. *A conceptualization of these benefits and attributes resulting in advertising and other marketing programs that consumers find highly distinctive, compellingly attractive and persuasive.*

- "Hair so healthy it shines" — Pantene
- "The best part of waking up is Folgers in your cup" — Folgers
- "Dawn takes grease out of your way" — Dawn
- "Strong enough for a man; made for a woman" — Secret
- "The quicker picker-upper" — Bounty
- "Love the skin you're in" — Olay

At its best, a brand's benefit promise will become a significant guide for future product and package design and development. More than a *provocative expression* of the brand's benefit, the promise becomes a *template* for *improving* that benefit. And, of course, a specific expression of a benefit like "The best part of waking up is Folgers in your cup" can form the backbone of a marketing campaign that will support the brand for years, even decades. It could even drive it to market leadership, as it did for Folgers.

The importance of this linkage between the brand's performance benefits and the clear, fresh, compelling communication of those benefits requires that our marketing (including all our agencies), research and development and customer business development people work closely together.

Creating holistic and tightly integrated innovation and marketing strategies that make a brand more appealing and harder to imitate is increasingly important today. Why? Because consumer choice has exploded. Best-in-class technology is migrating faster to other producers (including our own customers) and low-cost competition is growing. Only through holistic innovation will we be able to create great leadership brands, two or three times larger than their nearest competitors. This is why we not only need to push harder for breakthrough, sustainable technical advantages, but to imaginatively employ every other element — product aesthetics, package design, marketing programs and external endorsements — to create a brand that consumers trust as no other and come to see as part of their lives and homes.

I like the way Jorge Mesquita, president of our Global Home Care business, expresses this challenge. He says our aspiration should be to create brands that not only lead in their categories, but transcend their categories to become an intangible, yet real, part of a country's culture and day-to-day life. As we'll see, that is exactly what we have achieved with Tide and Dawn. It is what we are in the process of achieving with Olay and Swiffer. It is a priceless asset.

3. *A cost structure that provides superior value for consumers and financial returns that meet corporate requirements and justify continued investment.* In the end, the ultimate differentiator is superior value, which flows from

the realized and perceived benefit of the brand and its price. Of course, this is nothing new. To establish a leadership brand, we have always needed a business model, including a cost structure, that delivers superior consumer value. Identifying and delivering the right mix of product design, marketing support, cost and pricing is highly situational. It does not always mean inexpensive. It often differs from country to country. It is a moving target, changing along with consumers, competition and market conditions. We need to be alert and responsive to changing situations, anchored to only one commitment — *doing the right thing to provide superior consumer value.*

We cannot be complacent or assume that yesterday's formula for success will work today. You'll see later how we have gone off track from time to time in the value of our brands versus competition's, and how dearly this has cost us. But you'll also see how quickly we have been able to restore a brand's growth once we restored its value. You'll also observe instances where we've concluded that we can only operate in the higher-priced segment of a category, believing that trying to operate in the mid- or low-priced segments would result in a money-losing proposition. You'll discover how dangerous and erroneous this assumption is.

4. An Ability to Connect and Develop Technologies Inside and Outside P&G

Procter & Gamble is probably engaged in work across more technologies than any other consumer goods company in the world. From surfactants to polymers, from nitrates to nutritionals, from bone-building elements to flavors and fragrances, we're working on all of them, and many more. For over a century, P&G has leveraged competencies across multiple product categories *(see page 23)*.

For example, it was P&G's competency in controlling calcium to achieve superior cleaning in its laundry detergents that led to the technologies controlling bone mineral resorption used in our osteoporosis-fighting drug, Didronel.

Chuck Fullgraf, who played a leading role in creating our Toilet Goods and Paper businesses in the 1960s and '70s, put it this way: "Whenever we looked at entering a new business like shampoo or dentifrice, the first question was, 'Do we have technology applicable to this new area?' And if so, 'Do we visualize improvements we can implement that would make the product more attractive for the consumer?'"

Our ability to answer this question positively was an important reason why we acquired the Richardson-Vicks Company in 1985. We were confident we could bring improved technologies to its brands, and our people have done so superbly, as witnessed by the spectacular growth of Olay and Pantene.

The conviction that we could transfer health care and life science technologies to pet food was a powerful reason why we acquired Iams in 1999. That conviction is being fulfilled. P&G technologies that improve the health of pets' teeth and control their weight have helped almost double Iams' business in less than four years, making it one of the most successful acquisitions in P&G's history.

More recently, the opportunity to take advantage of proprietary P&G hair colorant technology was a powerful reason for acquiring Clairol's hair and colorant brands in 2001, and Wella's brands in 2003.

And it's not only technology we can link across categories. The same opportunity resides in our conceptual and marketing insights, as this example demonstrates:

- Olay achieved great success by presenting its Total Effects formula as addressing the "seven signs of skin aging." In a way, this was counter-intuitive. Olay was promising multiple benefits — seven of them — flying in the face of the familiar edict that you should only promise one. But by placing these benefits under a meaningful umbrella, women knew and appreciated what we were talking about.

- The Pantene brand team learned from Olay's success, developing a product and marketing campaign that addressed the six problems associated with dry and frizzy hair.

- Crest has reapplied this lesson, introducing a new "revitalization" formula for women that offers a combination of whitening, remineralization and breath-freshening benefits.

Our opportunity to gain competitive advantage through interconnectedness at P&G is as great as in any corporation given the breadth of the categories we operate in. But the sharing of knowledge and experience does not happen automatically. It takes a mindset that attaches great strategic importance to interconnectedness, along with simple structures and processes to ensure the timely, practical sharing of what works and what doesn't.

We also need to make these connections with external sources. The opportunities are unlimited. It's easy to forget that many of our greatest innovations at Procter & Gamble originated from external sources. Examples include the original formula for Ivory itself; the hydrogenation process used in Crisco; the critical surfactant technology in Tide; key fluoride technology in Crest; and, most recently, patents and products underpinning Swiffer and Crest Spin Brush. Developing innovations from external resources is especially important today, because of the dramatic shift in the source of innovation. Today, 30 percent of all patents being awarded go to small companies; in the early-'70s the figure was 5 percent. As one leader in our Research &

Technology Connections

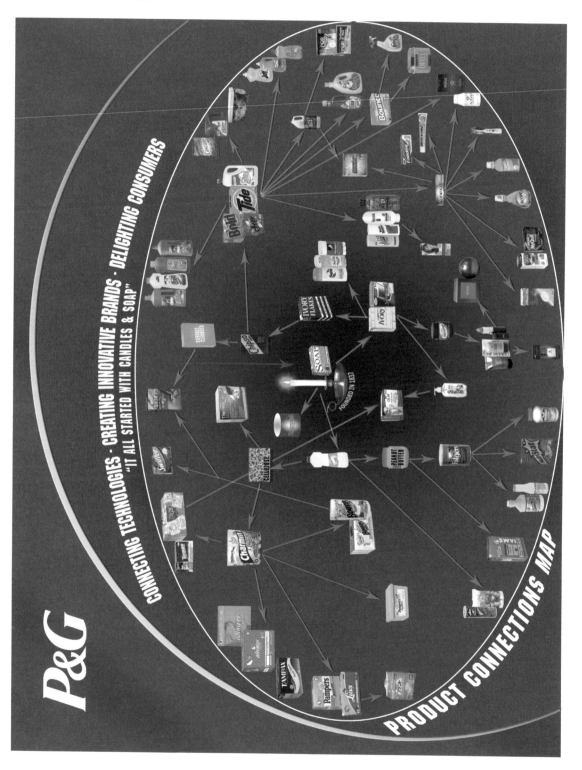

P&G's 16 Billion Dollar Brands ...
With More on the Way

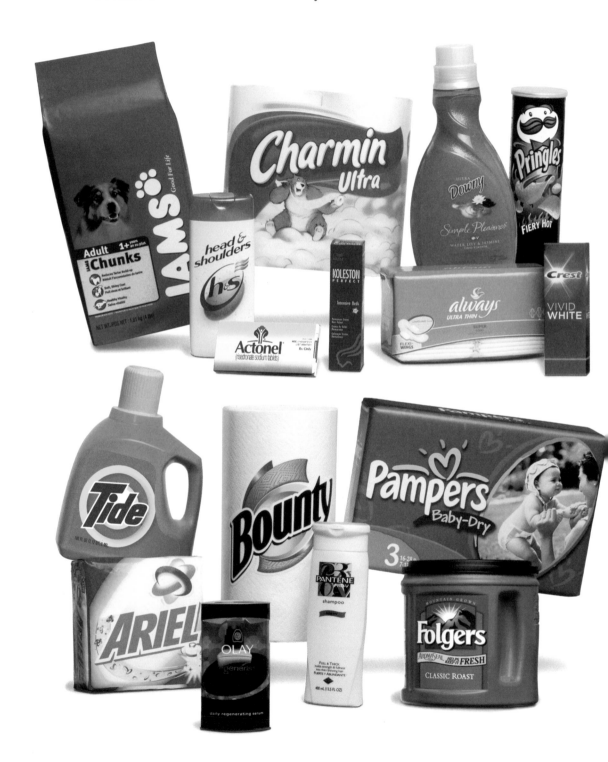

Development Department expressed it, we are moving away from "know how" to "know who."

5. "Champions" Who Create and Sustain Great Leadership Brands

P&G's greatest brand-building successes are often described as if they were destined to happen in some predictable fashion. But, of course, they were not. They happened only because of the insight of individuals who had an idea to create a great business and were unrelenting in pursuing it. They happened because of someone who saw a way to bring forth an innovation to satisfy consumers or gain stronger support from our customers. They happened because people were determined and able to gain a big edge versus competition.

Champions lie at the heart of P&G's success. Over time, we've created an environment in which ownership and championship have become part of the Company's "DNA." P&G people instinctively demonstrate these qualities. It's in our blood. As a result, examples of championship behavior abound throughout the Company:

- We literally would not have Tide, Pampers, Crest, Olay, Pantene, Bounce or Actonel (or many other leadership brands) if it had not been for individuals who advocated passionately for what they believed in, often in the face of opposition.

- We would not have Bounty if people like Paul Trokhan and Bob Haxby had not been convinced that they could create new papermaking technologies and make them work efficiently on high-speed lines in a way most people judged to be unattainable.

- We would not have Crest Spin Brush if a few individuals (whom you'll learn more about in Chapter 3) had not believed we could take a $4.99 mechanical toothbrush (which some, including the CEO of one of our competitors, reportedly described as a "toy") and turn it into a market leader in less than two years.

Champions take the initiative. They don't do so blindly. They don't allow their advocacy to overwhelm their objectivity. But they are willing to stick their necks out to make a difference. Carolyn Bergholz and Mary Jensen, leaders in our R&D department, did that for me. Their doing so proved crucial to my decision to acquire Tampax in 1997. The CEO of Tampax had contacted me to indicate he was open to selling us the brand. I was concerned this acquisition might involve us again in what had been one of the most searing experiences Procter & Gamble had ever encountered — the decision to withdraw Rely from the market because of its potential involvement in the serious disease, toxic shock syndrome. Bergholz and Jensen sensed my concern.

They asked to meet and assured me I should not allow this concern to stand in the way of the acquisition. They told me that ever since Rely we had been conducting exhaustive research and had been working with experts outside the Company to understand the disease. They took me through the benefits that came from clearer usage instructions. They demonstrated why we could be confident based on this research and analysis that Tampax did not carry a risk of toxic shock syndrome. It was a crucial intervention for me. We made the acquisition. And they were right about the safety of Tampax products.

We've also seen powerful championship from P&G partners. We would not have Cheer as we know it today had it not been for Peter Husting, Norm Muse and others at Leo Burnett insisting decades ago that we should move to an "all temperature" strategy. Folgers would not be the market leader today if it were not for Arthur Meranus, Susan Spiegel and others at the then Cunningham & Walsh Advertising Agency working with Bruce Byrnes at P&G to create and execute the brilliant advertising campaign: "The best part of waking up is Folgers in your cup."

Whether P&G's greatest brand-building successes came from the Company, an outside firm, or an agency partner, they happened because of champions. That will always be the case.

Many people have asked for P&G's "brand-building formula." Creating and growing billion-dollar brands is a complex business, but the essence of our time-tested formula can be found in these five simple factors.

Keeping Brands Young

Creating successful new brands that generate trial and achieve a leadership position is a formidable challenge. Few new brands and products in our industry pass this crucial hurdle. In fact, on average, eight of 10 new product launches fail in the first two years.

Challenging though it may be, launching a brand that becomes successful in its first years is only the beginning. Great brands maintain leadership for decades. They succeed by staying young. Beyond the five success factors, we must heed a few key lessons to keep P&G brands vital and growing.

- **First and Better:** We need to be first and we need to be better in delivering what appeals to consumers and produces greater total satisfaction for them. If in some cases we aren't first, and competition is, we must move quickly to neutralize our potential vulnerability. *We must never give consumers a reason to switch from our brand.*

- **Continual Holistic Innovation:** To ensure we're first, we must be certain we're allocating a significant amount of resources to upstream consumer learning and innovation. This requires dedicated staffing. People who are working on short-term executions while simultaneously trying to work on upstream innovation rarely have the time to do the latter. I have learned that painfully.

- **Value via Cost Discipline:** As we lead product innovation, we must also lead cost innovation. We need to be sure we're generating enough savings to launch our high-potential initiatives with enough investment and at a price that makes our brand a superior value. Continually increasing productivity and cost savings have to be ways of life.

- **Continuity of Expertise:** Every great brand I've ever observed has been led and staffed by men and women who have deep knowledge and experience with the brand and with its target consumers, competitors and relevant technologies. This is crucial, because the innovation and marketing breakthroughs that keep great brands young don't often happen as a result of "eureka light bulbs flashing over the head of some inspired genius." (This is a favorite saying of Craig Wynett's, a P&G leader in New Business Development.) Breakthroughs happen as a result of "the well-managed diligence" of experts on the brand who have passion and rich personal experience.

No P&G brand has enjoyed uninterrupted success. Those maintaining leadership over time have developed strategies and plans with these lessons in mind. And when they've stumbled, it's generally been because we have forgotten these lessons, if only briefly. A few stand-outs are particularly worth study.

Tide

In my view, P&G's greatest success of all is Tide. Yet its success has not come easily. And when the brand has struggled, it has generally been the consequence of failing to sustain a leadership pace of innovation.

When it was introduced in North America over 50 years ago, Tide took the market by storm. It has been the leader ever since. As I write this, Tide's volume market share is close to its all-time high of 30 percent (its value share is about 40 percent), despite the introduction of literally dozens of competitors over the last half century. Tide is more than four times larger than the No. 2 brand; its profit margin is well ahead of category average. Tide's success is the result of:

- A continuing flow of innovations that have kept Tide "the best of the best" both in fact and in consumers' minds: the best powder, the best liquid, the best in stain removal and the best in caring for colored clothes.

- Advertising that has presented Tide's benefits in a convincing and relevant way and made Tide part of nearly half the households in America.

- Competitive pricing and the most distinctive and compelling package design in the category.

- Finally, Tide's unmatched consumer loyalty and reach, which have earned it tremendous merchandising support from our trade customers.

It would be a dangerous misreading of history, however, to conclude that Tide's progress was either foreordained or easily sustained. Nothing could be further from the truth. In fact, during its half-century life, Tide's business suffered two severe setbacks. As shown in *figure 1*, Tide's market share declined by more than 25 percent during two different periods. Given Tide's enormous importance to Procter & Gamble's total business, it would be a wild understatement to describe these as unsettling events. I was around for both of them and, although I didn't work on Tide, believe me, this was *not* fun.

figure 1.

U.S. Tide Share

What caused Tide's share to decline? Very simple. We failed to bring better ideas and superior product performance to consumers. We failed to maintain a leadership pace of upstream research and innovation. We also lost our way in advertising a couple of times, moving away from highly relevant, contemporary and persuasive dramatizations of the benefits Tide can provide. And while it was not the only cause, I believe each of these mistakes happened when we placed less value on continuity and suffered from the consequent loss of expertise and experience.

A common source of Tide's problems in both the 1970s and '80s was a loss of focus on product and marketing innovation, not just on Tide, but on several of our other major brands as well. In the mid-'70s, this was partly a consequence of our having to defend the use of phosphate as a builder in our laundry detergents. Doing that consumed an enormous amount of R&D and Marketing time, distracting us from our product improvement program.

More insidiously, we fell victim at this point to the mistaken view that the laundry category was "mature" and capable of little growth. That, in turn, led us to overemphasize new brands in new categories at the expense of our key established brands, like Tide. When I returned from Europe in 1978 to lead the Packaged Soap & Detergent Division, I discovered six new brand projects. Not one was in the detergent category. I had the good sense to cancel three of them. I would have been even wiser if I had canceled two more, because they proved to be an inordinate drain on the development activity we should have been placing against Tide and our other leading laundry brands.

Tide recovered from these problems and has now returned close to its all-time highs. How? By regaining the lead in consumer-meaningful innovation:

- The rebound in the late-'60s was sparked by the introduction of enzymes in Tide powder, providing an entirely new level of performance on stains like grass and blood.

- The rebound in the mid-'80s was driven by the introduction of the first effective, heavy-duty, *liquid* laundry detergent and several major new technologies in Tide powder.

- The continued growth of Tide during the second half of the 1990s was driven by a succession of product innovations, including superior fabric-care technology.

Tide's product innovations have been supported by marketing programs founded on a deep and respectful understanding of today's consumer. Tide's advertising has shown the difference Tide can make in people's daily lives. It strikes an artful balance of communicating Tide's superior performance in

situations that are real, relevant and engaging.

Tide is the oldest heavy-duty laundry detergent in America. But it is fair to say it is also the youngest, based on its up-to-date product performance and its contemporary image. Very simply, because Tide understands today's consumers better than any other laundry brand, it has responded to consumer needs better than any other brand.

Ask 100 people in the United States which laundry detergent they would expect to deliver the latest improvement and best performance, and the great majority will answer "Tide." Consumer trust and confidence are the sources of leadership and growth on any brand. They have enabled Tide to triple in size over the past 15 years, giving lie to any notion that big brands can't grow strongly.

Dawn

Dawn dishwashing liquid is another example of a brand that quickly became a market leader by applying the five success factors, but then lost its way before resuming rapid growth.

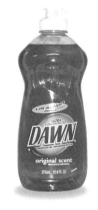

Dawn particularly highlights the *value* of identifying and developing a specific and meaningful benefit. At the same time, it punctuates the *risk* that an overly exclusive focus on that benefit can deter us from adopting other consumer-meaningful innovations.

Introduced in 1972, Dawn's proprietary technology provided a breakthrough in grease-cutting performance. It went into test market promising consumers superior overall cleaning. The brand performed satisfactorily in test, reaching a market share of about 10 percent. Dawn was about to go national when the brand decided that the advertising was too generic and the market share too small to justify broad-scale expansion.

I wasn't working on Dawn at the time, but I was close by and saw what was going on. I was impressed. These folks were setting the bar high! They weren't going to settle for a "just OK" result. I liked that.

The brand and agency went back to the drawing boards and emerged with a much sharper positioning: "Dawn takes grease out of your way." I'll always remember what one of the agency leaders said to me as he came by my office one day just as Dawn was being re-introduced: "John, we may not have as large a brand, but we will stand for something distinctive." If only all our predictions

were so *happily* erroneous! We knew grease removal was the toughest problem for consumers, but some felt it could limit Dawn to a relatively small share of the market.

This didn't happen. Grease removal was quickly seen as the standard of cleaning excellence, and Dawn became the market leader with a share of about 15 percent.

Following years of steady growth, Dawn lost its product and marketing initiative in the late-'90s. It suffered, not because of basic grease removal performance, but because of fragrance and package design. Colgate's Palmolive brand

figure 2.

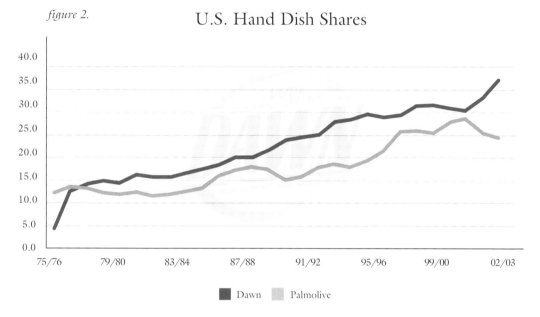

U.S. Hand Dish Shares

launched an attractive package and a series of fragrances. By the year 2000, Palmolive had cut Dawn's lead to less than four percentage points. How ironic! Indeed *maddening* would be a more honest description. P&G's introduction of Lemon Fresh Joy in 1968 was the first dishwashing brand to demonstrate consumers' interest in fragrance. Now, 20 years later, a competitor was beating us to the punch.

Why did this happen? We had become too singularly focused on the benefit of superior grease removal, which had underpinned Dawn's success. We weren't viewing the world through the consumers' eyes. We weren't focusing on the consumers' total experience during the dishwashing process. We had committed the cardinal sin of giving consumers a reason to switch from Dawn.

Fortunately, the story doesn't end there. Dawn has come back strong by developing its own preferred fragrance variations, presenting them in beautifully

designed bottles, and combining them with an improved grease-cutting formula. Once again, we see the payoff of renewing our brands based on a thorough and imaginative understanding of consumers' existing and emerging needs.

Secret

Secret teaches two important lessons: Don't over-react to competitive threats and don't assume opportunities for innovation are exhausted. These are both mistakes successful young brands can make, often keeping them from maintaining leadership over time.

At almost 50 years old, Secret is not far from its all-time share high and is the clear-cut market leader. Secret's success has not come easily. It has had setbacks along the way. As shown in *figure 3,* Secret leapt quickly to a share of 12 percent following its national rollout, only to fall all the way back to about 7 percent in 1974.

Secret's initial success was based on an extraordinarily insightful strategic positioning: It was the first effective deodorant made especially for women. It combined superior deodorant efficacy with a tailored fragrance that women preferred by a wide margin. Its positioning was as memorable as it was clear and simple: "Strong enough for a man, but made for a woman."

So why did Secret decline after its spectacular launch? The entry of strong, new competitors positioned for *all-family* use eroded the brand's market share. The all-family positioning was relevant and appealing; there was no doubt about it. But its impact on Secret's business was compounded by the brand's misguided response to this competitive reality.

Secret moved away from its unique focus on women to feature all-family performance. Here was a classic example of allowing a legitimate competitive threat to drive us away from what we do best, from our core reason-for-being. This change in strategy, combined with the lack of product innovation, sent Secret into a downward spiral.

Fortunately, we went back to the fundamentals that had produced Secret's success. By 1977, the brand returned to its positioning of "Strong enough for a man, but made for a woman." It was also strengthened by a series of important product innovations and more contemporary executions of its advertising strategy, thanks to excellent work by Leo Burnett. Secret had smartly adapted its core reason-for-being to changes in consumers' desires,

figure 3.

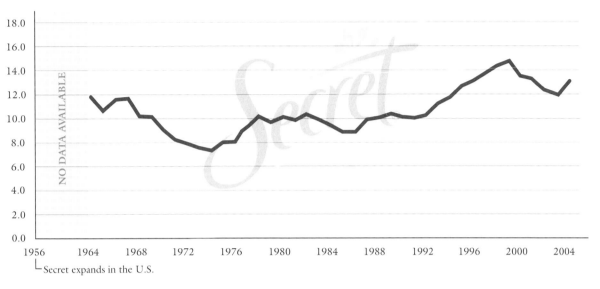

U.S. Secret Share

Secret expands in the U.S.

technologies and the surrounding competitive landscape. Its share recovered to more than 10 percent.

This wasn't the last time Secret would face an important share loss. During the first half of the 1980s, Secret declined by two share points. Again, the root cause was a lack of innovation. I had just returned from Europe to run the U.S. business, and I can vividly recall a suggestion in one of our product review meetings that the opportunity for any more significant innovations might not exist in the deodorant and antiperspirant category. Fortunately, we didn't buy that and we never should. I have never seen a consumer product category that can't create new innovations provided we stay close to consumers, invest in upstream product technologies, and use our imaginations.

New innovations did come on Secret: improved antiperspirants, more convenient forms, improved fragrances and more functional packaging. With them came renewed share growth. And by the early-'90s, Secret had become the No. 1-selling brand in the entire category.

Still, the challenges weren't over. They never will be. In 2000, Unilever introduced a deodorant/antiperspirant under the Dove name. By then, Dove had become the leading personal cleansing bar in North America. Secret's reaction to Dove's introduction was partially correct; partially not. It did upgrade its basic product form and introduced new versions and scents that appealed to teenagers. It improved its packaging graphics. Yet, in seeking to establish the brand's skin gentleness, Secret's advertising lost focus on its

primary antiperspirant benefit, a balance the brand has now redressed.

As I write this, Secret has still not regained its all-time share high, but it remains the strong leader — two-and-a-half times the size of Dove. It is still seen by women as the most effective and innovative brand. After more than 45 years, and despite many challenges, Secret remains very young.

Olay

The Olay brand started out strong, but then stagnated because it failed to apply the principles for keeping a brand young. That was the state of the brand when it came to P&G as part of the Richardson-Vicks acquisition in 1985. Initially, we struggled ourselves but, in the years since, P&G has leveraged virtually everything it knows about building great brands to turn Olay into a powerhouse. It has grown five-fold, becoming P&G's 13th "billion-dollar brand" in 2003.

Why? Because the Olay team has kept the brand young by
* Providing improved products and new forms that help women keep their skin younger looking, whatever their age.
* Keeping its package design fresh and contemporary.
* Using a highly creative marketing program that clearly and credibly communicates Olay's benefits.

figure 4.

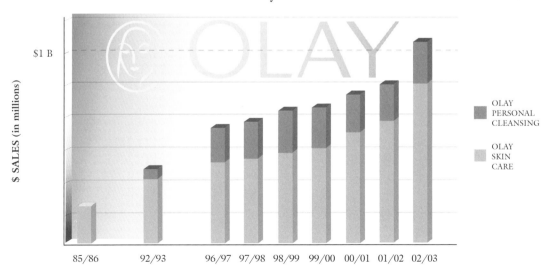

Global Olay Sales

$ SALES (in millions)

$1 B

85/86 92/93 96/97 97/98 98/99 99/00 00/01 01/02 02/03

OLAY PERSONAL CLEANSING

OLAY SKIN CARE

If all this sounds simple and straightforward, don't let me mislead you. A lot of orthodoxies and supposed truths had to be overcome to make the changes leading to Olay's growth. I can still recall the discussions in the mid-to-late 1980s. Many people thought Olay could only be a pink beauty fluid. After all, that's all it had ever been — not a UV moisturizer, not a cream, not white, not anything else. Almost no one thought Olay's product offerings should be expanded to include facial or body cleansing. For most, that bordered on heresy. Many others thought Olay had to come in a glass bottle. It always had. A plastic bottle could suggest cheapness! And there were serious concerns on pricing, too. Many people thought Olay could not command a significant price premium compared to other daily-use, skin care products.

The Olay team refused to be put off by these untested concerns. They learned that Olay's strong skin-care heritage would allow us to introduce personal cleansing products — first, a bar soap and then a body wash — and Olay quickly became one of the best-selling personal cleansing brands in North America.

Olay went on to introduce a whole new form of facial cleansing product, Olay Daily Facials, a gentle, wash-cloth-like substrate impregnated with cleansing and moisturizing agents. Here was another example of P&G leveraging technologies that had been developed in several different product sectors: Beauty Care, Paper, Fabric & Home Care and, believe it or not, Snacks & Beverages. In less than a year, Olay's share of the facial cleansing market tripled.

Olay also introduced new skin care formulas designed especially for more mature skin. In one of the most successful launches in skin care products' history, Olay introduced Total Effects in 2000. It achieved annual sales of almost $100 million in only 15 months. Olay Total Effects brought unique technology to meet a desire expressed by women around the world. They wanted a single product that addressed not one or two aging signs, but the whole range.

The Olay team faced many questions when it launched Olay Total Effects. One was pricing. Concept and use testing indicated that Total Effects could and should be premium priced, somewhere between typical mass market and department store brands. The team chose $19.99 as the target. *This represented a premium of more than 200 percent compared to other Olay facial moisturizers.* Would consumers accept that? Many of our retail customers were skeptical. So were a lot of people within P&G. But the product *was* unique, and the Saatchi & Saatchi advertising agency created compelling advertising to present its singular combination of benefits. The marketing plans also included endorsements by prestigious beauty care experts.

The result: Almost overnight, Total Effects drove Olay to global market

leadership in the facial moisturizer category.

More than anything else, I believe, Olay's success rests on the caring and intimate understanding that the champions, the people working on the brand, have for the women they serve. It is also a powerful testament to the importance of continuity. As I write this, General Manager and Vice President Gina Drosos has worked on this business for 13 years. She and her team know what women aspire to in skin care. They've kept Olay young by seeing it through the consumers' eyes. They have stayed focused on what really matters to the women who use Olay, not to those of us who manufacture and market it.

Old Spice: Resurrecting Your Grandfather's Brand

Old Spice presents the most remarkable example I've ever seen of our ability to revive a once great but declining brand and make it young again. Its history particularly highlights the importance of understanding our target consumers and providing bold, holistic innovations that delight them.

In 1990 P&G acquired Old Spice from Shulton. In Secret, we already had the leading antiperspirant/ deodorant brand among women. We hoped Old Spice would be the route to achieving the same position among men. That was our idea. But it was a long time in coming.

We knew the majority of Old Spice's sales was in its men's fragrance, packaged in a classic white bottle that found its way into older men's medicine cabinets to stay for years, sometimes even for decades, like a collector's item! Old Spice deodorant was small, unsupported and declining.

If Old Spice were to have a future, we knew we would have to bring young men into the franchise. It quickly became apparent that this would not be easy. Indeed, our first three years of effort suggested it might be impossible. We learned teenage boys wouldn't be "caught dead" with an Old Spice product. This wasn't a case of their viewing it as their father's brand. If young men knew Old Spice at all (and few did), they thought of it as their *grandfather's* brand. What an image to build on!

We developed one campaign after another. Nothing worked. Our biggest problem was that we were trying to nudge Old Spice's aging equity, with its sailing ship and white package, into the modern era. We wanted to enter the future while holding fast to the past. That simply didn't work. It rarely does.

Finally, a cross-functional group of fired-up champions emerged who made a sharp break in product, package and positioning. They introduced a new, bold red package and fresh advertising. It challenged young men to try this superior deodorant product by comparing it with the leading competitor and offering a "money back" guarantee to assure users of our confidence that they would like Old Spice better. And they *did*. A series of product improvements sustained the momentum. Pricing, which had been at a significant premium versus the market leaders, was brought to parity.

figure 5.

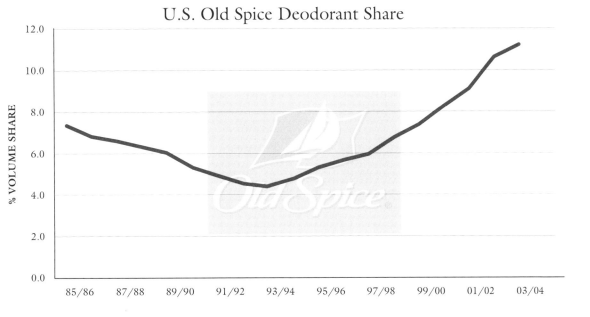

The brand took off. Sales have doubled in the past six years. Profits have increased fourfold. In summer 2003, Old Spice achieved outright volume leadership among men of all ages. Remarkably, it holds even stronger leadership among teenage youth, with a 33 percent share of that market, up fourfold from only 7 percent five years ago! It has become a vital, growing brand in North America, and its strong fundamentals are supporting its successful introduction into many new countries, including Mexico, Hungary, Russia, the Philippines and Greece.

From "your grandfather's brand," Old Spice has been turned into the "brand for today's aspiring man," a truly amazing transformation! The history of Old Spice proves a brand is like a living entity. It must change as consumers change, as technologies change and as competitors change. It must be seen by consumers as the "best brand for me *today*," even as it draws strength from the heritage of *yesterday*. Brands can achieve this if, and only if, we adapt the brand's innovation and strategic plan to respond to the changing consumer,

customer, technological and competitive environment around us. Old Spice has done this. It also shows the power of champions working together across functions. If those men and women on Old Spice had not introduced these innovations six or seven years ago, Old Spice would no longer be a viable brand. We probably would have sold it.

Mistakes Along the Way

A vital part of P&G's brand-building culture is our dedication to learning from what doesn't work. I know of no company that mines its failures for learning as rigorously as we do. And for good reason: Ignoring history is a sure way to repeat it.

The biggest mistakes we've made, often time and again, are not surprisingly mirror opposites of the success factors. We've failed to

1. *Understand and learn from consumers, including their attitude toward our competition.*

2. *Offer consumers a genuinely superior benefit and total usage experience.*

3. *Maintain a leadership pace of distinctive, meaningful innovation in product, marketing and other elements of a winning strategy. This has sometimes resulted when we strayed from a brand's core equity, and other times when we defined it too narrowly.*

We see these mistakes in the failure of new brands that could not succeed in the marketplace, and in the decline of once-great brands that should never have lost market leadership. Here are a few examples.

Citrus Hill Orange Juice

P&G entered the orange juice business with the purchase of the Ben Hill Griffin Company in 1981 and shortly thereafter introduced Citrus Hill. We believed we could use proprietary technology P&G had developed to deliver a preferred-tasting orange juice compared to Minute Maid and Tropicana, then (and now) the leaders in this market. Citrus Hill *did* offer an advantage in blind test, but it was much smaller than we had predicted.

We had also significantly undervalued the importance consumers attached to the "not-from-concentrate" process, which Tropicana used as its

marketing platform. To us, this sounded like a generic and superficial attribute that would tie Tropicana to costly sourcing locations near orange groves. How wrong we were! Not-from-concentrate proved to be a bell-ringer for consumers and a foundation for what has built Tropicana into a brand with annual sales of more than $2 billion. If we had done the type of research I described earlier to gauge consumers' reactions to the total brand proposition (the product, the package and the not-from-concentrate positioning), we would have known we were dealing with a formidable competitor. We were never able to develop a winning consumer proposition on Citrus Hill and eventually withdrew it from the market.

Monchel Bar Soap

Here is another brand that ran afoul of our failure to understand the source of a major competitor's strength and our inability to deliver truly superior performance in a key benefit area. We developed Monchel in response to Unilever's Dove, which had grown virtually without interruption since its introduction in the early-'60s. Dove used a synthetic formula and promised "not to dry skin the way soap can." It contained "one-quarter moisturizing cream" and it came in an attractive shell shape. We set out to create a winning proposition compared to Dove. We developed our own distinctive shell shape, a preferred perfume and an all-soap formula, which we believed offered superior mildness to Dove as indicated by our laboratory measurements at the time.

Those measurements were wrong — very wrong. We learned later through further development of our testing techniques that Dove *did* provide a technical mildness benefit. Over time, many consumers were seeing it. For years, we had failed to understand the real source of Dove's strength with consumers. No experience taught me more about the importance of having the right technical measurements. None underscored so eloquently the wisdom of the warning issued years earlier by Chief Executive Howard Morgens: "If we see a competitor's brand share continuing to grow, we should assume they have a product advantage. If we don't detect that product's advantage upon first review, keep digging, because it is probably there."

While Monchel was not a success, we didn't give up. Years later, in 1999, we finally did develop a product offering unsurpassed mildness and skin effects. Its name: Olay. It is now one of the leading personal cleansing brands in North America and growing strongly.

Ivory

Ivory is the saddest story of them all. It is the classic example within P&G of our misreading what a brand really stands for (and should stand for) in consumers' minds. Ivory was introduced in 1879 as the ultimate product for mildness and good skin care. Its excellent performance and superb value also made it the product of choice for other purposes, including cleaning laundry and dishes, but its roots always lay in its superior mildness for skin.

In hindsight, our actions over the years reflected a gross misunderstanding of this reality. For one thing, we became too enamored of the facts that Ivory was "99 $^{44}/_{100}$% pure," it floated and it was relatively inexpensive. These were important, particularly Ivory's economy, but they were not at the heart of what had made Ivory the choice of more consumers than any other brand. And these attributes were certainly not at the heart of what Ivory would need to be in the future, as new products entered the market, new technologies were created, and consumers' expectations for excellent skin care increased.

We lost touch with the consumer. We should have recognized that the essence of Ivory was its mildness and care for the skin. If we had known this and acted on it, we would have adopted superior skin-care technologies on Ivory far sooner than we did. Ivory, and not Unilever's Dove, would probably be the leading personal cleansing brand today in North America. In 1963, Ivory was the No. 1-selling bar soap in America with a volume share of over 60 percent. Today, its share is 4 percent. Ivory is still satisfying millions of consumers and, as I write this, Ivory is growing again. But if we had stayed in touch with consumers and honored their needs, Ivory would be a far larger brand.

As these examples illustrate, Procter & Gamble has never bought into the notion that brands have an inevitable life cycle. We have learned old brands need never die, as long as we keep them young. To be sure, *product* life cycles exist. We always need to be looking at how we can replace our current products with new ones that better meet consumer needs. If we don't, competitors surely will.

Learning from Personal Experience

The success factors I've outlined for creating great brands and keeping them young have not come from observation alone. They come directly from my own experience.

I have learned, sometimes painfully, that building and growing great brands is really a matter of sticking to the basics:

- Truly understanding consumers' needs.
- Creating a brand equity for consumers that is distinctive, compellingly attractive and persuasive.
- Maintaining a leadership pace of holistic innovation in product technology, packaging, marketing, and customer relations.

I was the brand manager on Cascade and Dash in the mid-'60s. Both brands grew in sales and profit during that time, but in hindsight, I succeeded on one and failed on the other. Cascade is the market leader today. Dash, at least in North America, is *gone*.

With Cascade, we built share in a growing market by focusing on the fundamentals. We improved the advertising, which focused on a distinctive, compelling performance benefit. And, we introduced a larger size to meet the needs of consumers who used their dishwashers more frequently.

Dash was a different story. I had an opportunity to make it a success but didn't take it. At that time, Dash's chief competitor was Unilever's All, which continues to exist. While it grew during my tenure, Dash wasn't on a sound foundation. We had an advertising campaign that seemed to be working, but the positioning (superior cleaning) was generic in a category where Tide already "owned" the ground of superior cleaning. I should have recognized that. In retrospect, our product improvements were superficial. We spent a lot of time fielding some ingenious promotions, and most worked, yet they weren't the foundation for long-term growth. We should have been developing a more distinctive strategic positioning and more significant product improvements. Nothing else really mattered.

Whenever I've seen us go off track on one of our great brands, it's because we have lost focus on the fundamentals or failed to execute effectively against them. When we're "hot" and really growing, it's because we've identified the fundamentals and are executing superbly against them. Our North American Fabric Care business has been a great example of this over many years. Results in 2003-04 showed excellent accomplishments in this category, the largest in the Company. Market shares were up with profits at all-time highs. Steve Bishop, general manager of this category, explains why:

As in much of the rest of the Company, the driver of our results has been a return to fundamentals. We've continued our innovation momentum and improved our advertising significantly. We've sharpened price points and our value equation where necessary. We've formed stronger partnerships with our customers. We've continued our aggressive cost reduction focus. We've become part of a trans-national, high-performance organization.

These are the basics. They create and sustain leadership brands.

The Increasing Value of Great Brands

The value of having a roster of great leadership brands, which earn the loyalty of two or three times the number of consumers as their nearest competitor, will carry even greater significance in the future than in the past, for at least four reasons:

1. Consumers will rely more on brands as "trust marks" to simplify choices as the pace of life grows even faster. A trusted brand is the instant assurance of superior performance, category-leading innovation and outstanding value. We want brands we don't have to think about twice when we shop — brands that have assumed an iconic quality, becoming part of our culture and day-to-day life. What is it worth to have earned a consumer's confidence to the extent that he or she writes down "Tide" rather than "detergent?" What is it worth to have a brand that mothers and fathers pass down to their children? A great deal.

2. They deliver scale. Only the largest brands will be able to offer the full range of products, package and size options to meet the needs of all potential consumers. Only they will have the priceless benefits of scale, cost efficiency and greater access to best practices and knowledge transfer.

3. They will offer unique value to trade customers. We must anticipate that most of our largest trade customers will place increasing emphasis on marketing brands under their own store label. As they do this, the one thing we can be sure of is that our customers will also make the strongest national and global brands available to their consumers and merchandise them strongly. Marginal national brands will wither.

4. They are the surest source of sustained growth. It will be harder to establish large, new brands in the future than it has been in the past. One reason is the tremendous fragmentation of media viewing by consumers. When I began my career, you could reach 25 percent of U.S. households on a single night with one TV commercial on "I Love Lucy." Today, even

the most popular TV show would deliver less than one-quarter of that reach. Another reason is the cost of marketing, both sampling and media. This isn't to say we won't create great new brands. We can and we will. But it will be more difficult. And that means once you have a great leadership brand like Tide, Pampers, Pantene or Always, the payoff for continuing to renew it by keeping it growing and young will be greater than ever.

A Stunning Story

If I needed any confirmation of the benefit of sustaining growth on our key established brands, I received it from a stunning story in *Advertising Age* in February 2003. I would have dismissed it as pure fiction if I had read it 20 years ago. It reported that Colgate Palmolive had announced that it would eventually sell its laundry business, effectively conceding victory in that category to Procter & Gamble. Colgate's Chairman and CEO Reuben Mark, one of the strongest competitors I have ever known, had acknowledged, "P&G's strength in the detergent category made any further effort by Colgate to build share unprofitable."

This concession was a direct result of our continued innovation, effective execution, and drive for cost effectiveness. It was the result of creating great brands like Tide and Ariel and keeping them young. Doing that is never to be taken for granted. It is a day-to-day, week-to-week undertaking. For more learning on how to do this, see the next chapter, "Let the Consumer Decide."

Creating Great Leadership Brands — and Keeping Them Young

Some Questions to Consider

1. What is your brand equity, brand strategy and business model? How do they differ from the competition's? Are they robust enough to win? What is the evidence of this?

2. What are the fundamentals for success on your brand? Are you satisfied that you know what they are? That you are implementing them? If not, what improvement(s) deserve top priority?

3. How are you planning to keep your brand young in the eyes of the consumer while staying faithful to its core reason for being? Do you have an innovation cycle that builds equity and value in your product's performance, design, marketing, in-store presence? Over the next year? five years?

4. If your brand is not achieving profitable share growth, do you understand why not? Are you focused on the few fundamentals to reestablish profitable growth? What are they? What are your specific plans?

5. Are you a champion for your brand or your project? How might you become a (stronger) champion? Do you have a team of champions? How could you make it a stronger team?

Chapter 3
Let the Consumer Decide

"The consumer is boss."

— A.G. Lafley, CEO

"We say the consumer runs our business. If you don't believe that, you're not going to succeed at Procter & Gamble."

— Ed Lotspeich
Former Vice-President
General Advertising

When it comes to doing "what really matters," no advice rings truer than *let the consumer decide*. A blunter way to say it is: *Never ignore the boss.* Some of our worst mistakes happened when we took it upon ourselves to make a decision for consumers instead of giving them the decisive vote. Not surprisingly, most of our greatest successes have come from doing the reverse. My career bears out the truth of this, both the good and the bad.

Looking back, the most catastrophic consequences I ever experienced from failing to let consumers decide came on Pampers Easy Ups training pants. It opened the door for competitor Kimberly-Clark (KC) to develop, almost on its own, what became a highly profitable business with sales of about $500 million per year.

For nearly a decade, KC was virtually without competition in this market as we at P&G struggled to innovate around blocking patents. KC used the rich profits from its pull-on entry to compete against us more effectively in the traditional diaper market.

In truth, the concept of a pull-on diaper was simple and transparently attractive: a diaper that you could pull on and off your child like underpants. Not exactly a controversial idea! P&G had actually conceived and started to develop this product in the early-'80s. We filed initial patents and had prototypes developed by 1985. But little more than a year later, we shut the project down.

This was not a thoughtless decision, but was it ever a bad one. And I was there. Why did we make it? Stand by. I'll answer that question in a moment. But first let me address a more general question.

Why Do We Let This Happen?

How can people who believe in serving consumers as much as we do sometimes fail to let the consumer decide? I have identified seven causes that can lead to this failure. Often several of them combine to lead us to a faulty decision.

1. We make a priority choice based on judgment without giving consumers the opportunity to tell us whether it's the right one. This was our mistake on Pampers Easy Ups.

2. We think too narrowly about what benefits a brand should (or could) provide, and what consumers would be willing to pay for those benefits. We usually fall into this trap because we fail to consider consumers' desired *total experience* with our brand. As a result, we're unwilling or too slow to test line extensions or brand variants based on a different array of benefits, including those whose cost would require (and potentially justify) premium pricing.

3. We project a positive consumer experience in one part of the world to consumers everywhere without proper testing. As we'll see, we have sometimes been led to do this by becoming overly fixated on a concept — such as speed or standardization. Other times we're blinded by our past successes.

4. We fall prey to the hollow lament: "We don't have enough time or enough money to do the research." I've found that the cost of failing to do sufficient research almost always exceeds the up-front investment, often exponentially.

5. We arrogantly dismiss a competitive idea as small or irrelevant.

6. We become so preoccupied with the amount of business in a particular product form, or with the capital we've invested, that we become reluctant to market a form that might cannibalize our existing business or make obsolete our current production process. When blinded by this trap, we usually re-learn the lesson (painfully) that if we don't introduce an innovation consumers want, a competitor will.

7. We concede to self-limiting assumptions about what we can achieve. We create false constraints on our ability to innovate, to enter adjacent categories and to succeed in new markets. These self-limiting assumptions leave us vulnerable to competitive attack and impede our ability to maintain a leadership pace of innovation or expansion.

I'll now describe a number of examples that illustrate the reasons why we sometimes *fail* to let the consumer decide. Following that, I will reverse direction, so to speak, and look at the mindset which is almost always present when we *do* let the consumer decide — which, fortunately, is most of the time at P&G. With this mindset, we commit to giving consumers the *total experience* they desire from our brands and from the benefits they can provide.

1. Failing to Let Consumers Tell Us Whether We're Making the Right Priority Choice

This was the mistake we made in closing down Pampers Easy Ups, which I described in the beginning of this chapter. Why did we do this?

First of all, we still had our hands full completing the product conversion from a rectangular diaper to a shaped diaper. We were already late. We had launched shaped diapers, which moms preferred by a wide margin, on our own Luvs brand. Kimberly-Clark's Huggies had quickly followed.

After a strong launch of the initial Pampers shaped diaper, we had followed with what we believed to be an improvement — a super-thin, more clothing-like diaper. Unfortunately, while the concept had tested very strongly with consumers, the execution was flawed. Partly due to leakage problems, and partly due to a negative perception of the very thin diaper, we were deluged with consumer complaints. We had to rapidly redesign the product.

The result of all this was that we felt enormous pressure to take everything possible off our plate so we could focus on our top priority: getting the product right on basic Pampers diapers. So, we shut down the pull-on diaper project entirely. Sadly, we even halted the development of patents and the protection of intellectual property that we had been first to identify.

We had made a critical priority choice without giving the consumer a vote. While making choices and achieving strategic focus are all-important, a few categories in our business (and baby diapers is one of them) are so important that we must vet our choice with the consumer, and cover *all* the strategically important options.

We rationalized our decision to delay pull-on diapers, because they were very expensive to produce — at least twice the cost of regular diapers. We didn't *think* very many consumers would be willing to pay this price.

Moreover, because we believed leakage prevention was the overwhelmingly desired benefit in the diaper category, and since we knew pull-on diapers would not offer a big improvement in leakage performance, we doubted if this premium-priced diaper would attract an important following.

In that judgment, we were wrong. Very wrong. If we had only let consumers decide, if only we had gotten data, they would have pointed us to the truth: A pull-on diaper was a big idea.

2. Defining a Brand Too Narrowly

Too often, we form *our own* view of the role a brand can play in a person's life rather than develop a consumer-defined view. Why does this happen?

For one thing, we sometimes become fixated on a technical performance feature and stop examining, imaginatively and proactively, how we can enhance the brand's total usage experience for consumers. Or, as we saw in the previous chapter, we may allow a key element of a brand's original equity to become a blinding constraint. That's what happened on Ivory. The "99 $^{44}/_{100}$% pure" trademark mesmerized us. We loved the fact that it floated. Crisco's original equity also blinded us. In Steve Bishop's words, we came to see Crisco as "white stuff in a can" rather than a "helper for moms to provide good food for the family." This latter view would have led us to introduce healthier forms, such as canola oil, earlier than we did.

At our worst, we are probably led to this error of defining brands too narrowly by plain arrogance. We allow our vision of what *should* be to become our conclusion of what actually *is*. We become so sure of our vision that we don't take time to test it in the market or subject it to scrutiny by peers and outside experts. We don't listen well enough to our own people. It's sad but true: Almost every time I've seen us make a big mistake, there were many in our organization calling for us to stop. But we were too busy, too intent on making a schedule, to listen.

More often, however, and much more insidiously, we have been led into this trap by our *very concern* for the consumer. We've been grounded in the belief that we could best meet consumers' varying needs by introducing different brands in the same category, rather than by extending the equity of an existing brand.

This tendency was probably reinforced, or at least enabled, by Neil McElroy's development of the brand management system in the 1930s. In the 1950s and '60s, it was easier and less expensive to introduce a new brand than it is today. You could sample households at a much lower cost and reach millions of consumers through an individual television program in a way not possible with today's fragmented media. (To be sure, a few brands were exceptions, like Ivory. It was such a strong equity, P&G *did* bring out companion products to the bar soap: Ivory Flakes and Ivory Snow.)

Alongside these historical realities was the concern that a new product form or a new flavor might dilute a brand's basic reason for being. Indeed,

there are many examples of brands that have added so many companion items they have ended up standing for nothing. However, our record shows that we have often been much more narrow-minded than consumers in understanding what they would like to have in one of our brands. We have been ideologically closed while consumers have been open to possibilities. As a result, we have been too slow to adopt valuable business-building innovations.

Crest. Former CEO John Smale tells one such story. In the 1950s, he had been the individual most responsible for capitalizing on the American Dental Association's recognition of Crest's efficacy, which led to market leadership for the brand. By 1968, John was advertising manager of the Toilet Goods Division. He and the Crest team were considering how to strengthen Crest's consumer acceptance. They identified a significant opportunity to broaden Crest's taste and flavor appeal. Crest had achieved its success with a single flavor — wintergreen. As time went on, however, new competitors had entered the market offering a range of flavors, many in the mint family. Crest's research showed that a large number of consumers preferred a particular mint flavor that we had developed. So, John forwarded a proposal to senior management recommending its addition to the Crest line-up.

The proposal was turned down — not for a month or two, but for over two years. Why? Some members of senior management felt a second flavor would dilute Crest's image by diverting consumers' attention from Crest's anti-cavity benefit. We eventually did add the mint flavor, and it quickly accounted for over 25 percent of Crest's total business. It didn't confuse consumers at all, nor did it weaken Crest's superior reputation for fighting cavities. It just gave millions of consumers what they wanted — a better-tasting toothpaste!

A second Crest flavor was controversial with us ... but not with consumers!

The story doesn't end there. Indeed, the history of Crest contains numerous episodes whose outcomes, good and bad, rested on whether we let the consumer decide. Years later, as John tells the story, a new competitor introduced a translucent gel form of toothpaste with considerable success. This time John was in the decision-making seat. He turned down the

recommendation to launch a Crest gel. Ironically, he had the same concern his predecessors had had about this new form possibly diffusing Crest's image. "We eventually *did* market a Crest gel," he acknowledges, "but later than we should have."

You would've thought by now that we would have learned the lesson on Crest. But we hadn't. Arm & Hammer introduced the first baking-soda toothpaste in 1986. We dismissed it. Why? We were confident from our clinical work that baking soda did not make an important therapeutic contribution to oral health. And we were right. But we had missed the point. Baking soda appealed to millions of consumers. It tasted and felt good to people brushing their teeth. It represented a certain "kitchen chemistry" that struck a chord with people. Six years later, we came out with our baking soda product, and consumers preferred it over competition. But we were six years too late.

To be clear, this concern about introducing a new form of a brand has often gone deeper than worrying how it might confuse the brand's image in the mind of the consumer. In some cases, the concern has rested on the reality that the new form does not fully match the performance of the existing product in an important benefit area. For example, the major reason we were late in getting a liquid formula on Tide was that we couldn't come up with one that cleaned as well as Tide powder. Once we changed our product performance target to superiority versus all liquid competitors rather than parity to Tide powder, we broke the deadlock. We had changed our mindset. We recognized that many consumers preferred the new liquid form because it provided a *different balance* of benefits, for example better solubility and greater convenience. Consumers valued those different benefits enough to accept trade-offs in other areas.

The lesson:
- Listen to what consumers say.
- Respect what the market tells you, and respond to it in a way that meets consumers' needs.
- Never give your consumers a reason to switch from your brand.

3. Assuming All Consumers Are the Same

As P&G has become a global company, we've learned that consumers are more alike than different. They have similar needs and similar aspirations for themselves and for their families. This is a wonderful thing for our business. It means that most of our technologies and core equities have global application. Still, we must recognize that there is no such thing as a "global consumer." We must not assume that consumer attitudes and behaviors are identical around the world. They are not.

Always. No brand illustrates the danger of making such an assumption better than Always. To begin with, I must emphasize that Always is one of the finest examples of brand creation in Procter & Gamble's entire history. It went from nowhere to a market-leading 25 percent share of the highly competitive feminine protection category — 50 percent larger than the No. 2 brand — in little more than a decade. It was one of P&G's great growth engines worldwide during the 1990s. Women loved Always from the start. It provided better dryness and absorbency and added important new benefits with the introduction of Ultra Thin pads and the "wings" design that offered added protection. Its advertising appealed to women emotionally and rationally.

Great example of brand creation ... and the reality that consumer preferences vary

Not for the first (or last) time, it was our very success with Always that got us into trouble. We had converted millions of women in Europe and North America to the new Ultra Thin product and we assumed women everywhere would respond the same way. We liked that prospect. We had a greater performance advantage versus competition on the Ultra Thin form. Our costs would be lowered by having most of our business in the Ultra Thin form. So we pushed Ultra across the board, almost to the exclusion of thicker forms.

What was wrong with that? A great deal, it turned out. We found that some women just about everywhere (and in some places the great majority of women) didn't buy our view that "thin was in." They didn't care that our technical tests showed that the Ultra form worked just fine. They preferred the body contact and the psychological reassurance they felt from a thicker product. Not only that, Ultra Thin came at a premium price. Many consumers just couldn't afford the higher cost.

Belatedly, we went back to the task of understanding the needs and preferences of these particular consumers. We developed a superior thick form. We're now giving consumers what they want, not what *we* think they should want. Our business is growing strongly.

Fairy Dishwashing Liquid. Again and again, we re-learn the need to understand and meet the needs of *individual* consumers, where they live. A wonderfully positive example of doing this occurred in Russia on Fairy dishwashing liquid several years ago. Our local organization concluded that Russian consumers would like to have a version of Fairy dishwashing liquid that contained an apple fragrance. Fairy was already the market leader in Russia. The idea of an apple fragrance sounded odd to most P&Gers outside Russia. A lemon or herbal fragrance? Fine. We had seen these work. But *apple*? What did apples have to do with a dishwashing liquid? A whole lot, the folks in Russia

На новый аромат!

Яблочнее Яблок!

Russian Fairy is a great example of responding to local consumer needs

felt, given the traditional presence of apples in the home, and they were right. As I visited Russia a month before writing this, I was delighted to see this variant accounting for over one-fourth of Fairy's market-leading 50 percent share.

Rejoice. Regional, national and ethnic differences need to be reflected not only in our products and packages, but also in our marketing, and sometimes in our brand names. There are few examples where our understanding of the local culture has meant more to our business than the name we gave to Rejoice shampoo in China. Rejoice is far and away the leading shampoo in China. Next to Olay, Rejoice is Procter & Gamble's second-largest brand in that country. It illustrates the power of choosing the right *Chinese* brand name.

While called Rejoice in English, it is called Piao Rou in Chinese, meaning "soft, smooth and flowing." As Sandra Beretti, a former Rejoice brand manager in China, says:

> *Piao Rou, in effect, embodies the shampoo category benefit for Asian hair. By virtue of our brand name, we "own" this benefit. No matter how many other brands claim to provide soft, smooth hair, Rejoice **is** soft, smooth hair. For Chinese consumers, Rejoice has become an icon. When we launched it in 1989, we could have chosen a name (phonetically), as many brands do, that sounded like the word "rejoice," but long ago my predecessor showed a lot of insight into the Chinese culture and language by selecting such a relevant and visual name for Rejoice.*

Rejoice in China demonstrates the benefit of choosing the right brand name

Advertising. Advertising is another area where sensitivity to the local culture is important. I vividly recall visiting our Eastern and Central European operations in the fall of 2000 and being impressed by how our best advertising reflected local cultural situations. I saw advertising on our No. 1 laundry detergent brand in Poland, which would not have been nearly as effective had it not portrayed family relationships particular to the Polish culture. I saw remarkably genuine and convincing Blend-a-Med toothpaste advertising in

Russia that used clinicals conducted in the Tula region to document our product superiority.

I'm not suggesting we won't have regional or even global advertising. Of course, we will. But many times local executions will make all the difference in the world between a mediocre and a breakthrough result.

4. Believing We Don't Have Time or Money to Learn

How often have we heard comments like: "We don't have enough time to do the research," or "We don't have any money" or, worse, "We know the answer to that question already"?

Much to my regret, I've found many things we think "we know already" that we don't know at all. One example that would be humorous if it hadn't been so painful involved the expansion of a new, pizza-flavored version of Pringles Potato Crisps into Italy. We had seen strong consumer acceptance of pizza-flavored Pringles in several countries, including the United States, Canada and the UK. The Pringles brand had just been introduced into Italy with results as strong as anywhere in the world. The idea of now introducing a pizza version looked like a "no-brainer." After all, who could possibly like pizza-flavored Pringles more than the Italians?

It turned out just about everybody! Lo and behold, Italian consumers had their own very specific notion of what pizza should taste like. And it wasn't at all like what they found in our new Pringles flavor. It failed miserably and, for a period of time, hurt the reputation of the total brand. Pringles has come through this, but the price we paid for not testing the pizza flavor among Italian consumers — for not letting the consumer decide — was very high.

As to not having enough time or money to conduct research, if these were ever good rationales, they are certainly not today. We can do Internet consumer research for little more than $1,000 and have the results back in a couple of days. There is no reason to "test things to death" (another trap). But we can get answers to key questions quickly and inexpensively, and save massive amounts of time and money by avoiding mistakes and subsequent rework.

5. Arrogantly Dismissing a Competitive Idea

We saw this earlier in our rejection of baking-soda toothpaste. We fell afoul of the same trap in Japan in the 1980s, when we initially regarded the introduction of compact diapers by competition as a small idea. We soon realized it was anything *but* small. Pampers' market share proved that by dropping from 85 percent to 8 percent in only about 18 months. Pampers' share today is back over 20 percent and growing strongly, but what a price! We also held off introducing pouch refills on shampoos in Japan for years, believing that consumers would soon grow tired of having to take the extra

step of refilling a bottle (as they have in some countries). But they haven't grown tired in Japan. With 46 percent of consumption in this package form, General Manager Werner Geissler approved the initiative, saying wisely, "We have to continue to stay in touch with reality and accept reality as it is and not as we would like it to be."

The lesson:
When in doubt, stop the internal debate. *Let the consumer decide.*

6. Fearing Cannibalization

Brands that quickly establish market leadership after launch tend to be innovation breakthroughs. They create new benefits or reset performance standards that render competing products obsolete. Ironically, these same brands can then be reluctant to innovate as boldly again, because they don't want to erode their base business. This is always a mistake, because if we don't innovate boldly, our competitors will.

Nonetheless, the fear of cannibalizing a brand's base business can be a strong inhibitor of innovation. The decisions that led up to the Pampers story at the beginning of this chapter are a perfect example.

Pampers. Pampers invented the mass market for disposable diapers in the early- to mid-'60s. By the early-'70s, Pampers had more than a 70 percent share of the North American diaper market. Disposable diapers at that time were rectangular, just like cloth diapers. Then, our scientists invented a shaped diaper that conformed to the body much like underwear. It provided better fit for babies, but cost substantially more per diaper than Pampers.

We were concerned that adding this high-cost feature to Pampers would risk losing consumers to lower-cost competitors, so we developed a second brand, Luvs, to carry this new, fitted diaper technology. Luvs was introduced in 1976. It was an overnight success, but it cannibalized Pampers' share severely, leaving the Company with a total share of about 65 percent.

In the meantime, Kimberly-Clark introduced Huggies, also a fitted, shaped diaper. By the early-'80s, still retaining its rectangular shape, Pampers' product had become clearly deficient. It had lost a quarter of its share. Still, a furious debate continued as to whether Pampers should stay at its current "popular price" and retain its rectangular shape, or move to the shaped form. We knew that moving to the shaped diaper would require premium pricing, and scrapping hundreds of millions of dollars of production equipment.

Surprisingly, some people, including a few in Research & Development, still believed inherent performance advantages justified retaining a rectangular

Fear of cannibalizing our base Pampers' business delayed our meeting consumers' needs

shape. They were convinced that Pampers' decline was mainly the result of poor marketing. The debate reached crisis proportions.

All this happened to coincide with my return from Europe in 1984 as I assumed responsibility for P&G's U.S. operations. I'll always remember my first major product review. The room was overflowing with people and it took only a few minutes for me to sense the deep disagreement: Should Pampers move to a shaped diaper or stay rectangular?

Tempers were running higher than at any P&G meeting I had ever attended. Hoping to get clearer on what to do, I asked to talk to mothers of diaper-age babies the next evening. I was sure others in the room had already talked to consumers. I wanted to do it myself.

I will always remember that night. It literally left me in a cold sweat. About a half-dozen of us went to a local shopping mall to observe a series of focus group interviews from behind a one-way mirror. We heard from three groups of mothers: one using Huggies, another using Pampers, and a third using both brands.

Their message couldn't have been more unanimous, or more alarming! *Every single mother preferred the shaped diaper.* The only reason Pampers' users said they were still buying Pampers was its lower price.

Mothers had decided and, then, so did we. We faced up to what we needed to do to serve the consumer. Our product had become an anachronism. As sometimes happens, a technological or product design innovation of such significance had been introduced that it had become a "price of entry" for any brand aspiring to category leadership. We had failed for too long to see that a shaped diaper had become essential to compete for a leading position in the diaper category. Now, we finally saw reality.

We bit the bullet. We ordered new production lines. We wrote down the value of our current lines, resulting in only the second year-to-year decline in Company profit in more than 30 years. We did what was right. Today, Pampers retains a three-to-one lead globally over its nearest competitor, Huggies. We wouldn't be the leader if we hadn't let the consumer decide in 1985. We would be an even stronger leader if we had let the consumer decide earlier.

Ariel. Our slow move to introduce laundry tablets into Europe in the late-'90s is a more recent example of our being slow to adopt a new product form for fear of cannibalization. To be sure, we had good reasons for doubting that a laundry tablet would succeed. We had marketed a laundry detergent tablet called Salvo in the United States in the 1960s, and it had been soundly rejected by consumers, because it often failed to dissolve completely. Other pre-measured laundry forms, including Tide pouches and multi-action sheets, had fared no better and had resulted in large financial losses.

Beyond the evidence from this painful history, we would have *preferred* that tablets *not* become a big factor in the market. Tablets would require significant new capital spending at a time when we had plenty of excess plant capacity to produce our granular and liquid laundry detergent brands. What's more, with our already strong laundry shares, tablets might heavily cannibalize our existing business. So, even though we had developed a good-performing tablet product that readily dissolved, we were reluctant to take it to the market.

Unilever wasn't reluctant at all. They wanted to reverse their market share declines and stop P&G's growth. They took Persil tablets to the UK market in April 1998. We quickly learned that many consumers liked this form. Times had changed since the failures of Salvo and the pre-measured laundry pouch. As a general manager once said to me, "The consumer has changed, but our anecdotes have remained the same." People had come to place more value on the convenience of the tablet form, and its solubility and cleaning performance had been dramatically improved. P&G's share of the laundry category in the UK quickly dropped by five points, falling into the mid-40s.

Pre-measured laundry forms — we were too slow to recognize times had changed

Seeing Unilever's success, we rushed ahead, appropriating tens of millions of dollars to provide capacity on blitz timing. We developed and introduced a superior product in Ariel. We have now surpassed Unilever's share on tablets and are back to a 50-plus percent share of laundry in the UK. Still, if only we had been listening to the consumer and not to ourselves. If only we had let the consumer decide. As former UK General Manager Chris Delapuente said: "The decision allowing Lever to get ahead of us proved very punishing, in profit and share. We are making progress, but it's real trench warfare battling with a formidable competitor. If we had launched tablets first, we might well be sitting on a share of 55-60 percent today."

7. Conceding to Self-Limiting Assumptions

Sometimes we're our own worst enemy. We become convinced that we can't do something: innovate in a mature category, expand into a market with entrenched competition, compete in multiple price tiers. As a result, we leave doors open for competitors who resist such self-imposed constraints. It's essential that we see these self-limiting assumptions for what they are, and reject them unless we're *certain* they are legitimate barriers.

It was a self-limiting assumption that Crest should come in only one flavor; that Tide should not be a liquid; that baking soda wasn't a meaningful ingredient in dentifrice; that Pampers users wouldn't pay a premium to get a fitted diaper. In almost every one of these cases, the issue wasn't so much our ignorance of consumers' needs and desires. We knew perfectly well that many consumers liked a liquid laundry detergent and a different flavor of toothpaste. Rather, our self-limiting assumption pertained to whether (and how) we could meet that need on a particular brand in a way that avoided undercutting its equity and its business.

Why are we occasionally trapped by self-limiting assumptions? After all, we're bright people. We're trying to do the right thing.

In the first place, we often don't recognize them as limiting assumptions. They are givens, unexamined truths; perhaps held subconsciously, not even articulated much less challenged. How do we cope with this potential pitfall? One way is to explicitly identify and write down the assumptions that underpin our business models and explore the possible options to these assumptions. How might we test the validity and relevance of our assumptions? What change in assumptions might make a different business model a better choice? How would we test that change?

P&G's laundry business provides an illustrative example. For years, we assumed we couldn't compete in the lower pricing tier of the laundry category in developing markets like China and India. We concluded we couldn't make any money in this tier and, therefore, we conceded the business to our competitors.

We added up our total system costs (e.g. formula, packaging, manufacturing, distribution and marketing) and identified the lowest price at which we could sell a brand and still make an acceptable profit. Unfortunately, in many parts of the world that price was far above what consumers were paying or could afford to pay.

Not for the first time, it took a crisis to force us to re-examine our pricing assumptions. As we'll see in the next chapter, it became clear that we weren't ever going to be the leader in the laundry business in China unless we could deliver a product to consumers for less than half the price we had previously thought possible.

We learned in India that our focus on serving only the upper income tier was severely limiting our business. As General Manager Shantanu Khosla wrote in January 2003:

> *Since 1997-'98, our business in India has declined by a third. Our pricing strategy had led us to narrow our focus to a small group of top-income households that only account for about 7 percent of laundry category volumes. Sadly, this strategy didn't even deliver the necessary consumption increases among the high-income consumer, because the drop in volume led to higher costs, which again led to further price increases — a vicious circle.*

Two thoughts raged through my mind as I saw this happening:

"If a competitor can meet these consumer needs, why can't we?"

"We're in business to serve *all* the world's consumers, not just the rich ones."

Today we are no longer constrained by the assumption that we can't develop better-performing brands at price points necessary to win the loyalty of the majority of consumers and still make money. We stepped back and challenged our costs. We became willing to consider the option of contract manufacturing. To provide performance superior to low-price competition, we've developed new technologies and dramatically reshaped our formulas.

Put simply, we changed our business model to meet the particular needs and desires of lower-income consumers — and still generate an acceptable profit for the Company. Chip Bergh, president of our business in the ASEAN, Australasia and India region, says it well:

> *We are focused now on defining where each brand must be priced to deliver the right return to all stakeholders, and then working our costs backward. Often this will point to the need to find a new business model to deliver the right cost structure to support our price. Once we know what we need to do, we get it done.*

Self-Limiting Mindsets That Can Prevent Us From Serving Poor Populations

In early 2003 at a conference in Davos, Switzerland, I heard Professor C. K. Prahalad, University of Michigan, address why many large companies fail to see the world's poorest populations as an opportunity. We need to understand *and respect* the needs of lower-income consumers. To do this, it's essential we stay aware of — and reject — self-limiting mindsets that can blind us. Prahalad described several of these self-limiting assumptions.

"The poor are not our target consumers." What companies are *really* saying is that their cost structures are totally out of line with what's needed to be able to sell to these consumers and make any money. They haven't examined alternative business models. In the great majority of cases, we're finding those business models are there.

"The poor don't need this product." This kind of thinking often misses how the focus is on a particular product form, rather than the function the product performs. For example, we might say that the lower-income consumers don't need a particular form of detergent. But we all agree they need clean clothes. We need to find the right product form, the right delivery system and the right supply system to meet the basic functional needs they can afford.

"Only developed markets will pay for technology." We're increasingly seeing how wrong this is. Meeting the needs of lower-income consumers at a price they can afford will often require new technology, and not just "trickle down" technology. We're finding this to be true on several of our businesses with innovations coming out of China.

"The bottom of the income pyramid is not important to the strategic health of our business." Not only does this miss the importance of scale economies, and the fact that the fastest growth in most product categories is occurring in the developing nations of the world, but we're also seeing innovations coming from developing markets that are proving applicable to developed markets.

"Intellectual excitement only occurs in developed markets." Another self-limiting assumption. Actually there is tremendous intellectual excitement in fulfilling the needs of the world's lower-income consumers, especially when it comes from discovering whole new models of operation.

'Get it done', they have. By changing virtually every aspect of our business model, P&G people are meeting the needs of an ever expanding number of our lower income consumers throughout India, Southeast Asia, and the entire developing world. As a result, our business is thriving.

While the first reason we sometimes end up operating with self-limiting assumptions is that we don't recognize them, the second reason is exactly the opposite. *We know perfectly well that we're operating by them and we are determined to continue to do so.* Why? Because we are following one of the cardinal rules of marketing: Maintain the integrity and simplicity of our equities.

We all know the fate of brands that have tried to stand for all things for consumers. They wither. In contrast, one great brand after another has been built on the back of a long-standing, simple equity:

- "Dawn takes grease out of your way."
- "The best part of waking up is Folgers in your cup."
- "Strong enough for a man, made for a woman."

And yet, as we've seen, our legitimate aversion to spreading ourselves so thin that we stand for nothing can prevent us from offering the benefits consumers want today.

We struggled for years to find a way to tell consumers that Tide would take good care of their colored laundry. We feared this new message could get in the way of Tide's standing for tough cleaning. Yet, we found a way to do it.

For years, we were traumatized by the challenge of figuring out how Head & Shoulders could stand for superior dandruff control and, at the same time, be a great choice for beautiful hair. It was a self-limiting assumption that we couldn't present both benefits. Eventually we did, thanks importantly to the creative work of the Leo Burnett Advertising Agency, which fashioned this simple and clear proposition, 'Head & Shoulders changes dandruff problems into beautiful hair'. As a result of the product and marketing innovation which has flowed to support this consumer promise, Head & Shoulders is the No. 2 selling brand in the world.

How do you overcome this pitfall of a knowingly held but incorrect self-limiting assumption? Here are two action steps I have found helpful:

1. Project how your brand's performance and position should evolve over time. Be conscious of your brand's heritage, but look forward to determine what will be needed for growth and leadership five years from now in light of developing competition, changing consumer needs, and emerging technology. Put together a strategic roadmap of

how the brand should develop in all its aspects — product performance, design, marketing, pricing — in order to provide a superior usage experience and value to consumers over time.

2. View the benefits your brand provides through the consumers' eyes, not your eyes, and not through the prism of technology alone. Test alternative concepts and products with consumers. Get a reading on what they want to buy. Let the consumer decide.

<div align="center">⋙·◉·⋘</div>

Delivering a Total Experience That Delights

The case histories I've cited have highlighted the negative consequences of our failing to let the consumer decide. This, of course, tells only part of the story. As you would expect, P&G *has* let the consumer decide most of the time. We wouldn't be the leader we are today if we hadn't been listening to our consumers and acting on what we learn.

This doesn't mean that consumers will always be able to tell us what they want or need. Often we'll need to interpret and imagine the product that will deliver an unmet need. Consumers said they wanted to relieve back pain without taking drugs, so we created ThermaCare heat wraps. Consumers said they wanted to find an easy way to collect pet hairs from floors, so we created Swiffer.

When we're at our best, we are the consumer's representative. We are the consumer's advocate. We operate with the consumer's interest at heart and we have a comprehensive, deeply ingrained knowledge of the consumer's needs. We imaginatively and expansively define the problem consumers would like to see solved, and the outcome they would like to achieve. We innovate to resolve the conflicts and contradictions consumers face. We provide that combination of performance benefits, aesthetics, package, form and price that gives consumers the *total experience* they desire and will lead them to buy our brand in preference to competition.

The Transformation of Hair Care

No example better illustrates this than the development of P&G's shampoo and conditioner "two-in-one" technology and the branding that flowed from it.

Believe it or not, we were wondering if we could make it in the hair care business in the mid-'80s, but then a series of breakthrough innovations arrived that set the foundation for spectacular growth.

It started with a technological breakthrough that answered a major, unmet consumer need. For years, we had known that the individual shampoo and conditioner products were not delivering the total experience consumers wanted. Shampoos tended to strip too much oil from hair. Conditioners left too heavy a residue. Moreover, many people thought using separate products was inconvenient.

Given the importance of the consumer need, manufacturers had been working for decades to combine the benefits of cleaning and conditioning in one product. Many clumsy executions of this technology had been brought to the market. The results were uniformly poor. The reason was simple: They didn't work.

By the mid-'80s, our R&D people were ready to introduce what they were convinced was an effective product execution of this concept. After four years of work, they had developed a unique formula that they knew technically would leave hair clean and at the same time well conditioned. Still, we weren't there yet. We now found that despite the technical facts, consumers were skeptical because of the experience they were having when using our new product. For one thing, our product was producing a low level of lather, suggesting that it wasn't cleaning well at all. So back to the laboratory we went for another year of work. Now we hit it. Ray Bolich created a silicone anionic formula that not only provided the desired end result, but also a total usage experience including the right amount of lather and a finished hair feel that convinced consumers the product was delivering on its promise.

figure 6.

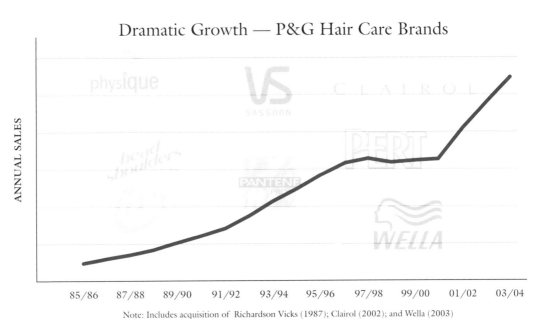

Dramatic Growth — P&G Hair Care Brands

ANNUAL SALES

85/86 87/88 89/90 91/92 93/94 95/96 97/98 99/00 01/02 03/04

Note: Includes acquisition of Richardson Vicks (1987); Clairol (2002); and Wella (2003)

As has often been the case, a better research method was key to this success. For the first time, consumers were asked to describe their experience while showering in a special facility where their voices were recorded. This provided a quality of input on the in-use experience we could not have obtained otherwise.

Still, even with this research in hand, many in the Company doubted that we should proceed to market. While generally positive, the quantitative research results were not off the charts. And the archives were filled with tales of failed "two-in-one" projects.

However, with strong leadership from passionately committed champions like Gordon Brunner, Franco Spadini and Ceil Kuzma who were leading our Hair Care research and development program, and Bill Connell, head of our Beauty Care Division, we decided to go to market. They wanted consumers to tell us if we had it right.

The technology was applied to Pert, a brand that we had successfully introduced several years before, but now was in a steep decline. Carene Kunkler, Pert brand manager, was convinced this technology could revive the brand's business. She was right. Almost overnight, the decline was reversed. Pert's share tripled, and that was only the beginning of the story. This breakthrough technology went on to be used in virtually all our hair care brands, including Pantene, which has become the No. 1 hair care brand in the world.

The hair care category had become a real problem child for P&G by the mid-'80s, delivering little growth and almost no profit. Talk about a turnaround! Hair care became one of the Company's great growth engines during the 1990s. Annual sales increased tenfold. Proportionately, profits grew even more. From a position of relative insignificance in the mid-'80s, hair care has grown to rank among P&G's top four largest categories today. Why? We had delivered on the total experience that hundreds of millions of consumers wanted for their hair.

Crest Gets It Right

I've already described several setbacks that occurred on Crest, because we failed to provide the total usage experience consumers desired. Fortunately, Crest has many success stories because we got the experience right. One occurred in 1985, at a point when our market

Crest Tartar Control ... We let consumers decide

leadership versus Colgate was being challenged. Our scientists had developed a new technology (pyrophosphate) providing a significant reduction in the formation of tartar on teeth. The question was how to use it. The initial plan on the table was to put it on a new brand called Pace and *not* on Crest. The reason will be a familiar one to you by now. Some people thought Crest should continue to stand exclusively for cavity reduction. They saw tartar control as a different benefit that could dilute and confuse Crest's anti-cavity positioning. Fortunately, several people responsible for the Crest brand didn't see it that way. They saw tartar control as simply another way of keeping mouths healthy and clean.

The debate raged, and I mean raged! The new brand, Pace, was about to go into test market at just about the time I assumed responsibility for the U.S. business. The Crest brand group decided to make one more pitch — to the new guy in town — *me*. They wanted this technology on their brand. I listened ... and agreed: *We would let the consumer decide.* A tartar control variant would go into test on Crest. We would also continue to evaluate it as a new brand. The rest is history. Crest, which had been losing share and had fallen behind Colgate, saw its share grow substantially. We regained leadership, moving from a 32 percent market share to 36 percent in less than a year. Here was a classic example of thinking broadly about what usage experience the brand should provide, and of giving the consumer the final vote on what that should be.

In the end, understanding what constitutes consumers' total desired experience is the key to our success. We must put ourselves in the shoes of consumers and approach them with genuine respect and affection. In my experience, developing that respect and affection (and the imaginative insights and innovations that flow from them) depends on one thing above all others: having direct, frequent and sympathetic contact with consumers.

Staying Close to Consumers

General Manager and Vice President Gina Drosos of our Skin Care Category told me of an unforgettable experience she had a few years ago at a focus group in New Jersey. She gained an important emotional insight that day into how women view beauty. In her words, it put her "on a mission to help women look and feel beautiful on their own terms."

Coming out of that research, Gina understood as never before that despite societal concern with problems stemming from poor body image in women and girls, most marketers were continuing to sell their products based on aspirations that are out of reach for the average woman. As Gina says:

I felt saddened and even angry that the perfect "super model" beauty portrayed by some companies was having the effect of making many women believe they were "ugly." I left that session determined to present Olay as a brand that could help women achieve their most beautiful skin, building their self-confidence rather than tearing it down with unattainable images.

The Olay Regenerist launch team, January 2003 — staying close to the women they serve. (l to r) Bobbi Jo Ehlers, Gina Drosos, Dr. Alexa Kimball (Stanford University), Noelle Fitzgerald, Remi Kent, Anita Kern, Michael Kuremsky, Lauren Thaman-Hodges, Maria Burquest, Phil Marchant

This is the type of insight that gives us the understanding of what consumers want and motivates us to deliver it. You don't get this sitting in an office. That's why Drosos and her team dedicate at least one day per quarter to a shared "consumer immersion" experience in the field. That's why Drosos never assumes that consumers around the world are all the same. That's why she and her team test concepts and products with consumers in each of Olay's top markets.

As Gina says:

We have found that while women want the same things overall — beautiful, young-looking skin — there are significant differences in their ranking of needs, product expectations and value perceptions. By getting broad consumer input early, we can efficiently build in opportunities for marketplace customization, like a lower percentage of a certain active ingredient to reduce irritation for Japanese women, or a whitening version for China, or a lower-cost package for Germany. This way, we gain the efficiencies of designing globally, while recognizing the need to win individuals' purchase decisions in every market we compete in.

Nowhere has this been better demonstrated than in mainland China. In January 1997, Consumer & Market Knowledge organization (CMK) Manager Lena Deng and Brand Manager Laura Xiong assumed new positions on Olay. They quickly concluded that the brand was performing far below its potential. They believed that by gaining an intimate understanding of women and how Olay could improve their skin condition, we could unlock that potential.

For three months they literally disappeared from the office. This was unheard of. They went across China talking to women about their needs, and how Olay could help fulfill them.

These three months set in motion a body of learning that has profoundly reshaped (and built) the Olay brand in China. It provided a far deeper understanding of many realities:

- Consumers' aspirations toward skin care and Olay vary greatly. Olay can be "Christian Dior" for women of modest means. For wealthier women able to afford skin care products of almost any price, Olay might be their basic regimen.

- The needs of many consumers are getting more sophisticated. Women in the affluent Eastern Seaboard were using a four- or five-step beauty regimen and needed more specialty products. This contrasted with the simple, two-step "clean and moisturize" process in less developed parts of the country. So, Olay created an array of products across the different price and image tiers to meet the diverse consumer needs.

- While women were in different places on the pyramid of needs and means, all of them aspired to keep moving up the scale, both in their ability to use the best skin care products and in their lifestyle. So Olay has kept bringing more high-class products to the Brand. Consumers like the fact that they and their Olay are upgrading together over the years.

- In-store presence is key to winning. The Olay team resolved to build quality beauty counters with great service. They learned that service didn't so much mean selling as understanding consumers sufficiently to help them select the solutions that met their needs. The counseling our beauty consultants provide has been critical in building consumers' trust in Olay.

Olay beauty counter — mainland China — critical to Olay's success

Olay's results in China:
- Sales have tripled in only six years.
- It's P&G's largest brand there.
- It's the second-largest Olay market in the world.

This is what deep, intimate consumer knowledge — what letting the consumer decide — has produced.

This commitment to truly understand the experience consumers desire pervades all our strongest operations.[1] It is why Deb Henretta, president of P&G's Baby Care business, and her team have created Baby Care Research Centers in Cincinnati, Ohio; Geneva, Switzerland; and Kobe, Japan. Hundreds of moms, dads and babies visit these centers every day. They test our products and participate in usage panels and focus groups. As Henretta says, "This provides daily interaction between P&Gers and our target audience. It gets managers out of the factory and into the nursery."

It's easy to agree on the importance of staying close to the consumer. It's a lot harder to do it consistently amidst the welter of day-to-day activity. That's why it is especially important that *leaders lead* in conducting the research. Beware of the notion that face-to-face research should be done only by junior people. Role-modeling by senior leadership counts for as much in this as it does in everything else.

And let us never forget. Our personal, imaginative and empathetic contact with consumers does even more than help us understand the *total experience* consumers are looking for. It generates that *affection* for consumers that fuels our determination to improve their lives. Allowing consumers to decide is not only the right business decision; it's also an enormously rewarding personal experience. It makes it possible for us to experience the motivating power of our Purpose as a company: genuinely improving consumers' lives.

[1] Berenike Ullmann, who led our Consumer & Market Knowledge organization in Greater China for over a decade and as I write this, does so in Eastern Europe, Middle East and Africa, eloquently expressed our opportunity and responsibility to understand consumer needs in this directive: "We must nurture consumer loyalty, and find ways to capture the trust of competitive users. A consumer in rural Russia said to us: 'If there is not enough money one month, we will just do without, except Tide. Tide cannot be replaced by anything else. I have to have my Tide'. Where we have consumer loyalty, we must preserve this faithful relationship and nurture it with formulations and perfumes consumers love, prices they believe are good value, in sizes that are right for them. We must make shopping easier for them by further improving our packaging and in-store presence. We have a duty to speak for the consumer in our decision-making process, and help guard against internally focused changes that are not consumer preferred, and not market driven, where 'Machine is the Boss' instead of 'Consumer is Boss'. We need to demonstrate humble learning attitudes; deeply understand consumers; respect for their choices; understand they are smart shoppers and we have something to learn here. We also need to dig out what consumer needs are still unmet and in what ways competitive products do not fully satisfy them, where ours could do so. In all ways, we must cherish consumers trust and love for our brands and we must do more to nurture this precious relationship."

Let the Consumer Decide

Some Questions to Consider

1. Who are your target consumers and what do they want, wish for, aspire to receive from your brand to improve their (and their families') lives?

2. Do you have a well-defined and firmly scheduled plan to gain insights from consumers on the total usage experience they want or might want from your brand? What is it? Does carrying it out receive top priority? Are you personally involved in carrying it out?

3. What is the total experience which your brand is offering your target consumer? Is it better than what your strongest competitors are offering? How do you know? If it's not better, why not? And what are you doing about it?

4. Which features and performance elements of your brand, of your competition and of the category are the most important in determining your consumers' assessments of their total usage experience? How does this vary among different groups of your consumers? How does your brand compare to your strongest competitor(s)?

5. What new benefits or services could be provided in your category over the next several years that would offer a major enhancement of consumers' usage experience? What are you doing to lead the identification and provision of these key opportunities?

6. What are the brand strategy and upstream product, packaging and marketing plans that provide assurance that your brand will be providing a preferred usage experience to your consumers in the coming year? three years? five years? How? In what way? How will this be better than competition?

 Do these plans include elements that will provide a superior and improving shopper experience at point of purchase? How?

 How have you prioritized your plans to manage business growth and strengthen your equity?

7. How could your brand do more to improve consumers' lives?

Chapter 4
Going for the "Big Win"

"Be ready to bet the farm, young man."

— Richard R. Deupree

"Only those who dare to fail greatly can ever achieve greatly."

— President John F. Kennedy

Those are bold words, but wise ones. Over the years I have realized that when it comes to doing what really matters, you have to be prepared to go for the "big win," not the safe win. This usually means having to overcome difficult challenges and often tough odds in the process. It means being willing and able to change the rules. It means being persistent and adapting to learning along the way. But I have also come to see it means going after that big win smartly and prudently. Failure to do so can be very punishing. This is an artful balance to achieve, as the following stories will show.

The year was 1976. The place, Rome. I was 38 and had been general manager of P&G's Italian subsidiary for about two years, which had been challenging. Inflation was extremely high, and price controls had been imposed by the government. Our major competitor had launched a price war.

But as I began my third year in Italy, things had settled down a bit. We were ready to handle a new brand and had narrowed the list to two contenders: Monsavon bar soap, the clear-cut, personal cleansing leader in France; and Pampers, a great success in the United States, but unproven in Europe.

P&G's profit situation in Italy and Europe was dismal at the time. Our Italian profits that year were less than $10 million. In all of Europe, our profits were less than $30 million. P&G was having a tough year globally, as well, since it was still recovering from the economic challenges created by the Middle East oil crisis.

We missed the "big win"

We knew that introducing Pampers in Italy would require a large and risky investment. The Monsavon investment would be much smaller. Not only that, the disposable diaper market in Italy hardly existed. As a result, we didn't feel a particular sense of urgency on Pampers. We thought we had time.

So we chose Monsavon bar soap as our entry. It looked easy, straightforward and not too expensive. We already had a strong position in bar soap with Camay, and a Monsavon launch could rely on distribution channels covered by our existing sales force. We would get back to Pampers a bit later, we thought.

What a mistake! A year later a local company called Lines, which already led the Italian market for diaper inserts, introduced a disposable panty diaper closely equivalent to the Pampers product. Making things even worse, Monsavon's performance was mediocre at best. Its French heritage did not translate well for Italian consumers, and the brand was eventually pulled from the market.

We introduced Pampers in Italy five years later. By then, Lines had built more than an 80 percent share of a now rapidly growing disposable diaper market. Catching up was nearly impossible. We negotiated for 10 years with the family owners of the Lines business and ultimately formed a joint venture. Today Pampers is the market leader in Italy, with more than a 50 percent share. But we could have achieved that position a decade earlier at a far lower cost if I had taken a long-term view in 1976. We could have gone for the big win rather than what I thought would be the safe win which, of course, turned out to be no win at all.

A Very Different Story: Winning Big in Eastern Europe

That lesson was very much on my mind 14 years later when Wolfgang Berndt, Ed Artzt, CEO John Smale and I faced a major decision: how to proceed in trying to create a business in Eastern and Central Europe.

The story begins in January 1990. I had just assumed responsibility for P&G's International business. The Berlin Wall had just come down. We sensed that the countries of Eastern and Central Europe were on the cusp of opening up for business in a big way. In the midst of the political, social and economic upheaval in the region, we and every other company had to answer the same question: How far and how fast should we move?

We did two things that enhanced our chances of making the right decision:

First (and at his request), we asked Wolfgang Berndt to develop P&G's entry strategy and plans for Eastern and Central Europe. Wolf was then running the Company's business in Canada and Latin America and was highly respected as an outstanding leader.

Second, we decided to visit the key countries right away to assess the situation firsthand. I'll always remember that trip in February 1990. John Smale, Wolfgang Berndt and I, among others, boarded a plane in London to make a week-long trip to Berlin in East Germany; Prague, in what was then Czechoslovakia; Budapest, Hungary; Warsaw, Poland; and Moscow, Russia.

Wolfgang Berndt led the way into Eastern and Central Europe

Going in, the experts told us we would almost certainly want to start up quickly in Czechoslovakia and probably in Hungary, as well. We were advised to move slowly into Poland and to stay away from Russia altogether.

Our trip led us to a very different point of view. It confirmed that we should move quickly into Czechoslovakia and Hungary and we did, appointing general managers almost immediately.

Our visit to Poland was a pleasant surprise. We had the opportunity to meet with two key leaders of the reform movement, Andrzej Olechowski and Leszek Balcerowicz. These were impressive men — smart, realistic, determined. U.S. Ambassador John R. Davis vouched for their capability and sense of purpose. We were ready to bet on their ability to succeed. We brought in a small management team and, with a strong local partner, Jacek Dzierwa, we were underway.

As we had been forewarned, Russia was a different story. We arrived in Moscow in the dead of winter. Our visit coincided with the return of Maestro Rostropovich for a stunning concert (which P&G co-sponsored) in the magnificent Moscow Concert Hall. Rostropovich was received as a returning hero after 17 years in exile. He capped his performance with Shostokovich's "Fifth Symphony" and John Philip Sousa's "Stars and Stripes Forever." It was a night we will always remember.

While Russia's cultural light shone brightly, the outlook on the business front appeared problematic. We had a full day of discussions, being ushered from one official's office to the next. We weren't always sure whom we were

meeting, but we sensed that each person was at least one notch up in the hierarchy.

We came to the final meeting, in the Kremlin. We crossed snow-covered Red Square, went through the Kremlin gates and were ushered to an imposing conference room at least 30 meters long and lit by enormous, ornate, golden chandeliers. Now we figured we were dealing with someone who could make decisions, and it quickly became obvious he had been briefed on every contact we had had earlier in the day.

His proposition was simple and unbelievably bold. He offered us the opportunity to buy the State factories throughout the Soviet Union — the

The Kremlin (as seen from Red Square)

entire business — for laundry detergents, personal care products and paper products. A bit more tentatively, he suggested we might want to consider acquiring some food plants as well. Needless to say, it was mind-boggling. It seemed as if the government wanted us to become a joint venture partner or, perhaps, even the successor to the government in what would continue to be monopolistic, controlled industries in virtually every category in which P&G competed.

The concept of competitive free markets clearly had not arrived! It didn't take a lot of reflection to know this was *not* where we should begin.

Fortunately, we found another way. A few months later, Enzo Ferraris, who was to become our first general manager in Russia, met the rector of St. Petersburg University. We decided to form a partnership with the University to help us start up our business, with headquarters in St. Petersburg. In fact, our first office was located at the University alongside the Neva River.

P&G Russian Customer Business Development Team, with Neva River, St. Petersburg, in background

Across the region, we made the choice to launch leading performance brands in several of our largest categories to quickly gain scale and presence. We knew if we weren't there quickly, our competition would be, particularly our European-based competitors.

We started recruiting and building a strong organization of local young men and women.

And, we made the needed investments (with appropriate government incentives) to provide local production. In fact, the way we did this involved an important strategic choice in itself. We created our Eastern European Product Supply structure based on a regional, rather than country-by-country, model.

Our competitors seemed to have a vision of Eastern Europe going down the path of Latin America with closed markets and high trade barriers for many years. We had a different vision. We anticipated, in part based on our contacts with government leaders, that these countries would come together rather quickly as reasonably open, low-tariff markets. So we followed a strategy that created large, regional plants giving us a significant competitive advantage in cost, capital efficiency and speed of innovation. This approach also allowed us to expand quickly into several global categories. In the years since, local product sourcing has been essential to our ability to offer P&G brands to consumers at prices they can afford. Interestingly, these production sites are now among the lowest cost in the P&G world and have become sources for exports outside the Eastern and Central European region.

Going for the big win also led us to approach government leaders and other members of the community with a clear explanation of the Purpose,

Values and Principles of the Company. I began virtually every initial meeting with government leaders and potential partners by reviewing our Statement of Purpose. I firmly believe their understanding of our commitment to the long term, combined with our results, helped us secure strong government support when and where we needed it most.

We achieved competitive advantage in Central and Eastern Europe in a host of areas:

- In the leadership position and reputation of our brands (among both consumers and customers).

- In the lower costs and faster innovation permitted by our scale and our regional product sourcing strategy.

- In the quality of our organization.

- In the relationships we were forming with governments and other local institutions.

Our strategy was sound and its execution strong.

Today, Central and Eastern Europe is one of P&G's strongest, fastest-growing regions in the world. Its expansion is fueling our ability to grow not only there, but in other parts of the world. We needed to be there. We had a strategy to win there. And we have. Big.

My experience in Italy as well as Eastern and Central Europe taught me that we must go for the big win. But it also taught me that we need to choose our opportunities wisely and attack them with well-drawn strategies and superb execution.

What It Takes to Win Big

Big wins carry big stakes and are intimidating for even the most confident, courageous leaders. Making decisions like when to go for a big win, what strategy to follow, and how to manage the risks is complex.

I have found that we are more likely to make these decisions correctly when we address four simple questions:

1. How big is the business opportunity?

2. Do we have a sustainable strategy that gives us the right to win?

3. Have we figured out how to win big?

4. Have we been thoughtful in managing the risks of big wins?

1. How Big Is the Business Opportunity?

First, in going for a big win, it is vital that we pursue opportunities where the long-term strategic consequences are commanding and the business potential is huge. Is the opportunity one that P&G cannot afford to cede to a competitor? Assuming we are successful, will the realization of this opportunity make a major contribution to the future health of Procter & Gamble?

As we've seen, we concluded that the opportunity to build leadership in the newly opened economies and societies of Eastern and Central Europe was one we would *not* cede to a competitor. The reasons P&G refused to quit in Japan, despite significant losses year after year, were that winning in Japan was of great strategic importance to Procter & Gamble, and that the payoff would be huge. We saw Japan as critical, not only because of the size and the purchasing power of its population. We also sensed that learning how to win with the highly demanding Japanese consumer would help us win with consumers in other parts of the world. And it *has*.

2. Do We Have a Sustainable Strategy That Gives Us the Right to Win?

I never faced this question more squarely than I did in deciding what to do with our pharmaceutical business.

That was by far the biggest strategic issue I faced in terms of P&G's portfolio as I became CEO in July 1995. P&G employees and outside analysts alike were asking the question: Should P&G stay in the pharmaceutical business? It was a relevant question. The pharmaceutical business represented only about 1 percent of P&G's total sales, and we were losing money. Also, we were very small compared to our major pharmaceutical competition. So what to do?

On the one hand, we knew the pharmaceutical market was enormous and far larger than any other category we participated in. And we knew it would grow rapidly as the population continued to age. Still, we faced the question: Did we have the right to win? Could we develop and execute a sustainable winning strategy?

That was the focus of the review I undertook upon becoming CEO amidst a chorus of analysts suggesting we were too small to succeed. We considered all possible options, from divesting the business to making further acquisitions. We knew success in pharmaceuticals was hugely dependent on product innovation, a strong suit for P&G. We also knew we had technologies growing

from our work in life sciences and our other businesses that could be the foundation for important new drugs.

This was a start, but it was very general. Turning P&G's pharmaceuticals business into a big win required clear, strategic choices about where to compete in the enormous pharmaceuticals industry. Gil Cloyd (who then led P&G Pharmaceuticals) and Mark Collar (its current head) selected a few therapeutic areas in which they believed we could achieve leadership

P&G Pharmaceuticals' clear strategy gave us the right to win

based on existing strengths and future Research & Development programs. They anticipated consumers' increasing role in health care decision-making and applied learning from our consumer businesses to create competitive advantage. They knew a small division couldn't afford a huge infrastructure, particularly given the uncertainties inherent in drug development, so they embarked on an extensive campaign to in-license, out-source and partner our way to flexible capacity and augmented capabilities. They identified improved productivity as a structural industry issue and executed other projects to boost our efficiency. Last, they established tough annual financial milestones with the expectation that we would be profitable by fiscal year 2003-2004, and thereafter make an increasing contribution to P&G's overall growth.

Today we are *ahead* of that path. P&G Pharmaceuticals reached profitability two years earlier than scheduled. It has achieved excellent growth on its established drugs (particularly Asacol and Macrobid) and now has its first billion-dollar brand, Actonel, for post-menopausal osteoporosis. An array of promising new drugs is in development. The future looks bright. We went for a big win in pharmaceuticals and we are on the road to achieving it.

3. Have We Figured Out How to Win Big?

Identifying the right opportunity and assuring ourselves that we have a sustainable, winning strategy is only part of the challenge. The next is to figure out how to win and then *do* it. The most successful big-win strategies do one (and usually several) of the following:

- Set breakthrough goals.

- Change the rules.

- Create new business models.

- Move first.

- Capture unique moments in time.

- Combine breakthrough gains with continuing improvements.

- Adapt to emerging learning.

- Tap the power of personal leadership.

Set Breakthrough Goals

Without a breakthrough goal — a stretching vision — a big win may occur, but it will be an accident, and a rare one at that. While accidents are welcome, you don't build a great company on them.

It has often been said that placing a man on the moon was first a victory of vision, and only after that a product of technology. I agree. Breakthrough goals open the door to breakthrough results.

Pampers. Maybe we would have been the first company to market a commercially affordable disposable diaper, even if Howard Morgens hadn't established a breakthrough goal, but I doubt it.

In 1961 in its first test in Peoria, Illinois, Pampers' retail price was 10 cents per diaper. At that price, we sold less than half of our objective; Pampers was too expensive for regular use. So the decision was made to drop the price by 30 percent. Sales picked up significantly; enough in many people's minds to justify expansion. But not in Morgens'. He was not at all satisfied. A breakthrough success is what he wanted. He wanted disposable diapers to be priced low enough to be an everyday replacement for cloth diapers, not an occasional, specialty-use item. So the price was reduced again and Pampers entered its third test market. *Now* we had it. Projected national volume exploded to a level 40 times greater than was achieved in the original test market. Then came a whole new challenge: how to sell a diaper at this price and still make money. But as I have almost always found to be the case, when we know what we have to do, we do it.

Ariel in Egypt. The history of Ariel laundry detergent in Egypt teaches this same lesson. We win big when we pursue big goals. We entered Egypt in 1986. One of our earliest brands was Ariel. However, it was competing only in the small, "low-suds" segment of the market, for use with expensive automatic washing machines. By mid-1989, Ariel still had only a 7 percent share of the laundry detergent market and was not growing.

Fuad Kuraytim, who led the growth of P&G's business in the Middle East and Africa, saw that we would never achieve a big win this way. He knew if we were to become the leader in the laundry detergent business in Egypt, as we

already had in Saudi Arabia, the Gulf States and Morocco, we had to compete in the dominant hand-wash sector of the market.

A new "high-suds" Ariel was designed for this purpose, and in January 1989 it was placed in a Cairo test market at a price of 85 piasters. This was more than twice the local competition and initial results were disappointing. Kuraytim believed that if we could drop that price to 50 piasters, we could increase our business dramatically *and* begin to make money. He knew the only way this could be done was to develop local manufacturing capability in Egypt, which would require the construction of a local manufacturing facility. And therein lay the problem.

At the time, Egypt was anything but an investment priority on the Procter & Gamble map. Its relatively unstable political and economic environment made it unattractive for capital investment. The initial estimated cost to build the facility was $15 million, putting it totally out of reach. But Kuraytim and his team were not about to give up. They worked with the engineers to design a non-traditional P&G facility, using second-hand equipment and local construction companies. They eventually were able to move ahead with a capital investment of $5 million, only one-third of the original estimate. Ariel's price was reduced to 50 piasters. Its share during the next four years exploded more than fivefold — from 7 percent to 37 percent.

Manufacturing facility, Egypt. Local production was essential — affording it was the challenge

Today, the Ariel franchise in Egypt is one of the strongest franchises we hold on any brand in the Procter & Gamble world. It has been the foundation for our becoming the leader in several other categories there, including Hair Care and Baby Diapers.

Change the Rules

P&G's fine fragrance business dramatizes how achieving a big win (indeed any win at all) required a strategy that changed the rules — not only the rules for P&G, but the rules for the entire industry.

P&G entered the fine fragrance business by accident. We made two acquisitions to enter the global *cosmetics* business: Noxell (Cover Girl) in 1989 and Ellen Betrix in 1991. We were focusing on cosmetics as a long-term driver of growth.

Winning in Egypt; the team that did it

Along with Noxell came a very small fragrance brand, Navy; Ellen Betrix brought with it a larger business, Eurocos Fragrances. It was headquartered in Germany, had annual sales of about $100 million and profits of only $2 million to $3 million. The business was highly fragmented. It included 11 brand lines, the principal ones being the original Hugo Boss men's line and Laura Biagiotti women's line. The business was concentrated almost entirely in Europe, with the balance primarily in duty-free shops.

The existing rules (the traditional strategies) for doing business in fine fragrances could not have been less inviting to P&G. Indeed, we seriously considered selling the fine fragrance business right at the start. For one thing, the channels of distribution — principally department stores and specialty fine fragrance shops — were new to P&G. The method of selling, which mainly involved "push" through the trade rather than "pull" from consumers, was antithetical to what had worked best for P&G. Moreover, common wisdom preached that there was no way you could test fragrances with consumers. This was an art acquired over time, it was said; a function of a "good nose." Finally, the turnover of brands was high; their life cycles short. New items, sometimes entirely new brands, were introduced to make each year's forecast.

Still, we decided to give it a go. After all, the global fine fragrances market is huge, with worldwide dollar sales today of above $12 billion per year. We did have considerable experience and expertise in developing preferred fragrances for our consumer brands, and while relatively small, we believed we had equities in the Boss and Laura Biagiotti brands that we might be able to develop into a growing, profitable business. So off we went, operating pretty much as the fine fragrance business always had.

P&G fine fragrances: We had to change the rules

Unfortunately, our early results provided little encouragement that we could realize our vision. Three years after the acquisition, our profit margins were still only about 2 percent, a genuine disaster!

It was at this point that Hartwig Langer stepped in. Langer, who joined the fine fragrance business as marketing director, had just been appointed general manager. It didn't take him long to see that if we were going to succeed in this business, we were going to have to totally revamp our strategies. We were going to have to change the rules.

Langer and his team set out to change just about every aspect of the way we'd been operating this business. How?

- First, by focusing on its key equities: Boss and Laura Biagiotti. The team was determined to make them enduring "classics." (Thanks to deep consumer understanding and continuing holistic innovation, that is what they've become.) Through superior consumer understanding, the team developed a clear segmentation strategy that provided the foundation for a stream of new items. It changed the industry rules, however, by not only targeting new initiatives to fill the segmentation model and build share, but also by maintaining the base business by building classics such as Boss Bottled.

- The team achieved competitive advantage in its supply chain by adopting new-to-the-industry standards, including a rigid process to design low cost into new initiatives, producing to demand, and reducing inventory. As part of this, the number of stock keeping units was cut dramatically — for example from 24 to 8 on Biagiotti Roma, and yet the business grew.

- The team started to test alternative fragrances with consumers and, sure enough, found that they *could* identify winners. Also, contrary to prior lore, they found they could identify fragrances that were preferred across many major markets, not just in one or two major countries.

- The team revamped the way it spent its marketing money, putting more effort behind consumer media and promotions, and less on trade "push" money.

- The Hugo Boss team worked to develop, for the first time, a true partnership with the Boss Fashion House which leveraged each party's respective strengths — the creativity and flair of the fashion house with P&G's brand-building and go-to-market capabilities.

- By letting consumers vote in the marketplace, the team discovered they could take the Boss equity, already growing strongly among men, and extend it successfully to women with "Hugo Woman."

As I have seen in so many businesses, fine fragrances has benefited tremendously from continuity. Hartwig Langer has been on this business now for over a decade. Several members of his leadership team match, or come close to matching, this continuity. Equally important, we've retained the experience and the talent of many of the key leaders who had joined Procter & Gamble as a result of our acquisitions. These men and women have been of tremendous benefit to the business. It takes time to develop the mastery of a new business, particularly one that is different. This shouldn't be surprising. After all, most of our competitors spend their whole lives in one particular business.

The results of these rule-changing efforts have been outstanding! In the 10 years following acquisition, sales increased sixfold, profits increased 40-fold and profit margins are above our corporate average. Hugo Boss has become the largest-selling men's fragrance in the world. Laura Biagiotti has become a "classic" and continues to compete successfully against new entries. Encouraged by this record, we continued to make additional acquisitions, including the Jean Patou/Lacoste fragrance license in 2001. In the three years since then, the Lacoste business has grown tenfold. Lacoste has become a blockbuster by applying the same strategies that have been driving Boss and Laura Biagiotti. Intense consumer research confirmed that Lacoste had strong equity values which had been lying dormant. Re-establishing this equity (sporting attitude) has provided a solid platform from which the team has been able to launch new initiatives based on a carefully developed consumer segmentation model.

Today, 12 years after entering the business, P&G is the second largest fine fragrance company in the world with legitimate aspirations to be No. 1.

———⟫◦⟪———

This willingness to change the rules is not only important to the success of our brands, but it has been vital to breakthrough improvements in our organizational design. This was true as Neil McElroy, who later became CEO and chairman of P&G, expanded the Brand Management structure in the 1930s. It was true as we established Category Management and Product Supply structures in the second half of the 1980s and, most recently, as we

adopted our Global Business Unit, Market Development Organization, Global Business Services, and Corporate Function organizational design.

No example is more compelling than the way our multi-functional Customer Business Development teams work with P&G customers. The model we use today was born, you might say, in Fayetteville, Arkansas, in 1986. That's where P&G and Wal-Mart formed a multi-functional customer team, the first of its kind in the industry. Over the next 15 years, Procter & Gamble's annual sales with Wal-Mart increased from less than $500 million to almost $8 billion. In fact, about one-quarter of P&G's total growth over this period came from growth with Wal-Mart.

Wal-Mart team, 2002

Yet, as is so often the case, the logic and inevitability of this success are far more obvious and compelling in hindsight than they were at the beginning. The idea to dedicate a group of people — not only from Sales, but from Finance, Product Supply, Human Resources and Marketing — to work with one account, and then to physically locate the team far away from our corporate headquarters where that account was located, was very controversial. Many considered it outrageous.

Here are just some of the questions that were relentlessly thrown on the table:

"What will all these employees do?"

"Why do people need on-the-ground support to improve logistics systems?"

"What do Marketing and Finance have to do with all this?"

"How can we justify this expense on our extremely tight budget?"

"Will our people still be supportive of Procter & Gamble, or will they become first and foremost advocates of the customer?"

It took personal courage for Tom Muccio, who led the development of this team, to go on the line with the investments he was proposing. (In truth, I have found that achieving a big win always involves personal courage.) Many doubted it would pay off. However, thanks to the conviction and professional credibility of the leaders involved, we went ahead. How fortunate it is that we did. The Wal-Mart team has been a towering success. It proved the value of the Customer Business Development teams that we have now deployed with customers around the world. It revealed new ways of taking costs out of our system and of working with customers to establish common goals and to improve the shopping experience for our consumers. Wal-Mart has not only become P&G's largest customer, it has also been a model for other customer teams that have gone on to define additional paths to success.

P&G set out to change the rules of how manufacturers work with customers, and created an industry-wide model that played to P&G's strengths. *That* is the power of rule-changing strategies.

Create A New Business Model

Creating a new business model — one providing far better value to a large number of consumers — is often the best possible route to a big win. This involves not only changing rules, but creating entirely new rules. This is what Dell did in the computer business and Amazon.com did in the book-selling business. Crest Spin Brush did it for P&G.

In fact, many of the new rules that created this business model were established before P&G even owned Spin Brush. They were set by John Osher in 1998 when he conceived the idea of developing a top-quality automatic toothbrush. It would retail for $5, only about a dollar or two more than the most expensive manual brushes, and *less than one-tenth* of what most quality automatic toothbrushes were selling for. Dr. John's became the brand

Crest Spin Brush, a new model for the toothbrush business

name, and following a small test it expanded nationally. The results were outstanding. At $5 per brush, parents were buying separate brushes for every member of the family, and sales quickly reached an annual rate of almost $50 million.

At that point, Osher's team approached P&G to propose licensing the Crest name, believing this would add great impetus to the goal of becoming the best-selling toothbrush in the world. We had a couple of people analyze the licensing proposal. They determined that the small amount of royalty revenue from the license would not be worth the effort. They were also concerned about licensing the Crest name to a small, 11-person company.

This could have been the end of the story, but it wasn't. A small group of people, including Mark Murrison, Irv Simon, Diane Dietz, Jennifer Dauer and Darin Yates, believed this represented a new business model that could become a big win. They proposed that P&G buy the business. In Yates's words, "The next four weeks had us climbing the management ladder to get approval to negotiate a deal. Within two weeks of board approval to negotiate, we had agreed in principle to the terms of the acquisition."

Meanwhile, consumer research was underway. The results were spectacular. "Consumers absolutely raved about the brush," Yates recalls. "We were probing as hard as we could for something negative and we were hard-pressed to get anything."

P&G acquired Spin Brush in January 2001, only six months after that first meeting with John Osher. We had some questions to answer:

- Pricing. Obviously $5 was a tremendous value. We had never entered a category with pricing so far below competition. Should we increase it?

- Advertising. The Spin Brush business had been developed without advertising. Should we change that? And if so, how quickly and on what basis?

- Integration. How quickly should we bring Spin Brush into P&G's operation? And who should lead it?

We began by opting for continuity. Darin Yates stayed on the brand to lead the team. The three entrepreneurs who started the business agreed to stay on for a period of time to "keep the business entrepreneurial." Then Yates and his team went to work to make other key strategic choices. As he explained it:

In contrast to most of our acquisitions, we continued to operate the business in many ways as a separate entity, rather than trying to fold it into P&G too quickly. That allowed us to go much faster than we otherwise could.

We prioritized increasing sales and quality customer service over short-term costs and efficiency. We were willing to airfreight products. That cost an extra 10 cents per brush, but we knew we were making many times that on every extra brush we sold.

We adopted the mindset of having to earn our way into advertising. We didn't do any at all for seven months. When we started, we advertised the price, which was very unusual for us.

We didn't get greedy on pricing. We might have said that with competition selling at $19.99, even at the low end, we could have taken an extra $2 or $3 per brush and been OK. We didn't do that. Yates recalls an early meeting with one of our major customers shortly after the acquisition was announced:

You could feel the tension in the room. People were dead silent. The first words out of my mouth were "We're not going to change the success model. We are not going to raise prices on this business." You could hear the sighs of relief in the room. At that point, the meeting was the largest customer "love-in" that I have ever been associated with. Sleeves were rolled up and we developed plans to drive this business to leadership together.

The result: We beat our acquisition economics hands down. We went into the acquisition targeting to double sales in Year 1. In fact, sales increased more than fourfold. Profit has been far ahead of target, too. The number of households using automatic toothbrushes has exploded by 55 percent. The automatic toothbrush market has been revolutionized by a new business model, and Crest is leading the way.

Move First

Moving first — to create a new category, to launch a redefining innovation, or to enter a new market — can influence the outcome of your business or your organization for years to come.

The story of Tide is a classic example of how difficult and rewarding it can be to seize first-mover advantage. Synthetic detergent technology had been under development since 1931. Dreft, a light-duty, synthetic detergent brand, had entered the market in 1933. But the development of a heavy-duty, synthetic detergent was a major technology challenge. Project X, which became Tide, was started in the late 1930s. During the next decade, it was almost shut down entirely several times, and it would have been if not

We knew it was big. The question: How large an investment should we make to gain first-mover advantage?

for the vision and the courage of a few individuals, especially David "Dick" Byerly, a researcher in the Product Research department. He refused to give up. By the end of the 1940s, we were confident we had a formula that worked. We faced a crucial decision about where to go with this breakthrough brand.

We knew Lever and Colgate were coming. The issue was how fast and how big an investment we should make to gain first-mover advantage. R.K. Brodie, who was vice president of Manufacturing and Technical Research at the time, believed we had a huge winner. He urged that we bypass traditional market testing to gain what he expected to be a two-year head start over Lever and Colgate. Others demurred, reminding people quite correctly that this would mean an essentially blind commitment of major resources, which amounted to as much as 5 percent of the Company's total annual sales (equivalent to over $2 billion dollars today!).

Neil McElroy: He took the chance on Tide; it made all the difference

Brodie insisted that he recognized the risk and said, "But this product has so many advantages. It is in a different class from any other new product we have ever introduced. Certainly there are risks, but the potential is so great I think we should take those risks."

It was a bold assessment. The day for a final decision arrived. Neil McElroy, then advertising manager, and Richard R. Deupree, then president, were in the room. As those who were present remember, Deupree looked from one person to another and turned to McElroy asking, "Mac, what do you think?"

McElroy replied:

It sure is a tough one, but from what I have seen and heard today, I think it's the best prospect I've ever seen in P&G. For my money, I would take the chance and blast ahead as Mr. Brodie suggests. If the product turns out to be a winner, as it appears to be, a two-year lead would be like a license to steal.

Deupree nodded, turned to the group and said summarily, "OK, crank 'er up. Full speed ahead! Mac, you ride herd on the operation."

"Full speed ahead" was certainly the order of the day. The first manufacturing plants — in Cincinnati, Port Ivory, Chicago and Dallas — had already been built as Tide was going into its first test markets. Another four plants were authorized even before the first four had started up. How fortunate it was that we went for the big win like this. From the very start of national expansion, our main problem was keeping up with demand. As one store manager in Wichita, Kansas, observed after seeing Tide hit the market, "Customers lined up for blocks. I'd never seen anything like this before, and I have not seen anything like it since."

P&G ended up with the two-year head start it had gone for. It made all the difference. By 1952, Tide was six times larger than Unilever's largest laundry brand and four times larger than Colgate's largest.

Capture Unique Moments in Time

Tide is an example of an opportunity to move first and fast that we created through outstanding innovation and marketing. In other instances, the opportunity may present itself when we least expect it, and in many cases, when we are least prepared for it — but the need to move fast and decisively is equally great.

I will always admire John Smale's courageous, last-minute decision to acquire Richardson-Vicks. Here, surely, was an acquisition that could only be described as going for the big win. And it was a cliff-hanger all the way.

Richardson-Vicks came on the market in 1985 as a result of an unfriendly tender offer by Unilever. In many ways, this was *not* an opportune time for P&G to consider a major acquisition. We were in the middle of a major organizational change. We faced difficult business challenges on several of our established brands. And we were working to recover from the first decline in P&G profits in over 20 years.

However, one thing you learn in this business: You don't choose when a strategically attractive acquisition becomes available. And here it was.

P&G had looked at Richardson-Vicks many times over the years. We admired its leadership brands, including Vicks' over-the-counter cold remedies, Olay skin care and the Sassoon hair-care line. Following Unilever's unsolicited, unfriendly offer, Richardson-Vicks' management approached several companies, including P&G, as potential white knights. We had only a couple of weeks to decide if we would make a bid and, if so, what it would be.

We knew this would be the largest acquisition in our history. Fortunately, one of our former executive vice presidents, Jake Lingle, had served on the

Richardson-Vicks board of directors following his retirement from P&G. He knew the company well. With the need for a quick and correct decision, we called Lingle and asked for his advice. It was simple: "Buy it if you possibly can." His rationale was straightforward. Richardson-Vicks believed in brands and believed in people just as we did.

We got to the day when final bids were due. About six of us assembled in John Smale's office. Representatives of Goldman Sachs, our financial advisor, were on the phone. They urged that we increase our bid by another dollar per share to be confident of topping what they thought was a competitive offer uncomfortably close to our own. Strong, differing opinions were voiced around the table. A few thought our bid was already too high, and we should stop where we were. A number of us, most importantly John Smale, thought we ought to follow Goldman's advice. The stakes were high. John decided: "We'll go up the extra dollar."

As the history unfolded later, we learned that dollar was the margin of difference compared to the next-strongest offer. This led P&G to become the owner of Richardson-Vicks rather than someone else. The $1-per-share increase amounted to less than 2 percent of the purchase price — a reminder that small differences can make all the difference in the world! I've never forgotten that lesson. When the upside looks big, the strategic fit is strong, and your instincts say Go! — do it. As Deupree said, "Be ready to bet the farm."

<div align="center">⇒➤─0─◄⇐</div>

When it comes to seizing a unique moment to go for a big win, we're not just talking about which brand to introduce or whether or not to make an acquisition. We're also talking about whom we promote.

I'll always remember one particular promotion decision. The situation precipitating it was an unhappy one. It occurred in 1974 when I had been general manager in Italy for just a few months. One day my only two marketing directors, both Italians, independently came into my office to tell me they were resigning. Nothing I said could dissuade them. How could this happen? I wondered. The two senior leaders of my Marketing Department are leaving and I don't even speak Italian yet!

I faced a decision. Should we promote two young Italian brand managers, Sandro Baldini and Riccardo Catalani? They had been in their positions for less than two years, half the tenure one would typically expect before promotion. The alternative was to go outside of Italy and bring in two, more-experienced non-Italians to run the Marketing Department. I had come to know Sandro and Riccardo well during my few months in Italy and had a high regard for them. They were young, but I was confident they could do the job. I felt sure

they would keep growing and believed they would some day be strong candidates to run all of Italy and other parts of the Company.

I called Ed Artzt in Brussels. He was then leading our European operations. I described the situation and reviewed the options, telling him I thought we should promote Sandro and Riccardo. He agreed and that's what we did. I went down to their offices to tell them that we had selected them to fill these two vacancies. I have never seen two people more surprised or pleased!

I am reminded of something Howard Morgens, one of P&G's great CEOs, once said: "Try to promote a strong person a bit before he or she feels they are ready and then stay close to them." We did that in this case with a marvelous outcome. Sandro went on to become general manager of Italy and all of Southern Europe before his untimely death in 1993. He was an extraordinary leader and an extraordinary man. Riccardo also became general manager of Italy, and later of our Poland and Baltic operations.

Howard Morgens: "Try to promote a strong person a bit before he or she feels they are ready and then stay close to them."

Consciously or not, I drew a number of lessons from this memorable experience as to what really matters. It made me even more willing to put my faith and trust in younger people of outstanding character and ability. Almost never have they failed me. And in making personnel decisions, I have learned to ask myself this question: At this unique moment, what choice is most likely to produce the big, *long-term* win for the *individual* and for the *Company*? Answering this question boldly and correctly is especially important as we strengthen the diversity of our Company by advancing minorities and women into positions of increased responsibility in line with their ability.

Combining Breakthrough Gains and Continuing Improvements

It is important to remember that big wins are almost never the product of a single big leap forward. Wolfgang Berndt has observed that achieving a big win *in the long run* often results from "a combination of discontinuous improvements followed by a series of incremental improvements that build on the discontinuity."

figure 7.

North American Fabric Care Total Delivered Cost Trends

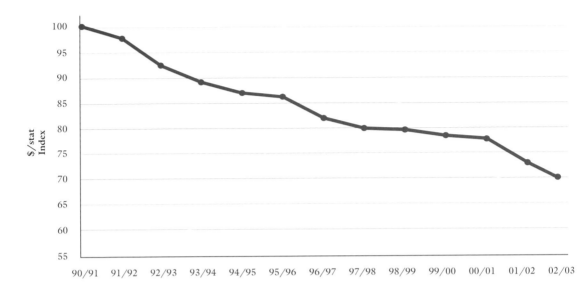

This has been true in the history of virtually every P&G leadership brand. Tide, for example, has had major technological breakthroughs, such as the introduction of enzymes and color-safe bleach. But it would not be the leader it is today if it weren't for dozens of other incremental improvements over the years, such as preferred fragrances and better solubility.

Jif, which ultimately merged with the J. M. Smucker Company, presents a particularly striking example of the payoff of steady incremental progress. We introduced Jif in 1956. Over the next 45 years, we built its share to more than 30 percent, yet the maximum share gain in any one year was less than three percentage points. This was an almost picture-perfect record of steady, year-to-year progress for Jif. Its product acceptance showed continual improvement, its advertising became stronger, and its excellent product quality and customer support were maintained.

No example better illustrates the payoff of continued improvement, interspersed with periodic discontinuous improvements, than the reduction in the total cost of our laundry detergent brands. As shown in *figure 7*, the absolute cost per unit of our North American laundry products declined every year from 1990-91 through 2002-03 by a combined total of over 30 percent. This decline occurred despite the impact of inflation and the cost of numerous product improvements. These reductions in cost have enabled P&G to sustain the necessary competitive consumer pricing while maintaining appropriate profitability.

For perspective, if P&G's total delivered costs had increased in line with the rate of inflation over these 12 years, they would be twice what they are today!

My point is that as you develop big-win strategies you must also plan for the small-step improvements that will follow. If you fail to do so, even the most brilliant leaps forward will prove to be unsustainable.

Adapt to Emerging Learning

"No plan survives contact with the enemy," the historian Helmuth von Moltke once observed. He could just as easily have been talking about what often happens when our big win strategies and plans hit the marketplace. We need to be wise and decisive when modifying them in light of emerging learning.

I encountered no more stunning, or challenging, example of this in my career than our entry into the laundry detergent business in China. It is a story that is still unfolding. Because of its significance, I will relate its lessons in some detail.

The decision to enter the laundry detergent category in China is easy to understand.

- Laundry is Procter & Gamble's largest category, by far, with annual sales of over $33 billion.
- P&G is the leader in laundry worldwide and in most major countries.
- China is the largest laundry market in the world in tonnage. (The U.S. is the leader in dollar sales.)

P&G entered mainland China in 1988 in a joint venture with Hutchison Whampoa and several local partners. We began by conducting research with consumers across the country. It showed a strong, pent-up desire for high-quality beauty and personal care brands. So we started in hair care (with Head & Shoulders and Rejoice), in skin care (with Olay), and a short time later in personal cleansing (with Safeguard). While the start-up was challenging, we did well. Today these brands are category leaders.

By the early-'90s, we concluded we were ready to enter the more capital-intensive laundry business. Our multi-national competitors were also getting underway, but lower-cost, lower-quality laundry brands comprised most of the market.

We faced a major strategic choice. We could start small, selling niche brands built on global success models at high premium prices. (Recognizing the low income of most of the population, we knew this would have produced

small, single-digit market shares.) Or, we could go for the kind of big win we had achieved in Mexico, Saudi Arabia and Morocco. In these countries we had achieved laundry detergent shares of more than 50 percent in a reasonably short time. We chose the latter strategic objective. To accomplish it, we knew we would have to introduce brands at multiple price points, including some with very low costs and pricing. We concluded the best way to execute that strategy would be to acquire strategically located production sites and leading local brands in several key regions of China.

We formed joint ventures with six plants across the country and acquired two major local brands in Beijing and Guangdong Province. We introduced Ariel and Tide nationally at two different price levels. Our goal was to combine strong national share positions on these brands with the leading lower-priced local brands to achieve a majority share of the market. This, we believed, would be the big win.

But it didn't work out that way. Not even close. The strategy failed. Why?

First, we quickly found we had underestimated detergent production capacity in China. We discovered more than 50 laundry detergent plants. New local brands kept popping up. What made it worse was that their price was only about half that of the local brands we had acquired. No doubt this was, in part, because the wages and working conditions in these local competitive plants were far below what we would have tolerated. We also wondered whether our local competitors were paying taxes.

As if this weren't enough, *counterfeit* detergents, including counterfeits of our own brands, flooded the market in unprecedented quantities.

Our cost structure added more pressure. P&G's overhead costs came on top of those of the local factories. Our costs increased at the very time we needed to lower them, bringing us to a significant loss position. We decided to increase the price of our local brands to get to a profit break-even. The response from Chinese consumers was loud and clear: "We can't afford these prices."

Volume declined by over 70 percent on our local brands, even as the price differential between the local competitors and our Tide and Ariel brands grew larger. Not surprisingly, their volume declined too. All of a sudden, we were losing over $10 million per year. Our laundry business in China was in a death spiral.

Seeing no practical way to exit this predicament, we changed our strategy. We consolidated production in two laundry plants, withdrew support from our local brands, and focused entirely on Tide and Ariel. As we did this, we realized we were accepting the likely outcome that our shares would be small for many

years. Our hope was that Tide and Ariel would become recognized as the quality laundry detergents in China and as incomes improved, they would grow slowly over time.

While modest versus our earlier vision, this seemed like the only realistic strategy to help us survive — that is, until another new piece of learning emerged. All of a sudden, we saw Unilever take their No. 1 global brand, Omo, and start selling it at about half the price of Tide!

Initially, we thought they had lost their minds, but as we dug into their cost structure, we learned they weren't crazy at all. They were operating at a profit break-even. In a short period of time, their business tripled.

This presented us with a question. Were we going to stand by and watch Unilever develop the leading brand in the largest laundry detergent market in the world?

You can imagine our answer: "No!" The size of the prize would have made that suicidal.

Not for the first time, the actions of a competitor had provoked us to a strategy and plan we should have reached earlier. We went back to our drawing boards to develop new strategies and plans based on new learning and experience to give us the right to win:

- We committed to making Tide the best value detergent for a majority of Chinese consumers, leaving Ariel to win in the upper end of the market.

- We created a Tide formula specifically tailored to Chinese washing conditions. Our experience allowed us to eliminate costly ingredients, which were providing marginal value to the Chinese consumer. This dramatically lowered our costs, yet still provided superior performance.

Tide in China
On a path to leadership, at last!

- We learned how to significantly increase the percentage of raw materials sourced locally, and we began to outsource manufacturing to lower cost facilities.

93

These strategic choices have been implemented superbly over the past five years. With the critical support of the Beijing Technical Center, our laundry formulas are increasingly meeting specific local consumer needs. Continually lower cost distribution and manufacturing models are being implemented. Tide's consumer price today is more than 60 percent below what it was in 2000. Volume has exploded with our laundry share now over 15 percent and continuing to grow. From a point five years ago when we were wondering how we could stay in this business, we now have the legitimate aspiration to achieve profitable market leadership in the largest laundry detergent market in the world. I have no doubt this is what the organization will achieve, as it already has in virtually every other category which P&G has entered in this great country.

In the end, our success in China laundry will depend, as it always does, on offering a better value to consumers and having a cost structure that provides an attractive return on our investment. That, in turn, will continue to require that we wisely and decisively adapt our strategies and our plans to the learning that emerges from experience.

Tap the Power of Personal Leadership

The final point I want to make about how to win big is that it all comes down to leadership — to the creativity and skills of individuals. It takes inspiring leaders to make big wins happen.

This is a point worth celebrating. Time and time again, we see an individual leading the way: establishing the goals, the strategies and the plans while creating and sustaining the conviction and determination that the goal can and will be reached. This is why it is so important at the outset to assign the right leaders and to assemble the right team on our largest opportunities.

We especially need strong leadership when we face our toughest challenges. P&G's first 15 years in Japan certainly qualify as one of the Company's toughest challenges. I know of no better example of the importance of strong personal leadership than our hard-won success there.

Three people stand out as most responsible for creating and implementing a winning strategy and organization in Japan: Russell Marsden, Durk Jager and Ed Artzt. Russell joined the Company in the UK. I came to know him in Italy where he worked for me as advertising manager and then as general manager. He went to Japan to lead that challenged operation in 1982. At about the same time, Durk went to Japan as advertising manager. We had already been in Japan for nine years, and we were still losing more than $10 million per year.

A number of reasons account for our dismal early results in Japan. They began, as our negative results usually have, with our failure to understand the

Russell Marsden (l.) and Durk Jager: Their strong personal leadership took us to success in Japan

consumer. Far too often, we tried to win in Japan by simply adopting products and advertising that worked in America. As a result, we were way off the mark in providing products that best met the Japanese consumers' needs. Our advertising, too, reflected a poor understanding of the Japanese consumer.

Beyond this, we didn't understand, or perhaps more accurately we didn't properly *respect*, our Japanese customers and the distribution system they operated in. We concluded that the same techniques would work in Japan that worked in the United States. They did not.

By the time Marsden and Jager reached Japan in 1982, Ed Artzt had assumed responsibility for P&G's International business; John Smale was CEO. They believed that despite all the challenges (we ended up losing $300 million before we turned profitable in Japan) we should stay. Our board of directors agreed. While everyone recognized that success was not assured, all agreed that success in Japan was imperative.

Artzt convinced the Company that we now had a better strategy — one that would reduce our reliance on the laundry detergent business (where competitors were selling brands for virtually no profit), and build our presence in the hair care and feminine protection categories. Not only did we have differentiated technologies in these categories, they were important to our competitors' profits. Artzt believed that by extending P&G's product line into these categories we would dilute our competitors' willingness to sacrifice their own profits to defend against P&G's entry.

Major meetings were held in Hawaii to finalize our strategy and to make sure that, in Artzt's words, "everyone on both sides of the Pacific understood that 'this was it.'" As Jager recalls:

> *It was a very tough meeting. I had been there for not quite two years, and I was kind of running operations while Russ Marsden was dealing with the government and trade issues. I was in the middle, hiring young Japanese students and recruiting talent from our organization to help us with our plan.*

At the end of the meeting, people were aligned and ready to make the turnaround happen. Tragically, soon after the P&G Japan group returned to Osaka, Russell Marsden had a stroke from which he did not recover. As he would have wished, Durk and the team continued with their turnaround plan.

Today, Japan is one of P&G's five largest country operations. Following Jager's tenure, it has continued to benefit from strong leaders, most recently A.G. Lafley, Bob McDonald and Werner Geissler. Japanese men and women have continued to advance to increasingly important leadership positions. The learnings about what it takes to succeed with the highly discriminating Japanese consumer have given us insights and products of great value outside of Japan. And while I cannot prove it, I believe P&G's success in Japan has limited the incursion of P&G's Japanese competitors into countries outside of Japan. Strong, personal leadership made this happen.

4. Have We Been Thoughtful in Managing the Risks of Big Wins?

This is the fourth and final question. So far in this chapter, I have laid out principles for *capturing* big-win opportunities. An equally important part of a big-win strategy is *managing* the downside risks. These can be substantial, and giving them insufficient attention can be deadly. It's not enough to figure out how to win. You must also know how not to lose.

Two key lessons emerge from my experience as being most helpful in managing the risks of big-win opportunities:

- Know where to draw a line in the sand — to establish clear milestones that indicate whether you are on a path to succeed or should change direction or stop the project altogether.

- Act on the lessons of history — to avoid costly mistakes that often can be anticipated from previous big-win efforts.

Draw a Line in the Sand

Unless we are disciplined, the pursuit of a big win can become a license to continue going after a strategy that simply isn't working. *Trying harder* won't get the job done. People in situations like this deserve the warning that the definition of insanity is expecting better results while continuing to do the same thing. At moments like this I have found it invaluable to *draw a line in the sand*.

It requires:
- Establishing a clear set of goals.
- Determining clear and well-chosen strategies everyone is aligned with.
- Identifying key barriers to success and the action steps to overcome them.
- Setting a timetable, including funding and performance milestones.

Drawing a line in the sand forces tough, objective thinking. It forces us to see things as they are, not as we would wish them to be. It is often the difference between success and failure.

The Tissue-Towel Business. Drawing a line in the sand has proven crucial to P&G's eventual success in the tissue-towel business, not once but twice.

The first intervention occurred more than 40 years ago, in 1963. We had acquired the Charmin Paper Company in 1957 and our business was struggling. Charmin itself was not doing well. We had introduced White Cloud toilet tissue and Puffs facial tissues, but they were achieving limited success. We were losing money. We had little to show for our entry into this business, and we had no obvious strategic path to success.

CEO Howard Morgens knew we were at a moment of truth. He called on Ed Harness, then in charge of our Toilet Goods business, to take over. His mandate to Harness could not have been clearer: *"Make the Paper Products Division profitable or get out of the business."* Harness accepted the assignment with one proviso: that Morgens would give Harness the people he needed on his team to win. Morgens agreed.

Could we make it a profitable leader?

It didn't take Harness long to figure out who he wanted. He went to Ed Artzt, who was then running Tide. Ed recalls the event vividly, "It was one of those moments when I knew I was in trouble the minute he called me."

"You've got to come help fix this paper business," Harness said, and Artzt agreed. Harness's next stop was Harry Tecklenburg, an enormously creative technologist who was to later become the Company's chief technology officer. (Here was a classic example of the Company's willingness to give organizational priority to a struggling business critical to P&G's future. Here, too, was affirmation of the knowledge that nothing makes an impact on a business's success so much as the strength of its leadership.)

Harness's initial review of the business produced a somber conclusion: We should cut our losses. He drafted a memorandum recommending discontinuation. Before forwarding it, he decided to consult with his colleagues one more time. He learned about a new development and it was an eye-opener. P&G's researchers, led by Fred Wells, were close to perfecting a new proprietary papermaking process (CPF) that would produce softer, more absorbent tissues.

This was anything but a slam dunk. Wells conveyed the reality of the situation honestly to Tecklenburg.

Overall, the product objectives that have been made possible by CPF are essential to taking over leadership in product definition, and subsequently leadership in pricing and profitability. If I may get in a few words of philosophy, here is an extremely clear case where our objective is defined by what we must do, rather than what, with certainty in a given period of time, we can do.

That was enough for Harness. Instead of recommending we abandon the category, he recommended a significant investment to purchase new paper

Paper plant, Mehoopany, Pennsylvania

machines and a pulp mill for a site in Mehoopany, Pennsylvania. He believed we were at one of those *unique moments* I described earlier in this chapter. In a real sense, he was "betting the farm" ... but against very clear performance expectations.

An enormous amount of hard work lay ahead. The technology still required major development. Artzt can still recall his visit to see the first CPF paper machine working:

> *It was running at about 1,500 feet a minute when I walked onto the plant floor and something went wrong: Toilet paper was flying all over! ...Can you imagine a 30-foot-wide roll of toilet paper flying through the air like a New York ticker tape parade? It was a nightmare.*

Still, as Artzt observed many years later, "Morgens had the resolve to recognize the magnitude of the problems that we faced and to create the A-Team to fix them." Fix them they did. CPF versions of Charmin and Bounty were perfected, enabling their successful expansion across the nation. Both brands achieved leadership share positions and profitability by the early-'70s.

Despite this progress, we were still not producing investment-grade returns. That led to intervention No. 2. In 1985, CEO John Smale drew his line in the sand. I can still recall the meeting. Smale couldn't have made it clearer to me (I was then president of the Company): "We are either going to dramatically improve our financial returns, or we will never build another tissue-towel machine anywhere."

Once again we needed a radical improvement in product quality and cost.

Just as Ed Harness had experienced 20 years earlier, there were some promising but very expensive technologies in the pipeline. Chief among them was a group of related projects called CPN. If successful, they promised to significantly improve the consumer acceptance and dramatically lower the cost of our Bounty and Charmin products. If they failed, we could see no basis for success.

These were extremely challenging technical projects. Several had been in development for almost a decade. Expansion would involve capital expenditures of hundreds of millions of dollars. Several times we considered abandoning this development project altogether. But we didn't. Why not?

We knew that the already huge Tissue/Towel market had great potential for growth. We knew we had brands in Bounty and Charmin that had earned strong loyalty with consumers. The question was whether we had the technology and conceptual ideas to grow them profitably.

Importantly, I had met experienced technical leaders, champions like Bob Haxby and Paul Trokhan, who conveyed their deep conviction that they *did* have these ideas. They told me they understood the line we had drawn; they agreed with it and they could deliver it. They told us to stick with the technology program, and we did.

Over the next five years, we commercialized the CPN technology. It made every bit the difference we'd expected in the softness, absorbency and strength of our products and in lowering the cost of producing them. Our market share on Bounty soared from 21 percent to 41 percent, and our share on Charmin grew from 21 percent to 28 percent.

Today Bounty and Charmin are strong, profitable leadership brands in North America and are expanding successfully to parts of Western Europe and Mexico. They are among P&G's 10 largest brands worldwide in sales and profits. All of this flowed from drawing a line in the sand ... not once, but twice.

With senior Turkish leadership team in Istanbul (Bosphorus in background)

Turkey. The case history about drawing a line in the sand that I will remember longest did not involve a brand, but a country: Turkey.

Procter & Gamble was late going into Turkey. We acquired a local company (Mintax) in 1987 and with it several local brands. Henkel and Unilever were already well established and held strong shares in most of our categories. Our acquired brands were reasonably well known, but their product quality was average at best, and they were losing share. In 1990 we introduced

Ariel laundry detergent, the leader in Western Europe. To say competition did not welcome us would be an understatement.

Fast forward to 1994. I was responsible for our business in Europe. Things were going badly in Turkey. We were losing about $25 million in that year alone. Turkey was carrying a larger sunk investment than any subsidiary in the entire P&G world. And it was getting worse. The financial challenge was so imposing that many wondered whether we should be there at all. What should we do?

As I looked into the situation, I realized the direction that we in P&G senior management had been communicating to the local organization was downright confusing. At one moment, we were exhorting them to build share. The next moment, we were calling for the organization to cut its losses and get profitable. This was the antithesis of good leadership.

So in 1994, in the midst of a rare and heavy snowstorm, some members of our senior management group and I arrived in Istanbul to meet with the local team to draw our line in the sand.

We called for a plan that would break even in three years, no "ifs, ands or buts." We said we would do this by achieving greater focus in laundry detergents. This meant concentrating on the fastest-growing segment of that market — consumers who owned fully automatic washing machines. Dramatic cost reductions were made so our brands could be priced right and be profitable. The production of our Ace bleach bottles was moved in-house so we could make money on that brand. And we took other measures, too. But the most important was that all of us agreed on a multi-year plan: clear goals and a set of strategies and milestones to tell us if we were on track. We stuck with them and the team delivered. As always, the most important factor of all was strong, on-the-ground leadership, from General Manager Rainer Bastian and his whole organization.

This was not to be the last time our Turkish organization would draw a line in the sand to pull itself up from great adversity. Turkey was struck by a massive currency devaluation in February 2001. When the Turkish lira was devalued over 100 percent, the rate of inflation rose to more than 60 percent, and over one million people lost their jobs. What did this mean for P&G Turkey? It meant that our $400 million subsidiary became a $200 million company overnight. It meant a subsidiary that had risen to be one of our top-ten profit contributors in the world ran the risk of going into the red. But Turkey didn't go into the red. Not for a moment. The local organization drew a line in the sand. They declared this wouldn't happen. And it didn't. Knowing the women and men of this organization as I did, led by Werner Geissler starting in 1998 and then by Paul Hart, I knew they would exceed any reasonable expectation of what could be accomplished. And they did, delivering financial results

far better than any competitor, while at the same time strengthening our market shares.

Being Prepared to Call It Quits

Sometimes we'll draw a line in the sand, establish benchmarks for success, and then fail to achieve them despite our best efforts. It is our willingness at this point to do what usually comes hardest — abandon the project or shift to a radically new direction — that allows us to achieve the success rates on our initiatives that are needed for strong overall progress.

Swiffer Glide is an example. Developed as a flanker to the very successful Swiffer franchise, this was to be P&G's first entry into the glass and furniture cleaning category. The product was a non-woven mitt, with a cleaning side and a buffing side. After several iterations, testing showed we had a strong concept and a well-accepted product. That was encouraging.

Still, projected *repeat* usage was weak despite several improvement attempts. The team consulted with experts. They underscored the low odds of success. They pointed out that there were no simple fixes. The proposed product required a significant habit change and offered poor value. Compared to lower cost, already-available alternatives, the added benefit to consumers was marginal. Still the temptation was there to go ahead. After all, the product form was distinctive. The Swiffer brand name was strong. Maybe we would pull it off. But the team didn't buy that. The upside potential didn't look big enough. The issue of value couldn't be overcome, so the team canceled the project.

Of note, learning emerged from this project that later helped create a winning proposition in *Swiffer Duster*. Here we were able to deliver great value by providing a product like no other that deals with hard-to-dust items, such as window blinds and air vents. Swiffer Duster is well ahead of objectives.

Act on the Lessons of History

A second key learning in managing downside risks is to act on the lessons of history. Recognizing how much our P&G culture values learning, there's no excuse for repeating avoidable mistakes that undermined our prior efforts.

A study of P&G's recent new brand and major established brand initiatives highlights several lessons that are of continuing relevance.

- **We need to choose fewer initiatives and do them exceedingly well over time.** Establishing a strong, new brand is a multi-year undertaking. Too often we approach it with an investment plan covering only 12 months. Consciously or not, "launch them and leave them" can become the modus operandi. That doesn't work. It took several years to achieve broad trial

even on our strongest new brands, like Pantene and Always. Innovation must continue. The lesson: Beware of embarking on so many business initiatives that we fail to do a top-notch job on those with the greatest potential.

- **We must avoid underestimating what our competitors will do to defend their business, and what we will actually do to support our own initiatives.** Otherwise, we overestimate our volume forecasts and hence often overbuild capacity, with major negative impact on profits.

- **We need to recognize the difficulty and time it takes to change consumer habits.**

- **We should offer consumers a superior value and not allow our financial goals to drive pricing.** Instead, we should get our costs down to the level needed to provide both superior consumer value and acceptable return for P&G.

- **We can't allow corporate mantras such as "speed and stretch" to override an objective assessment of whether we are ready to go and whether our financials are realistic.**

- **We need sufficient continuity of expertise.** The study of our biggest successes and disappointments highlighted the benefits of mastery, improved communication, and focus on the long term that continuity provides.

Not surprisingly, many of Procter & Gamble's greatest recent successes have grown from a team's pausing long enough to learn from earlier experience and factoring that learning into their plans.

Take Crest Whitestrips. This new brand has more than doubled its going-in sales objectives. In developing its plans, the team looked at recent learning and consulted with corporate marketing experts, using them as the "devil's advocates" to point out potential pitfalls.

- They anticipated that a competitive entry would erode pricing in the second and third years of the launch, so they built price declines into their financials from the very start. This foresight allowed them to move quickly when that prediction became a reality.

- They took a proactive "launch and leverage" approach (versus "launch and leave"), fielding a series of technical and marketing innovations that continued to build new-user trial over the first two years. The team knew this would be important for Whitestrips, because it has

a long purchase cycle, requiring a constant dose of new user trial to sustain growth.

Olay has also been disciplined by incorporating relevant learning in its initiative plans. While Olay Total Effects achieved great success (driving Olay to skin care leadership), examination of the experience revealed that the investment in Total Effects had resulted in the base business declining. So on Olay's next

Smart application of earlier experience helped Crest Whitestrips achieve breakthrough results

major skin improvement initiative, Regenerist, the team ensured that we had news on the base brand at the same time as the item's launch. The result: Not only is Regenerist a success, but the total Olay brand has grown faster than ever. It's a wonderful example of learning from history.

—————⇒»·❊·«⇐—————

As we have seen, going after a big win seldom leads to a quick win and almost never an easy win. We've had to learn as we go. Still, the fact that we won't always (let alone immediately) achieve all the big wins we pursue must never stop us from going after them in the first place. We must continue to pursue them, applying the principles and lessons we've learned. This is the only way we will sustain the growth and leadership of our great Company.

Going for the Big Win

Some Questions to Consider

1. What is your vision of your big win? Is your definition of victory as broad and bold as it should be? How do you define success? How will you know you've achieved it?

2. Do you have a sustainable strategy that gives you the right to win? Why are you confident it's a winning strategy? Have you used peer review and external input to appraise the realism of your judgment, and your strategic choices and plans?

3. How could you change the rules of competition or the business model in your category or business to achieve a big win?

4. Is there an opportunity to seize "first-mover" advantage in your business?

5. Are you being brutally honest and objective with yourself as to the reality of your business situation?

6. Have you drawn a line in the sand to come to grips with the reality of your situation and to ensure that your goals, strategies, timetables and milestones are being set, with full alignment, to achieve your vision?

7. What lessons from history are you applying to avoid previous pitfalls and to maximize your chances of success in pursuing your big win?

8. Do you have a plan that recognizes that achieving a big win in the long term usually requires a combination of breakthrough improvements and continuing incremental steps built on top of that improvement? What is the plan?

How We Keep P&G in the Lead

This section is anchored by a review of the organizational qualities — the values, practices and relationships — that have enabled Procter & Gamble to be not only a strong company, but a vibrant *community*. I explain why I believe this is P&G's greatest competitive advantage.

Case histories bring to life the fundamental truth that by *doing* good, including doing what's right in supporting our communities, we're *gaining* good for our business in many ways.

Chapter 5
Receiving Good by Doing Good

"It isn't enough to stay in business and be profitable. We believe we have a responsibility to society to use our resources — money, people and energies — for the long-term benefit of society, as well as the Company."

— John G. Smale

"Never doubt that a small group of thoughtful, committed citizens can change the world; indeed, it's the only thing that ever has."

— Margaret Mead

I hadn't been on the job at P&G for more than a month when my brand manager called me into his office to tell me he had a project for me. I was poised in anticipation of embarking on my next work assignment. Something big. Something special. When I arrived, he asked if I would take part in the United Way campaign. He wanted me to solicit funds from small business owners in the eastern part of Cincinnati. He wanted me to do something not for the Company, but for the community.

Talk about a surprise! I hadn't even heard of the United Way, and I had no expectation that a company like P&G would invite its employees to devote business hours to such a cause. Little could I have imagined then that 31 years later, as president of P&G, I would chair the entire United Way Campaign for the Greater Cincinnati region with a goal of raising $44 million. Little could I have known that this would be the first of many times that I would see the Company's commitment to our communities in action — and how providing this support would often lead to business benefits we could not anticipate.

Like the time in 1989 when I walked into George Bunting's office in Hunt Valley, Maryland. Bunting was the CEO of Noxell, the corporate home of Cover Girl Cosmetics. He and his family were key shareholders of this still privately held enterprise. We were hoping that at some point in the future, Noxell might be open to consider an alliance or sale of its business to P&G. But this was the first time I would be meeting Bunting; my intention that day was simply to get acquainted.

To my great surprise, Bunting said we had come at an opportune moment. He was considering selling the company, because he didn't believe he had the resources to expand Cover Girl globally. Then he said something I'll never

forget: *"Procter & Gamble is the only company I could envisage selling to."* I asked him why. "Because," he said, "of your commitment to your brands, to your people and to your communities." We went on to acquire Cover Girl, and today it is the best-selling cosmetics brand in North America. We sealed the deal not only because of our business record, but because of our proven commitment to a Purpose and set of values (including support for our communities) that Bunting found to be as important as we did.

<div style="text-align:center">⎯⎯⟫•0•⟪⎯⎯</div>

Virtually since P&G's founding in 1837, top management has believed that our Company has a responsibility to use its money, energy and resources for the long-term benefit of society. This belief is embedded in P&G's Statement of Purpose:

> *We will provide branded products and services of superior quality and value that improve the lives of the world's consumers. As a result, consumers will reward us with leadership sales, profit, and value creation allowing our people, our shareholders and the communities in which we live and work to prosper.*

Why, you might ask, do we bring this matter of *our communities prospering* to the highest level of our corporate Purpose? It's easy to understand a corporation's responsibility to shareholders, as well as its responsibility to consumers, customers and employees. But why this emphasis on *communities?*

It's rooted in the belief that corporations have a responsibility to give back by helping to make our communities, our society and, indeed, the world, places where we want to live, which are safe and habitable for our children and for their children. In recent years, we've seen the downfall of companies that have not embodied this responsibility. The results have been devastating for the companies, their employees and their communities. Commenting on these financial and ethical scandals, Professor Richard Fedlow of the Harvard Business School nails the issue: "To look at a corporation and to think that its sum and substance is to be a money-making machine with no other function to perform in this world is asking for trouble. We have asked for it and we are getting it."

Corporations, of course, cannot do it all. They must first be financially successful. If they aren't, they're of value to no one. Moreover, many community activities can only be carried out by the women and men who've dedicated their careers to public and social service. But, the financial resources and the human talent that reside in corporations today — with their capacity for innovation, organizational effectiveness and cost efficiency — make them uniquely able to help lead the needed improvements in education, health care, the environment and other important issues society faces today.

Every aspect of society is influenced by corporations and the standards they set. The impact they have is as much social as economic. Most people will spend half of their waking hours at work. The degree to which the work environment encourages individual initiative, teamwork and respect for others influences life outside the workplace, as well as within it.

I will long recall a tour of our plant in Johannesburg, South Africa, in the early-'90s. I was with a black shift manager in one of our production modules. We had only been operating the plant for about a year. He and I were walking down a corridor when I asked the young man how he felt working there. I'll never forget his response.

"It is exciting and empowering!"

"In what way?" I asked. He looked directly at me, seeming surprised at my question.

"Before, no one would have ever talked to me the way you are now. Not only that, now when we walk up and down the hall and a white person comes, we have our heads up. We expect to talk to them. Before, we would have had our heads down."

You just know a change in attitude like that makes an impact, not only on life at work, but on life in general. I witnessed a vivid example of this as P&G started up business in the previously communist countries of Eastern Europe. As our youngest employees joined Procter & Gamble in Russia, Poland, Romania and Ukraine, most discovered for the first time that their individual initiative was truly desired and valued. They weren't sure we were serious in the beginning when we told them, "We need your ideas"; "Do what you think is right"; "Take charge." Most of them, because of the political climate of their countries, had never been asked to speak up. But they soon came to see that we were serious, and they responded magnificently.

Elena Checkovskaya, a leader in our Eastern European Human Resources organization, explained it to me clearly:

P&G changed my mentality. I became much more practical and results oriented. I realized that I should not wait until something good happened to me, but needed to decide what I wanted and just go for it. P&G taught me not to trust the barriers that my mind creates, like, "It's too difficult; I'm too young for it; I don't have experience." Going ahead is a part of P&G culture. It breeds leaders.

Rarely do we do all we should in living up to the ideals of how we live and work together. But we have that capability and that responsibility. As the late

Robert Goizueta, a personal friend and brilliant CEO of the Coca-Cola Company, once said, "While we were once perceived as simply providing services, selling products and employing people, business now shares in much of the responsibility for our global quality of life."

Our Responsibility for Doing Good

Like anything else, a corporation's responsibility to the community must begin with a set of strategies and principles. I have always believed we need to begin by focusing on those activities for which we are most directly responsible and that have, or can have, significant impact on consumers and society as a whole. This carries three imperatives for P&G:

1. *Ensure that our products and our manufacturing processes are safe for consumers, employees and the environment.* As we've acquired plants, for example, in Eastern Europe, China and other developing parts of the world, we've often found that we need to place much of our initial capital investment in improving worker safety and the impact of our manufacturing processes on the environment. Often, we become the industry leader in these areas, and we've tried to share our learning with others in the industry.

2. *Pursue the development of commercially attractive products and services, which also contribute to the quality of people's lives.* This is precisely what our Purpose of "improving the lives of the world's consumers" is all about. It's what we mean when we declare our commitment to "Touching Lives and Improving Life." Historically, this commitment led to our pursuit of better hygiene for people through products like soap and shampoo, and a healthier cooking agent in Crisco. It also led to the development of Crest with fluoride to prevent cavities, and to Actonel for the treatment and prevention of osteoporosis. I believe that the past is only a prologue to a richer future, given the products that P&G has been developing over the past decade. They not only include pharmaceuticals and other health care products, but technologies like those promising to provide safe drinking water for the many people who don't have it today.

3. *Be a good role model by operating with high ethical values.* Never has this been as important as it is today. Never has the public outcry for responsible and ethical behavior from corporations and institutions of all types been so loud and clear. The plethora of well-publicized corporate misdoings has undercut trust in business. In a 2002 study reported in the *Wall Street Journal*, 57 percent of respondents said they thought the standards of corporate leaders had declined over the past

20 years. Just four years earlier, only 42 percent of respondents had agreed with that statement. A *Time*/CNN poll conducted in summer 2002 reported that 71 percent of those polled thought the "typical CEO is less honest and ethical than the average person." People are calling for "the revitalization of traditional virtues," as Daniel Yankelovich describes it: honesty, respect for customers and employees, and responsible corporate citizenship.

<center>⇒►●◄⇐</center>

Beyond these responsibilities, three strategic priorities guide our actions at P&G:

1. *We focus on activities that can make a significant long-term contribution to our communities.* By *long term,* we usually think of decades, not months or even years. This leads us to focus on children's development — specifically, education and health, with special emphasis on children in need. It also leads us to seek alliances with strong, strategic partners to achieve outcomes that we could not deliver alone. Finally, it leads us to build relationships that will last, recognizing that major improvements in societal outcomes take time and are likely to happen only with continuing, trust-based collaboration with other organizations.

2. *We recognize that the most valuable community support P&G can provide is to tap the interest and energy of P&G people.* This is even more important than writing a check.

3. *We start closest to home.* We believe it is those communities where P&G people live and work that will most benefit our business, and where we and our employees can make the biggest impact.

The Opportunity for Receiving Good

Supporting our communities is the *right* thing to do. But it's also the *smart* thing to do.

Often the benefits of P&G's corporate citizenship have been foreseeable and planned; they've been one of the reasons we undertook the activity in the first place. At other times, the benefits have been unexpected; they've occurred collaterally with an activity we undertook solely because of its inherent rightness. Planned or unplanned, the result is the same: Those who do good generally receive good.

Benefit No. 1 — Building Brands

Community programs can build our brands' businesses and strengthen their reputations. Procter & Gamble's work to improve oral health is a good example.

Our oral care education programs today are preventing tens of millions of cavities among children every year, all around the world. At the same time, these programs are introducing children and their parents to our dentifrice brands, Crest and Blend-a-Med, earning loyalty and helping these brands achieve leadership shares.

Procter & Gamble's involvement in oral care education goes back more than half a century. The American Dental Association recognized the clinically proven cavity prevention provided by Crest. On the strength of this recognition and extensive dental hygiene education programs in secondary schools, Crest achieved market leadership in the United States.

Since then, we have extended our oral health programs to many countries of the world, including Russia, Poland and the Balkans. In China, we've worked with the government to reach over 80 million school children in over 275,000 schools in more than 600 cities. Research shows cavity rates declining by 20-50 percent for children participating in these programs.

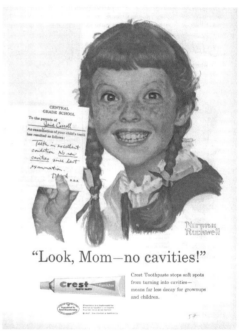

"Look, Mom—no cavities!"

Crest's proven ability to prevent cavities earned it recognition from the American Dental Association in 1960. This helped vault Crest to No. 1 in the dentifrice market.

It would be hard to overestimate the importance of these programs to the people of these countries. Fifty years ago, the average teenager in the United States had more than 10 cavities. Today, thanks to the introduction of fluoride and better dental hygiene, the average number of cavities has been reduced to fewer than three. In fact, that's about the same number that Chinese children have experienced, thanks to a diet largely free of sugar. But that diet is changing, and changing fast, as candies and sweetened beverages are being consumed in increasing quantities. Unless preventative action is taken, cavity rates in China could balloon into the teens, just as they once were in the

Helping to prevent tens of millions of cavities in China

United States. Added to all the other health care challenges China faces, this would be a problem of devastating proportion.

The leaders of the Chinese Ministry of Health have been aware of this threat for many years. I met with the Minister of Health on several occasions during the 1990s and participated in many conferences to discuss how we can work together to combat this threat. I remember one conference in particular. It occurred in Beijing. Six or seven speakers were on the agenda, one of whom was the assistant minister of health. He had been allotted five minutes on the carefully orchestrated schedule to introduce our cooperative oral care education program. Well, once he began, I could see that allotted five minutes expanding — to 10, 15 and then 20 minutes. I could sense the emcee's consternation building as he glanced repeatedly and anxiously at his watch.

I sat there just *delighted*. The vice minister could have gone on all night as far as I was concerned. Without understanding a word of Chinese, there was no mistaking his passionate commitment to his subject. I learned later that he was explaining to the audience how good oral health affected the body's total health. He wasn't about to stop until he was sure his audience fully understood the gravity and scope of the problem he was intent on preventing. He left me with an even greater sense of responsibility to contribute all we could through our educational programs to prevent this from happening.

That's what we're doing. And as a result, China has already become one of Crest's largest-volume markets in the world. It's no surprise that Crest's purchase levels and image ratings are significantly higher among consumers who are aware of our education program.

Many times over the years, I've also had the pleasure of meeting with Dr. Valery Konstantinovich Leontiev, the head of the Russian Dental Association, to discuss P&G's classroom education program. As part of this program, we placed carefully controlled studies to verify its clinical benefits. To our delight, the results showed a cavity reduction of close to 50 percent among children who had participated in the dental care classes. A couple of years later, we were able to present the results of these clinical tests in television advertising, which has helped our Blend-a-Med brand become the leading and highest-rated toothpaste in Russia. Not only that, our participation in this program has elevated P&G's standing in the Russian academic and scientific communities as

Dr. Valery Konstantinovich Leontiev (center) and Robert Gerlach (P&G Cincinnati) with translator; Paris, November 2000

signaled by this public pronouncement by Dr. Leontiev: "I've seen many words on paper from many private enterprises and institutions around the world. But what a pleasure to see your people at P&G follow the words written in your Company's Statement of Purpose and Principles and Values."

I've talked about what we're doing to improve oral health in China and Russia. But we should not forget: Oral health remains an issue in *developed* countries like the United States. I was reminded of this by the shocking results from a research study conducted in Cincinnati, Ohio, in summer 2001. It revealed that 46 percent of eight-year-olds in Cincinnati Public Schools had *untreated cavities.* I learned this is typical of urban areas in the U.S. This is crazy! I thought. We may not have the cure for cancer, but we know how to treat cavities. Recognizing the problem, Crest has launched a program that provides free check-ups for youngsters through Boys' and Girls' Clubs across

the nation. This is not only resulting in healthier teeth (initial results show a 51 percent decrease in gingivitis and a 29 percent reduction in plaque), but it's introducing children to the Boys' and Girls' Clubs. And the exposure these youngsters gain to Crest will help our Crest business grow.

This combination of social health impact and business growth is not limited to P&G's oral care business. We have helped enable healthy daily hygiene habits with education programs and personal cleansing products such as Safeguard, and we've improved girls' and women's feminine hygiene with products such as Always and related classroom programs.

Extending the benefits of our brands by providing consumer education often requires that we form alliances with government ministries, schools and other partners. Sometimes we do this on a single brand, sometimes on many brands. It calls for a significant commitment of resources, financial support and employee time. But it's proven to be the right thing to do — for our communities and for the growth of our business.

Alliances — with retail customers and non-profit organizations — are also critical to the success of our brands' cause-related marketing programs. An example is the Special Olympics, which enables children who have disabilities to compete in athletic events they will remember forever.

Benefit No. 2 — Attracting the Best People

By helping to create livable communities — with good schools and health care systems — we create communities P&G employees want to live in. It's that simple. This is why the largest portion of P&G's corporate contributions go to support *local* educational and health care institutions.

You just can't have a livable community without strong education. That's why P&G supports the improvement of education in many ways, including substantial grants to colleges and universities. Today we are also providing funding for secondary education, knowing how important it is to our employees. But this is about more than money. It's about individual P&Gers leading efforts to strengthen local school boards and schools throughout the world.

We give strong support to local mentoring programs. For example, in 1987 I was proud to help create a world-class mentoring program in Cincinnati called "One-to-One." I was motivated to do this after seeing the amazing difference that hundreds of individual P&G employees were making in students' lives as mentors in a local high school. Today, this program serves over 2,000 students in Cincinnati.

In the U.S., our support for good health care and human services stands alongside education as a foundation for a livable community. This support takes many forms, the largest going to local United Way organizations, food banks and relief organizations like the Red Cross. Our commitment to these organizations goes back to William Cooper Procter. He was one of the earliest directors of the United Way in Cincinnati, joining it a year after its founding in 1916. Today, the per-capita giving to the United Way Campaign among Procter & Gamble employees ranks among the top three major corporations in the United States. P&G employees led the formation of United Way organizations in many countries outside the U.S., including Mexico, Venezuela and Brazil. We do all this to be good corporate citizens for sure, but we also know that United Way organizations improve the quality of life for our own employees.

There's another way that our commitment to our communities helps attract and retain strong employees. For many, it may be the most important. *Most men and women want community service to be part of the mission of the company to which they commit their careers.* Again and again, I've heard young men and women cite P&G's commitment to serving the community as one of the reasons they decided to join the Company. Just read what this young student from Yale University wrote to me after spending an externship with us during the year:

> *Before the externship, I read great things about the P&G ethos. After a week of meeting P&G people, from brand managers to engineers, it is very apparent that the core values are taken to heart. I was not only amazed at how everyone was so excited and passionate about their brands, but also at how P&G realizes its vision to make the consumers' lives better, not only through charity work in the U.S., but also in places like China, by developing new products and health education. You were right. There are strong similarities between (students) at my university and P&G people in terms of attitude, aspirations, enthusiasm and pride toward their work, the wider community and their families. I felt right at home by the end of the week and would love to return as an employee next summer.*

What difference does this type of attitude make? It cannot be measured precisely, but I've found that it can be the difference that leads a person to choose one company over another — and I'm sure it's a motivating factor in employees' decisions to spend their careers at P&G.

Procter & Gamble's leadership in developing family-friendly television programming has had this type of impact on some of our employees. Former Global Marketing Officer Bob Wehling, who led this initiative, recalls more than once having a person comment to him in the course of an elevator ride,

"I was considering another offer, but I decided I wanted to stay with a company that is trying to make a positive difference in society."

Benefit No. 3 — Creating Markets

By helping, even modestly, to create a better-educated, more affluent and healthier society, we contribute to developing markets in which people can afford our brands.

This may sound like a long-range goal, and it is. But for a company that has already been around for 167 years — and still thinks of itself as young — that's all right. This is why we support the improvement of education in virtually every part of the P&G world. For example:

- In Romania, we have worked with IBM, the Ministry of Education, and the "Save the Children" organization to provide computers in schools with free access to the Internet. This program has also provided a powerful lift to Procter & Gamble's reputation. Almost half of Romanian consumers in a recent research study rated Procter & Gamble No. 1 in the country for being a "good corporate citizen."

- In Malaysia and Singapore, we have contributed nearly $1 million to a three-year program led by UNICEF and the Ministries of Education to support the education of children with special needs, such as Down's syndrome and cerebral palsy.

- In Angola, our Italian Dash brand is working with UNICEF to provide educational materials that are now reaching about a quarter of a million school children.

- In Thailand, Procter & Gamble initiated a program called "Feed Children for Better Education." It grew out of the stark realization that an estimated two million primary school children did not have a regular lunch at school, thereby reducing their learning abilities as well as threatening their health. Today, over 500,000 children are benefiting from this program. It brings together the Ministry of Education, 16 private companies and more than 150 popular celebrities. A local TV channel contributes three hours of free air time; the telephone company of Thailand provides free telephone lines to receive contributions; and the Bangkok Bank provides free transfers from country branches to the main donation account in Bangkok, advertises the program on 1,100 ATM screens and places materials in its banks. Again, this is a "two-way street," because through our association with this effort, P&G's reputation in Thailand has been strengthened, and so has our business.

Benefit No. 4 — Building P&G's Reputation

Much emphasis has been placed recently on the intangible but very real value of a company's reputation. Our reputation for supporting communities and for doing the right thing strengthens P&G's image and contributes to our business in vital and often unexpected ways.

Several examples illustrate these unexpected benefits.

"Project Hope" in China. Procter & Gamble worked with the Ministry of Education in China for almost a decade on an initiative called Project Hope. Since 1996, we have built 76 schools in remote rural areas of the country, bringing formal education to thousands of students for the first time. And we've committed to building another 24, bringing the total to 100. We've built these schools in China because we know good education is the foundation for productive lives. We knew Chinese children desperately needed these schools. However, this activity also helped make senior Chinese government officials aware of P&G's commitment to China, immeasurably strengthening our reputation.

Global External Relations Officer Charlotte Otto greets students during the opening of a new school in China

I experienced this myself in meetings with senior government officials, including former Premier Zhu Rongji. To be sure, the government's interest in Procter & Gamble is founded first and foremost on the jobs we provide and the taxes we pay. But there's more to it than that. In every meeting I had with the premier, he expressed his awareness and appreciation of what we were doing in communities, particularly our work with the Ministry of Education.

Our involvement in the community mattered to Premier Zhu Rongji, and I believe it influenced his actions — prompting him, for example, to combat more aggressively such issues as product counterfeiting and illegal, cross-border shipments that were plaguing our business.

Overcoming Boycotts. We've seen similar benefits in the Middle East, where boycotts against our brands in several Arab countries emerged as an outgrowth of the tragic Israeli-Palestinian conflict. Boycott calls were particularly vocal in Egypt, especially on Ariel laundry detergent. Ariel is one of the strongest laundry franchises we have anywhere in the P&G world. Ironically, however, the name reminds Egyptians of Ariel Sharon, the current prime minister of Israel, a generally feared and hated man in Egypt. It is hardly surprising that some people in Egypt wondered whether Ariel was an "Israeli brand." Rumors were even spreading that buying Ariel detergent hurt the Palestinian cause. As the Israeli-Palestinian conflict continued unabated, we faced a serious boycott.

Fortunately, the local P&G organization was able to address this through the support of many different stakeholders, who have come to know and trust us since we started business in Egypt in 1986. We had a lot going for us when we obtained this support — a strong business, a strong and committed local organization that loves P&G, and a strong reputation and loyalty with consumers which Ariel had earned over the years. All these factors together helped us to convey to the general public the truth about P&G and our business in Egypt, including the facts that:

- P&G is a non-political, truly international company.
- P&G is one of Egypt's major foreign investors.
- More than 98 percent of our employees in Egypt are Egyptian.
- We locally produce almost all the brands we sell in Egypt.
- We're an important source of exports and continue to grow.
- We are active and responsible corporate citizens through numerous initiatives and efforts, including the construction of schools in rural areas and the contribution to health improvement programs in local communities.

A strong token of support from government and media stakeholders for P&G was displayed by the prime minister of Egypt's visit to the P&G plant just outside Cairo in summer 2002, accompanied by six of his cabinet ministers, for a nationally televised event. It highlighted the importance of P&G, its employees and its brands to the economy and to the Egyptian community.

Our business in Egypt continues to grow today in a healthy manner. This is largely a result of our ability to communicate the substantive contributions we have made over time to Egypt, the deep roots we have in the country and because of the respect and trust we've earned with Egyptian stakeholders and consumers alike.

Preferred Acquisition Partner. Another benefit I've seen come from P&G's culture and reputation has been its impact on several important acquisitions. I previously mentioned the Noxell acquisition. Another occurred during the

start-up of Procter & Gamble's operations in Central Europe. It was 1991. The Berlin Wall had come down two years earlier, and we had made the decision to begin operations in Poland, Hungary, Russia and what was then Czechoslovakia. We concluded that we should acquire a local laundry detergent plant somewhere in Central Europe.

Doing what was right helped make us the preferred acquirer of the plant in Rakovnik

After investigating dozens of sites, we settled on a plant in Rakovnik, a small town located about 100 kilometers from Prague, as the best in the region. The challenge we faced was that several of our key competitors — Unilever, Henkel and Benckiser — were also pursuing this plant.

Our product supply experts visited the plant, as did those of our competitors. I visited officials in Rakovnik and Prague, and wrote letters to members of the government, making the case that we would be the best company to acquire the plant. Finally, after several months of investigation and bidding, we were successful. About a month later, I visited the plant to assess the situation and tell the employees how pleased I was that we were working together and how much I looked forward to our future. Just as I was about to leave, the plant manager came up to me and asked if I would like to know why he had so strongly recommended to the government officials that Procter & Gamble be the company to acquire the plant. I told him I would love to know.

What he told me was instructional and inspiring. He said that when our competitors' representatives had come to the plant, their focus had been almost entirely on how they could reduce costs and eliminate people. The P&G people were a stark contrast to that, he said. They, too, had emphasized the need to be more productive, but their *primary* emphasis had been on how we

could improve product quality and ensure the workers' safety. It was that difference in emphasis, he said, that led him to recommend P&G as the buyer. I don't know how decisively the plant manager's recommendation affected the government's decision, but I suspect it played a part.

Six years later, Procter & Gamble's reputation and our values also had an impact on the acquisition of Tambrands (and the Tampax brand). In May 1997, Ed Fogerty, then CEO of Tambrands, called me and asked if we could meet. A few days later, he was sitting across the table from me in our 11th floor dining room, explaining that he and his board of directors had reached the conclusion that the company could not build the business independently. To my immense satisfaction, he went on to say that Procter & Gamble was the only company which he could envision committing his brands and people to.

P&G's reputation helped lead to the acquisition of Tampax

Discussions ensued and a transaction was concluded. No other company was involved in the bidding. Today, Tampax remains the leading tampon in North America and is growing strongly and expanding into additional countries around the world. Here was an unexpected benefit that grew from years of P&G men and women trying to do what they believed was right.

Benefit No. 5 — Personal Reward

For me, the most unexpected benefit from supporting our communities is the most personal. It has two dimensions. The first is the way it can fuel our sense of ownership and responsibility to improve consumers' lives. I experienced this, unforgettably, in a distant corner of the world near Lake Naivasha in Kenya. I was attending one of our feminine hygiene classes, which we offer each year to over 13 million teenage girls in more than 70 countries.

It was a hot, humid day. I walked into a schoolroom and saw over 100 young ladies dressed in splendid red uniforms. A nurse stood in front of the class and began her lecture. For the first 45 minutes, she referred to one chart after another, talking about menstruation and the way the body develops. "You shouldn't be afraid," the nurse said. "Menstruation is natural," and she proceeded to tell the students why. Toward the end of the lecture, she talked about the different products the girls might use, starting with paper and cloth, and then moving to more effective products like a Tampax tampon or an Always pad. She explained how Always worked. She demonstrated its performance compared to cloth and other pads. I could tell the demonstrations

were convincing — the young girls' eyes were glued to the nurse and you could have heard a pin drop.

Teenage girls learning about Always

The session ended after an hour. The girls left with a sample of Always and a brochure to take home to their mothers. I was sure they were going to ask their mothers to buy Always, using part of their scarce incomes. I knew the product would benefit them. Equally, I felt the responsibility we had undertaken. We had promised a product that was superior, and I knew it was important that they be able to buy it at the lowest possible price. As I walked from that school room, I said to my associates, "You know, if we ever reach a point where we can't deliver what we promised with Always, we need to send a telegram to the mothers of those young ladies to tell them we have to withdraw what we said. … Let's never have to send that telegram."

My personal involvement with this educational program gave me a sense of our responsibility to our consumers that I otherwise wouldn't have had. It also gave me a tremendous sense of personal and professional satisfaction as I experienced first hand how one of our brands and our commitment to education could make a real difference in women's lives.

The other dimension of the benefit I've received from supporting our communities is the growth and learning I've gained from being placed in new leadership situations and coming to know other people, especially those who are different from me.

In particular, my work in the community has deepened my appreciation of the ultimate difference made by inspirational leadership. I have seen

outstanding principals change the learning environment in their schools and improve student proficiency scores by as much as 50 percent in only two years. And I have seen two women, Miriam West and Maria Cholak, build a world-class mentoring program, recruiting mentors by the thousands as a result of their committed, charismatic leadership.

The impact that well-chosen community service can contribute to our personal growth is one reason why I advise young men and women to get involved in their communities at an early age. The amount of time we devote to these activities must, of course, fit in with what's needed to do our jobs and support our families. But I have found it to be of far greater value than I ever could have imagined. It is a learning and motivational experience not to be missed.

<div align="center">※➤◦◄※</div>

In the end it comes down to this. Each of us has only one life to live. We want it to be in pursuit of a purpose worthy of our best effort. One of the elements which makes that pursuit so satisfying at P&G is the opportunity to contribute to the society around us. What makes this doubly satisfying is to know that our collective efforts to do good will help strengthen P&G's reputation and help our business grow, often in ways we can never fully anticipate.

Receiving Good by Doing Good

Some Questions to Consider

1. What is the reputation of your brand/business in the community? Is it helping build the equity and image you need to build the business?

2. What activity are you carrying out or planning that will build your brand's/business's reputation and strengthen its business while making a valued contribution to the community? Do these activities involve more than a monetary contribution? like personal time? P&G products? know-how?

3. Do the leaders of your community view P&G as a valued, contributing member of the community? Why or why not? Is there additional action you should take to establish a positive answer to this question?

4. What experience have you had in the community that has added to your appreciation of the values which underpin effective leadership and a good life? What effect has it had? How might you take greater advantage of or add to that experience?

5. Are the efforts of your business focused against a common audience, cause, to make an impact — or more scattered and unfocused?

6. Have you identified opportunities to link P&G brands into existing programs as a way to improve lives within the communities we operate?

Chapter 6
The Power of Community:
P&G's Greatest Advantage

"While my career took me away from the P&G family, my appreciation
for the firm has never weakened, and my gratitude for how it prepared
me for life can never be over-emphasized. My wife of 36 years was with
me at the reunion. Her revelation was strong — not so much about
the talent of our peers (a given), but rather of the integrity and values
shared by so many, and of the realization that the people of Procter &
Gamble are truly special ... then and now."

— Patrick Hill
Reflecting on a P&G Alumni Reunion
(After an absence of more than 30 years)

In April 2003, more than 400 former employees of Procter & Gamble
returned to Cincinnati, Ohio, for the largest-ever reunion of "P&G alumni."
Some were CEOs and directors of other companies. Many came from distant
parts of the U.S., and a number were from outside the country. They spent two
days getting reacquainted with old P&G friends and learning from one
another. Beyond the dinners and receptions, there were keynote speakers,
panels and break-out sessions.

What causes a group like this to meet? Why would men and women who
had left Procter & Gamble from one year to more than 30 years ago take the
time to fly to Cincinnati for a reunion?

I asked them.[1] They all said pretty much the same thing. They believe that
an important part of who they are today — their standards, values, knowledge
and capabilities — was developed during the time they spent at Procter &
Gamble. They feel this way whether they were with the Company for a year, a
decade or a career. They continue to believe in the Purpose and Values of the
place. And they remain proud of their association with P&G, proud of the high
standards P&G set for them, and grateful for the chance to have been among
people of extraordinary ability and commitment.

[1] At the luncheon held for the alumni on April 26, 2003, I asked the attendees to fill out a card
addressing two questions: (1) What was your most memorable recollection of your experience
at Procter & Gamble? and (2) What do you believe is most important to assuring P&G's success
in the future? The answers were informative and sometimes humorous. You'll find a sampling in
Appendix I.

What was most palpable at this reunion of former employees was the sense of community and pride that bound us together across generations, disciplines, geographies and even other employers. I believe this unique sense of community is P&G's least tangible, yet most distinctive and difficult-to-match competitive advantage.

It is essential that future generations of P&G employees be aware of the community that exists within our Company and understand why it exists, why it matters and what can threaten it. They also need to know how to nurture, strengthen and leverage the P&G community for the benefit of our Company, our brands and, ultimately, themselves.

The purpose of this chapter is to address these issues to help perpetuate the P&G community in coming generations.

What Is Community?

Robert Putnam, in his book *Bowling Alone*, talks about the many benefits of being a community. We, at P&G, will have no trouble recognizing them.

- Community allows people to resolve collective problems more easily.

- When people are trusting and trustworthy, and when they have repeated interactions with fellow members, everyday business and social transactions are less costly.

- People who have active and trusting connections to others ... become more tolerant, less cynical and more empathetic to others.

Let me be very clear here. I am not talking about some theoretical, abstract concept. I have witnessed and experienced the *practical benefits of community* at every level of P&G's organization, in every function and in every part of the P&G world.

Mark Ketchum, former president of our Baby & Family Care business units, speaks eloquently about the benefits of community. When colleagues have contributed their best, he remembers feeling

> *... incredibly well-connected with the people I was working with ... close in knowing what they thought and felt, and what they had passion for. Close in the common objectives we shared and the dedication we had to achieving them. Close in the honesty and candor between us. Close in our belief that nothing could stop us — that our destiny was in our control. We shaped the culture that we needed to accomplish great things.*

That is what a sense of community can provide.

The recognition that we are part of a unique community at P&G begins our first day on the job. In fact, I believe it can begin even earlier — during the recruiting process, when we decide to accept an offer from P&G.

We can't fully understand the degree to which we'll bond with the Company and its people when we're new employees. But even in those early days, we recognize that we're part of something special.

We understand that we have joined not just a company, but an institution with a distinguished character and history that we are now responsible for perpetuating. Recognizing P&G as an institution is crucially important, because the characteristics that have earned the Company its stature are also the factors that build community among P&G people over time:

- A shared Purpose worthy of a lifetime's effort.

- Leadership results in achieving our Purpose.

- Values that we are proud to live by and that we honor in our day-to-day decisions.

- The ability to constantly renew ourselves while preserving our core.

The Characteristics of the P&G Community

A Shared Purpose Worthy of a Lifetime's Effort

The sense of community at P&G is grounded in the Company's Purpose. Although it had long been embedded in the conviction, statements and actions of P&G people, Procter & Gamble did not actually commit its corporate Purpose to writing until 1986. As we were approaching our 150th anniversary, we recognized that thousands of new employees were joining the Company as we expanded rapidly into new countries across the world. Moreover, we had just made the largest acquisition in our history, the Richardson-Vicks Company. For these reasons, we concluded we should commit the long-held beliefs of the Company to paper. We took several months in the process. Dozens of people were involved. From this came our Statement of Purpose, Values and Principles (*see figure 8 on next page*).

It is easy to put a Purpose and set of Values and Principles down on paper. What matters is how well we live them in our decisions, especially those demanding a choice between the expedient and the principled, the short term and the long term. As I have watched these decisions being made over the

P&G PURPOSE, VALUES AND PRINCIPLES

Long-Held Beliefs and Commitments: The Foundation of All We Do

PURPOSE

We will provide branded products and services of superior quality and value that improve the lives of the world's consumers.

As a result, consumers will reward us with leadership sales, profit and value creation, allowing our people, our shareholders, and the communities in which we live and work to prosper.

VALUES

Consumers

P&G Values
Leadership
Ownership
Integrity
Passion for Winning
Trust

P&G Brands

P&G People

P&G brands and P&G people are the foundation of P&G's success. P&G people bring the values to life as we focus on improving the lives of the world's consumers.

PRINCIPLES

- We show respect for all individuals.

- The interests of the Company and the individual are inseparable.

- We are strategically focused in our work.

- Innovation is the cornerstone of our success.

- We are externally focused.

- We value personal mastery.

- We seek to be the best.

- Mutual interdependency is a way of life.

years, I have come to see P&G as a living, breathing institution, and a community of individuals whom I have felt fortunate to be associated with.

It began as I experienced the Company's true commitment to the consumer. I had been with the Company about six months and had just forwarded my first major business proposal to senior management. It called for the national expansion of a second size of Cascade dishwashing detergent. The test market was a runaway success. Agreeing to my proposal looked, to me, to be a "no-brainer." It didn't turn out that way. Jack Hanley, the head of the division, called me to his office. It was the first time I had been there — the top floor of the office building — the seat of power. This was a big deal. I was primed to answer a dozen questions. But Hanley had only one: "Do we have enough evidence of the consumer acceptability of this new, larger size to justify expanding?"

What kind of question was this? I thought. Couldn't we all see that the business was booming? Wasn't that enough for him? No. He wanted to be sure that the product's solubility would be acceptable to those consumers who only used their dishwashers once or twice a week and for whom the larger package would last for many months. He wanted to learn more. He wanted the truth. Indeed, it seemed everybody I met was after the truth.

That inspired and excited me. These people weren't interested in *who* was right, but *what* was right — above all, what was right for the consumer. I can still remember going over consumer research with Ed Artzt, my brand promotion manager, in 1964. "What do consumers really want?" he asked. "Is there a subgroup here that is expressing a concern we need to deal with? Get to the truth."

Ten years later, in 1974, this unrelenting commitment to the consumer was on my mind when I confronted an issue on a new brand, Bounce, a fabric softener that comes in impregnated sheets and works in automatic clothes dryers. We were testing Bounce in Kansas City. We were meeting all our business goals, but an issue had arisen around the possibility that Bounce might be causing the inside of dryers to lose paint and rust.

Jim Bangel, one of P&G's outstanding thought leaders today, had recently joined the Company and was working as a statistician evaluating the paint removal issue. Here, 28 years later, is how he recalls what happened:

Our Market Research folks ran a large study, gathering data from consumers about their dryer experiences, asking tons of questions and inspecting their dryers. I asked for a printout of all the raw data. I reasoned that if Bounce was causing problems, then the more Bounce loads that were run each week, the more problems we'd see. So, for each of

the consumers, I made a small slip of paper with the information on how many Bounce loads they used per week, the age of the dryer, and how much paint and rust their dryers had. I sorted the slips of paper by Bounce loads and dryer age and, sure enough, it showed the more Bounce you used, the more paint removal problems you had.

I shared the results with the folks in Product Development and they asked me to quickly come to a meeting with management. This was the first time in my career I ever met a vice president or anyone from Advertising and I was very nervous. Fortunately, the advertising manager went out of the way to make me feel at ease and comfortable. His name was John Pepper.

I didn't know anything about presentations and had come to the meeting without any handouts. John gently encouraged me to write the key facts on a flip chart. It took only a few minutes to show the powerful data. I recall John quickly saying something like "This decision is straight-forward. The data and logic are perfectly clear. We need to reformulate Bounce." Over the next year or so, we did reformulate Bounce and we ended up with a hugely successful brand.

The lesson for me was significant. Here I was the lowest peon in the Company, with not a political bone in my body, easily able to sway management on such an important and sensitive topic. I realized that P&G would do the right thing once the data was clear. I truly loved P&G from that point on and planned my career around trying to always be the person with great data and simple, common-sense logic!

As I reflect on Jim Bangel's cinematic recollection of this event, I am reminded how the decisions we make in a split second often express with the greatest clarity what really matters to us. Decisions that flow from trusting our informed gut instincts. They convey our real values and create memories that last a lifetime.

It was only a few months after this experience on Bounce that I encountered another demonstration of the Company leadership's unwillingness to compromise on doing right by the consumer. I had just arrived in Italy as general manager and we were in deep trouble. Our laundry detergent brands, which constituted almost our entire business, had been placed under price controls; however, the raw materials we were buying to make them had not. Their prices were going up dramatically in a hyper-inflationary economy. This was an ugly situation, to put it mildly. We and the rest of the industry were losing more money every day. So the entire industry shut down the production of laundry detergents and we went into round-the-clock negotiations with the price control authorities. Finally, following several days of hair-raising

discussions, the government agreed to release our regular brands from price controls, provided we and other members of the industry introduced new, *regulated* laundry brands with formulas and (lower) pricing agreed to by the government.

We moved ahead with the new brand as fast as possible, knowing it was the only way we could profitably return to business. Given its regulated low price, I knew we couldn't afford to make this product as good as our regular brands, but I insisted with the rest of the industry that it meet basic quality standards. I can remember pushing some of our competitors to increase the level of cleaning ingredients to a higher level than they preferred. We then came to the issue of perfume. Somewhat reluctantly, I agreed to a relatively low level, just enough to cover the chemical smell. I forwarded the proposal for this new brand to Cincinnati and it quickly reached the desk of CEO and Chairman Ed Harness.

Harness could have commented on several things in this proposal ... for example, the lack of profit and the plain-looking, rather unattractive package. But he made only one remark. "John," he wrote, "you do whatever you think right, but do not bring this product to market unless you feel consumers' acceptance of its odor will meet P&G's standards."

I suppose my first reaction when I read this was I should have thought of that. But even more, my heart was lifted because once again I was seeing principle and concern for the consumer rule the day. I went back to my industry associates and told them that, like it or not, I was increasing our perfume level. Through his actions, Ed Harness had brought to life the principle that we will not compromise on the commitment to do the right thing for our consumers. That's the kind of shared purpose worth living for that leads to community.

Leadership Results

The second characteristic of the P&G community is holding ourselves accountable for achieving leadership results and being leaders in all that we do. A shared purpose worth living for is essential, but not enough. We must achieve (and practice) leadership in accomplishing that purpose for our community to be created and sustained.

Ours is a culture of leadership. It is a defining characteristic that binds us together as a community of P&G people. We are driven to be the leader in every business we compete in. We stay focused on being the best in what we do. We don't win every contest, but more often than not, we emerge on top. By being a winner, we attract winners and then motivate and energize each other to become even better. I cannot overstate the importance of this.

I thought P&G was a winning firm when I joined it. While I hadn't analyzed the subject in great depth, it seemed to me that I recognized more brands from P&G than from any other company ... brands like Tide, Crest, Ivory and Spic & Span. I had been told that P&G was the best marketing company in the world, and that it provided better business training than any business school.

My impression of P&G as a winner was deepened immeasurably by what happened during my interview — not with P&G, but with a company I had talked to before coming to P&G. The company was Scott Paper, then the clear-cut leader in the disposable paper market. I chose to interview at Scott primarily because its headquarters was located right next door to the Philadelphia Naval Shipyard where I was stationed. I had already decided I'd join P&G if I were offered a job but felt I owed it to myself to interview one or two other companies. I finished answering the interviewer's questions and, as usually happens, he asked me if I had any questions to ask. I told him I did. Just before entering his office, I had read an article in Scott's house magazine discussing P&G's growing presence in the toilet tissue business. Today, I know the article was talking about P&G's Charmin, which we had acquired in 1957 and which was starting to expand regionally. I asked my interviewer what he thought about this. I don't recall his precise words, but I do vividly recall what he conveyed to me in his response. He not only respected P&G, he was genuinely frightened by what P&G's entry would mean to the future of Scott's business.

My appreciation of P&G as a leader grew. I knew even more that P&G was where I wanted to be. I was reminded recently that this phenomenon still lives when a newly promoted brand manager recalled his amazement when a recruiter from a competitive company told him, "If you have the opportunity to do marketing at P&G, do it."

We do not rest until we achieve leadership. And in those cases when we lose the lead, we don't rest until we get it back. We are acutely dissatisfied when one of our brands isn't delivering performance that consumers prefer to competition. It must always be that way. We hold high standards and high expectations of success; we're determined to win, yet humble enough to learn from competition. We're objective enough to see things as they are, and determined enough to take every action within our means and in line with our values to win.

Over time, as we fight competitive battles together, as we learn from consumers together, as we achieve leadership together, we become an ever-stronger community.

Defining Values

The third characteristic of the P&G community is having values that we are proud to live by and honor in our day-to-day decisions and actions.

We describe our values as Leadership, Ownership, Integrity, Passion for Winning, and Trust. We complement them with Principles that guide choices and actions.

I've already emphasized the importance of leadership. It is up to each of us to choose to lead in our area of influence. Leadership needs to be part of the DNA in each of us.

Two other elements of our values and principles stand out as important drivers of community within P&G: integrity and our belief in the growth and development of P&G people.

One of the most important reasons people join P&G is its integrity. They want to be part of a company of individuals they can always trust to act ethically. Perhaps *the* most important reason people choose to spend their entire careers at P&G is because they have grown certain that P&G people will always try to do the right thing.

"I've stayed because I know that P&G will always try to do what is right."

— Chip Bergh, President
ASEAN, Australasia and India Operations

I received many thoughtful notes upon my retirement. None meant more to me than those from individuals who indicated that my emphasis on the ethical values of the Company had reinforced their decisions to stay. Jim Barnum wrote me one such letter:

I am still here after 18 years of service as a direct result of the high ethical standards that you have championed and propagated. Such a moral high ground cascades into everything we are, think and do as a Company.

It's a fact: This commitment to act on ethically sound values and principles explains why I and so many outstanding people have made our entire careers at Procter & Gamble despite opportunities to leave for what, at least initially, would have been much bigger jobs.

Our Values and Principles mean the most to us in times of crisis. As I point out several times in this book, we had such a crisis in Procter & Gamble as we went through the major change in 1999-2000 called "Organization 2005." In a fundamental sense, it was our strength as a people and our faith in what we

stood for as a Company that brought us through. I heard a powerful expression of this from Marta Foster, a director in our Information Technology organization, at an employee luncheon in April 1999. "What is helping people get through this tough change is their trust in the Values and Principles of the Company." I could see a lot of head-nodding around the table as Marta said that. She was absolutely right.

Operating with integrity also earns the trust and respect of external partners. This is true in our dealings with government officials and non-profit organizations like UNICEF and the World Health Organization. It is especially true in our work with trade customers. Rob Steele, president of our Market Development Organization in North America, summed it up this way after meeting over 50 of our largest customers:

The single most important equity P&G owns with our customers is trust. Not all retailers like the way P&G does business, but all retailers expect and trust P&G to do business fairly and equitably. Customers have high expectations of P&G. They believe that P&G must set and meet higher standards than other consumer goods manufacturers. This means we must strive to do and be right on every initiative, every marketing program, every package choice and every pricing decision that impacts our customers.

Trust with our consumers, trust with our customers, trust among ourselves — they go hand-in-hand. Together they build community. Trust grows from deeply felt values that take their life from actions and decisions, particularly decisions that involve choices showing we care deeply about these values and we intend to do the right thing no matter what.

I have seen this again and again, even when we faced that most difficult of decisions — the need to reduce employment. During the second half of the 1990s, for example, we had to significantly reduce the number of people at

Novomoskovsk plant — An example of reducing employment ... with respect for the individuals involved

our manufacturing plant in Novomoskovsk near Tula, Russia. Like most of Russian industry, productivity at this plant had been far below other manufacturing plants in the P&G system. When operations began in 1993, we had *four times* as many employees as we could productively use. We knew we could not price our brands competitively

operating this way. We also realized that unemployment was high in the Tula region, so our displaced employees would probably find it difficult to land another job. We took this as a major challenge. Not only were our costs going to be competitive, but we were also going to protect the livelihood of our employees as far as we could.

We set out to create the most effective outplacement plan ever seen in Russia. We spun out parts of the plant production we weren't interested in (for example, aerosols and linoleum flooring) as small, stand-alone enterprises. We created a training center, the first of its kind in the region. We offered generous compensation packages to those men and women who were ready to retire.

While not without hardship, our Russian organization handled this reduction in employment with respect and concern for the individuals involved, and they knew it. (It is not surprising that having taken actions like this throughout our history, we have had plants whose operators knew they were about to lose their current jobs and yet set all-time production records just weeks before the lines were shut down.)

It will always be the tough decisions that require us to choose between short-term expediency and long-term goals that determine whether our commitment to do the right thing is merely a nice-sounding pledge, or something we live by no matter what. Consistently making decisions based on principle is not always easy. A few lofty words in a book can make it sound simple and commonplace, but it is not. Like everything else, Ed Harness confronted this reality head-on:

Hardly a day passes when each of us doesn't have the occasion to make a decision, large or small, involving a choice between the expedient and the principled. Making a hard decision, the decision based on principle, usually seems to involve a short-term sacrifice on the part of the Company. Our history clearly demonstrates that we've gotten where we are through consistency in making our decisions as a matter of principle. This Company must continue operating on the principle of what it believes is right rather than what will make everyone happy next week.

Doing what we believe is right. That's the clarion call. And sometimes it will demand sacrifice. Jorge Montoya, president of our Latin America organization, recalls one such time. He was just assuming responsibility for our Latin American business in 1985. It was a difficult period. Our business was fragile, making less than half-a-billion dollars in annual sales and virtually no profit. Montoya arrived in Mexico to learn that our major account, representing 30 percent of our business, was literally boycotting every P&G brand. Why? One of the buyers had asked us to give him a new car. Jorge's reaction: "No way!" It took three months to get this boycott behind us. Finally

a friend told the buyer that P&G just wouldn't change its policy. We had gone into the red; we were losing money. But we didn't change our policy. Finally the boycott was withdrawn. It is by making decisions like these and standing on our principles, that values are built.

That wasn't the last time Jorge Montoya would face such a decision. Several years later, he learned that a number of external business relationships had been formed in one of our Latin American countries between a few of our top managers and members of their families. While not a violation of the law, and in fact common practice in that country, it was a clear violation of P&G's Conflict of Interest Policy. And the people involved knew it.

There was not a trace of hesitation in Jorge's action. He let go two-thirds of the top development people in one of our departments. This was regretful, anguishing. He knew the individuals involved. We had been working hard to develop local talent. But it was a decision on which he did not hesitate. He did inquire where we might have gone wrong. How might we have emphasized our standards more clearly? What could we learn from this incident? But the action he had to take was clear, and it was action taken in a difficult economic and political circumstance; in a country that had suffered coup attempts, government scandals and financial crisis. Yet, none of these factors, challenging as they were to our business, led Jorge to think twice about what he needed to do in order to uphold the Values and Principles of the Company.

As I write this, there is great dissatisfaction with corporations because of a growing number of reported unethical practices. This is not the first time we have encountered unprincipled behavior in the workplace. Nor will it be the last. Greed and malfeasance are not going to disappear from the human race. Still, as Gordon Marino, a professor of philosophy has observed:

> *The issues that provoked the present crisis were not overly subtle. You don't need a weatherman to know which way the wind blows, and CEOs do not need a business ethicist to tell them right from wrong. What they need is the character to do the right thing, which is to say, the mettle to avoid the temptation to talk themselves out of their knowledge of right and wrong, even if that knowledge lowers their profit margins.*

Still, it can be difficult to know where to draw the line on what appears needed for the short term and what is right for the long term. For example, how much media can we cut on a brand at the end of a fiscal year in order to help make the current year's profit forecast and still be doing the right thing? How long should we continue to carry a pricing differential (which we know takes us off our pricing strategy), versus a competitor, hoping eventually the competitor will follow? These aren't life and death questions, but they are the kind that test us. They are ones I wrestled with. They rarely lend themselves to

formulaic answers. They call on our experience, our judgment and often our courage, to do what we believe is right.

⊰⊷●⊶⊱

Another aspect of P&G Values is equally important: our belief in the growth and development of P&G people. This, too, is a crucial source of community. I experienced it right from the start. I was with the Company only a matter of weeks before I saw my boss, Ralph Browning; his boss, Jack Clagett; and his boss, Ed Artzt, show genuine commitment to my training. They spent hours with me.

I had read about P&G's training in the recruiting literature. Now it was happening to me. A month after I joined the Company, I found myself in my brand manager's office asking to do a project which, as lore had it, I normally would not have been able to work on for another year or so. His reply: "Go ahead. Let me know how I can help." This was freedom to learn; to do all I thought I could. P&G really did believe in the possibilities of people. They were committed to helping individuals grow.

In a talk to students at Harvard Business School 25 years later, Ed Artzt eloquently expressed what I experienced sitting in front of him in the fall of 1963: "People sometimes refer to the early training at Procter & Gamble as 'boot camp.' While it isn't 'dancing school' [he was right about that!], it does serve the purpose of producing winning managers who learn how to think and plan strategically at a high level of professional skill."

But I identified even more with the advice Artzt then offered the students:

Work for people who care about your progress — not just your performance, but your progress, your growth. There is a big difference. The woods are full of people who can run things; they can get performance out of their organization. But they don't know how to make people grow. They don't have mentoring skills and instincts.

Ed Artzt had these skills and instincts, and I and hundreds of others benefited from them.

While in Sales training in Nashville, Tennessee, I experienced another dimension of P&G's concern for its employees that reveals itself, especially in difficult times. One of my fellow sales representatives told me how the Company had helped one of his children get emergency medical treatment, flying the boy to a specialist to get care not available in Nashville. I didn't know businesses did that type of thing. Now I knew that P&G did.

Years later I saw this again, when Debbie Vargo, a P&G associate, told me how P&G had cared for her and her baby boy, Dylan. He had been born prematurely while she was in San Francisco on a business trip from Cincinnati. After 13 days in the intensive care unit, Dylan was stable enough to move, but his weight had dropped further. Intensive care was still required. Wanting to minimize cost, the insurance company's direction was to keep Dylan hospitalized in California. But P&G intervened. The Company flew the family home on Stanford's air ambulance with two physicians and a nurse on board. That way Dylan could receive special treatment at Cincinnati's Children's Hospital and Debbie could be closer to her husband and their friends for support as they watched their infant son fight for survival over the next critical weeks. Debbie recalls:

P&G chose to do what was right, and in doing so, created my defining moment with the Company. I became forever bonded to the Company, driving my passion against our business objectives. This experience has shown me, on a very personal level, how powerful and sustainable real commitment can be when we truly bond.

I have seen this concern for people acted on all around the world: in times of personal illness and in the face of natural and man-made disasters — floods, earthquakes and war. One of the worst earthquakes in modern history occurred in India in January 2001 in the State of Gujarat. It registered 7.9 on the Richter scale. The death toll exceeded 30,000; more than 500,000 homes were destroyed. As always, P&G's first priority was to ensure the safety of its employees and then help them recover. One of our key account managers, Arvind Chari, lost his home in the earthquake. After the event, he expressed his gratitude for the Company's support to Gary Cofer, our country manager in India:

Gary, I'd like to thank all the employees of the Company and you for all the help, direction, love and affection I got during the most scary moment of my life. My boss told me that I should not worry and take care of my family and should not risk either, even a wee bit. He not only understood my concern but was quick to even anticipate my mother's worry and anxiety. Procter was not my first company when I started in my career, but I am certain that I will continue with this fantastic organization until the end of my career.

If I've learned anything over the years, it's that the future of P&G, indeed the future of any institution, depends on its people. Richard R. Deupree may not have been literally right, but he was right in essence when he said decades ago: "You could take away our brands and our buildings, but if you left us our people, we could rebuild the whole thing in a decade."

Severely damaged building at Bhuj, following earthquake in India, 2001

All of this gets back to the central importance of people. We know it is the individual men and women of P&G who make it go, and they know it too. As John Smale put it in 1986: "Why were the thousands of people who preceded us committed to the success of Procter & Gamble? Because they believed *they* were the Procter & Gamble Company, all of them together."

P&G people relish the investment that others have made in their growth and their well-being. The return on that investment is not only their own contributions to the business, but the passion and responsibility they, themselves, embrace for developing others. It is a "virtuous cycle" of growth that strengthens the bonds of community within P&G and creates formidable competitive advantage.

Renewal From the Core

The fourth characteristic of the P&G community is our commitment to preserving the core of P&G while being willing to change virtually everything else to stay in the lead. Over time, as we learn how consistently the Company has reinvented itself and its brands, while staying true to our core Purpose and Values, we come to appreciate how difficult and rare this really is.

One of my favorite business books, James Collins' and Jerry Porras' *Built To Last*, includes the visual shown below (left). It conveys a message worth a thousand words. I have modified it slightly (right).

I use it to make a simple point: The growth, indeed the survival, of any great institution requires that it maintain a dynamic, often tension-laden balance between preserving its core values while creating the future.

Easy to visualize; easy to say; much harder to do. After all, what exactly is the core? How do we preserve the core without becoming frozen in the past? What pace and how much change can we undertake and still retain the stability and confidence that come from preserving the core?

At P&G, our core is embedded in our Purpose, our Values and our Principles. It is especially important to have clarity on our core values in a rapidly changing world that requires greater independent action from every employee. I learned the truth of this the hard way. We lost our grip for a time on some of our core values during the Organization 2005 change, which we embarked on in the years 1999 and 2000. And we paid a heavy price for it. For example, in seeking to bring more attention to Total Shareholder Return (TSR) and our share price, we took too much focus away from the consumer and from our market shares as a critical measure of how well we were serving consumers. To be sure, a leading TSR is an important and necessary outcome. But, pursued without the underlying recognition that it is the consumer value of our brands that will ultimately determine TSR, it can (and did) take us adrift. I recall placing monitors in our lobbies to showcase our share price. It would have been a lot smarter if I had showcased our market shares or our customer service performance.

Still, preserving the core is only half of the equation. In order to achieve our vision of being the best consumer products company in the world, we need to be ready and able to undertake major change.

Doing this can be challenging! It is difficult to maintain energy for change when you've been successful. Success, particularly sustained success, brings with it the inclination to preserve, to follow existing models — often to a fault. And yet the need and opportunities for improvement in how we operate are all around us. Consumers change, technology develops, competitors progress, business models alter, business becomes more global. New products must deliver the total experience consumers desire. Savings are achieved by revamping the supply chain as an integrated whole, not just in pieces. Opportunities abound to innovate and operate more efficiently.

While P&G people have always possessed an instinct to innovate, I have often seen us throttled by tradition or, to say it more nobly but no less dangerously, by the instinct to maintain what's worked. We saw that in an earlier chapter as we pursued, too long, an overly narrow view of Crest's equity,

and as a result missed out on several market-changing consumer needs. How do we avoid this trap? External focus is key: learning from consumers, customers, suppliers, academia — the best experts, no matter who or where they are. We must maintain a fierce openness to dissident points of view and internally and externally benchmark our performance versus best-in-class results.

As A.G. Lafley recently charged the organization, we must be "change leaders." Emphasizing the need to draw on the "strength of our Purpose, Values and Principles," A.G. went on to describe exactly what he expects change leaders to do consistently well:

- *Stay in touch with reality.*
- *Anticipate alternate scenarios.*
- *Make clear choices that produce advantage.*
- *Inspire action in those around them.*

As we do this time and again, keeping P&G and its brands in the lead with consumers and customers, we thrive. This, too, strengthens the bonds of community.

Taken together, these characteristics — a shared purpose, a culture of leadership, living our values, leading change without losing our core — define the sense of community that sets P&G apart.[2]

Let's look now at the benefits we reap as a result.

The Benefits of Community

Great Team Building

When we are working together as a community focused on a common goal, taking full advantage of our mutual and individual capabilities, we operate with the effectiveness of a great athletic team. A contemporary expression of this spirit is organization flow. It is to a business what being "in the zone" is to a sports team. When flow is achieved, an organization reaches maximum performance through clarity of focus and concentration on the task at hand with a great sense of control and confidence. Here's how Jorge Mesquita, president, Global Home Care, defines the dynamics of this state:

[2] One of the least understood and rarely examined dimensions of the change needed to remain a strong institution is that required to redesign our organization structure in ways which respond effectively to changes in the environment and take full advantage of the capacity of our people. I examine this key subject as it applies to the history of Procter & Gamble in Appendix II.

Everyone understands each other's roles so actions become seamless and intuitive instead of transactional and bureaucratic. Self growth through experience and accomplishment is achieved, and there is a sense of becoming part of a greater cause.

Mesquita describes the requirements needed to achieve this and they're precisely what make for a strong community.

A family-like environment, full of passionate, focused and positive people; a fluid and flexible organization design; open, rapid and transparent communications; and a steady rhythm of engagement with work life.

The sense of being a community produces fierce commitment and loyalty among the employees of any organization. I have experienced it in my working relationship with Yale's outstanding President Rick Levin and his top team, just as I have experienced it at Procter & Gamble. Indeed, I've never heard anyone convey the power that a community can provide more compellingly than one of the members of Rick Levin's leadership team, Alison Richard. I worked with Alison as a member of the Yale Corporation during most of her nine-year tenure as provost of Yale University. In late 2002, she was appointed vice-chancellor of Cambridge University in England. During a press briefing on one of her first visits, she was asked a question that no one had anticipated: "If you could take one thing with you as you move from New Haven to Cambridge, what would it be?" Although she hadn't rehearsed the answer, Alison said afterwards that she knew instantly what to say:

Alison Richard (provost) and Richard Levin (president) at Yale University commencement. They demonstrated that with a sense of community, "the sky's the limit."

If there is one thing I could bring, it would be the sense of warmth and partnership and shared purpose that I feel with my many friends and colleagues at Yale. You can have the biggest endowment in the world, and you can have the best governance system in the world, but if you don't have that sense of community, then all that is for naught. If you do have that sense of community, then the sky's the limit.

Being a Community Strengthens Us as Individuals

The benefits of being a community extend beyond what we gain as a group or a team. They have everything to do with our personal growth. A young brand manager said to me recently, "I am inspired by the people I work with." So am I. I am a better person because of the people I have interacted with at Procter & Gamble. The decisions I've seen others make, the challenges I've seen them take on, and the character I have seen them demonstrate, have all influenced me in sometimes subtle, but meaningful, ways.

I have felt this influence from those I have worked for — men like Ed Artzt, John Smale and Ed Harness. You'd expect that. But I have also been strengthened by the actions and character of women and men who have worked for me and alongside me. And I think of so many unsung heroes — men and women in Treasury, Tax, Consumer Relations, Customer Business Development, our plants — who, through their competence, commitment and courage, take the actions and achieve the results that make this Company what it is today.

I could go on with other examples, but these will suffice to make the point that I am a different and better person because of the lessons and inspiration I have received from hundreds and hundreds of men and women whom I have known at Procter & Gamble. *And that has been possible because I have experienced P&G as a community.*

Gaining these benefits has required one thing more than any other — personal, open relationships. There is no way we can benefit or learn from another person if we aren't open to appreciating that person in the first place. That is why it is so important for us to take the time to form relationships. I deeply resonate to the words of the writer, Terry Tempest Williams: "It is the sanctity and celebration of our relationships that not only support a good life but create one. In friendship, we spark and inspire one another's ambitions." I would emphasize that this is why, as we work to strengthen and take advantage of the diversity of our organization, we must look first to strong, close, personal relationships as the foundation for progress. All this can only happen in a community.

Being a Community Builds Pride

Being part of a strong community provides another benefit, and it's an important one. It instills confidence and pride in what we are part of. There is no easier way to gauge that pride than by sensing how you feel when you are asked that simple question: "Whom do *you* work for?" For 39 years, I answered proudly, "I'm with P&G." I am not alone in that feeling. Again and again, fellow P&Gers have shared with me their pride in answering that question. Mark Ketchum says it this way: "I have always been proud to belong to this Company. Proud when asked what I did and whom I worked with, whether I

was being asked by family, friends or whomever." Chuck Fullgraf, who years earlier led the same businesses Ketchum did, recalls: "Almost everyone with whom one talks is respectful of P&G as a Company. I think this is an important factor to the employees — to be respected as a group as well as an individual."

No example of this pride of being part of P&G touched me more than the story told by Chuck Retrum. He was a patriarchal role model for me in my early years at Procter & Gamble. Manager of our Kansas City Sales District, Chuck was the epitome of professional competence and character. All of us young folks in marketing wanted to test our new ideas in Retrum's territory. We knew if anyone could make it work, he would. And we enjoyed being with him. Some years after his retirement, Retrum was in Surabaya, Indonesia. He was calling on a small company there, and the gentleman who was the manager asked:

Chuck Retrum, a role model of professional competence and character

"What did you do in America?"

"I worked for 38 years for Procter & Gamble."

"Procter & Gamble! I, too, worked for Procter & Gamble for 15 years before Sukarno and his government literally forced P&G to leave. I want to tell you something, Mr. Retrum. You worked for the greatest company I have ever known. They are a company of total integrity, great progressiveness, and absolute honesty, led by the kind of people whom I want to know as friends."

That, too, is the benefit of being a community.

Maintaining Community

It's easy to celebrate the value of having a strong sense of community. It's a much more difficult task to maintain and strengthen it. Sustaining the P&G community requires a balance of individual actions and company policies.

It's Up to Us
Like anything of importance, building a strong sense of community begins with the deep conviction that it is vital to our business success and to our

personal happiness. *It starts with a commitment from each one of us — as individuals — to create community in our own circle of influence.* It starts with honest answers to questions like:

- How much care, respect and affection do we show for one another?

- How much trust do we convey to one another in our routine interactions?

Each of us knows that we are far more likely to give all we've got when we see ourselves as valued members of a winning team, operating in an environment of support and learning. Each of us wants to know that we count. Each of us needs an abundance of those two commodities in shortest supply in our society: a sense of purpose; and a realistic understanding that what we do matters, and that we are appreciated.

It was more than a century ago, in 1890, that William Cooper Procter uttered what I regard as one of the most significant statements ever made in Procter & Gamble's history. In describing what he considered "the spiritual inheritance of our Company," he referred to three qualities: "hard work, fair dealings" and what he termed "our affectionate dealings with one another." No one could have been surprised to hear the phrases "hard work" and "fair dealings," but "affectionate dealings with one another"? That surely was unexpected. It was important then. It is even *more* important now.

In this candid shot taken on annual Dividend Day at Coney Island, near Cincinnati, William C. Procter (r) was caught in a rare moment of relaxation. (8/4/28)

The very thought of Christmas calls for the spirit in service to others. Shall we not make this spirit endure throughout the coming year by trying to appreciate each other's problems, and by working together to make our Company more closely show mutual affection and respect? With such a spirit of service, we will attain greater heights; without it, our future will be limited. May each year bring to all of us this spirit of service and affection.

P&G's first Christmas card, 1924

Procter returned to this same theme almost 40 years later as he scripted the words of Procter & Gamble's first Christmas card in 1924.[3]

Sixty-two years later, John Smale, then CEO, expressed this same conviction as he addressed the Company's employees on the occasion of our 150th anniversary:

> *The Company's tradition of caring for its people is perhaps the most important part of its character. If we ever lose that, if we ever stop caring about each other, we stop cooperating. If we stop caring about each other, we lose our common vision, our sense of purpose, our commitment to the success of our Company. And should that ever happen, this Company will no longer be unique among the world's business organizations.*

Still, we all know that our concern for people is communicated not by cards or speeches no matter how eloquent they are, but by what we do day-to-day, especially in our relationships with one another. This was brought home to me recently as I read through hundreds of responses from employees describing what they recalled as the most powerful experience in their careers. In one response, a young Chinese employee described how she had experienced the support of her previous three supervisors:

[3] No leader in Procter & Gamble's history has understood and acted on the value of the individual more than William Cooper Procter. His attitude toward people has powerfully affected the character and practices of P&G to this day. They also have been a powerful motivator and source of inspiration for me. For these reasons, I explore Procter's beliefs and actions in more detail in Appendix III.

I am so lucky to have had three immediate managers in the past seven years — they helped me grow. Looking back, the first manager was just like a father, helping me. The second was like a brother, encouraging his little sister to go forward. I felt that I grew a lot and learned a lot. Now I can manage an event for over 400 people and do a presentation in a big group. The third manager — he's just a good coach and a good friend. He gives me clear guidance and advice and I grew from a secretary to a person who handles a category's product supply. I am so proud of myself and deeply thankful for my managers' support. I do believe that P&G is a great company. Managers care about people. I will work for this Company until I retire.

Most opportunities to be sensitive to another's needs will occur in ordinary circumstances. Their everyday nature makes them no less important. Sometimes, however, in a time of natural disaster, or a global or business conflict, our respect and caring for one another will be tested at an even higher level. We've experienced this as P&G people have set out to find fellow employees in the midst of earthquakes and floods. We've even had a few occasions when P&G people have been called on to stand by their associates in situations where their very lives were at risk.

One such occasion occurred in Lebanon in the 1980s. It had been ravaged by a ferocious civil war starting in 1973. Throughout those years, P&G's plant in the suburbs of Beirut continued to operate almost without interruption. As our Lebanese Plant Manager Ziad Shaaban wrote me: This was a result of the "loyalty, courage and spirit of belonging that brewed in the hearts of its people who braved the risks they daily faced as a result of shellings, bombings, snipings, kidnappings, booby-trapped cars and explosions." Although "our employees came from a variety of backgrounds, religious faiths and beliefs," Ziad explained, "they practiced the motto 'one for all and all for one.'"

A day came when this motto was tested in the most significant way possible. A group of local militia, armed with machine guns and grenades, showed up at the factory gate demanding that all the people belonging to a faith other than the militia's be handed over for questioning. The guard on duty, who happened to be of the same faith as the local militia, refused the request saying, "The people in the plant are one solid entity," and that their only objective was to accomplish a hard day's work to earn a living for their families. The militia persisted in its demand. At that point, the guard sounded the alarm and brought all the manpower from the plant to the gate. Most of them, also, belonged to the same faith as the militia, yet their message was loud and clear: You will only take those people over our dead bodies. The militia left.

This extraordinary event in Lebanon tested our concern and loyalty for our associates at the highest level. P&G people had risked their lives to protect their

associates. I was reminded of this when I read a poignant eulogy in the *New York Times* honoring Captain Callaghan of the New York City Fire Department, who died while leading his firefighters into the World Trade Center following the cataclysmic terrorist attack of September 11, 2001. In this compelling eulogy, I learned about the role of "comrades."

> *Comrades are people who work side-by-side closely sharing the responsibility for the success of what they do. There is a distinction between comrades and friends. Friends and brothers forgive your mistakes. You can take your ease with them — tell them tall tales. Comrades are different. Comrades need you to be better. They keep you sharp. They take your word literally.*

I have had hundreds and hundreds of comrades (and friends, too) in my career at Procter & Gamble; associates with whom I have shared a sense of responsibility, a sense of dependence on one another. Nothing builds a spirit of community more than this.[4]

Few of us will find our loyalty called upon as Ziad Shaaban did in Lebanon, or Captain Callaghan did in the World Trade Center in New York on that morning of September 11. However, I suspect each of us has had our own personal experiences of coming to feel trusted and valued at P&G, and we have all experienced the reality that knowing we are trusted has an impact on how we feel and how we perform.

> If I know you value me and want me to succeed and believe in my capability to contribute meaningfully, I will behave differently than if I believe you feel otherwise. I will spend less time worrying about positioning myself to better your view of me, or to avoid what I feel is skepticism or hostility. I will spend more time focusing on the business issue at hand, pushing for creative solutions and open-mindedly assessing and testing those logically.

— Anne Lilly Cone
Consumer & Marketing Knowledge organization

[4] There's no part of the Procter & Gamble world where I felt a stronger sense of comradeship and community than in Latin America. Jorge Montoya and I attribute this to several factors. The region has a common heritage in language, education, history and strong family values. Moreover, the P&G organization has had to overcome many economic and political crises together. Finally, in Jorge's words, the "leaders in each of the countries worked under the same basic principles of humbleness and servant leadership." Whatever the foundations, the sense of community was unmistakable. What is it? Montoya's answer:

> *It is embedded in the trust in each other's professional capability and integrity. It came about because of the unequivocal need to pull together in the same direction, toward common objectives. We had to prove to the Company we could succeed. There was no place for distraction, dissent, misalignment. We either work together toward the same goals, or the Company could easily change priorities. It really started from a basic need.*

I want to register one other point here. The more we actually *come together physically* as a community, the more likely it is we will feel the trust and sense of identity that enables us to act as a community. I will always recall sitting in Cincinnati's Music Hall in late 1967 for my first Annual Meeting. I had been with the Company for about four years and I was listening to Tom Bower, who was then in charge of P&G's business in Europe. He was talking about how we were building our European business against tough competition. We had been in Italy for about 11 years and in Germany for only six. It was exciting. It sounded like the French Foreign Legion. I was proud to be part of this Company.

I remember many other Year-End Meetings: the lessons they taught, the pride they built, and the comradeship they created and rejoined. And I was not alone. One fellow employee was speaking for many as she reflected on the Year-End Meetings we had in Cincinnati. She recalled that they were often long and the weather usually cold or rainy, and even as she acknowledged that she'd sometimes "skip parts of it," she went on to the heart of the matter:

> *I usually liked to sit alone, because without fail I would cry out of the pride, affection and the emotion I felt for the success, dedication, smartness and goodness of the Company. I loved the success stories from around the world, and I loved to bring faces to the names of our leaders.*

This woman touches on one of the precious benefits of our being a community. While a company of more than 100,000 employees dispersed around the world cannot assemble all in one place, we do need to come together physically in groups, from time to time, to share the realities of our business situation, our hopes and goals for the future, and how we intend to achieve them. It is through such gatherings and sharing and interaction that our energies are rekindled, relationships are formed and we become and remain a community.

As I have tried to convey, building a strong sense of community is an everyday affair. Personal relationships and group interactions make it happen. They occur top down, bottom up and peer-to-peer. Every one of us is part of this and needs to be. A retirement party in a plant, a meeting in a corridor, the celebration of a 10-year anniversary, the retirement of a 40-year veteran, the welcoming of a new employee, a gathering in someone's home — each of us can take the initiative. One by one, year after year, simple interactions like these bring us together; they show that we care, we trust one another and we are in this together.

Sound Policies and Practices

While each of us has a role to play in forging a strong sense of community, senior leaders have a particular role to play through the policies and practices

they establish and through the actions they take. These practices and actions can be for the better and, unfortunately, they also can be for the worse.

Promote From Within

Probably no practice has contributed more over time to Procter & Gamble's sense of community than "*promote from within.*" This policy is based on the expectation and the reality that the great majority of P&G's future leaders will come up through the Company, having joined it relatively early in their careers. They will establish their right to progress through the results, capability and character they demonstrate on the job at P&G. This practice of promote from within has a great deal to do with creating our sense of community. By growing up together, we get to know one another better. We communicate more effectively and we get to the real issues faster. We make decisions more confidently with all the conscious knowledge and intuitive insight that can only come from our prior experience with each other's judgment, track record and character.

Promote from within explains the tremendous emphasis we place on recruiting, training and career development. We know that if we fail to recruit or develop a generation of managers, we do not have what some would call the luxury of "going outside" to hire a legion of senior managers. We realize that it is the encouragement, the guidance and the learning we provide to those who work for us that will influence their development, just as we were influenced by those we worked for.

Our practice of promote from within helps maintain the consistency of character, which I believe represents the most important competitive strength of P&G. Late in 2001, John Smale expressed this eloquently in a note to me:

> *It has always seemed to me the Company's character is what pulls us through difficult times. And that character is, I think, all intertwined in the continuity of the character of the people at P&G. P&G shapes the character of the people who work for the Company beginning in their 20s and continuing through their careers. And they, in turn, shape the Company's character.*

> *It would seem unlikely to me that a corporate leadership which was created differently every generation by hiring from outside the Company could maintain the consistency of character that represents the competitive strength of P&G.*

I could not agree more. There is no way I can imagine our having been able to navigate so well through the major changes and challenges that we faced in the last several years if we hadn't had the benefit of the relationships and common commitment that drew such vitality from our having grown up together in pursuit of common goals.

One other point: Our practice of promoting from within naturally leads to more employees having lengthy careers with Procter & Gamble. And this, in turn, facilitates employees' living in and experiencing different parts of the Procter & Gamble world. We bring people from our far-flung developing markets into our larger business centers, and vice versa. This helps us learn what it's like to serve consumers and customers in different parts of the P&G world. And it adds immeasurably to our appreciation of the benefits of diversity.

When you get to the top in P&G, everyone has been there 25 years. You know one another. You share the same values — the same culture. You react, perhaps, differently on matters of judgment, but you react the same on points of principle, and points of integrity. Other companies don't have that. I sit on boards on which the executives all come from different company backgrounds. They are like temporary lodgers. At Procter & Gamble, because of our promotion-from-within policy, we've all grown up together. *Luckily for us, most other companies scorn our promotion-from-within policy.*

— Michael Allen
Group Vice President (Retired, 1994)

To be clear, our practice of promoting from within is not free of risks. We can become too insular, too internally focused. We must respond to this challenge by creating strong external relationships, by benchmarking versus our best competitors, and by bringing in the best experts. We must make it as easy as possible for the strong men and women who join P&G through an acquisition or joint venture to bring their unique strengths to the Company. And, of course, we must always retain the flexibility to reach out to hire individuals with the expertise we need in a field or for a position that needs talent we have not yet developed.

Still, we should never underestimate the contribution made by our practice of promoting from within. I am convinced that the sense of community within P&G would erode dramatically over time if it were not for our commitment to develop leaders from the ground up, and for the shared Purpose and set of values this creates.

Strategic and Operational Clarity
A vital foundation for nurturing a strong sense of community lies in giving every employee a clear understanding of

- The realities of our business situation.
- What we intend to accomplish.
- How we intend to do it.
- How each person is expected to contribute.

William Cooper Procter expressed this need clearly more than 80 years ago in 1919.

> *The chief problem of big business today is how to shape its policies so that every employee, whether in office or factory, will feel they are a vital part of the Company, with a personal responsibility for its success and a chance to share in that success. To bring this about, employers must take the people into their confidence. They must know what they are doing and the relationship of their work to the business as a whole.[5]*

An instrument that has been very helpful in recent years in providing the linkage of Company goals with each person's work is our "OGSM," a written, easily communicated statement of our Objective, Goals, Strategies and Measures. One of the first things that Durk Jager and I did when I became CEO and he COO in July 1995 was to develop an OGSM that was deployed throughout the Company. The OGSM provides clear goals and identifies the strategic choices to achieve them. It defines the measures we will follow to assure that we are on track to reach our goals. The OGSM helps groups work together toward common goals, across functions, geographies and up and down the line. Steve Bishop, general manager of our North American Fabric Care business sums it up nicely:

OGSM form

> *The OGSM continues to serve as an excellent tool to focus the organization on those few things that really make a difference. We use it as the centerpiece of our capability-building program. The first way we do that is by ensuring every employee has a work plan tied to the OGSM. We did a survey after the last deployment and found nearly perfect compliance.*

[5] In his superb book *Self-Renewal*, John Gardner says it this way: "Without some grasp of the meaning of their relationship to the whole, it is not easy for individuals to retain a vivid sense of their own capacity to act as individuals, a sure sense of their own dignity and an awareness of their roles and responsibilities. They tend to accept the spectator role and to sink into passivity."

Colleen Jay, general manager of our North America Home Care business, deployed her OGSM against the theme, "You are the strongest link." Every individual in her organization identified the one key project or action that he or she saw as the "strongest link" to delivering the organization's overall goals.

The Importance of Face-to-Face Communication

Building a strong community takes a lot more, however, than deploying an OGSM. It requires open, principled and sometimes tough, but always respectful, conversations. That's what leads to wise and timely decisions. Rebecca Henderson, a professor at MIT who has consulted with P&G from time to time, describes this requirement well as she advocates "high conflict/high respect decision-making." This is decision-making committed to the pursuit of truth against a common goal. It is decision-making among people who know and trust one another enough to "tell it like it is" and yet not put one another on the defensive.

Developing the level of trust that is a precondition for high conflict/high respect decision-making necessitates that we come together, face to face, to know one another and decide what we intend to accomplish together.

In-person meetings are especially important when we are reviewing a person's performance and career development. They are irreplaceable in starting up a relationship with a partner, such as an advertising agency, a customer or a supplier. Take the relationship that we are developing with an emerging leader in the retail trade in China, Chairman Ji Xiaoan. I first met Chairman Ji in Beijing in October 2000. He came to visit us in Cincinnati the following June, and I met with him and his top team again in Beijing that October. Neither of us speaks the other's language. And yet, we have come to share the conviction that we can accomplish a great deal together and have established a partnership to do it. I don't think this would have been possible if I hadn't been sitting across the table from Mr. Ji, sensing the depth of our mutual commitment to this undertaking.

Challenges to Community

As important as it is to implement actions and policies that *build* community, it is just as important to *avoid* policies and actions that can *undermine* community. On the one hand, the sense of community at Procter & Gamble has a long heritage. On the other hand, it can never be taken for granted. This is true particularly because so many of our employees are young, and because the pace of change and the generally heightened sense of job insecurity can raise the question: Are people still really P&G's most important asset?

Several principles can help us avoid the mistakes that undermine community.

"Do No Harm"

We can perhaps best begin with the essence of the Hippocratic Oath. We should take care that our policies and actions do no harm ... that they not inadvertently undermine our sense of community.

Every management decision will impact the sense of community and the trust that underlies it: deciding who gets promoted, establishing sales and profit goals and the bonus plans attached to them, setting travel budgets and designing office space, outsourcing and reducing employment.

Withdrawing long-accustomed benefits without clear justification is a prime example of doing harm. We have seen some companies do this recently by sharply reducing, even eliminating their retiree health care plans. We must also design our compensation systems so they do no harm. For a time, the criteria for awarding short-term bonuses to the men and women in our Global Business Units and Market Development Organizations were differentiated. They failed to encourage collaboration. Fortunately, we spotted this defect quickly and fixed it.

Deal With the Toughest Issues — Correctly

Do no harm doesn't mean we won't undertake difficult and challenging decisions. There is no way a business could survive without taking on such decisions. In fact, there is no way anyone could do what's right without taking on such decisions. All easy things to say. But much tougher to do. No decisions I've ever faced brought this reality home to me so much as those that involved reducing employment and, more recently, outsourcing activities, which, while important, are not activities that P&G brings superior value to.

If we are to carry out changes like this in a way that doesn't undercut that sense of community which is so valuable to us, there are two imperatives.

First, it must be crystal clear that a given change is essential to the Company's long-term health. It needs to be obvious that the change is required to better serve consumers and to be competitive versus our strongest competitors. And if the change does involve a reduction in enrollment, that reduction must flow from the elimination, simplification or restructuring of work. It must not flow from piling more work on those who are to remain.

Second, the change must be executed in a way that the people affected not only see it as right for the business, but believe it has been managed in a way that honors their contribution to P&G, treats them fairly and gives them the opportunity for the best possible future career development.

I recounted earlier how we handled a significant reduction in employment in our Novomoskovsk plant in Russia with a plan never before seen in that

country. This parallels our action in situation after situation when we have had to reduce employment.

Outsourcing key activities or selling business units has, if anything, posed an even bigger challenge to our stated conviction that "people are our most important asset." Despite the challenge, I believe we have generally succeeded in executing our plans in a way that demonstrates the respect for and commitment to P&G people — respect and commitment that are an intrinsic part of being a community. Our decision, for example, to sell our Jif and Crisco businesses to the J.M. Smucker Company was powerfully motivated by the conviction that these businesses, and the careers of the P&G people who moved with them, would have better prospects for growth in the hands of this focused food company. What's more, we knew that the values of Smucker were much like our own.

In outsourcing elements of Global Business Services, our choice of companies was powerfully influenced by the career development opportunities and benefits offered by the different candidates. Several companies were specifically rejected because their benefit programs did not measure up to the standards that we believed people moving from P&G should have.

Still, we shouldn't kid ourselves. Even when handled in the best possible way, there's no pretending that these decisions don't impact the perception that employees have of the community to which they belong. Not too many years ago, a broadly held view in Procter & Gamble was that if you did a good job, you were virtually assured of a lifetime of employment. That was never totally true. There were examples throughout our history where circumstances forced reductions in force. But they were rare. Over the last 20 to 25 years, this has changed. People doing a fine job in a plant or in a sales unit sometimes have found their jobs being eliminated. And people doing outstanding work in certain functions have found their work being outsourced to another company.

Can a strong sense of community be retained in the face of realities like these? Yes, provided the changes are seen as fundamental to the long-term achievement of our mission and are carried out with respect for the people involved. Will people's attitudes be precisely the same as before? Of course not. Can we still retain the inherent benefits of being a community that I've described earlier? I believe we can. And it's important we do so if for no other reason than that these benefits will become even more of an advantage as it becomes increasingly difficult for a company to achieve this community spirit.

Avoid the Pitfalls of Bureaucracy

Uncontrolled bureaucracy is another challenge to a strong community. Like many other vulnerabilities, it can be the outgrowth of what is good and valid. "We need better controls," we say. We want to keep a "good" person in a

"worthwhile job." We staff up quickly to cover a new project. Yet, the weaknesses that grow out of bureaucracy are deadly: too many levels; too many check-off points; unclear decision-making rights; lack of accountability; lack of motivation; and, ultimately, lack of timeliness in achieving decisive results.

Bureaucracy can take many forms in a company as large and disciplined as P&G. We distort productive processes like High Performance Work Systems by "key elementing" or auditing them to death. We create a mindset that it is more important to "get your ticket punched" in a series of positions rather than to stay in one place long enough to make a solid and lasting contribution.

John Smale captured the pitfalls of bureaucracy with chilling precision:

> *When a company achieves a long period of sustained dominance, the human factors of pride, arrogance and complacency seem to overtake many more noble qualities. Bureaucracy seems to replace a spirit of entrepreneurialism, and the size and complexity of the bureaucracy grow disproportionately with the growth of the business itself.*
>
> *Individual efforts become focused internally rather than externally, with more and more emphasis on internal processes and detailed analytical reports and presentations — and less emphasis on interaction with the customer and less urgency in anticipating and responding to changes in the competitive arena.*

We suffer from some of the pitfalls of bureaucracy, particularly when it comes to decision-making. In an opinion survey conducted in April 2002, more than four in 10 P&G employees said our culture discourages leaders from making firm and clear decisions; this increases to almost six in 10 among our more senior leaders.

How do we avoid this pitfall?

- Don't put off until tomorrow a decision you should make today.

- If you are in a lead position, make it clear whether you expect to be involved in a decision or not. If you intend to be involved, get involved at the point that will lead to the fastest and most effective achievement of the objective.

- Make the decisions on your own that you should. Involve others when you feel they can be helpful. But take responsibility for the decisions that you should handle in order to take timely action.

- Ensure that the people who need to be involved in making a decision are present at a key meeting.

- Before a meeting starts, identify the decisions that need to be made before it ends. As the meeting concludes, review how you have done against that objective. If any decisions are left unmade, be clear about what will happen next to make them.

Honor the mandate: "Agree, disagree, but when the decision is made, commit."

Avoid Misguided Politeness

Being overly polite can also destroy community over time. Being unwilling to engage in honest and decisive debate on issues that need to be debated and resolved conveys distrust and, ultimately, a lack of respect for the individuals involved and affected.

One writer acidly describes this misguided attachment to politeness as "pseudo-consensus," which leads to "pseudo-community." Members of a group might want to avoid conflict and they skirt tensions. This is dangerous on any subject, but it's particularly so when it concerns personal relationships. In well-known author Stephen Covey's words:

The cause of almost all relationship difficulties is rooted in conflicting or ambiguous expectations around roles and goals. Clarifying expectations sometimes takes a great deal of courage. It seems easier to act as though differences don't exist and to hope things will work out than it is to face the differences and work together to arrive at a mutually agreeable set of expectations.

This has been an area of personal challenge for me over the course of my career. Influenced, I am sure, by my inherent respect for other people and my optimistic nature, I have sometimes had a distaste for interpersonal conflict and have been reluctant to tell people something they didn't want to hear. I've worked to overcome this tendency by recognizing that being direct and decisive is precisely what I need to be in order to be of service and carry out my responsibilities.

Several years ago, we seized on a metaphor to describe a simple action to put the uncomfortable issues in front of us. We described it as "putting the moose on the table." As the metaphor goes, one day a group comes together and standing right smack in the middle of the table is a big, ugly and dangerous moose. Still, no one mentions it. People stretch and bend to address each

"Putting the moose on the table."
Illustration by Marshall T. Clark

other between the moose's legs, talking about one triviality after another, all without acknowledging "There's a moose on the table and we'd better do something about it, or it's going to kick us in the teeth."

Today at P&G, if people are engaged in a discussion that someone feels is not addressing an issue, they'll often interject, "There's a moose on the table." The discussion stops and the gut issue is put on the table to be resolved.

Avoid "Management by Bumper Sticker"

One of the most significant challenges to community, especially to the open debate and objective decision-making community can foster, is our tendency to transform an operating practice into a rigid dogma ... or a good idea into an immutable ideology.

Too often, I have seen an operating practice, which is appropriate in some circumstances but not in others, morph into dogma that becomes so fixed it almost seems insubordinate to question it. Sometimes this happens because a senior manager has a point of view about a subject that gets communicated too dogmatically. For example, following a period when we have had too many teams, I've seen senior managers take the position that "teams are bad." Valid in a given situation, this comment becomes generalized with the result that teams go underground or are not used when they should be. Or, someone concerned that we have become too process-oriented declares that "process is something to be avoided." Or, "speed" and "stretch" become clarion calls so dominant that if someone questions whether we have enough data to justify a particular action, he or she is regarded as not being "on board" or is labeled "risk-averse."

Needless to say, reactions like these inhibit debate and honest disagreement. They fight against our ability to reach reasoned decisions appropriate to the situation. I liken this to "managing by bumper sticker."

In my own experience, the pursuit of "single-point accountability" became a striking example of how management by bumper sticker can get us into trouble. Early on, we went too far in making single-point accountability a litmus test of the legitimacy of our Organization 2005 design. To be sure, we needed to drive for clearer and simpler accountability. Our decision-making had become too complex and too slow. We had input from functions, geographies and product lines intersecting almost every key decision. The process was inefficient. Enormous energy was being consumed internally, and the results were predictably cumbersome and slow.

The undoubted complexity of this decision-making process led us to act, but in a too-simplistic, too-mechanistic way. We concluded, for example, that pricing decisions would be put into the hands of the Global Business Units

(GBUs). Yet, those decisions also needed to be *informed* by the Market Development Organizations (MDOs) in the individual countries. Working with their customers, they could see from moment to moment what our competition was doing. It didn't take long to see that our profit objectives could only be achieved by joint plans and superb execution emerging from our GBUs and MDOs working closely together.

This is not to say that we don't need to understand who the ultimate decision-maker is on an individual issue. We do. But equally, we need to understand how that decision can *best be made*. In many cases, that will require drawing collaboratively and efficiently on the insights and experience of different people — all aiming at a common objective and being rewarded for achieving it.

Sidney Finkelstein, in his book, *Why Smart Executives Fail*, has another way to describe this trap of managing by bumper sticker. He calls it the trap of the "magic answer." We fall into it when we let all our decisions be guided by one principle that we believe is the panacea to success. This can lead us to focus on a given model or principle to the exclusion of all others.

In order to avoid magic answers and inappropriate dogmas, we must beware of self-delusion, and of extending situational success to a universal rule of success. We must beware of leadership more intent on demonstrating boldness than on achieving the ultimate purpose of the organization. We must beware of the natural desire for simplicity and predictability to lead us away from a more complex, but possibly more correct, solution. We must beware of failing to consider the downside contingencies, what competition might do, the risk of one of our assumptions being wrong, and the possible unintended consequences of our actions. *Above all, we must stay in touch with the concrete realities of each particular situation.* As Thomas Friedman warned in describing the tragic history of the Middle East in his book, *From Beirut to Jerusalem*, "If you don't gradually let reality in to temper your mythologizing, it will sooner or later do so on its own."

It is the principle-based, yet particular examination of an individual situation that distinguishes the mature and wise decision-maker. The best leaders have an eye for, indeed a fascination with, the discriminating detail. They test their strategies and plans against the specific realities of the market.

Good leaders are sensitive to practices that are situational and that should be bound by the circumstances attendant to that particular situation.

Don't Confuse the Means With the End

More often than not, when I have seen us allow a practice to become dogma, it has been because we confused the means with the end. For example, following the mantra of "standardization" in the late-'90s, we set out to market our European laundry brands using standardized, European-wide product programs and advertising strategies. In doing so, we lost touch with consumers in the individual countries. We lost sight of our pre-eminent goal of building profitable share by serving our consumers.

We've changed that. We are no longer insisting on one European advertising campaign on our laundry detergent brands. Rather, where appropriate, we are developing advertising for each country that recognizes the particular historical, cultural and competitive situation in that country. We've discarded the notion that we should only pursue product initiatives offering regional application, and we are again recognizing the legitimacy of introducing important product and marketing initiatives relevant to the consumers in a major country.

We've shed what had become an overly limiting preoccupation with eliminating complexity and are recognizing that the benefit of having a particular brand size in a particular country may outweigh the cost of the added complexity. In short, we are focusing on what really matters: winning with the consumer, winning with our customers, beating competition and doing all of this profitably. As a result, our European laundry business is now going from strength to strength.

I should have caught this tendency to oversimplify matters. More than a decade earlier, I had recorded in my journal my concern about our tendency to think in labels and generalities. "These become excuses for not considering individual ideas on their own merit and for not exposing oneself to the bite of individualized, concrete thought for each business and for each situation. Labels become an excuse for terminating thought."

More generally, I recall the wise counsel of Bart Giamatti:

We must beware of voices that are scornful of complexity, and contemptuous of competitive views and values. These voices can be encouraged because they are said to be "idealistic" or "decisive." What they are is precisely not idealistic, but in their simplifying, reductionistic. It is that civil conversation — tough, open, principled — between and among all members of the institution that must be preserved. If it is, community is patiently built. If it is not, the place degenerates.

Bart Giamatti: An Extraordinary Leader

While a classmate of mine at Yale, Bart Giamatti and I didn't know each other well. We moved in different circles, his in many ways more expansive, intellectually and socially. I was more narrowly focused: on my studies, on the Yale *Daily News*, on the Naval ROTC Program. While our paths didn't cross at all then and did only slightly later, I came to admire him greatly for his convictions and for what he said and did.

Bart Giamatti — an extraordinary leader. A classmate of mine, who became president of Yale and later commissioner of Major League Baseball.

At Bart's memorial service, Leon Rosenberg, former dean of the Yale Medical School, beautifully captured the essence of Bart Giamatti in his eulogy:

> *Bart understood that advancing a vision — not exercising a style — is the ultimate distinction between a leader and a manager. He understood, too, that the future of the institution he loves depended on the quality of the leader's vision and, as importantly, in that person's capacity to persuade the institution of the validity and worth of that vision.*

Live Our Values

Nothing — absolutely nothing — does as much harm to a sense of community as the perception that senior managers aren't practicing the Values and Principles of the Company, and that no one is doing anything about it. While no one will practice our Principles and Values perfectly, the belief that our leaders are striving to practice them as well as they can is fundamental to our sense of community.

I know I speak for thousands of P&Gers in saying that nothing has given me greater confidence in Procter & Gamble over the years than my conviction that the people I was reporting to were trying to do the right thing. I didn't agree with every decision they made, but I did believe they were making the decision based on what they felt was right. That meant everything to me.

Having leaders who try to do the right thing places tremendous importance on our requesting broad-based feedback to ensure that the individuals we promote do, indeed, live by the Principles and Values of this Company. One of the major benefits conferred by our practice of promoting from within is the enhanced likelihood of making a valid assessment of this. In the future, no single thing will have as great an impact on the strength of P&G as a community as the quality of the women and men who move into senior leadership positions.

For the same reason, if we see a person failing to act in line with our Values and Principles, we must bring that forcefully to his or her attention and, if necessary, to senior leadership. Behavior that is at odds with our Values and Principles is cancerous. It cannot be condoned. Unchallenged, it will undermine our sense of community and our results as nothing else will.

It would be all too easy, yet a grave mistake, to read the preceding paragraphs nodding "of course," and then move on, acknowledging we have just read an obvious truth, but confident it has little (if any) relevance to us. I raise this caution because we all have to be aware that issues will arise which we will need to be alert to and guard against.

Years ago, for example, I discovered a situation in one of our smaller European countries where the general manager had been flagrantly violating our policies regarding the treatment of our customers, including the offer of unauthorized vacation trips for some of them. When we finally discovered the problem, I learned the practice had been going on for years. Many employees knew about it. Indeed, the behavior had become so obvious that they assumed we in senior management *had* to be aware of it. And since we had done nothing, they assumed we condoned it. No wonder they questioned whether our Values and Principles were worth the paper they were printed on. When we finally took decisive action, we could almost hear a sigh of relief meaning, "Our principles are for real." We should have discovered the situation much sooner.

Pursue Truth

In the same vein, not too long ago I came across a series of provocative postings on the P&G intranet dealing with the most priceless asset of this Company — intellectual honesty. They emanated from an initial posting by an R&D research fellow titled: "Truth held hostage." He had raised an alarming question: "Is the P&G culture intellectually honest?" His answer was a chilling one: In too many cases, our communication was "less than truthful." That captured my attention like no other posting I'd ever seen on the intranet.

I called the research fellow immediately. I wanted to know his specific concerns in detail. Rarely, if ever, he replied, was this a question of people

literally lying. Rather, it involved selective use of data or failure to point out a genuine risk, obviously major issues. What causes such behavior in a company of good people? It could be a number of things: the desire to get a project funded at all costs; a feeling that "competing projects are presenting only their most positive results, so we must do the same"; or a lack of trust in other people's ability to properly assess the risks, so they aren't disclosed.

Whatever the cause, the cost of such behavior is enormous, both to the business and to the character of the Company. This posting stimulated a review of the history of recent initiatives. Its purpose was to identify risks or data that might not have been properly disclosed or considered. It was revealing and sobering, as indicated by these two examples.

- A major initiative on one brand resulted in shipments 83 percent below the stated objective. The review showed a full disclosure of the risk of premium pricing had not been made. Pre-test market testing had shown the value rating to be in the bottom third. We went ahead, even though our most recent review of initiative performance failed to show even one market success with a value rating in this third.

- Another initiative had shipments almost 50 percent below objective. The review revealed that the copy, which had been used nationally, scored well below normal in both its persuasion measure and recall, even though the recommendation for expanding the initiative said that "new copy was being developed which would drive stronger trial than the 'above normal' advertising used in test"!

Reactions on the intranet from a number of people who read the original posting indicated that the research fellow's observations were not unique. "Your monthly is a breath of fresh air," one respondent wrote: "I am envious of your courage ... like you, I've witnessed a lot of 'truth hiding,' half truths and exaggerations from where I am." Another wrote: "Rewards are given for perception, not on reality, and there's rarely any penalty for exaggeration, omission or hyperbole. It is indeed viewed as 'the way things are' and no serious effort to amend the situation has ever occurred, in my experience."

I am not suggesting that these observations describe everyday incidents. Of course, they don't. Nor are they unique. Sustaining the values of the Company will always depend on individuals' willingness and courage to stand up for what they believe is right, sometimes against a body of opinion that suggests doing otherwise.

Summary: Our Highest Priority

I have commented at length on the power of the community that resides within P&G because I believe it is a rare and difficult-to-match competitive advantage. Competitors can imitate P&G strategies. They can develop similar competencies and design virtually identical organization structures. They can even hire former P&G leaders. But they cannot replicate the community within our Company that has developed over generations.

I believe the concept of community has never been of greater value, nor at greater risk.

It is of greater value because the world in which we compete has become extraordinarily complex. Our sense of community enables us to operate in the midst of complexity with the simple clarity that flows from a shared purpose, a shared belief in leadership, and shared values and experiences. We can face and lead change strengthened by the bonds of the personal relationships that unite us as an organization of P&Gers.

It is at greater risk because we have grown into a large, complex business. Employees are scattered around the world. We are acquiring new companies and attracting new partners. And we are faced with ongoing decisions that can sometimes seem in conflict with P&G values.

Capturing the value of and minimizing the risks to community will not only make us a stronger and more successful company. It will also make P&G a place that will be more satisfying for every one of us — a place that, even more, will elicit the deep-seated feeling any institution treasures when found among its members: "I can't imagine finding a better place to be ... I can't imagine being in the company of better people."

In the end, the one thing most capable of protecting and strengthening the P&G community is the P&G community itself — every one of us. It is our highest priority as an organization of men and women who have our sights set on improving consumers' lives and perpetuating the institution we have joined.

The Power of Community: P&G's Greatest Advantage

Some Questions to Consider

1. Am I taking steps in my own circle of influence to build a sense of community with my associates? What more might I be doing? What more will I do?

2. Am I creating open relationships with those who work for me and with me? Are we sharing clear expectations of one another on how we can best work together and how our working relationships might be improved?

3. Am I being clear and honest with those who work for me about their performance? where it is strong? where it can be improved?

4. Am I striking the right balance between being a strong champion for what I believe in and yet remaining objective in assessing risks and benefits and sharing that assessment with others involved in making an important decision? Am I contributing to a culture of intellectual honesty?

5. Am I avoiding the trap of allowing "bumper sticker" ideas and dogmas to get in the way of principle-based decisions that are sensitive to the particular situation?

6. Am I giving those who work for me a clear understanding of the realities of our business situation? Are we having discussions that allow us to jointly determine what each of us is going to do to achieve our business goals? How can I improve this process?

7. Am I willing to share bad news with those who need to hear it?

8. Am I getting the tough issues (the "moose") on the table? Is there a particular issue I need to be bringing to the table right now? what is it? with whom?

Early Days

My sister, Elizabeth, and I (circa 1947)

In the Navy (1964)

My parents, Irma and John, outside the first house I lived in (circa 1940)

Early Days and Family

Francie and I shortly after our marriage (1970)

As general manager of P&G's Italian operations (1974)

The Pepper family at Dartmouth — (*l to r*) Douglas, Francie, John, David, Susan and I with Pounce and Molson (1997)

Francie and I (2004)

Three CEOs Under Whom I Served

Ed Harness

Ed Harness led the Company as CEO from 1971 to 1981 amidst its most challenging days in the post-World War II era. It was a time of high inflation, slow economic growth, Middle East oil crises and the greatest product safety issue the Company has ever faced — Rely tampons, which Harness removed from the market because they could not be categorically excluded as a cause of serious illness. I cannot imagine our having had a stronger leader to take the Company through this time.

Harness was what one would rightfully call a "man's man." Still carrying the build that had marked him as an outstanding football player at Marietta College, Ed — gruff, no nonsense — had limitless integrity, a huge heart and a human touch that was extraordinary. As John Smale, who succeeded Harness as CEO once said, "In a company whose greatest asset has always been its people, Ed Harness brought an enormous understanding of his fellow men and a 'touch' that brought out the best of them. It is hard to imagine a greater skill in a company such as ours."

Ed was a role model for me and countless others. He embodied character and integrity. No one has ever spoken more eloquently to the need for principled actions, yet he was as practical and straightforward in his thinking and actions as they come. He was a source of enormous inspiration to me.

John Smale

One of the most outstanding leaders in P&G's history, John Smale served as CEO from 1981 to 1990, leading the Company to tremendous growth around the world and in our brand portfolio. John brought to every task the calm assurance and determination of a man who had grown up believing that problems were meant to be solved and challenges were made to be met; solve and meet them he did. Believing deeply in the importance and power of product innovation, Smale oversaw expansion of the Company's research and development capabilities to new and higher levels. Never losing touch with reality, never losing his capacity to see things as they are, John made the tough personal calls when he had to.

A great believer in people, he recognized it was they who made the ultimate difference in the business. John brought together the qualities of wisdom and courage, concern for people and commitment to the long term in a manner I've never seen exceeded. He combined a deep belief in the foundational values of P&G with an open-minded urgency to identify and make those changes needed to keep P&G a leader. He's been the most valuable of mentors and is a special friend of mine to this very day.

Ed Artzt

A teacher par excellence, a master builder of brands and people, Ed Artzt led the Company as CEO from 1990 to 1995. I had the good fortune to work for Ed at the very beginning of my career and for a large portion of the last half of my career. Known quite properly as a tough taskmaster, Ed is a perfect example of one of those teachers who demands the most, teaches the most, and (in retrospect you realize) gives the most.

Possessing one of the finest strategic minds I've ever known, with a fiercely competitive and pragmatic spirit, Ed had an enormous influence on just about every product division in the Company. He was the principal architect of the growth of our International business during the last quarter of the 20th century. His love of the business and his commitment to excellence and to winning were of the highest order — and very contagious. Every time I made a request, he was there to help me and to help the Company — no questions asked.

Leadership Teams I Was Part Of

The team I worked with after becoming president in 1986. And what a powerhouse it was: (*l to r*) Executive Vice President Tom Laco; CEO and Chairman John Smale; me; and President Ed Artzt, International.

Durk Jager and I served together as COO and CEO from 1995 to 1999. People said we were different in many ways, and we were. But we were alike in seeing many needs for change. We didn't complete all we started, especially Organization 2005, but we set a course that was necessary and which, under A.G. Lafley's leadership, has created unique advantage.

It was a delight to serve as chairman alongside Chief Executive A.G. Lafley. I could not have been more pleased or proud of his accomplishments.

P&G Associates Around the World:
A Never-Ending Source of Learning and Inspiration

The "advance guard" in opening Eastern Europe and Russia (early 1990s)

Our Russian organization

(*l to r*) Herbert Schmitz, Fuad Kuraytim, A.G. Lafley, Sheikh Ismail (our partner in Saudi Arabia), me and Kerry Clark

Associates and spouses enjoying themselves in Italy

With our start-up team in Saigon, Vietnam, 1996

African-American Customer Business Development reunion — North America

With our Customer Business Development team in Beijing

Plant dedication: Timisoara, Romania, May 14, 1997

With associates in Pakistan

With members of the Mexican and Latin American organization

P&G Boards of Directors with Whom I Served

Introduction to the board — 1984
(*Front row, l to r*) Thomas Laco, John G. Smale, Owen B. Butler, Edwin L. Artzt
(*Second row, l to r*) Ashley L. Ford, Joshua Lederberg, Theodore F. Brophy, Marina
v.N. Whitman, John E. Pepper, James W. Nethercott, Charles T. Duncan, Amory
Houghton Jr., Edward G. Harness, Gerald V. Dirvin, Richard J. Ferris, Walter F.
Light, David S. Swanson, Robert A. Hanson, David M. Roderick, Frank R. Milliken,
Powell McHenry

*Throughout my almost 20 years of participation on Procter & Gamble's board of
directors, I had the benefit of the wisdom, the direction and the support of an
outstanding group of men and women, especially at our most challenging
moments. They cared (and care) deeply about the future and success of the
Company and contributed mightily to that success.*

Nearing retirement — 2003
(*Top row, l to r*) A.G. Lafley, Norman R. Augustine, John F. Smith Jr., Margaret C. Whitman, John E. Pepper, R. Kerry Clark, Richard J. Ferris, Domenico DeSole, Ernesto Zedillo, Ralph Snyderman, Johnathan A. Rodgers (*Bottom row, l to r*) Lynn M. Martin, Joseph T. Gorman, Charles R. Lee, Marina v.N. Whitman, Robert D. Storey, Bruce L. Byrnes, W. James McNerney Jr., Scott D. Cook

Receiving Good by Doing Good

P&G built 100 schools in rural China from 1995-2004 as part of "Project Hope"

Global External Relations Officer Charlotte Otto greets students during opening of a new school in China

Children attending donation ceremony

One of several meetings with Premier Zhu Rongji. He was very aware of and appreciative of P&G's Project Hope. It strengthened our relationship.

P&G As a Family Affair

Early Dividend Days (Coney Island)

Family fun at Coney Island (1957)

P&G Philippines: Employee children
entertain visiting guests (1990s)

Family Day at our Pomezia plant in
Rome, Italy (mid-'70s)

Working with Leaders

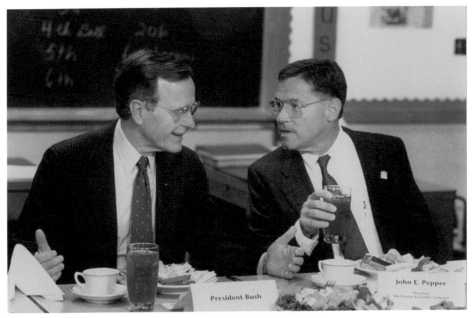

President George H. W. Bush came to Cincinnati in 1989 to recognize the Cincinnati Youth Collaborative, which I co-founded with the vice mayor and superintendent of Cincinnati Public Schools

Signing agreement of cooperation, St. Petersburg University. With me are Mayor Anatoly A. Sobchak (St. Petersburg) (*left*) and Rector Stanislav P. Merkuriev (St. Petersburg University) (*right*) c. 1991.

With President Ernesto Zedillo of Mexico (*third from left, front row*). We had toured one of our plants and opened a new P&G-supported school. President Zedillo later joined P&G's board of directors.

With President Bill Clinton (*center*). I worked with his administration on trade and education policy. Here he is recognizing our mentoring program. Miriam West (*left*) was its remarkable leader.

New Challenges

With Yale's president, Richard A. Levin, in my new role as vice president of Finance & Administration, Yale University

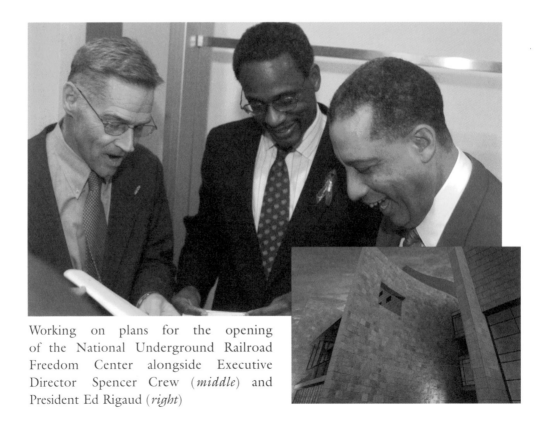

Working on plans for the opening of the National Underground Railroad Freedom Center alongside Executive Director Spencer Crew (*middle*) and President Ed Rigaud (*right*)

How We Live Our Lives

I explore what underpins everything else: our leadership and the values by which we live.

I examine the value of *passionate ownership* that P&G people bring to the business.

I highlight the importance of building and taking advantage of our *diversity* and look at what we need to do to make it happen.

In *Personal Model for Living*, I describe the life goals I've pursued and the qualities of living and values I've tried to embrace to achieve these goals.

Finally, I share my convictions that when all is said and done, life at P&G, as well as the success we achieve, is a *family affair*.

———→>-0-<←———

Chapter 7
"A Passionate Sense of Ownership":
The Key to Success and Satisfaction

"I think I overcame every single one of my personal shortcomings by the sheer passion I brought to my work. I don't know if you're born with this kind of passion, or if you can learn it. If you love your work, you'll be out there every day trying to do the best you possibly can, and pretty soon everybody around will catch the passion from you — like a fever."

— Sam Walton, Founder, Wal-Mart

"Passion leads to enthusiasm and enthusiasm is vital. There is no perfection of technique that will substitute for the lift and spirit that enthusiasm produces. Some people keep their zest until the day they die. They care about things. They reach out. They keep a sense of curiosity. They enjoy the risk of failure. They allow themselves some moderately cheerful expectations of the future."

— John Gardner, Founder, Common Cause

"I've never met people who care so much about their company as Procter & Gamble people."

I've heard this countless times and no comment pleases me more. It is the source of the passionate ownership that leads to strong individual leadership in the midst of P&G's strong corporate culture. Often, a strong corporate culture and strong individual leadership will *compete with* one another. They *reinforce* each other in P&G. I believe it is the passionate sense of ownership that we feel, the commitment to make a difference personally, that explains why. This is a vital part of what makes us the Company we are. It is a tremendous source of competitive advantage.

In this chapter, I will share and describe:

- The contribution passionate ownership makes to our business and to our satisfaction as individuals.

- What I have found to be most important in building this sense of ownership, and what I've seen get in its way.

- My experience on how we can help nurture personal ownership for one another through a culture of trust and high expectations.

I started to experience "P&G ownership" very early in my career. In fact, my earliest and most indelible memory was formed not in Cincinnati, where I began my career in marketing, but in central Tennessee where I went on sales training after being with the Company for 12 months.

It was there that I met Bill Prendergast. Bill's passionate determination and ability to own the business in every retail store he called on in the small and medium towns that made up his section in central Tennessee brought home to me the difference one individual can make to a business.

Bill was a professional par excellence. Standing close to 6'6", built like a defensive lineman, plain spoken, good humored and quick to get to the point, Bill exuded confidence and determination. There was never a question about whether he would meet his sales objectives; it was only a matter of how much he would exceed them.

But what most impressed me about Bill, and what I remember today, was his feeling of total responsibility for the success of the business in his sales territory. He took the display of a competitive brand as a personal affront. He was a man of no excuses. If a brand failed to reach objectives in his territory, in his stores, it was his responsibility to make it right.

This deep sense of ownership goes way back in the history of P&G. It stems from a conviction that we are joined together in the pursuit of a worthy goal, and that each of us has an important role in achieving that goal. Perhaps no one talked about the importance of this attitude more eloquently than Richard Redwood Deupree. He was born in Covington, Kentucky, in 1885. Deupree crossed the Ohio River to join Procter & Gamble as a clerk in the mailroom at the age of 18. Years later, he became the first person outside of the Procter and Gamble families to lead the Company. An individual of powerful intellect, unrelenting discipline and strong character, he served as president from 1930 to 1948, a period marked first by severe worldwide economic depression and then by global conflict.

Richard Redwood Deupree was the first head of P&G other than a Procter or a Gamble. He built the Company's business — and values — in challenging times.

Shortly after being elected president, in the early stages of a depression that would last years longer than he or anyone could have imagined, Deupree had this to say in an address to his fellow P&G employees:

It will interest you to know that, in spite of this most distressing period, our Company has made progress. No one can say which is the most important factor in our progress. Certainly one of the most important is the unity of spirit and ideals brought out in the cooperation of P&G people for the common good of the Company.

Far more than Deupree could have realized, Procter & Gamble people would need every bit of this "unity of spirit for the common good" — this sense of ownership — during the coming decade. By 1941, the Company's sales and earnings *had* grown ahead of where they were when Deupree talked to his fellow employees that day in 1931 at Ivorydale, but only after recovering from a decline of more than 50 percent in the toughest years of 1932 and 1933!

The importance of people who act with intense ownership for the business always means the most in times of crisis. We saw this during the depression of the 1930s. We saw it again, 70 years later, in Pakistan. Pakistan borders on Afghanistan, a country ruled in 2001 by the Taliban, supporters of the Al-Qaeda terrorist cells that engineered the horrific attacks on New York and Washington, D.C., on September 11, 2001. P&G's business in Pakistan was still relatively small in 2001. We had only entered the country in 1991 but had already built market-leading share positions in the Hair Care and Personal Cleansing categories. Our bar soaps were produced in a small plant located a few kilometers from the center of Karachi.

Late in 2000, we had approved an investment to expand the plant's capacity. The start-up of the new plant happened to have been scheduled to begin the day before the terrorist attacks on New York and Washington. Three non-Pakistani P&G technicians were on site assisting the local Pakistani employees in starting up the new line. Given the concerns about possible follow-up terrorist attacks, especially on non-Pakistani employees of U.S.-based firms, it was decided that the three technicians should leave Pakistan immediately. A further constraint on the production was posed by the strikes called by several political and religious parties.

Still, our P&G people were not about to let this get in the way of the effective start-up of this important investment. Shortly after their arrival in London, the non-Pakistani employees re-connected with the plant team via telephone and videoconference to help them fine tune the operation. Our Pakistani employees refused to go home. They stayed overnight in a hotel within walking distance of the plant to avoid a possible shutdown because of

transportation strikes. The results were spectacular: In the midst of all the tension and uncertainty, the plant delivered a new production record. That is passionate ownership of the business.

Jim Lafferty, former general manager of our Poland and Baltic operations, claims that "passion is worth +10 index points in business growth," and he may well be right.

Sometimes it is our newest employees, looking through fresh and unvarnished eyes, who see most clearly how we care about our business. Here is how a university graduate, who was interning at P&G in spring 2001, described his experience to me:

I have always, perhaps sadly, been taught that there were significant discrepancies between sheer passion and deep care about one's work, and the routine reality one ends up facing every morning. However, Procter & Gamble surprised me. No matter whom we met and what they did, people spoke about their work as if it was the single, most essential element to the functioning of the Company. I mean, you know somebody cares when their eyes gleam and they can't get enough words in about the chemistry of dishwashing soap!

What is it that accounts for P&G people feeling such a passionate ownership for our business? What can we do to sustain our own sense of passionate ownership over the years? And, what can we do to help others — those who work for us and with us — build and sustain their own feeling of ownership? These questions are important to the future of P&G or any other institution. My own experience has led me to the conclusion that two elements above all others drive the deepest feelings of ownership:

- Being intimate with the business, on a personal level.
- Creating a culture of trust and high expectations for one another.

Building Our Sense of Ownership by Being Intimate With the Business

My own feeling of personal ownership starts with my long-held belief in what we stand for as a company, and from my commitment to see us succeed, win and be our best. But that belief draws its strength from something else. I describe it as *intimacy*. Intimacy may seem like a peculiar word to sum up the experiences that have built my passionate ownership. But that's it for me. *Intimacy* ... with consumers and customers, competitors and colleagues.

It Starts With Consumers

We *must* be intimate with consumers. We must put ourselves in their shoes. We must think like them. Doing this requires that we go beyond understanding consumers as some aggregate compilation of statistics or demographics. We must respect and have affection for them *as individuals*. This is our responsibility. The day we stop thinking about consumers as living, feeling individuals, and the day we stop caring about what we can do to make their lives better through the brands we create and the information we provide, will be the day we stop being the company we aspire to be.

I'll never forget the inspiration and energy I have gained from my frequent contacts with consumers — my visits to homes in India, for example. The apartments were small, the furnishings scant, but the warmth and love of family were all around me. When I heard a mother talk about how VapoRub had helped her baby's cold during the monsoon season, I was affirmed in the value of what we do as I could be in no other way.

Nor will I ever forget my visits to homes in China — in Xi'an, Beijing, Kunming and other cities and villages. With me were Berenike Ullmann, who led our Consumer & Market Knowledge organization in China for more than a decade; and Dimitri Panayotopoulos, the vice president and general manager who led the remarkable development of our China business with extraordinary focus and spirit for more than six years. My journal entry describing home visits in Beijing captured the feeling I have had time after time:

> *A most enjoyable day. As always, I learned so much — and above all, I am reunited with the responsibility and opportunity we have to serve the individual consumer. I am again overwhelmed by the simplicity of consumers' lives — and the vital need for quality in our products and the best possible value. (10/24/98)*

The first woman I talked with that day in a small, two-room apartment in Beijing knew the exact price of every product she bought, down to the equivalent of a few pennies. After offering us tea, another woman talked to us while nursing her 18-month-old baby. Her comfort with us made us feel at home in a matter of minutes. She liked Pampers, she said, because they were good for her baby's skin and her baby looked "smart" in them. That was the *good news*. The *bad news* was that she had stopped using our Whisper feminine protection pads, because she had discovered open ends to the pads in one of the packages she bought. Believe me, nothing tells you how much consumer loyalty depends on product quality as an encounter like this. Before we left, this same woman said she wanted to share three dreams with us: that her daughter prospers as she grows up, that the hospital she works in prospers, and "that China gets better and better as a country."

I took away many impressions and quite a few feelings from the hour or so that this young mother allowed us to spend with her. I had a deeper appreciation of the need to keep the price of our brands as low as possible. I knew full well that whatever this mother was spending on one of our brands could have gone for clothing or food for her family. I was reminded that despite the huge cultural and economic gulf that separated her family and mine, our deepest hope was for the well-being of our children. Her dream that "China gets better as a country" reminded me how appropriate it was that we were working to contribute to the community in China by building schools and by providing hygiene and oral care education.

Visiting with a family in Beijing, China. I learned so much this way and was inspired, too.

As mentioned earlier, I will never forget attending a class outside Nairobi, Kenya, during which a nurse told young girls what it means to reach puberty and why Always was the best product to help them through their periods. How could I possibly have left this session without feeling an overwhelming commitment to ensure that Always remained the best-performing product and best value brand — always?

I was infused again with the passion that only face-to-face contact with consumers can provide during a visit to Turkey in April 2001. I was with Paul Hart, general manager, and Meltem Karahan, director of our Consumer & Market Knowledge organization. We were listening to a group of women describe how a recent and devastating economic crisis was challenging — and changing — their families' lives. As I recorded in my journal:

I was greatly moved by the challenges these women were facing: Husbands had lost jobs or moved to much lower-paying jobs; one woman who had lost her home had to move in with her mother-in-law; some were no longer able to give their children the tutoring needed to help ensure they went to college.

The women also talked about how the economic situation was having an impact on their use of P&G's brands. One mother explained she was reserving our premium-priced feminine protection brand, Orkid, for her daughter, while she used a lower-cost, poorer-performing brand. You can imagine how that made me feel. This was the real world. I left those interviews driven more than ever to support the efforts of our Turkish organization to improve the value of our brands.

Learning like this can occur anywhere if we seize the opportunity. Fuad Kuraytim, who headed our Middle East and Africa business, told me this story about a visit he made to a remote area of Yemen. Converting consumers from using plain bar soap for washing their hair to using shampoo was the goal of the P&G team he traveled with. They drove to a small market center where villagers came from far away to shop on market day. Their van had a loud speaker to attract a crowd, and a couple of drummers ($2 for half a day) were hired. The team had brought along a chair, buckets of water and a hairdresser. Kuraytim recalls what happened next:

As we were looking into the crowd, I saw an elderly man of about 70 years. I asked him when was the last time he washed his hair. He looked at me with piercing eyes and a defiant face and said ... "Never!" I asked him to sit down in the chair. He took off his headdress and I asked our hairdresser to wash his hair. You should have seen the color of the water! But our shampoo did the trick. As we dried his hair and combed it, he stood up feeling proud and happy. I asked him, "How do you feel now?" He stroked his hair with his hand and said, "I feel 20 years younger. I feel like I want to get myself a new bride!" That day we sold several hundred sachets of our shampoo brands and a few dozen bottles. At the end of the day, I felt we did change consumers' lives for the better.

It is from such experiences, from first-hand human contacts like these, that we come to appreciate the meaning and importance of what we do. It is from them that our passionate ownership is fueled.

A lot of our most important learning occurs in stores. And no wonder. It is here that consumers encounter what A.G. Lafley aptly calls "the first moment of truth." Can they find our brand easily? Are they attracted to it? We learn and the learning provokes action. I will long remember, for example, sorting through packages on the bottom shelf of a CVS drug store in Providence,

Rhode Island, with a consumer and Nancy Kane, head of our CVS customer team. Nancy and I had observed a woman who was obviously struggling to find the version of Pantene shampoo she wanted. We had recently made a package change, including new product descriptions. There we were — on the floor trying to help this woman figure out which Pantene package she should be buying. I *hope* we helped her make the right choice! One thing for sure — if I needed any reinforcement on the importance of making the description of our various formulas clear and easy to understand, this was it.

Passionate ownership characterizes our employees around the world, sometimes in very novel ways. In the Philippines, our organization has created what General Manager Johnip Cua describes as the most effective, trial-generating technique he has ever seen. It's called "Demo Selling." Like most good ideas, it is very simple: P&G employees demonstrate the superiority of new P&G brands with consumers in outdoor markets and in their homes. The results have been outstanding, with trial rates for our new brands of 80 percent and repurchase rates of 40 percent. As Johnip Cua told me:

The work is not easy. Our people have to work outdoors under extreme tropical conditions — either very hot or very wet, and usually flooded streets — and in smelly public markets. But in spite of all these hassles, they love their work and they are helping us grow our business. That's passionate ownership.

P&G employee demonstrating P&G brands in Manila

No wonder P&G is the marketplace leader in almost every category in the Philippines.

It isn't surprising that intimate contact with consumers builds passionate ownership. Personal contact with the people we serve reminds us that every purchase decision represents an important and deliberate choice by a consumer based on the performance and the value of our brand ... and the consumer's trust in our Company.

Staying Close to Our Customers

I have also gained a deep sense of ownership for the business from the close contact I have had with our trade customers. It started back in 1964 in Nashville, Tennessee, where I was on sales training. There I learned how to work with customers to build each other's businesses, and to serve consumers together. What's more, I learned how much satisfaction and fun there can be in doing that.

Although it was more than 40 years ago, I can vividly recall working with Buck Freeman, the head merchandiser of my largest account, C.B. Ragland, to select items for his advertising circular. Our aim was to increase his total sales and profit as well as P&G's. I can recall discussing how I could sample areas surrounding his stores with Ivory Liquid, again with the intent of building his business and ours.

This was just the beginning. I remember my relationship over many years with Sir James Blythe, the CEO of Boots, a leading prestige drug and cosmetics chain headquartered in the United Kingdom. P&G's business with Boots at the time was not healthy. We had many disagreements; trust levels were low. Sir James and I decided that we would work with our teams to make things better. We met in the office and we met over dinner. We came to know and appreciate one another. We affirmed our honest intent to pursue common goals and undertake initiatives to achieve those goals. There were a lot of opportunities. We were unhappy about the development of our diaper business. Boots was unhappy because we were not using what they regarded as their unique shopping environment and consumer reach to introduce new high-end toiletry products. We had resisted this idea. It was unorthodox. Now we decided to give it a try and it worked. We had understood Boots' needs; they had understood ours. And our business grew significantly.

I will always value my relationship with Cal Turner at Dollar General as a wonderful example of how our mutual commitment to serve consumers can result in a strengthened partnership. I was with Cal at his office in Nashville for no more than five minutes when I knew I had met a kindred spirit. I learned how much he cared about serving consumers of lesser means and how determined he was that our brands be priced at levels that they could afford. I

believe he sensed the same passion on my part. We became more than business associates; we became friends. And while there were honest differences that emerged in our relationships, we worked through them, and our business prospered.

I had a very similar experience with the power of passionate ownership halfway around the world, in China. I was in Beijing on business and conveying P&G's support for the 2008 Olympics to the mayor of the city. I learned that an up-and-coming leader of the Chinese retail trade, Chairman Ji Xiaoan, had flown with his team to Beijing from Bangkok (where he had been on business), specifically because he wanted to meet me. It took only a few moments for me to sense (from the tone of his voice and sparkle in his eyes) the deep passionate ownership that Chairman Ji felt for the business. We have met about every six months since then, in Cincinnati or in Beijing. Our teams have become close. Our partnership has been forged in a mutually reinforced foundation of passionate ownership, with exciting and improving business results flowing from this.

Staying Close to Competitors

Staying close to our competitors has also built my sense of ownership. It has made it crystal clear that as honorable as they may be (and I have found most of our competition to be quite honorable), the fact remains that our competitors covet our business. They want to beat us. They want to win the loyalty of the very same consumers whom we seek to serve. The only way we get to keep and build the business we "own" is by doing a better job.

Staying close to our competitors means knowing them as individuals. For me, it began 40 years ago. My nemesis during sales training was a Colgate man named Barnes. He probably doesn't remember me today, but I remember him. He was introducing Ajax laundry detergent into the Nashville market. Ajax was a powerful brand name in those days, the leader in the household cleaning market, with a good product and advertising that featured a dazzlingly effective visual — the "White Tornado" that swept away all the dirt in front of it. Colgate had decided to introduce a laundry detergent under the Ajax name. Barnes was competing with me, directly, in *my* stores. He was taking *my* shelf space — shelf space that had been allocated to Tide and Cheer — more space than he deserved. I was in our largest stores two to three times a day during the months of 1964, doing everything in my power (and it was a lot) to ensure that we did not lose one case of business. I sold extra displays. I secured extra ads. I was in those stores as they opened to be sure the shelf space was right. I knew Ajax would win some consumers. But if I had anything to do with it — and in my stores I felt I had *everything* to do with it — I didn't intend for them to be *my* consumers! And as I recall, they weren't.

That was just the beginning. Though I wasn't aware of it then, this early relationship with a formidable competitor — an individual — helped lead me to want to get to know my direct competitors as individuals in almost every role that followed. As I reflect on it, this knowledge has done many things. It deepened my understanding of the intentions and capabilities of our competitors. It made it far less likely that I would become arrogant or complacent. Finally, it grounded me in respect for most of the individuals I've competed against. That's helped from time to time in needed communication.

I could cite no better example of this than Reuben Mark, the dynamic and successful CEO of the Colgate-Palmolive Company. You may recall him earlier (Chapter 2) announcing that Colgate could no longer compete against Procter & Gamble in the laundry detergent business. He has certainly competed elsewhere, particularly in oral care. We've done battle on Crest versus Colgate around the world for decades, and at times, believe me, this has felt very personal.

I knew Reuben well enough to know that as China and Eastern and Central Europe opened up for business, he — and Colgate — would be there, trying to beat us. I was not about to let that happen. I felt passionate ownership for our business. I knew he did, too. That led us to move ahead aggressively.

But there was more to my relationship with Reuben Mark than the commitment to win. There was mutual respect. My respect for him was based not only on his business acumen, but my knowledge of how he treated people — specifically how he treated a Colgate executive who had sustained a severe, disabling injury and whom I had come to know and compete against in Europe many years earlier. I learned how Mark had provided special transportation for this employee to attend Colgate's annual meetings year after year. I also knew that Mark had been one of the early supporters of a scholarship program that gave every child in urban schools in New York the opportunity to go to college.

I learned of Mark's respect for me in an unusual way. I had written him (quite uncharacteristically) to make a contribution to a major non-profit institution I was helping to create, the National Underground Railroad Freedom Center. He called me on the phone and asked in his typical no-nonsense fashion how much was I looking for. ("How many cases of Tide do you want?" was the way he expressed it!) I suggested a figure and he said he'd do it. I thought that was the end of the matter until I walked into the office the following morning to learn that he had telephoned and had asked me to call. He said after talking to me the day before, he had pondered the question of why he had agreed so readily to my request. He told me he wanted me to know the answer. *It was his respect for the way that I and Procter & Gamble operated.*

Why was that mutual respect with Reuben Mark (or any competitor) important? It helped ensure that while being fiercely competitive, we competed fairly, and that in those moments of sharp disagreement, for example on a legal matter, we could pick up the phone to see if there was an *appropriate* way to resolve the situation.

In summary, being close to our competitors makes us more open to learning. It taps into our innate competitiveness, and in the best of cases, it creates a foundation for mutual respect which, in turn, can create the foundation for sounder decisions.

Being Close to Fellow P&Gers

If close relationships with our consumers and customers and competitors have fueled my passionate sense of ownership, and they have, my relationships with fellow P&Gers have done that and one thing more. They have inspired me! I've been inspired by the capability and commitment of P&G people all around the world. That inspiration has in and of itself deepened my sense of ownership. It also has brought with it a sharp awareness of *my responsibility* to lead strongly — to create an environment where people find it easy to recommend what they believe is right; where issues are debated vigorously and openly; where we drive to get on with things, to learn, to be on the offensive, to win.

For me, being close to P&G employees has been like receiving one blood transfusion after another. My spirits have been lifted and my energy refueled. It's always been that way. Whether it's been a meeting with the Meijer Customer Business Development team in Grand Rapids, Michigan, or the Tesco team in England; or a meeting with our employees in the Cabuyao plant in the Philippines or the Mehoopany plant in the United States; or having dinner with our employees on the River Neva in St. Petersburg, or alongside the Bosphorus in Istanbul, the result has been the same. I've left with thoughts in my mind like:

With people like this, there's no way we could fail to win.
It just doesn't get better than this!
I'm so proud to be in the company of such people.

These meetings showcased the passionate ownership of the P&G people I was with. At the same time, they fueled my sense of ownership.

There is no substitute for the inspiration this type of contact gives us. It reaffirms the ownership our fellow P&Gers feel and it reinforces our own. Reading a report won't do this, nor will listening to a lecture or having a meeting in our office. It can only come through close contacts and authentic conversation.

Often the most meaningful contacts for me have come unexpectedly, like this one. I was having lunch with about 25 technicians at our plant in Sacramento, California. I asked them what benefits they saw in the high-performance work system, which had recently been put in place. I had asked this question many times before and received answers that, while encouraging, weren't particularly memorable. Not *this* day. The answer I received from one technician stunned me! *"I feel I have contributed more to the business, and feel better about doing it, in the last year than I did in the entire first 25 years of my career."* He said it with burning conviction. Those few words told me more about the benefits of a work system founded on meaningful, individual ownership than any report I would ever read.

Two decades later and thousands of miles from California, I experienced another dose of inspiration as a result of an authentic conversation I had in a quiet, tree-lined park in Warsaw, Poland. I was with Jacek Dzierwa, a man of simple but profound

Francie and me with Jacek Dzierwa, a valued partner in Warsaw, Poland

wisdom. He had joined us as our partner when we started business in Poland in 1991. I instantly recognized Jacek as a man of impeccable character and sound judgment; before long, he became a friend. He and his wife welcomed me to their home. I learned about their daughter, who was in school in England; their pride in her was unmistakable and easy to identify with.

We had been reviewing the business in the office with a large group, and toward the end of the meeting, Jacek said he wanted to share a few thoughts with me. I could tell he had something important on his mind. Jacek is one of those people you listen to especially carefully, because you know he wouldn't be saying something unless it was important.

The meeting had had its difficult moments. Our business had gotten off to a fast start in Poland, but we had run into some challenges. The conversation, as I recall it, had indulged in too much finger-pointing. Jacek also had sensed — how, I'm not sure — that I was engaged in some internal debates within the Company about how fast and how far we should expand our business in Eastern and Central Europe. In any event, I could tell he wanted to talk, and I suggested the two of us take a walk.

Our conversation, which occurred more than five years ago, will remain with me always. Jacek spoke quietly, clearly and ever-so-positively. He urged that I remember the importance of doing "the right things at the right times." He affirmed the need "not to amplify negative and complaining voices," but rather "to reinforce people who are in the midst of winning." He expressed the belief that we "are at a unique moment in history and what we do over the next five to 10 years will have a decisive role to play in determining the course of our Company for years, indeed decades beyond." It wasn't that Jacek's thoughts were radically new. I had pondered them all before. What made the difference to me that day was how poignantly and authentically he expressed them. Jacek punctuated their importance for me in a way that conveyed his passionate sense of ownership and that fueled my own. He led me to think even more deeply about my responsibility to move P&G as wisely as I could into the future.

Countless times I have been moved to a deeper sense of commitment by the ownership displayed by those who work alongside me. Their passion has reinforced and inspired my own. Talk about a virtuous circle.

It's Not Just at P&G

My appreciation of the power of passionate ownership has also been drawn from my experience outside P&G. If there is one quality that characterizes every great leader or performer, it is the quality of having a passionate sense of ownership for what they do. I have seen this from afar in leaders like Martin Luther King, Jr., up close in the best teachers I had at Yale over 40 years ago, and in the president of that university, Rick Levin, with whom I work today. I have seen it especially in two inspirational leaders of a nationally acclaimed mentoring program, Miriam West and Maria Cholak. The ownership (and competence) of these two women transformed what would have been a good mentoring program into a great one that has won one national grant after another. I participated with Miriam and Maria in many presentations to recruit mentors. When I was with them, I knew we could not fail. I knew that their knowledge and conviction in the opportunity this program offered for individuals to make a difference in a child's life would lead volunteers to step forward. And they have, in the thousands.

I've seen this same power of passionate ownership in the Cincinnati Public School system in the person of Sharon Johnson. Several years ago, Sharon was assigned as principal to an urban elementary school that faced the typical challenges: Most children were from single-parent households; many were already behind at least one grade; and fewer than 50 percent were passing the state-mandated proficiency tests. Sharon Johnson changed that. This was *her* school and she was not about to accept these results. In just two years, the number of students meeting the state proficiency standards doubled. The student population hadn't changed; the parents hadn't changed; and not many

Sam Walton: A Passionate Owner and Great Ironing Board Cover Salesman

A few people have a special quality that combines a passionate ownership of the day-to-day business with the ability to think strategically about the future. I've never observed anyone who possessed this quality more than Sam Walton. Sam cared personally about every customer. It was unmistakable. And he related to every store associate as an individual, even while he was implementing entirely new store formats and other strategies enabling Wal-Mart to become the most successful retailer in the world.

Sam Walton

Walton's down-to-earth, passionate ownership for the business is evident in a story I heard from Charles Butt, the owner of H.E. Butt, a leading retailer in San Antonio, Texas. He said he'd called Sam to ask if he could bring his leadership team to Wal-Mart's headquarters on a learning mission. Sam said he wasn't sure he could help, but he'd be happy to try.

Soon after that, Charles and his team arrived on their plane and went to meet Sam in one of his stores. As Charles walked in the front door, he could see Sam at the end of a long aisle deeply engaged in conversation with a shopper. Charles walked up and Sam said, "Charles, I'll be with you in a moment. I'm talking to this young woman." Sure enough, he was trying to sell her an ironing board cover!

Ultimately, the woman put the cover in her cart. Sam turned to Charles and asked him with great seriousness, "Charles, do you know how many worn-out ironing board covers there are in this country?" Charles had to confess he had no idea. Sam said, "There are millions ... of them, and this is a problem we are going to fix. We are going to sell a million ironing board covers this month." Charles told me he had no doubt that Wal-Mart would sell those million ironing board covers — and, in fact, they did. That's what intimate contact with the business can achieve.

Sam's profound concern for the business didn't stop with knowing his shoppers. It extended to his contacts with all of his employees. It's no surprise that he called them associates. He meant it. Less than a week before he died, Walton was inviting store managers who had achieved outstanding results to his hospital room, so he could congratulate them. In doing that, Sam was doing what only he — and each one of us in our own way — could do. He was helping instill in them a sense of personal ownership by conveying trust, high expectations and the simple fact that they mattered.

of the teachers had changed, either. I only had to be in the school building for half an hour to see why this had happened. I could see the impact of passionate ownership in the attitude of the teachers (positive and determined) and in the eyes of the students (shining and proud). That is the power of passionate ownership. It's the same everywhere.

Nurturing Ownership for One Another by Creating a Culture of Trust and High Expectations

Personal ownership is, above all else, something we do for ourselves. It is a choice we make by throwing ourselves into a business and by developing intimate contact with it. However, we can nurture and encourage ownership for one another. How? By conveying trust and high expectations, authentically and honestly. Knowing you are trusted contributes mightily to your feeling of ownership.

Bob Galvin, the former chairman of Motorola, tells the story of being asked if his father, Paul, who founded the company, had done any one thing to motivate him. "Oh yes," he said, "he treated me to the most demanding discipline. He trusted me."

Think about that. Is there anything that instills a deeper sense of personal ownership than trust? As Galvin went on to say: "If you know that I trust you, you don't dare let me down."

Yet, it is easier than we might think to undercut someone's sense of trust. We can create barriers to personal ownership without even knowing it. Often these barriers are rooted in the expectations that we convey to others. The comments we make and the questions we ask establish a set of expectations, positive or negative.

Some comments and questions liberate us to go out and take ownership of a situation. Other comments do just the opposite, like:

Be sure you're totally buttoned up before you go ahead.
Be sure you have the support of your boss.
Prove to me this is right.
We've tried that before.
You'd better not take this on. The chances of it not working are too great.

Just as some comments and questions can suppress a sense of ownership, others can turn it on.

2

What Is Trust?

Trust is a core value of P&G that

- Empowers our relationships.

- Is the glue that holds everything else together.

- Allows us to be open with one another.

- Allows us to take risks in advancing ideas and to openly confront disagreements and controversial subjects.

- Lets us take "No" for an answer and not consider it a personal affront.

- Drives out fear — the greatest inhibitor of all to new ideas and great achievements.

- Is built by sharing clear and honest expectations of one another.

- Is not an immutable quality that one person has and another can discover; rather it is a function of a two-way relationship.

- Is the most powerful of motivators.

Consider the power of the simple question: *How do you think we should do this?*

Tom Muccio, former president of our Wal-Mart Customer Team and recently retired, relates a favorite question he likes to ask: "If I could give you three wishes to help you achieve your objectives at a higher level, what would they be?"

How often do you give someone a pat on the back for an achievement that represents significant progress toward a challenging goal, even if that goal is not completely realized? Carlo Soave, long an outstanding leader in our Purchasing Department, tells a story about an experience he had in buying orange juice. On the day of the final negotiations, he invited his boss to the session, confident of getting a 50 percent reduction. It turned out the supplier was only willing to give him a 10 percent cut. Carlo was very disappointed. He felt he had let the organization down. Following the meeting, he went in to apologize to his boss, who said, "You did a great job getting 10 percent. This is a very tough supplier. You'll get your price with time." Carlo will never

forget that short exchange. It brimmed over with trust and high expectations. (And knowing Carlo, I'll bet he did get his price.)

Angela Pasqualucci, then senior director on Procter & Gamble's business at the Jordan, McGrath, Case & Partners advertising agency, described eloquently how close relationships lead to trust — and that to a passionate sense of ownership.

Over the years, I've built strong friendships and bonds with people at P&G based on trust. These friendships began during phone conversations (many times hours in length), meeting preparations, dinners, cocktails and business trips. During the course of doing business, true friendships developed. True friendships in the sense that many of these people have met my family, and many of them were present at my wedding four years ago.

The people at P&G I work with treat me as a real partner. Together, we put our heart and soul into our work, and there's an unspoken commitment to not let each other down. I feel ownership for the businesses I work on, because I know people I care about are relying on me to help them build their brands and succeed in their careers.

I once asked Herbert Schmitz, who led the development of our business in Central and Eastern Europe, what most contributed to his effectiveness: "It's the feeling of ownership and trust. The feeling that I control my own destiny ... that the people to whom I report have confidence in me, trust me."

Herbert Schmitz was a leader in creating P&G's business in Central & Eastern Europe

Lessons of Trust From Three Leaders

I identify with those feelings of ownership and trust. So many people have trusted me. They gave me the freedom to carry out decisions. They gave me the benefit of the doubt, again and again.

Ed Artzt: Learning by Doing

It began early in my career — in 1964. I had been with the Company for about six months. Ed Artzt (who became CEO in 1990) was my brand promotion manager and was considering my proposal to reintroduce Duz Soap. As late as 1948, Duz was still the largest-selling laundry brand in the United States. But by 1964 its share had declined by more than 80 percent, following the introduction of synthetic detergents led by Tide. I proposed re-sampling the

brand and restarting advertising in upstate New York, where the water was soft. For that reason, soap still cleaned relatively well and left a soft feel on clothes, which some consumers found attractive.

Looking back, I suspect Artzt knew that the idea was the longest of long-shots. Yet, because I was advancing a proposal that didn't involve a great deal of risk, and because I did so with a lot of conviction, he let me go ahead. He tells me, today, he thought it could work; and if he says that, I suppose he did. But I am sure an important motivation in his mind was to let me learn by doing.

The re-introduction of Duz Soap didn't work. It wasn't even close. I learned a lot from that. You always do from things that don't work. But I gained a lot more from the trust and confidence which Artzt's decision conveyed. *I realized that he saw me owning my own business.*

Tom Bower: No Second Guessing

A decade later, in 1974, I experienced this again. It was my first year in Italy as general manager — a very difficult time. The Middle East oil crisis was at its height; inflation was running in double digits; the Communist Party was close to unseating the Christian Democrats to take leadership of the country. I'd been on the job for only a few months. Our total profit forecast in Italy was less than $5 million. I walked into the office one day and got bad news: Henkel's Dixan, the leading competitor to our No. 1 laundry brand, Dash, had cut its price. We knew from experience that if we failed to match Dixan's price, we would lose significant market share, perhaps even market leadership. Yet, matching Dixan's lower price would take us from our meager profit into a loss position and would significantly reduce P&G Europe's total profit for the year.

The early builder of P&G's business in Western Europe. Tom Bower trusted me.

That night from my home in Rome, I telephoned Tom Bower, then the head of P&G-Europe. I was nervous, but I knew what I had to do. I told him that I had concluded we should drop the price of Dash, despite its negative profit consequences. I didn't know what Tom would say. I *did* know this would be terribly punishing to his forecast. He listened to my recommendation. His response was immediate and decisive: "Go ahead. You've obviously thought

this through. You're doing what you need to do." Not "Let's think it over"; not "Can't you do it for less?" No, he just said, "Go ahead ... you're doing what you need to do." What trust! If I didn't feel ownership for the business after that, I never would. (Today Dash is the clear-cut market leader in Italy, and a *strong* profit contributor.)

John Smale: Words I'll Never Forget

Ten years after that, I had a similar experience in Europe. Again, I was advancing a difficult recommendation that would have a negative short-term impact on profits. We were proposing the national expansion of Vizir, a new liquid laundry brand in France. Early test results were encouraging, but not totally conclusive. Still, consumer acceptance of the product was strong, and I felt certain that competition would beat us to the market if we didn't move quickly. (I was determined not to repeat the sad story that had happened in the United States many years before when Unilever beat P&G at introducing liquid laundry detergents.)

Having advanced the proposal three times without gaining agreement, we scheduled what we agreed would be the final phone call. I was in my office in Brussels. John Smale, then CEO, and Ed Artzt, then the head of P&G's International business, were in Cincinnati. Smale was looking at my most recent proposal. He again saw my recommendation to go ahead. What he said to me that day was very simple: "Well, John, we put you in charge of this business. If you are still convinced we need to go ahead, that is what we will do." Fewer than 30 words spoken almost 20 years ago ... and I will never forget them. No decision could have gone further in telling me that Smale and Artzt *trusted* me as the owner of my business and that they *expected* me to run it well. My sense of responsibility and determination to do my job were elevated to new heights. Happily, Vizir went on to achieve its objectives.

As I reflect on my career with the Company, I remind myself how often people have helped me build this sense of confidence and empowerment. Some contacts were significant and explicit like those I've already related. Others were more subtle, but no less meaningful.

I recall the comment that Ed Harness made to me, almost as an aside in, I believe, 1980. We were passing each other in the hall between our offices one morning, when he stopped for just a moment and made the simple observation: "Someday, John, you know you may need to run this place." That was 15 years before I became CEO. Can you imagine the impact those words had on me? That prospect had only existed in the dimmest recesses of my mind. Ed didn't have to say that. He wasn't giving me a performance review. He wasn't making a promise. He was just being himself — openly, honestly conveying trust and an expectation that greatly elevated my awareness of the need to do my best.

Positive feedback sustains people, provided it's authentic. Honest conversation sustains all of us when it is with someone we respect. Why? Because it shows we matter.

Recognizing the impact others have had on me, it should come as no surprise, I suppose, that consciously or unconsciously, I have tried to do the same for those who have worked for me.

Years after the event and quite by accident, I read about the impact of one decision I was involved in that I was not even aware of at the time. The country was Egypt; the year, 1993. The front line leader was Fuad Kuraytim who, as we have learned, was a primary architect of P&G's strong business in the Middle East. Fuad had concluded we needed a second laundry brand in Egypt — one priced below our market-leading Ariel brand, which was starting to be encroached upon by lower-priced entries. He logically concluded the brand should be Tide, given the brand's great strength in other Middle Eastern countries, as well as North America. At the time, Fuad was reporting to me as president of International. Ed Artzt was CEO. Normally I would have cleared the introduction of a new brand with Artzt.

One Sunday afternoon, as I was going through my mail at home, I came across a piece of correspondence indicating that we were planning to launch Tide in Egypt. That was the first I had heard about the plan. I was surprised and I called Fuad that evening at his home in Geneva. I asked him if it was true that he was launching Tide in Egypt. He said he was. I asked him when he planned to proceed, expecting it would probably be several weeks away, allowing time for normal approval of the proposal. Much to my surprise, Fuad told me he had planned to announce the launch to our customers in Egypt the very next morning. He apologized for not letting me know earlier. He asked if he could go ahead. I told him yes, I would let Artzt know. This didn't strike me as a particularly big deal at the time. The proposal made sense. The financial risk was reasonable. But almost 10 years later, in an interview following his retirement, Fuad cited this as a "prime example of the entrepreneurial support and freedom" that he had been given to build P&G's business in his region. I smiled with a sense of satisfaction as I read this. We often fail to recognize how seemingly simple decisions help other people build personal ownership for themselves and experience the feelings of confidence and empowerment that flow from it.

It was enormously gratifying to hear from some of these people when I retired in July 2002. One was Diane Dietz. She is one of the strongest leaders whom I've had the privilege to know. Diane has led the Crest brand from a variety of positions for almost a decade. What she had to say pleased me greatly because it indicated that, at least in some measure, I had been helpful to her in the way so many people had been helpful to me.

Your passion for the business and the people truly raises the bar for all of us. The times when you shared words of wisdom about Crest, shared a laugh, celebrated a small victory, are times I will never forget. In the same way you have told me of inspiration you have gained by having people believe in you, you have given me that gift. Your belief in me and my team energizes me to put forth even more effort.

We have no greater responsibility (or opportunity) than helping those who work with us to be all they can be. We are most likely to do this, not by detailed inspection of other people's work (though that will sometimes be indicated), but by what we do to empower them and give them confidence — by participating in the establishment of goals and strategies, by intervening when we see they can use our help to grow, and by conveying a high level of trust through our personal interactions. It is through natural and authentic acts like these that people who report to us, and those who work with us, will come to see us as champions of their success. Doing this takes more than a proverbial wave of the hand or a nice word or two; it takes a commitment to work with them to achieve that success. That is what builds confidence. That is what fosters ownership and leads to great careers.

As Craig Wynett, a close colleague of mine, has aptly said:

Now more than at any time in our history, the critical success factor at P&G is the knowledge, insight and talent of our people. We cannot simply order, coach, or instruct people to the level of achievement that is required for success in today's world. People will work here and give their best only to the extent that they are confident and that they are inspired. Their commitment will ultimately come from within, but it must be shaped by a clear vision, and by strong leadership that inspires and conveys trust.

Act As an Owner

People sometimes ask me, "What does it take to be successful?" My answer is simple: Act like an owner and help others do the same. Identify your passion. No one can know your passion like you. Commit yourself to it. Bring it to all you do and in a way that respects and mobilizes the ideas and energies of others. Help them be strong owners, too.

As Max DePree perceptively recounted in his wonderful book, *Leadership Is an Art*, each of us asks only a few questions, silently or not, about our work environment. The answers to these questions reveal whether we will act as owners or not.

- Does what I do count?
- Does it make a difference to anyone?
- Can I be someone here?

- Am I doing what I'm really good at?
- Can I own this place?
- Is this a place where I can learn something?
- Would I show this place to my family? Or am I ashamed to show it? Or do I simply not care?

And these are the questions I ask myself to gauge whether those working for me feel a sense of ownership:

- Does my manager trust and value me as an individual?
- Is my manager telling me honestly where I stand, what I'm doing well and what I need to do better?
- Does my manager genuinely care about the development of my career?
- Is he or she actively involved in helping me learn and grow?

If these questions can be answered in the affirmative — loudly, decisively — we know we have a place in which we will feel a passionate sense of ownership and in which those working for us will as well.

This thought was on my mind as I neared the conclusion of my first address as CEO to my fellow employees in 1995:

You can take our goals and strategies and give them to another organization, and that organization may succeed, but it will not excel at the level of this organization. Why is that? I think it is because there is no other company anywhere in the world whose people believe so passionately in what they are doing. You are never fully satisfied. You are always looking for a better way. You bring courage and vision, careful thought and relentless initiative, to everything you do. Most important, every one of you cares deeply about winning, and about making a difference. Time and again, I have seen these characteristics make the difference between being No. 1 and No. 2.

This is what a passionate sense of ownership brings. It is the difference between being No. 1 or being No. 2. It is what makes us the Company we aspire to be.

A Passionate Sense of Ownership

Some Questions to Consider

1. How much ownership do you feel for your business? If it is less than you'd like, why is that? What can/will you do about it?

2. What level of ownership do the people working for you have for their business? Are you sure you know? Can it be strengthened? If so, how will you do it?

3. Do you have trust-based relationships with those working for you as well as with your peers and those for whom you work? Consider this — person by person. If you do not have the level of trust you'd like in a relationship, why is that? What can/will you do about it?

Chapter 8
Diversity: The Benefits It Brings;
The Challenge of Achieving It

"The first requirement is that there be equal opportunity and a free flow of talent from all segments of the society into the roles that are crucial to the society's future vitality and growth. Mobility must not be obstructed by our visual barriers of caste or class, wealth or family, race or religion."

— John Gardner

"I never really felt 'in the house.'"

— Lloyd Ward
Former P&G Employee

People often ask me, "What is the single, most positive change you have seen in Procter & Gamble over the course of your career?" My answer: the dramatically increased diversity of our employees.

When I joined P&G in 1963, our just over 35,000 employees were largely white, mostly male and more than 90 percent were U.S. nationals. Today, our more than 100,000 employees include women and men representing virtually every nation, religion and ethnic background in the world. This is a source of incalculable strength.

The longer I've lived, the more I've come to appreciate the benefits of diversity — for organizations and for each of us as individuals. I've learned how ideas, energy and executional excellence all grow from capitalizing on the experiences, insights and capabilities of different people. Paraphrasing Margaret Wheatley, I've come to depend on diversity because I can't see enough of the world through my own eyes. And yet I've also seen how easy it is for stereotypical, prejudiced, elitist perceptions to get in the way of appreciating the benefits differences bring.

Too often we rest easily in our personal comfort zones, content to be only with people who are "like" us. Yet, in doing so, we forego the learning and energy that flow from relationships with people who are *not* like us.

Richard H. Brodhead, Duke University president and former dean of Yale College, expressed it well:

I have always regarded the intellectual cost of separationism to be as great in its way as its social cost. In this country, those who have stopped thinking are typically those who have stopped interacting with people who might make them think; namely, people who do not already think more or less the same as they do.

Perhaps no single person taught me more about the key to unlocking the power of diversity than Lloyd Ward. He was an African-American coming out of Michigan State University who joined P&G as an engineer. Lloyd left the Company fairly early in his career and then came back, eventually becoming general manager of our Dishwashing business. One day, I heard Lloyd was planning to leave for a position at Pepsico. I knew him well and I was alarmed. I called Lloyd and said I needed to see him. I offered every reason I could think of for him to stay, but to no avail.

Lloyd Ward helped me to see how to unlock the power of diversity

Many years later, Lloyd called me to ask if I could give him some career advice. I said I'd be delighted, and he came to Cincinnati. Over dinner, I offered him what thoughts I could on his career, and then I told him there was something I wanted to talk about. I asked him if there were anything I could have done that would have led him to stay with Procter & Gamble. He said, no, he didn't think so. Not at that time. He told me he knew I cared a lot about him and that he loved many things about the Company. "But," he said— and this is what stopped me in my tracks — "I never really felt 'in the house.'"

These words, spoken ever so matter-of-factly, hit me right between the eyes. I knew immediately what he meant. I knew it because *I* had come to feel in the house. I felt that way because of the kind of relationships P&G people had built with me, and I with them: personal relationships that went beyond everyday business, such as invitations to their homes and to join them in local community organizations. Mine were relationships which conveyed that my colleagues respected my views — even sought them out — and that they cared for me as a person.

This was one of those experiences that led me to know that relationships matter most. Relationships are what allow people to have confidence, to trust and to feel in the house. Relationships founded on trust, respect and high expectations are the keys to our growth. It is harder to forge these relationships

with people who are different from us, but that makes them no less important. Indeed, that is what makes them *more* important.

For the last quarter of a century, I have been working, with steadily increasing conviction, to create environments and relationships that build and take advantage of diversity. I've done this with a deepening awareness of

- *Why* diversity matters — to our business and to each of us as individuals.

- *How* we as individuals can make diversity happen and reap its benefits for the business and for ourselves.

These are the points I will develop in this chapter by discussing five lessons I have learned over the years:

1. Diversity must be experienced to be embraced. There's no substitute.
2. Diversity is all of us.
3. Diversity is strongest when people can be their authentic selves.
4. Diversity is a strategically important business imperative.
5. Diversity happens when leaders lead.

Lesson 1: There Is No Substitute for Experiencing Diversity — A Personal Journey

Growing up, I didn't even know what diversity meant. Certainly not in the way the term is used today. I was hardly aware of the issues embedded in racial and ethnic differences. I'm not saying I wasn't conscious of differences in color and ethnicity, and the issues that arose around them. Of course I was. But they hadn't taken on human, visceral, daily significance — as something that touched my life, that burned inside, that became truly personal, that drove me to act in a particular or different way.

I grew up in a mostly all-white city in an all-white neighborhood. If my grade school wasn't all white, I don't remember it being otherwise. When I went to Yale, it was not only virtually all white, it was all male.

It is ironic to think back to some of the things I studied at Yale and compare them now to my deep involvement in the creation of the National Underground Railroad Freedom Center. The Freedom Center is an institution dedicated to illuminating and drawing lessons of courage and cooperation from freedom's heroes, past and present, challenging and inspiring us to take courageous steps for freedom today. I was a history major at Yale. I studied slavery, which is a focus of the Freedom Center's story. The subject of my senior thesis was "The Influence of the Institution of Slavery on the Diplomacy of the Republic of Texas." It received an excellent grade and won a prize for the best history paper in my senior class. But as I re-read that thesis today, with

its 200-plus pages and reams of footnotes, I find it totally devoid of recognizing the *human impact* of slavery. "Bloodless" is the only way I'd describe it.

Then I entered the Navy. I was responsible for men (and they were all men) of different races. But I was not conscious of the benefits this diversity might bring, nor was I conscious of how being a person of color might have represented a barrier to the African-Americans and Hispanics in my unit.

When I joined Procter & Gamble, it was primarily a U.S. company with a bit of off-shore business. The management was almost all male and all white. That's pretty much the world I lived in — at least as I saw it — for the next 10 years.

So when and how did I begin to gain an appreciation of the benefits that can grow from people's diversity? And when did I begin to appreciate the challenge of achieving these benefits?

Interestingly, it did not begin in the United States at all. No, it began when I went to Europe as general manager of P&G's Italian operations. For the first time in my life, I was living and working with people who spoke different languages, had different ethnic and cultural histories, and had substantially different life experiences from my own.

It was this experience that gradually opened my eyes to the power of diversity.

At first, I was amazed at the stereotypes that existed within P&G itself among the Italians, Germans, French and English. I still recall a retreat held in 1974 at a seaside resort in Belgium. We came together to express openly how we felt about one another. I exaggerate only slightly when I say some Italians felt the Germans were so lacking in human feeling that they were like Teutonic automatons. Some Germans thought Italians were too lackadaisical and undisciplined to do good work. It's easier, I suppose, to see prejudice for what it is outside one's own culture. As an American sitting there among my European colleagues, I was struck by how little they understood one another. In those days, the extent to which we shared our experiences didn't go much beyond mailing each other photographs of our best in-store displays.

Then, slowly but surely, people started to come together. We began to function as a regional business with ideas emerging from each of our national subsidiaries. We started to see the power of shared experiences. We developed better advertising ideas and better products. We saw similar benefits in manufacturing, purchasing and just about everything else. It happened as people started to live and work together. It wasn't *words* that did it. It was *experience*.

That was the beginning of my journey. I was coming to see the importance of people knowing each other as people. This experience fundamentally changed how I perceived and interacted with people as individuals, and it shaped the way I would lead as I progressed further in the company.

I came back to the United States in 1977 determined to capture the benefits that could come from diversity, while also continuing to learn about the challenges of achieving them.

I received brave feedback from P&G people on the reality of these challenges. During a lunch conversation, an African-American man told me he felt as if he were a 12-cylinder car. Yet during his workday at P&G, he could only operate on eight cylinders because he had to expend so much energy trying to fit in.

Others brought home to me how easy it is to engage unconsciously in racially biased behavior. One day I was with several young African-American marketing managers. They told me how their bosses, in reviewing a recommendation, sometimes looked past them to a *junior* white woman in the group, implying that she would be more likely to have the right answer. Probably it was an unintended slight, but no less injurious to the human spirit — particularly if you believe, as I do, in the self-fulfilling prophecy that what we accomplish depends to a large extent on what those closest to us believe we can accomplish.

A similar experience was shared with me recently by an Asian-American associate whose boss appeared to look past her — again to a junior white person — for the answer to a problem. Behavior like this shows not only how people of color and other ethnicities are affected, but women, as well. Indeed, this encounter impressed upon me that I hadn't been adequately sensitive to the issues many face in bringing their full determination and capabilities to bear in the workplace.

Another indelible memory was struck during a diversity training session when I was asked to role-play a black female who had just taken a job in our Lexington, Kentucky, plant. In this exercise, I was being supervised by a white male who had two major problems when it came to the people who worked for him: women and African-Americans. Here I was, the embodiment of both his problems. He didn't like me one bit. During that 30-minute role-play, I almost reached the point of strangling the woman who played the male supervisor. She was someone I had known and admired for most of my career. That day, she played this role so effectively I might have concluded that she'd spent her whole life preparing for it. Her words, her attitude, her tone of voice and her body language conveyed disrespect bordering on scorn. At least for a few minutes (though it seemed far longer) I knew what it felt like to be harassed, humiliated, trapped and confined.

During the same time, I was also continuing to experience the *benefits* of diversity, especially as we moved to category management of our business in the United States in 1987. I could see that the more diverse category teams — not only in gender, race and nationality, but in their functional representation and modes of thinking — had more ideas, more energy and better bottom-line results. This wasn't some theoretical hypothesis on my part. I was observing it. I was experiencing it. I was starting to see that a diverse group of strong people had a huge advantage compared to a more homogeneous group in any undertaking that depended on creativity and reaching a diverse market.

Likewise, my experience in the Cincinnati community was underscoring the power of diversity. In 1987, I co-founded the Cincinnati Youth Collaborative with Ken Blackwell, then vice-mayor of Cincinnati; and Lee Etta Powell, the superintendent of Cincinnati Public Schools. They were both African-American. We tackled many tasks and opportunities in the Cincinnati Youth Collaborative: childhood development, mentoring, better health care, and scholarships, among others. In each case, it was clear to me that it would have been inconceivable to tackle these issues without the insights of our diverse team. I'd be sitting there at a table with people from Urban Appalachia or from the African-American community and with educators and childcare experts, and I'd hear perspectives and ideas that I knew I never would have had on my own. Again and again, I had the reaction: "We could never have done that without them." I was seeing our ability to build on each other's ideas and to act with greater effectiveness as an inclusive team.

Experiencing diversity did something for me beyond conveying new ideas. *It opened my eyes even more to the power of the human spirit to achieve great things despite great challenges.*

That strengthened my own spirit. I have seen what people from different and often disadvantaged backgrounds have been able to achieve because of their courage, their determination, and their personal commitment to succeed. I have witnessed how others who care about them and want to help them succeed contributed to that success.

This perception was greatly reinforced by a mentoring relationship I had with a young man named Kevin Andrew. I met Kevin in 1989, when he was a senior at Woodward high school. Even though he was a top student and point guard on Ohio's best high school basketball team, he still wasn't sure he would go to college. Neither of his parents had gone, but they were determined that Kevin and his sister would.

To abbreviate an extended but inspirational story, Kevin did go on to college — to Dennison. His first six months proved difficult. In fact, after the first couple of months, he told his father he wanted to come home. But his

My friendship with Kevin Andrew and his parents deepened my appreciation of the power of the human spirit

father said no. Kevin could come home after the first semester if he chose, but he had to see that through. I kept in touch with Kevin during this period. His father traveled to Dennison almost every weekend to be with his son. Kevin graduated *cum laude* from Dennison three years later. Since then, he's gone on to get a master's degree and an excellent job. And in July 2002, 13 years after Kevin and I met, my wife, Francie, and I went to Columbus, Ohio, to attend Kevin's and his fiancée, Linda's African wedding ceremony with their extended families. The willpower and perseverance I saw in that young man as he achieved one success after another, and the encouragement I saw his parents give him — reaching out, and traveling on weekends to support him — were an inspiration.

All these experiences, beginning with my earliest days in Europe, made it clear: *There is no substitute for experiencing diversity if we are truly to understand its benefits and be motivated to take the action to make it happen.* That's why it's so important that we not just talk about diversity as if it were some abstract condition of existence, but make it happen in our own lives.

Lesson 2: Diversity Is All of Us

It is vital for us to appreciate that diversity includes all of us. Diversity embraces inclusion, not exclusion. If diversity is defined in a way that suggests it *only* involves minority employees, it is incomplete. It may even risk alienating other employees. But more importantly, it will fail to engage us in developing a mindset and in taking actions that can help us all. As I said in a note in April 1989 to the U.S. organization I was then leading:

> *Diversity describes the unique talents and perspectives each of us brings to Procter & Gamble. These unique talents and perspectives grow out of all the things that make us a unique individual: race, sex, personal experiences, functional backgrounds, temperament, religion and nationality.*

Today I would add culture, family traditions and sexual orientation to that list.

Women in P&G

One area where P&G has made excellent progress is in recruiting and utilizing the talents of women. It helps to be approaching my age to fully appreciate what women have accomplished in P&G over the last 40 years. Seeing where we are today, it's hard to believe how recently women have begun assuming major leadership positions at P&G. When I joined the Company in 1963, management was essentially an all-male domain. That's the way it was in society-at-large, and that's the way it was at P&G.

A month ago, I re-read the brochure I received as a new hire. Published in 1962, it describes the opportunity for "Management Careers in the Marketing of Consumer Products." There on page one — in stark print — it says: "New *men* tell us that before joining the Company it was difficult to understand the extent of the opportunity provided for growth and advancement." Here, in this statement from a company that believed from its very beginning that people are the heart of its success, it sounds almost as if women didn't exist. This brochure didn't talk about the opportunity to become a "Brand manager"; it talked about becoming a "Brand man." What a humbling reminder of how prevailing culture can define the boundaries of our view of equity. And what a profound reminder that we must take it upon ourselves to chart the future when it comes to providing equal opportunity to all.

The role of women in P&G has been transformed over the course of my career. Coincidentally, it happened that I was on the interview panel that brought one of the first women, Peggy Wyant, into Advertising in 1967. We didn't hire our first African-American woman manager, Elizabeth Morrison, into Sales until 1972.

The progress made by women since then has been tremendous. One of the Company's four vice chairs is a woman. Women are presidents of many of our global businesses, including skin care, baby care and personal cleansing. Women lead many of our most important brands and Customer Business Development (CBD) teams. Women have run our plants in China and Nigeria and many other parts of the world. It is impossible to conceive the results Procter & Gamble has achieved over the past two decades were it not for the leadership that women have brought to our business. Individually and together, they have contributed ideas and insights that otherwise would not have been present. And without wanting to indulge in over-generalization based on gender, they have changed and improved the character of the leadership of the Company in ways which, while hard to measure, are very real. They include, but are by no means limited to, a deeper sensitivity to the needs of our consumers, so many of whom are women.

Women continue to progress to the highest ranks of the Company's leadership. As recently as 1991, the Company had only one female vice

P&G was recognized as one of the top 30 companies for executive women (by the National Association for Female Executives). From left to right: Carol Evans, Jeannie Tharrington, Jane Wildman, Deb Henretta, Kim Jones, Lisa Jester and Betty Spence, President NAFE

president. As I write this, there are 56 women at the vice president or corporate officer level and the first female vice chairman of the Company (Susan Arnold) was appointed in July 2004.

Women will continue to play an increasing role in the leadership of the Company and our results will continue to benefit from this.

Nationality and Religion

Diversity also embraces differences in nationality and religion that too often have been marked by bitter enmity. That was brought home to me in a special way in fall 1999 at a meeting in Bucharest, Romania, to deploy our annual goals and strategies. Bucharest is the headquarters for our Balkan operations, which include nine different countries. Employees were present that day from each of those countries, including several that had recently been at war with one another and were still divided by bitter religious differences. Toward the end of an evening of grand celebration, one person after another came up to me to tell me how inspired they were by being able to work together in P&G against a common purpose and set of goals. Their faces literally glowed as they told me this. And so did mine.

In the summer of 2000, I was in Moscow attending an all-employee meeting to share our strategies and goals for Eastern Europe. It had been a year since we had consolidated our separate operations in Russia, Ukraine and Belarus. The initial reaction from our Ukrainian and Russian employees to this

union ranged from skepticism to dismay. "How could this work?" they wondered. After all, the histories of these countries had been marked by frequent conflict. Yet, in the space of just one year, the Ukrainians, Russians and Belorussians were experiencing how much they could accomplish together.

Employees from our Balkan operation

Our Ukrainian employees were exporting an effective anti-counterfeit program and a Pampers hospital program to Russia. Our Russian employees were transporting a success model for Fairy dishwashing liquid to Ukraine. People were starting to live and work together. Barriers were coming down. The strengths being brought by both groups were being felt in the business and just about everyone could see it. This was diversity in action.

Lesson 3: Diversity Is Strongest When People Can Be Their Authentic Selves

The third lesson I've learned is how essential it is that we be our authentic selves. The longer I live, the more I like to hear someone be described with the phrase: "What you see is what you get." We need to recognize that everything in our Company, everything in life, depends on personal leadership, and personal leadership depends on our being faithful to ourselves.

The women and men whom I've seen succeed at the highest level have been those who've let their strengths and ideals shine through. You will sometimes hear that people who join P&G become "Proctoids," implying that you've got to be robot-like and act a certain way around here to get ahead. To an extent, that's true. You must know what you're doing. You can't go around hurting people. You must live our Values and Principles. But within these broad parameters, the range of behaviors and styles of leadership in P&G are almost as numerous as our employees. The P&G CEOs I've known have varied greatly in their leadership styles. The same is true of our CBD team leaders and our general managers, right across the board. Thank heaven for *that*. It is a source of enormous strength, but it cannot be taken for granted. People do look for signals. They always will. They look for simple templates or patterns of behavior that might elevate their chances of success. That's why it's so important for us to celebrate the value of each individual being his or her genuine, authentic self.

To achieve this, we must have an environment in which people feel free, empowered and supported to live and to act in the way they believe is right. People shouldn't be constrained by any notion that they need to adopt a certain style or form. Each of us needs to bring the best of who we are to work. We need to be who we are. This is how the power of diversity gets released. This is what it means to be "in the house."

Lesson 4: Diversity Is a Strategically Important Business Imperative

We've come a long way in recognizing and taking advantage of the benefits of diversity during the course of my career. Yet we still have a long way to go. It is vital that each one of us personally makes the journey. It must begin and end with the realization that creating and capitalizing on diversity is not only morally right, but it is a strategically important business imperative. This imperative rests on two simple foundations:

- *Superior organizational performance* — resulting from our attracting and retaining the best talent from all sources, and achieving the creativity and excellence of execution that comes from taking full advantage of the experience and skills of different people working together.

- *Winning in the marketplace* — resulting from our better understanding and responding to individual consumer and customer needs. In a recent e-mail to me, Bob McDonald, vice chairman, Global Operations expressed this eloquently:

The actions we need to take to understand and delight our individual consumers are congruent, if not identical, with those we need to take to understand and help our employees reach their full potential. That is why diversity is such an essential strategy for us. If we are not doing a good job with a certain group of employees, chances are we are not doing a good job with that same group of consumers, and vice versa.

P&G's business in China provides strong support for Bob's point, particularly our Crest business. In China, we got off to a slow start on Crest following its introduction in 1997. Three years later, our share was still in low single digits and only about one-quarter of Colgate's. The stakes were high. With Colgate already having the lead worldwide, we knew it was unlikely that Crest would ever achieve global leadership if we did not win in China.

We're on the path to winning, and our diversity is a big reason why. China is now Crest's second-largest volume market in the world, and as of December 2004, we have for the first time achieved market leadership. Why? Because we are realizing the benefits of having Chinese employees working at the Beijing Technical Center as part of a diverse team. They have launched initiatives that

grew out of their unique understanding of Chinese culture and consumer needs. They've improved Crest's acceptance by incorporating herbal ingredients particularly appreciated by Chinese consumers. They've developed a lower-cost formula that meets the needs of hundreds of millions of Chinese consumers who couldn't afford the formulas developed in the West. Here, as elsewhere, our ability to take advantage of the diversity of our work force is allowing us to launch product, marketing, and cost-cutting initiatives that meet the needs of the diverse consumers we serve.

Lesson 5: Leaders Must Lead to Make Diversity Happen

This is my fifth and final lesson. It is one thing to state the business case for diversity. It is another to make diversity happen. That takes leadership. Talk is cheap. We must avoid the risk of allowing a general pronouncement of the values of diversity to lead us to believe that we have accomplished something. I have seen this too often. We must beware of that "feel-good/we're-on-the-side-of-virtue" mindset that allows us to believe we are making real progress when we're not.

We must also beware of our own stereotypical visions. It's tempting to convince ourselves that we have shaken off the prejudices of the past. That is dangerously arrogant. We shake our heads today in disbelief at the stereotypes that affected ages past. Just pause and contemplate what the *New York Herald* could write in 1852: "How did woman become subject to man ... ? By her nature, just as the Negro is and always will be ... inferior to the white race." Outlandish? Yes! A view held by many people at the time? Also, yes. And recall that women didn't even get the right to vote in the United States until 1920. Yet these examples serve as a reminder that we, too, must remain on guard to avoid stereotypes (even if more subtle) that can limit our appreciation of the individual strengths flowing from our diversity.

So ... what *do* we do? *We lead.*

We make our teams and our work groups more diverse — today, not tomorrow.

We express and *act on* our beliefs, our convictions, and our expectations of the importance of diversity in clear, no-nonsense terms, authentically from the heart. I was reminded of this by several notes I received marking my retirement in July 2002. One came from long-time associate Beverly Grant, an African-American who is a key leader today in our CBD organization. Beverly took me back to a meeting I had in January 1987, when she had been with the Company for only two years. She recalls the scene:

We met in a conference room near your office. During that one-hour meeting, you shared your perspective on your experiences here at P&G, as well as the potential you believe all employees have if they work smart,

demonstrate leadership and develop their ideas in winning propositions for the Company. Wow, did you inspire me as a second-year employee!

I do not cite Ms. Grant's recollection to suggest that I was doing something unique, or that I always did it as well as I should. I cite it to emphasize that we, as leaders, must express our expectations firmly and repeatedly.

We create a climate of inclusiveness — or we don't. We do it by making sure everyone realizes they are in an essential role; that they matter. We create it by being sure that people recognize they have an important voice in what counts, and by demonstrating that by the way we interact with them. For example, if we see a team member's proposals being inappropriately discounted, we intervene. We recognize that if we don't do this, the person making the proposal will likely feel as if "they weren't even there." Few feelings are so debilitating.

Making diversity happen doesn't stop there. It requires specific actions and relentless follow-up in

- Setting clear goals, establishing strategies and action plans, and measuring results.

- Developing and following up on individual career plans. Improving diversity isn't a matter of aggregate statistics or class advancement. It is a matter of individual advancement.

- Ensuring that a caring mentor is available for everyone.

- Ensuring we have the right family/work policies and support systems in place.

- Holding people accountable and making it clear that making progress on diversity is not optional. (We have taken important new actions to reinforce accountability at P&G. A portion of the stock options that senior managers receive now rests on how good a job they are doing in improving diversity, and no one can receive a top development rating without being rated strong on diversity.)

We can never take diversity for granted. Diversity isn't something you put in place and then expect to be sustained on automatic pilot. I've learned this the hard way. Many pressures exist in any company, including P&G: sales and profit growth, return on capital, meeting quarterly objectives. If diversity isn't a priority with the leaders as a strategically vital means to achieve these results, for which they will be held accountable, progress may occur for a while but will not be sustained.

Finally, through it all, let us never forget the overriding importance of showing we care about one another ... one by one. This was brought home to me by a profoundly simple, but moving letter I received when I retired. It was from an Asian-American woman with whom I had worked for many years. "Thanks for making me feel personally valued and cared about. Knowing that folks like you know me and appreciate my contributions and are watching out for me makes me feel 'in the house'!"

We will not reap the benefits of diversity — personally or for the business — by checking off a "to-do" list. We need strong personal relationships founded on respect, trust, and a belief in our common humanity. We all have benefited mightily from such relationships. They have heightened our expectations and our confidence, and expanded our feelings of influence and belonging. For most of us, it is easier to have personal relationships like this with people who are the same as we are than it is with people who are different.

This is a tendency we must overcome. As Fellow Charles Handy of the London Business School wrote in his essay "Beyond Certainty": "You won't have much sympathy for those you never meet or see. We need to rub up against people different from ourselves just as much as we need to join up with our own sort for comfort and security."

I offer you this advice. Establish a deep, personal relationship with people who are different from you. I've been fortunate to establish a handful of relationships like that over the years. None has been more important than the one with Judge Nathaniel Jones, Sixth Circuit Court of Appeals, currently honorary co-chair of the National Underground Railroad Freedom Center, and formerly chief legal counsel to the NAACP, the leading civil rights organization in the United States. Judge Jones has shown me what principled leadership and personal determination can achieve. My relationship with him over more than a decade has been enriching, mind-opening and inspiring. It's testimony to the reality that we can learn from one another and grow. Seek out your own relationships and nurture them; I am confident it will be the same for you.

My friendship with Judge Nathaniel Jones is testimony to how we learn from one another and grow

In the end, like anything else that is challenging and important, making diversity happen requires that we *care*. It requires our strong personal leadership in our circle of influence. It's up to each one of us to do this — to make the personal investment to make the journey, to hold ourselves accountable, to make a difference.

As Robert Kennedy said to an audience of young people in South Africa on their Day of Affirmation in 1966:

> *Some believe that there is nothing one man or one woman can do against the enormous array of the world's ills. Yet ... it is from numberless diverse acts of courage and belief that human history is shaped. Each time one of us stands up for an ideal or acts to improve the lot of others, or strikes out against injustice, we send forth a tiny ripple of hope.*

It is from our own "acts of courage and belief" that progress in diversity will be made. It is by creating concrete career plans and taking responsibility for making them happen; by inviting someone who is different from us "into our house"; and by establishing relationships that show we care and support achievement. It is by trying as best we can to create *advantage* from our differences, and not be separated by them. It is through these actions, all within our control, that we and our business will benefit from the unique abilities and experience we have to offer one another. As we do this, we will take a giant step toward being not only a more successful company, but also a greater force for positive change in the world.

Diversity: The Benefits It Brings, The Challenges of Achieving It

Some Questions to Consider

1. How diverse is your organization/work group? in all aspects? right now?

2. Are you experiencing the benefits of diversity in your work life? How? In what way?

3. Have you established a clear-cut goal to strengthen diversity within your work group? What is that goal? How will you measure its achievement? Do you have clear strategies and action plans to achieve the goal? Are the plans being actively worked? Are you holding people accountable?

4. Do the people who report to you feel in the house? How do you know? Are you doing what you can so they *do* feel in the house? Do *you* feel in the house?

5. Are you creating the strong personal relationships so important to helping each other be all we can be?

Chapter 9
A Personal Model for Living

"Service to others brings out the best in each of us and nurtures our selflessness and elevates our sense of human possibility. It reinforces our common bond of humanity by reducing the distance between 'me' and 'them.'"

— James Friedman
Former President, Dartmouth College

"We must create a life worthy of ourselves and of the goals we only dimly perceive."

— Andrei Sakharov

I hesitated to use this chapter title, yet I had no choice. I worried it would sound pretentious or — worse — complete, final, as if I had it all figured out, this matter of living. And, of course, I don't. It's been a journey and the journey continues. Many of the experiences I relate here will make that clear. Yet, how could I possibly write about what really matters without including this most fundamental description of how I've tried to live my life?

I've approached the subject using a model *(illustrated in figure 9)* that I created for a class on leadership, which I taught at the Yale School of Management in spring 2000 during my brief retirement. Teaching at Yale was an opportunity I relished, not only because it allowed me to return to my alma mater as a professor, but, more importantly, because it gave me a chance to spend time with young people who were forming their own ideas about how to make a difference in the world. I wanted to distill all that I learned about leadership into a form they could consider as they prepared for their careers.

The model I created was in some ways not as simple as I had hoped. But when I shared it for the first time, the students appeared to latch onto it. They asked probing questions and later a few of them wrote to tell me that they intended to use some of the ideas as they embarked on their careers. Since then, I've found this model useful for discussions on leadership that I've had with P&G colleagues.

figure 9.

A PERSONAL MODEL FOR LIVING

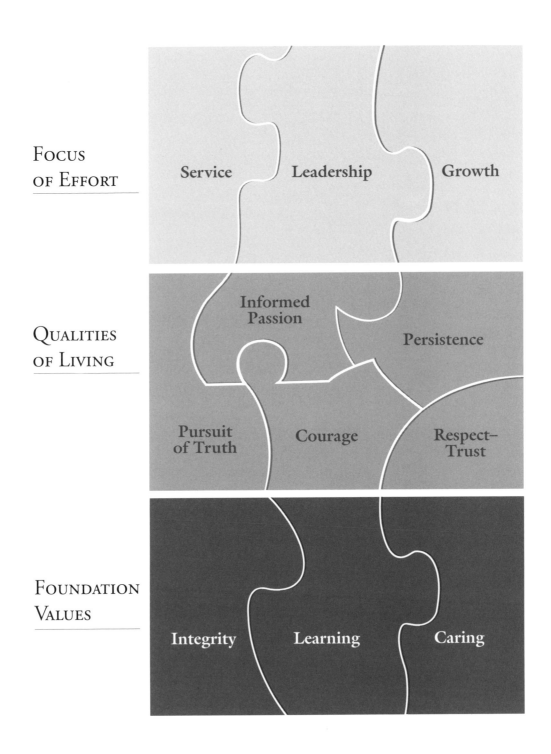

FOCUS
OF EFFORT

Service Leadership Growth

QUALITIES
OF LIVING

Informed
Passion

Persistence

Pursuit
of Truth Courage Respect–
Trust

FOUNDATION
VALUES

Integrity Learning Caring

The model has three levels, each tightly connected with the others. The first level describes *what* I've wanted to achieve in life. Many years ago, I narrowed this to a list of three goals: *service* to others; *leadership* in our business and in what I do; and *growth*, professionally and personally. I have found these goals to be relevant and useful in focusing my life's effort. They became my "North Stars," my guiding lights.

The second level describes *how* I commit to achieving these goals — at home, at work and in the communities where I've lived. I think of these as the qualities of living or values that have guided my actions as I've pursued what I want to achieve. There are five: *informed passion, pursuit of truth, courage, persistence,* and *respect and trust.* It is these values that, upon reflection, I believe have guided my day-to-day choices about how best to serve, to lead and to grow.

The final level of the model is the most foundational. It describes *who* I aspire to be in every dimension of my life. It describes the values that I hope will infuse all my goals and all my actions to achieve them. Three values best describe this for me: *integrity, learning* and *caring.*

As I say, all three levels of the model are tightly integrated. We need to make choices at each level and live our lives in accordance with those choices. Setting goals without values can lead to a life of achievement by any means, good or bad. Clarifying values without goals can lead to a life well-lived, but one which still falls short of its potential to make a lasting difference in the world. Identifying foundational qualities, which will infuse our choice of goals and actions no matter what, makes it more likely that we will achieve the continued growth, contribution and satisfaction we seek for ourselves and for the institutions and individuals we admire, serve and love.

I'm conscious in presenting this model that every one of you could share your own principles of life with me and I would likely benefit from them. Each of us develops our own guides on how to live our lives. Still, if the personal experiences that I share here — positive and negative, joyful and painful — prove to be of some value in considering what these guides might be for you, then my purpose will have been served.

The descriptions and ordering of the components of this model are, in a sense, arbitrary. You might choose a different word than I have. You might reorder the components. Still, this model has helped me explain to others some of the most important lessons I've learned. I use it here in that spirit.

Finally, to state the obvious, it is no great feat to write down a list of values. It's far harder to live by them, especially when they are not self-evidently aligned. As you will see in what follows, all is not straightforward; all is not settled; all is not easily resolved.

Part I
My Goals: Three North Stars

Service

If I had to choose the single goal that has been of greatest importance to me over the years in deciding how to act, it is that of *service*. By service, I mean doing everything in my power to help the individuals and institutions I am involved with to strengthen and fulfill their highest potential.

The Development of My Commitment to Service

Make no mistake, service was far from my mind when I entered the gates of Yale University in 1956, or boarded the destroyer *USS Blandy* to begin my Naval service in 1960, or walked through the doors at Procter & Gamble in 1963. If anything, the one thing on my mind at each of those moments was *survival*.

This is not to say that my orientation to service doesn't draw on some fairly deep roots. I suspect it traces back to my religious upbringing in a Catholic home, and to my education, first with nuns and then with English Benedictines at the Portsmouth Priory School. I don't recall these teachers talking about service per se. However, I do recall their unmistakable focus on achieving excellence for some overriding purpose.

So, too, my Navy experience had roots of service in it. I served in a period of history when there were no active wars. Vietnam was just starting to heat up. We spent countless hours in exercises at sea, chasing what we thought were Russian submarines around the North Atlantic. (They usually turned out to be big fish.) I spent the final year of my three-year tour in the Philadelphia shipyard outfitting PT boats for Vietnam. My time in the Navy was often intimidating. It demanded that I step out and lead. That was all to the good. I was growing up in many important ways: grasping the responsibility and building the confidence to lead; starting to appreciate the wider, diverse world of people around me. But my orientation to service here was on a small scale. It was less about serving my country than being rated number one in our squadron for an operations exercise, or having the senior admiral agree that our recently re-outfitted PT boats were ready for commissioning.

When I arrived at Procter & Gamble in the fall of 1963, my first thought was to keep my head above water. I had been warned that this would be a testing environment, and I took the warning seriously. But after all, I had completed four years of tough academic work at Yale and survived three years in the Navy. So while I didn't come in overconfident (among my shortcomings, that has rarely been one), I thought I could handle it. It was as challenging as predicted, and I was delighted. To find the intellectual challenge every bit as great as I had at Yale was an exciting discovery. I focused squarely on learning the job and showing I could do it well.

Then, bit by bit, hardly being conscious of it, my orientation toward service started to grow. Why? I was beginning to see the Company's commitment to service — the commitment to develop products for consumers that would improve hygiene, simplify the laundry task, reduce cavities, and improve diets. I was seeing the Company's commitment to its employees, by treating them fairly and supporting a good life for them and their families. I was seeing the Company's commitment to serving its communities. I found all this uplifting. This business wasn't *just* about making money.

How did this affect me? I am not able to trace it year by year, but about 1970, having been with the Company for seven years, I committed to paper what I saw then and still see now as my overarching personal mission:

- *Be all I can be; develop to the fullest and follow my best instincts; learn constantly; be trustworthy to what I know is right.*

- *Be of service:*
 First, to my family, above all.

 Second, to P&G — to support its growth and success; and to support its leadership, based on serving the consumer and attracting and maintaining the loyalty of employees, who can rightly conclude they've had the most fulfilling career imaginable. Capitalize on opportunities that I uniquely see. Lead productive change.

 Third, to the community — to give back through leadership by helping and improving where it's most needed.

In 1980, this concept of service emerged again as I described in my journal the qualities of the P&G leaders I had most come to admire:

They have a tremendous personal interest in leaving their individual stamp on the business ... in contributing to the business. They feel great ownership of their area of responsibility. They are looking for new areas and new ways in which to contribute new ideas that can build volume and profit and people.

Six years later, my still-deepening commitment to service was evident as I reflected on my just-announced appointment as president of Procter & Gamble:

I pray to God for the courage and wisdom to know the right thing to do and then to do it. I pray for the ability to convey to others the conviction I have in their importance and a sense of uplifting enthusiasm — and not too much solemnity — about the task we are undertaking.

My commitment is to do everything in my power to help perpetuate the success of this great Company and the special environment it offers for the growth and satisfaction of its employees. (1/86)

Eighteen months after making this journal entry, I had one of the most significant learning experiences in my life. It occurred over the course of two days in Bedford, Massachusetts, at a seminar loosely (if somewhat presumptuously) described as "Leadership and Mastery." I wasn't sure what I was getting into, but several people whom I respected told me I should attend. About 40 people were there (only two others from Procter & Gamble). Fortunately my wife, Francie, had agreed to join me. She, too, had been intrigued by the course title. When asked, as we all were, why she had come to this seminar, she undoubtedly gave the most straightforward (not to mention humorous) response of the day: "I wanted to see what my husband was up to." The place broke down in laughter.

The facilitator said the purpose of this session was to help us get clear on our life-purpose, and to share with others our deepest convictions, concerns, hopes and dreams. Truth be told, that didn't sound like fun, and I wasn't looking forward to it. I worried that my hopes would sound pretentious or naïve, and as for disclosing my concerns — I was sure that was going to be uncomfortable. And it *was*. But ultimately, this was one of the most meaningful experiences I've ever been through, on many counts. While the vision I expressed wasn't new, by fleshing it out and sharing it publicly, my commitment to it was enhanced. My core objective of being all I can be and helping others do the same was reinforced by the fact that others saw it as important and credible.

I came to the deeper realization over those couple of days that a sincere commitment to serve my vision could give me greater power. Here is how I expressed that vision for Procter & Gamble at that seminar:

The Company will be growing in volume and profit and overall market share as we do a better job of producing better value/quality products for consumers in a state-of-the-art operating system. What makes this

Focus of Effort
 └ *Service*

possible, above all, are the people. They are working together against clear goals, aligned yet independent. They act as owners of their own business. They believe deeply in the purpose of the Company and their own jobs and feel a great compatibility between the Company's purpose and their own life goals. They respect and value one another. While independent in their views, often vigorously so, they know that by working together, by supporting each other, and by helping each other grow, we will achieve more and be stronger as an organization than we would be otherwise. They know that trust is what counts. They expect to keep learning and growing.

Since I wrote this, 17 years have passed. I wouldn't change a word today.

I experienced something else during those remarkable two days. I found myself enormously affected by the ability to identify with other people, more or less intuitively. I sensed their goals and their feelings, and they sensed mine. And they were mutually reinforcing. I realized anew that people are all pretty much alike. We seek the same things. We all want to be all we can be. I was reminded how rarely we're inclined (or have the courage) to inquire about each other's hopes and dreams, and to communicate personally and candidly. I left with a much deeper conviction that a big part of my job would be to do just that.

What Are My Priorities?
Choosing service as a life's goal provided immediate benefits. It helped me make choices.

Ultimately, life is all about making choices, both business and personal. An orientation to service has helped me focus and order my priorities among my family, Procter & Gamble and my extracurricular activities. It has made me consider more deeply what my most important responsibilities are, where I can do the most good, and how I should spend my time. That's what I was grappling with as I wrote the following journal entry, a few days after John Smale told me he was recommending to the board that I be appointed president:

If there is one thing I need now, it is the confidence and perspective of knowing and being able to carry out a vision firm enough to be understood and to capture people's imaginations, and yet flexible and broad enough to accommodate and nurture the creativity and new ideas that will be developed by our people, and the changes that will be required in our business. It is time to look inward and decide clearly what it is I want to do for this Company and my family. (12/85)

What Role Should I Play?

The orientation to service also has helped me choose the particular role I should play and action I should take in a given situation. It has helped me understand that I should not base this choice on what will make me feel comfortable, but rather on what I believe will be right for the individual or organization I serve.

In his book *The Seven Habits of Highly Effective People*, Stephen Covey talks about getting the right balance between *courage* and *consideration*. At times, I have placed too much weight on consideration; I've erred on the side of too much tolerance; or I've failed to make the call on a contentious decision as decisively as I should have, based on my personal instincts and knowledge of the situation.

One example of this occurred in 1996 when I was CEO. We were changing the terms on which we did business with our customers in western Europe. The effort started in Germany and was extended into France a couple of years later. The intent was laudable. We wanted to ensure that we had equitable trading terms for our different customers. We wanted to take waste out of the system and provide greater pricing transparency for consumers. All well and good. But we overstepped our rights.

It is our right, indeed our duty, to treat our customers equitably. Customers who provide equal support and benefits to P&G and our brands should receive equal value in return. But we went beyond that. Without trying to get into the details, we told our customers how they ought to receive their benefits. Many saw this as a threat to their profitability and individual business strategy. Put bluntly, we had gone beyond being principled. We had become impractical, even arrogant in our position. And our business suffered greatly. I should not have allowed this to happen.

I couldn't be sure, but my instincts told me this wouldn't work and that we were overstepping what we had the right to ask of our trade customers. My failure was not only delegating the decision when I shouldn't have but failing to sufficiently penetrate the issues surrounding the decision.

The lesson:
Don't delegate when it's your decision to make. That's what the call to service demands.

I wish I had internalized that lesson better as we began the implementation of Organization 2005 in 1999. I worried that the communication of the desired changes in our culture had become a "trashing of the past." I thought it failed to focus sufficiently on the *specific behaviors* we should improve (for example, being more decisive and open) and had become a sweeping and vague denigration of P&G's culture. I feared we were failing to do precisely what I have always described as being so important: approaching change as a process of purposeful renewal, one that needs to be undertaken boldly even while remaining consistent with our most fundamental values. As one employee said to me later, "We kept being told and believing that we were fat, dumb and slow." You don't motivate or strengthen an organization of fine people that way.

Of course, I made these points. And accommodations were made to my point of view. But in hindsight, not enough. I should have made my position count for more. Much more. My failure to do so was an abdication of my responsibility to serve.

All of this became very clear to me upon my return as chairman in June 2002, working side by side with CEO A.G. Lafley. Our first trip was to Europe, and on our return I wrote in my journal:

We need to strengthen our relationships with our customers. We've had too many "wars" with our customers. We have to remember — they are our customers, not the other way around. In addition, we need to reinstate the "in the blood" conviction that the people of this Company are truly its heart; the reason for its success in the past, today and in the future.

As I wrote this, I knew that I might have headed off these issues if I had exercised my responsibility to make the decision more fully.

To be sure, this is a tricky area. People sometimes have to find their own way and learn through their own mistakes, as I so often have. Even more to the point, what I had believed would prove to be a mistake often proved *not* to be a mistake at all, but an unexpected victory. Still, I have learned the hard way to be wary of the siren song to over-delegate.

So how does one draw the line on this issue? First, by being sure you thoroughly penetrate and air important issues. Present your concerns and expect those on the other side of an argument to persuasively articulate the reasons why these concerns are not valid. Second, reserve the right and accept the responsibility to decide unilaterally when the issue is of critical importance.

As time has passed, this concept of service has helped me get the right balance between courage and consideration. It has helped me muster the courage to make the decisions that are mine to make, pursuing what I believe is true, no matter how challenging or controversial it may be. The concept of service, in the words of the Cadet Prayer at West Point, has helped me "choose the harder right instead of the easier wrong."

This is what I felt called upon to do as we made the final decision to enter Russia in 1991 and launch P&G laundry detergents and dentifrice in China in the mid-'90s, despite strong, contrary views. It is what I felt when we decided to adopt Domestic Partners Benefits in the United States despite understandable and well-meaning concerns among some.

The concept of service has taught me that, from time to time, after all the discussion is done, I must simply exert the personal force of declaring what is to be. As Steven Hayward remarks in his excellent book *Churchill on Leadership:* "Especially in a crisis, the genuine leader must simply exert his personal force and summon up his willfulness." This echoes words I recorded in my journal in March 1997:

> *"Even more, I need to stay front and center with the executive committee and declare where we stand and where we're going. Not in a manner a bit tentative, but well thought out and risking myself in saying what will often be controversial ..."*

What Style of Leadership is Appropriate?
The concept of service has also helped me address a question you often hear raised: What style of leadership is appropriate? For me, this is the wrong question; it takes you nowhere. The right question is, What behavior constitutes service in a particular situation?

Sometimes the situation will require you to take decisive command. The debate has gone on long enough. The facts and different points of view are on the table. The decision is yours to make.

At another time, the right mode of leadership will be to engage in debate or discussions.

And yet later, the right mode will be to support another person. Determine how you can best be of service in a particular situation, and you'll *know* how you can help.

How Can I Help Others Be All They Can Be?
In no area is the commitment to service more relevant, more needed and more

rewarding than in the service we can provide one another — service to help others be all they can be.

Robert Greenleaf, in his wonderful essay "The Servant as Leader," presents us with a simple litmus test to assess how well we're doing that: "Are those we serve becoming healthier, wiser, freer and more autonomous while being served?"

My effort to do this began long ago. Just as my first brand manager had done for me, I spent hours with my assistants to help them learn the ropes. I worked hard to be sure they had a project of their own which, well done, would not only provide learning, but make a difference to the business, giving them the confidence that can be gained in no other way. I recall providing guidance, but letting them try things on their own.

I remember learning the need to provide straight and sometimes difficult feedback. I found this to be the most uncomfortable type of interaction. While it was more than 35 years ago, I can still recall the first time I had to tell a young assistant, eager and very talented in many ways, that I didn't think his strengths represented a good fit with Marketing. I urged that he look into Sales and he did. Years later, I was delighted to check back and see that he had had a long and distinguished career there.

Caring and being honest with each person is a gift to help others be all they can be.

How Do I Provide Honest Feedback?

This touches on one of the more important challenges we face. How do we give difficult feedback? How do we do so in a way that's honest yet constructive, not obscure or destructive? I've had to do this many times. I've had to tell people that they would not be promoted or that their chances of being promoted were severely limited by a particular behavior. I've had to tell others that a project they believed in would not be pursued. How do you best do this?

The answer has become very clear to me: Do it in a way that serves them and the Company best. Tell them what you would want to hear if the positions were reversed, with openness and honest caring. And do it right away. Don't let concerns pile up. People deserve to know the truth — the sooner the better.

People need to know (and most *will* want to know) that you're "putting all the cards on the table," not in an indifferent or destructive way, but in a direct and personal way — a way that both reflects and aspires to a relationship so based on mutual trust that, even with this difficult interchange, trust is built further.

There are two kinds of critics in life: those who criticize you because they want you to fail and those who criticize you because they want you to succeed. People can smell the difference a mile away. If you convey to people that you really want them to succeed, they will take any criticism you dish out. If you convey that you really hold them in contempt, you can tell them that the sun is shining and they won't listen to you.

—Thomas Friedman

I don't mean to suggest that these conversations have been easy for me. They haven't. I've often sweated about them in advance. I've prepared multiple drafts of talk notes. But without exception, I've found honesty and openness to be the best policy. I haven't aimed to do what would make me feel comfortable, or merely satisfied, in discharging my responsibility. Rather, I have aimed to do what I believed was needed to truly serve the best interests of the business and the individual I was talking with.

How Do I Serve Those Who Report to Me?

I have faced a related question in this area of service to others — one that often occurred as I assumed positions of greater responsibility. How could I best serve the individuals who were in the same position I was in just a short time ago? How much latitude should I give them? How much direction should I provide? To a degree, of course, the answers are situational. They vary with every move, with the experience of the people around you, and with the significance of the decision you face. But with all the situational variation, I have found that helping those reporting to me to grow and become as effective as they can be involves four things:

- Ensuring we are pursuing the right vision together.

- Being thoroughly aligned on key goals, key strategic choices and the expectation of each individual's role and responsibilities in achieving them.

- Taking the action I should to remove roadblocks and provide the resources for the individual and organization to succeed.

- Creating a positive, empowering working environment — one that encourages high levels of personal ownership, innovation, executional excellence and respect for the value of teamwork.

As I look back on my journal entries over the years, I see one after another laced with this commitment to service. Often they reflect difficult challenges and sometimes personal doubts. But I always see the commitment to live up to the responsibility I had been given, and the opportunity to extend the record of leadership and accomplishment that has made P&G the Company I love.

This discussion of service has a risk. I recognize that it can come across as an oversimplified, euphoric view of human nature — and of my own motivations. I wouldn't want that. John Gardner said it best in his book, *Self-Renewal*:

> *Having rejected the oversimplified view of our nature as wholly materialistic and selfish, we must not fall into the opposite error. Humans are complex and contradictory beings, egocentric but inescapably involved with their fellow beings, selfish but capable of superb selflessness. We are preoccupied with our own needs, yet find no meaning in life unless we relate ourselves to something more comprehensive than those needs.*

It's true. Our motives are complex and rarely, if ever, totally pure. Indeed, there is a healthy and necessary balance between a sense of self and selflessness. Still, at its best, I have found a commitment to service reduces that preoccupation with self that can deter the right action. It has helped take me outside myself to engage in dialogue that risks embarrassment, to work for the greater good and to identify and then try to do what is right, for my family, my friends, my Company and my community.

Leadership

Leadership is my second goal. I have found a wonderful, driving, motivational power in the relationship between service and leadership. On one hand, I take great satisfaction from serving a consumer (or customer or fellow employee). Introducing a drug like Actonel to fight osteoporosis, bringing dental education to millions of children around the world, helping a customer get started in a new country, or mentoring a fellow employee who can benefit from my experience are all examples of this. They give life to the creative urge to do what's right and achieve excellence for its own sake, entirely apart from what a competitor might or might not do.

At the same time, I draw adrenalin-pumping, motivational power from winning in the market versus the best competition. Being the leader in virtually every country in eastern Europe; opening up a 24-percentage-point-share lead on Pampers versus Huggies in the UK; going from a massive share disadvantage to Unilever in the laundry category in Turkey to a 15 percent advantage; tripling our facial cleansing share on Olay — these are just a few

examples of the big competitive wins that drive us to leadership. Service and leadership are complementary motivators. Joined together, they make for greater success and satisfaction than can be drawn from either one alone.

Service and leadership are joined in other direct ways. For example, the burning commitment I had that Procter & Gamble lead in opening up the key developing markets of the world has helped us serve our shareholders, because doing this successfully has spurred the Company's growth. Our market share leadership has also helped us serve employees who have joined us in these developing countries (through more and better jobs), as well as communities (through, for example, education and health care programs that improve individual lives).

My commitment to leadership has grown steadily because of the capability and character of Procter & Gamble people and the results they have achieved. We have outstanding people. We work as hard or harder than anyone else. Why *shouldn't* we be leaders in what we do?

Leadership is not some academic or abstract concept. It is very personal.

A young intern asked me several years ago what was the most important lesson I had learned in my career. I answered immediately, "Personal leadership makes things happen."

How true that is. No set of policies, no set of strategies, no techniques can displace the importance of personal leadership. I've been privileged to see the impact a leader can have in many venues. I've seen it through the accomplishments of the leaders of P&G subsidiaries, categories, functions and brands. I've seen it through leaders of nations, universities, businesses, non-profit organizations, school districts and school buildings.

Leadership requires a leap of faith. It calls on people to go where they have not gone before. It requires disciplined, often difficult choices. It asks us to grow and to think about things in ways we haven't thought about before. It asks us to work for the common good. Yes, personal leadership makes things happen.

During my career I've seen many models of effective personal leadership, and I've constructed a few myself. Of them all, I regard what we at P&G call the "Five E" model as the most effective. The five E's are *envision, engage, energize, enable and execute. Figure 10* displays my interpretation of the Five E model. It describes the Mission of Leadership: "to guide and enable purposeful growth of individuals and institutions; to help create and retain a purposeful future." It makes it clear: Personal leadership is service in action.

Focus of Effort
└ *Leadership*

figure 10.

MISSION OF LEADERSHIP

To guide and enable outstanding accomplishments and the purposeful growth
of individuals and institutions to help create and sustain a purposeful future.

KEY ATTRIBUTES OF A LEADER

- Develops strong personal character — starting with integrity.

- Believes deeply and passionately in the purpose of the organization. A huge appetite to win. The team comes first. "One Team, One Dream."

- Commits and makes a huge personal contribution while helping others be all they can be.

- Challenges the status quo constantly. Always seeking to improve.

- Conveys deep respect and trust in others and the desire to help them grow.

- Pursues and stands up for what he/she believes in with wisdom, courage and persistence.

KEY LEADERSHIP SKILL BEHAVIORS

Envision:	Engage:	Energize:	Enable:	Execute:
Create the future and "change the game"	*Build relationships and collaboration*	*Inspire people, gain enrollment and commitment*	*Build capability to deliver results*	*Show the way in delivering superior, winning results*
• Envisage and anticipate the future, seeing possibilities, not limitations.	• Build strong working relationships that create trust and intense candor.	• Inspire people to achieve the future and stretching goals.	• Take personal responsibility for resolving the most difficult problems, improving systems, removing roadblocks and providing resources to get the job done.	• Act as a powerful role model in demonstrating professional excellence and know-how in getting the job done.
• Set high, stretching audacious goals.	• Value and proactively involve others to constructively resolve conflict and deliver common objectives.	• Show how the institution's goals and values are in sync with the goals and values of the people who make it go.		• Staff for excellence.
• Participate personally in establishing and communicating key choices (strategies and priorities) that change the game to our favor.		• Instill a sense of urgency, discovery, excitement and reality.	• Value, strengthen and use the diverse skills and experience that individuals bring to the organization/team.	• Develop clear priorities, measures and plans to implement strategies.
	• Listen actively, communicate in a transparent way and encourage others to do the same.	• Provide the climate of freedom and trust to take risks, to learn, to go for the big win.	• Reward and celebrate success and contribution.	• Ensure individual work plans are aligned to overall plan and establish clear expectations.
	• Leverage cross-organization collaboration (internal and external) to achieve win/win solutions.		• Provide excellent training, coaching and honest feedback.	• Review progress routinely, surface issues, remove barriers, and make clear and tough calls to achieve objectives.

More recently, in my current position at Yale University, I've become aware of another compelling (and quite complementary) leadership model. Its author, Professor Robert J. Sternberg, captions it: *"WICS — Wisdom, Intelligence, Creativity, Synthesize."* Professor Sternberg summarizes the model as follows:

> *An effective leader needs creative ability to come up with ideas, academic ability (intelligence) to decide whether they are good ideas, practical ability (intelligence) to make the ideas work and convince others of the value of the ideas, and wisdom to ensure that the ideas are in the service of the common good rather than just the good of the leader or perhaps some clique of family members or followers. A leader lacking in creativity will be unable to deal with novel and difficult situations, such as a new and unexpected source of hostility. A leader lacking in academic intelligence will not be able to decide whether his or her ideas are viable, and a leader lacking in practical intelligence will be unable to implement his or her ideas effectively. An unwise leader may succeed in implementing ideas, but may end up implementing ideas that are contrary to the best interests of the people (or organization) he or she leads.*

Growth

Growth is my third goal. I have come to regard growth as a way of life — for each of us personally, for our individual businesses and for our Company as a whole. I can still see the sign sitting on the desk of my division manager, Wally Abbott, as I entered his office for the first time in 1969: "Find a Better Way." And while it has been said differently over the years, this drumbeat of finding a better way still goes on.

Growth is important in many ways. First of all, it's proof that we are serving our stakeholders. If our market shares aren't growing, it means we are not serving our consumers as we should. If our sales and profits aren't growing, we aren't serving our shareholders as we should. And if our business isn't growing, we aren't creating career opportunities as we should for the women and men who will create our future. When I joined the Company in 1963, our sales were little more than $1 billion per year. Today they are above $50 billion. Then, we had about 35,000 employees. Today we have more than 100,000. Growth has created these jobs. And, in the long run, growth is the only alternative to decline. That makes it an easy choice.

As with service and leadership, growth is a very personal undertaking. It has many dimensions: intellectual, emotional, spiritual. It is doing things we've never done before; sometimes doing things we didn't even dream we could do. Growth requires learning, and never has learning been as important as it is

FOCUS OF EFFORT
└ *Growth*

today. It has been the search for growth that has led me each and every year, for as long as I can remember, to set down my goals for the year ahead and register what I need to do (and not do) to achieve those goals.

The pursuit of personal growth led me increasingly to risk new experiences. It led me to throw myself into uncomfortable and sometimes even frightening situations that challenged my deepest understanding of myself. Over time, out of experience and, I suppose out of habit, this has become easier, even if seldom totally free of anxiety. But recognizing that this is the only way to grow has led me to do it.

Here is a final point about growth, and it takes us right back to the commitment to service: I believe we should pursue growth not for growth's sake, per se, but to be of service. I've seen companies that wanted to grow for growth's sake. The outcome has usually been a sad one. None will remain longer in my memory than the advertising agency, Saatchi & Saatchi. I was a close friend of one of its founding brothers, Maurice Saatchi. Maurice is one of the brightest intellects and most stimulating individuals I've ever known. By the mid-1980s, Saatchi & Saatchi had established itself as one of the leading agencies in the world, growing rapidly and creating great advertising.

Still, I found myself increasingly worried. Year after year, as I talked with Maurice, I was lifted by his intellect and incredible energy, all of which helped P&G's business. But I worried that almost everything he talked about involved becoming "No. 1" — for its own sake. He wanted to be bigger than everyone, not only in advertising, but in consulting, in communications, in everything. A rash of mergers followed. I expressed my concern, but my advice was too little and too late. Not long afterwards, Saatchi had to unwind most of its acquisitions. For awhile, it disappeared altogether as an agency. The attention to the consumer and to creating great advertising that had made Saatchi a leader had been overtaken by the pursuit of growth for its own sake.

We at Procter & Gamble have not been immune to this risk. During the transition to Organization 2005, I believe we pursued the goal of achieving increased top-line growth too unilaterally. To achieve our goals, we took some price increases that were not justified and embarked on a more rapid new brand development program than we could effectively execute. I should have known better. Growth is vital, of course; it is the only alternative to decline. But it must be growth geared to achieve our ultimate purpose: for P&G, providing superior service to all our stakeholders, starting with the consumer; for me, being all I can be and helping others do the same.

Part II
Five Qualities of Living

To achieve these goals of *service, leadership* and *growth*, there are five qualities that I've found most important.

Informed Passion

If there is one quality that has characterized every great leader I've ever known, it's *informed passion*. Men and women with informed passion are single-minded. They have a dream, a vision, and they will not let it go. Being goal-directed, they don't deviate from their objective, and they're ready to sacrifice for it. They are so informed and so prepared, they almost always achieve it.

I'm not describing a style here, but rather a clear, burning conviction in the importance of what you are doing and the importance of doing it well. From Michael Jordan to Sam Walton, from Martin Luther King Jr. to Mother Teresa, from the most effective teacher I've ever met to the most effective men and women I've worked with at Procter & Gamble — they all share this quality of passion. It can be a quiet passion or one that is expressive, but there's no mistaking it. You sense it; you feel it; it moves you; it's contagious.

You've got to love something to feel this type of passion. You have to feel it is worthy of your best effort, and you need to know you can make a difference. This is the feeling I had at P&G almost from the day I walked in the door. It's a priceless asset and a great gift. It is the feeling I have today, post-retirement, as I work at Yale University and as I help create the National Underground Railroad Freedom Center. I wrote in December 1987:

> *As you go through life in a business, there are a few things you learn and see so clearly and so consistently that you come to know them for certain. There aren't too many things like this. For many, you have to make room for exceptions. Others you have to qualify. My list of what I know for certain begins with this: Individuals of great commitment make the difference in business and in life. Great things happen because people who are deeply and honestly committed to a bold, yet realistic vision make them happen. These are individuals who have the ability to engage the enthusiastic support, energy and abilities of others in the pursuit of a goal. Other people join in the pursuit of this goal because they, too, recognize its importance and come to see it as their own, and because they know they can make a big personal difference.*

These are people of passion.

However, passion alone isn't sufficient. For a long time, I described this leadership quality purely and simply as *passion*. Not anymore. Today, I add the word *informed*. Informed passion is grounded in understanding, in disciplined preparation and execution, in balancing risk and opportunity, and in personal mastery. Informed passion means you have knowledge based on facts.

Ed Artzt tells a wonderful story of how he learned this lesson when he was brand manager on Comet back in 1955. Comet was expanding nationally in the United States. The market leader was Colgate's Ajax, and it was defending its business aggressively. Comet was not meeting its objectives. Artzt and his boss were called to the office of Howard Morgens, then chairman. Morgens got right to the point: "What is wrong with Comet and what should we do to fix it?" Artzt responded that two things needed to be done. "First we need to re-sample. We blew the fall mailing by dropping millions of two-ounce samples too late, along with the start of the Christmas mail. Postal carriers dumped millions in the waste cans, because the load on their backs was too heavy." That was straight talk, entirely typical of Artzt. No gilding the lily.

"Second," Artzt continued, "we need to beef up media in the seven major urban markets. They represent one-third of the cleanser business. Colgate is concentrating Ajax's defense there, and we haven't adjusted our plan accordingly. We tested in Peoria, which is not a major market, so our test didn't tell us what to expect." Clearly, Artzt understood the problem and he had a plan to deal with it. You can imagine how Morgens liked that. "How much money is involved?" he asked. "About $3 million," Artzt said. "Go ahead. Do it," Morgens directed.

Artzt remembers:

I was floored. There were no questions, no memo and no channels. Howard Morgens wanted to know if the guy charged with fixing Comet understood the problem. When he saw that I did, he turned me loose. Today, they would call that empowerment. From that moment on, I knew it was knowledge that made P&G tick. Since then, I've told brand managers not to worry about how much formal authority they have. Superior knowledge of the business, not rank, is the way for an individual to have an impact.

That kind of knowledge is what turns passion into informed passion.

Artzt's experience takes me back to a question I was asked not too long ago by a group of young employees: "What does it take for a young person to be able to lead a decision within a group of much more experienced senior managers?" My answer was simple and it gets to the heart of informed passion:

First, you need to know what you're talking about. You need to know the subject better than anyone else.

Second, express your point of view on the subject with all the passion and conviction you feel. Don't hold back. Don't try to act "buttoned up." Be yourself. A strong leader appreciates nothing more than hearing a proposal from a young manager who knows what he or she is talking about, has obviously penetrated the subject fully, and believes deeply in the proposal being made.

Third, be ready to persist in advocating your point of view. To be sure, consider and respond thoughtfully to input and concerns. But remember, even the greatest of new ideas, indeed *especially* the greatest of new ideas, will rarely be accepted on the first try. Why? Because it will almost surely involve important change. That will make persistence a must in advocating your point of view.

Pursuit of Truth

What a marvelous quality I have seen this to be — the pursuit of truth. Not always achieved, but always sought. Facing reality. Pushing back in the name of truth. What could matter more? Nothing inspired me more in my early years at P&G than this. But it didn't begin at P&G. It began at Yale. One of the things I loved most about my studies was the belief that we were pursuing the truth, for truth's sake. Like it or not, welcome or not, we pursued it for what it would teach us. I didn't know if I'd find this in business. It was a wondrous discovery to find it at P&G.

Pursuing truth first means facing reality. We all know it: The first requirement for solving our problems is that we identify them early, appraise them honestly and avoid complacency or evasion in fixing them. We aren't good at it. Humans have never been good at it.

"No problem is so big and complicated that it can't be run away from."

— Charlie Brown, Charles Schulz's wonderful character

We must be especially mindful of the role we play in creating an environment that encourages people to face up to problems as we assume positions of greater responsibility.

"The higher up you go, the more people will try to agree with you and please you in other ways, including telling you only the good news. Make it easy for people to disagree with you. Encourage an environment where problems, disagreements and conflict can surface quickly! That's how we get the best resources against them. And make sure you share reality up the line — the same way."

— Wolfgang Berndt

I've seen some managers be so intimidating (probably without intending to) that the people around them wouldn't dare risk conveying bad news. I've seen other managers, equally tough-minded and committed to high standards, operate in ways that people knew the only thing that counted was getting the facts on the table.

That's how I've always seen Mark Ketchum, retired president of our Baby & Family Care business, operate: always ready to tackle the toughest issues. I will long remember how he faced up to the need to change how we did business in the baby care category, bluntly reporting to the Company's senior management in 1997:

We've allowed ourselves to get beat on product in a category where innovation is singularly most important; we became increasingly short-term focused and reactionary as competition came into the market. We have a crisis, but we haven't yet agreed to the strong medicine it will take to restore our business health. We won't solve this problem in small increments. We need strong medicine.

Strong medicine is exactly what Ketchum, Deb Henretta and their team provided. Our diaper business is now growing strongly. Jim Collins says it rightly in his book *Good to Great:*

There's nothing wrong with pursuing a vision for greatness, but the good to great companies continually refine the path to greatness with the brutal facts of reality. Leadership is about vision, but leadership is equally about creating a climate where the truth is heard and acted on and the brutal facts confronted.

I agree. Of all the requests I made of those who worked for me, I believed in none more than this: "Tell me what you think, and act on what you believe to be true."

As I learned the history of P&G, I was thrilled to find there was nothing new about this commitment to face the facts of a difficult situation. We can go all the way back to 1921 and hear William Cooper Procter frankly critiquing the business problems P&G faced following World War I. In his address to the management that year, Procter minced no words:

> *The management have no bouquets for themselves — [we] over-expanded, the organization became weakened, the attention of the management was diverted from their immediate duties of production ... extravagance and carelessness were the natural fruit of their neglect. No fault nor weakness nor neglect in any business develops, but what the head management is primarily responsible for it.*

The starting point to turning the business around in the 1920s was the same as it has been at every other critical juncture. We have to have, as Procter said then, "the courage to face the facts."

I wish I had faced the facts more directly, at times. If I had it to do over again, I would have been more realistic in setting the profit goals that we adopted with Organization 2005. It was naïve of me to expect to navigate the greatest organizational change in our history and expect to *increase* the rate of volume and profit growth. This did not reflect a cold-eyed assessment of the disruptions that would inevitably be caused by this change, and the learning curve we would need to pass through. These overly ambitious goals were one of the reasons we priced too aggressively on some of our brands. It was one of the reasons we went ahead with too many initiatives, with some of them insufficiently proven. We have moved smartly to correct these missteps, but they shouldn't have happened in the first place. More diligent pursuit of truth would have led me to more realistic goals and, as a result, wiser actions.

Identifying what is truth is often not an easy task, especially on the big issues. But, we have an important safeguard for the pursuit of truth at P&G — a valuable tool to face reality. It is our respect for data. We need to carefully distinguish between what is *opinion* and what is *data-based*. That's not to say that opinions and judgments don't count. They do. But we need to be fact-based and data-based in our decision-making as far as humanly possible.

Pursuing truth also means pushing back, sometimes many times, often against people in senior positions. Gibby Carey, a wise and esteemed Marketing vice-president (now retired), expressed the idea perfectly:

Pushing back is a way of life at P&G. It is grounded in the trust that the best ideas and hardest data will prevail over the biggest initials. It happens at all levels. What may pass for insubordination elsewhere is taught to our young managers. At the topmost rungs of the Company, I have seen senior executives go back to the CEO when they were sure they were right, again and again, in a way that would be suicidal in other companies.

Tom Muccio had to push back to get the Wal-Mart team formed in the first place, and he had to push back again to get the needed financial and marketing staffing located at Wal-Mart's headquarters in Arkansas (Chapter 4). I had to push back to move into Russia as quickly as we did, to launch laundry detergents in China, to move into other underdeveloped markets, and to accelerate multi-cultural diversity.

Likewise, many of the most important business decisions I've been associated with turned on people's being willing to push back on me. The expansion of Ariel in the UK in the mid-'80s at premium pricing only happened because Jurgen Hintz and Harald Einsmann, then leading the UK and Europe, respectively, pushed back on me. They convinced me this would work, and were they ever right!

And it's not just within P&G that we need to push back. We need our advertising agencies to push back. For example, I doubt if Cheer laundry detergent would even exist today if Peter Husting, then account supervisor at Leo Burnett, and a few of his associates had not pushed back on Procter & Gamble in 1969-70. They told us we needed to reposition the brand for effective, "all-temperature cleaning." That wasn't our idea at all. We thought it should be positioned for superior cold-water cleaning. Husting and the agency thought otherwise. That made all the difference in the world. They pushed back to pursue the truth. The founder of the Burnett Agency, Leo himself, would have been proud. As he once said, "If you have the facts on your side and honest commitment in your heart, you rarely lose by fighting for your idea all the way." That's the kind of leadership that our business — in fact our lives — depends on.

I have seen this many times in Procter & Gamble. I've also seen it in my family relationships and in the nonprofit organizations I work with: the Cincinnati Youth Collaborative, Yale University and the National Underground Railroad Freedom Center. We learn from one another (indeed we are inspired by one another) when we are at our best; when we exhibit

genuineness and conviction; when we are willing to push back in the search for truth. Shortly before writing this, I experienced it in the person of Lisa Popyk, then the marketing director of the National Underground Railroad Freedom Center. In a brainstorming session involving three people, all her senior, she continually challenged the correctness of the conclusions. I wrote her afterwards:

> *Yours was as fine an example of the "pursuit of truth" as I have seen. Your intellectual integrity, your clawing for clarity where it was needed, your unwillingness to settle for the vague and mushy point, your willingness to challenge an already-agreed-on position are wonderful examples of the courage and integrity we need in our daily lives.*

The outcome of this pushing? A far stronger partnership between the Freedom Center and the eBay Corporation, with a contribution of more than $1 million.

The pursuit of truth takes us beyond the realm of our business lives to the heart of our entire lives — to the essence of our responsibilities and our personal relationships.

In my view, no one has conveyed more eloquently what the pursuit of truth calls for than Václav Havel, famed playwright, courageous dissident and the first president of newly freed Czechoslovakia in 1990. Writing in his book *Politics and Conscience*, Havel offered this timeless mandate:

> *We must trust the voice of our conscience more than that of all abstract speculations and not invent other responsibilities than the one to which the voice calls us. We must be guided by our own reason and serve the truth under all circumstances as our own essential experience.*

Courage

In some ways, courage is the most important quality. That's because it enables everything else to happen. It enables us to act on our deepest convictions and move forward, even when faced with incomplete information. It gives us the strength to stand alone when necessary. In early 1986, a few months before becoming president of P&G, I made this journal entry to express the deep emotions I was feeling at that point in my life:

> *To be greatly ambitious while knowing one's limitations takes courage. The counsel of timidity is to stay low rather than to risk great failures. The counsel of cowardice and prudence is to avoid getting hurt. I need to lead boldly and with confidence. I will. Courage is basic. Without courage there is no virtue.*

Sandy Weiner: A Profile in Courage

Many people at Procter & Gamble have inspired me by their courage, none more so than Sandy Weiner. Tragically, he died of cancer at the age of only 46. Sandy was one of the finest executives I've ever known. He had all the essential qualities of leadership: intelligence, decisiveness, self-confidence, openness to learning, belief in others, and an unwavering sense of values. Strategically focused, equally superb in execution, he brought enormous value to every business and every individual he touched.

Sandy Weiner

My respect for Sandy Weiner and the inspiration he left me with grew in a special way as I witnessed his heroism in battling the brain cancer that ultimately led to his death. He was the epitome of physical and moral courage. He was not deterred by the pain he suffered, nor was he led to withdraw because of the severe disfigurement that resulted from operations on his jaw in the latter stage of the disease. Uncomplaining, Sandy continued contributing to the business and coaching fellow employees despite chemotherapy treatments and one operation after another. Right after seeing Sandy in December 1985, I recorded my feelings about this marvelous man:

> *I just saw Sandy Weiner. The outlook is grim. Apparently the chemotherapy isn't working. The tumor continues to grow. His courage and stamina are overwhelming. Even in his pain, he was there yesterday talking to a youngster about a career in marketing. Talk about courage. That's courage!*

Nelson Mandela said it well:

"Courage is not the absence of fear, but the triumph over it."

My own experience has proven this to be true. To me, courage means:

- Being willing to put aside fear of failure, recognizing that to accomplish anything of real value, we must risk wrong decisions.

- Being willing to take a stand long before I'm certain of success.

- Standing firmly for something I believe in and not allowing the views of others to deter me.

- Fighting for what I believe in, especially if it's controversial.

- Being willing to ask others for their commitment: To ask "I need your help now"; "I need you to believe in each other." Not always easy requests to make, but often necessary.

Courage is the willingness to follow your deepest instincts, even if the future is not clear. I'll always remember what a speaker said at my oldest son, John's graduation: "Sometimes you have to *leap* before you *look*." You're called to embark on something you're not sure you can do, but you know it's right and you know you need to try. I have found many of the most important things in my life have been like that.

That was the case when we entered new business categories in China and Eastern and Central Europe. It was also the situation when we undertook Organization 2005. As I've said, I wish I had done differently many aspects of that organization change, but even so, I know it was right to move ahead.

I called on the strength of courage in early 1999 when I agreed to lead the Development Campaign for the National Underground Railroad Freedom Center. I didn't know then exactly how we would achieve our fund-raising goal of $110 million, but I felt certain that this institution could bring great benefit to racial understanding and cooperation in this country, and that I should play a part in making it happen. These decisions were ultimately sound. They were guided, in the words of Bart Giamatti, by the combination of all my "sometimes contradictory inner truths, the visceral, the open-hearted and the tough-minded."

I've found that you cannot make important changes or introduce new ways of working without controversy. Today, the notion that effective teamwork is critical to achieving a high performance work system would cause little disagreement. But my journal notes reveal that this idea was not readily accepted as I introduced it to our U.S. organization in December 1986:

Still a lot of controversy within the division manager group on the role of teams. I need to make my position clear and spell out more effectively the direction I want to go. I'm plowing ahead, saying as boldly and as clearly as I can what I believe is the right course for us to follow and why.

"Plowing ahead" is usually what it takes. I was reminded of this recently as I contemplated the anguished words of a distraught U.S. State Department official lamenting the world's prolonged lack of response to the mass killings in Bosnia: "If you want to take ownership of an issue, you have to do more than hold meetings. You have to make risky decisions and prove you have the courage of your convictions." [1]

Courage is an intensely personal matter. It is physical and moral. We muster and strengthen it in the depths of our hearts and souls, sometimes during the lonesome dark of night. We are tested and challenged. But in the end, it is the defining strength from which great achievements are born.

Sometimes we're conscious of acting courageously, and sometimes we're not.

Laurent Philippe, who led our business magnificently in Morocco, then Russia, then Greater China, and who is now leading our Western Europe Market Development Organization, recently shared this recollection with me:

It was October 1998 in Moscow, only a few weeks after the dramatic devaluation of the Russian currency. You and I had been store checking the whole day. Moscow was gloomy, as only Moscow can be at the early approach of winter. I recall we did not see a single P&G shopper that day. We had abruptly priced up to recover dollar sales, but local ruble salaries had been kept under close check by the government. I was pretty depressed. But you were forward looking, as always. First, you bought a tube of Blend-a-Med for yourself, gently pretending that you had forgotten your toothpaste from home. So we had at least one P&G purchase decision made that day. More importantly, several times you expressed to the group your strong conviction that the leading brand equities and share positions we had built in Russia before the crisis would serve us well, and that after the crisis we would emerge stronger than ever before. As we now know, this is exactly what happened. What a great lesson of courage and of leadership you gave me on that very day!

What I said to Laurent and our team that day wasn't calculated. It wasn't a special intervention. In fact, I didn't recall it at all until Laurent brought it to

[1] Cited by Samantha Power in her Pulitzer Prize-winning book, *A Problem From Hell.*

my attention more than six years later. All of which can serve to remind us that often our most meaningful acts of leadership are spontaneous, drawing on our commitment to service and to our deepest-held values of courage and persistence.

While acts of courage are intensely personal, we can nurture and encourage courageous acts from others, as well. I often ask individuals participating in a large group for their personal point of view. For a moment, I sense the hesitation. People would rather not speak up. But with just a little coaxing, someone does speak up and others follow. They say what's on their minds. We benefit from their points of view and they have, perhaps, experienced an act of courage whose impact lasts long after the event.

Mark Ketchum did this with brand and advertising agency teams. He refused to accept an "agency point of view" that allows the opinions of individuals to be hidden behind a single, unilateral recommendation. Mark said:

> *I go around the room and make everyone in attendance declare their personal point of view on a storyboard, a concept, a selling line or whatever. I know this has made an impact, because my long-term agency partners play back the positive effect this has had in cutting through the politics — and sometimes dysfunctional hierarchies — in the world of advertising.*

It does more than that. Motivating others to act courageously becomes habit-forming and character-building.

Acting bravely is easier said than done, of course. Making the right decision — especially what could be a "gutsy" one — can be very lonely. You're going against the grain; against the majority. You believe you're right, but you can't be sure. In a speech he gave at Harvard in 1886, Oliver Wendell Holmes Jr. described in stern terms the role of the leader when facing the toughest decisions:

> *Only when you have worked alone, when you have felt around you a black gulf of solitude and isolation like that which surrounds a dying man, and then entrust [yourself] to your own unshaken will, then only will you have achieved.*

Decisions that rise to that level of tension will not happen often, but happen they will. And it is only with courage that they will be made well. As

Edmond Burke, the 18th-century British statesman said, "The only thing necessary for evil to prevail is for good men to remain silent." [2]

The choice is ours:

- Will I speak up? Do I act on behalf of what I know is right? Or, do I opt to go with the flow, even if I believe the flow is going in the wrong direction?

- In a meeting when I hear something unfair or inappropriate being said about another person, do I speak up or let it pass?

- If I see misalignment among people who need to work together to achieve a goal, do I do my best to correct it? Or do I let the situation pass in stony silence, hoping somehow it will correct itself, as unlikely as that may be?

In making choices like these, we draw on the deepest foundations of our character, which have been built over the years through countless, individual decisions. No one of them may seem that important, but collectively they are the cornerstone we draw on as we make the most significant decisions in our lives and careers.

This was certainly true for me. I drew on the lessons learned from past decisions as I made every major decision — whether it was changing an organizational design, expanding a major brand, entering a new country, or handling a weighty personnel matter.

I have always come back to three simple checks in order to test if my decision is a correct and courageous one:

- Is it consistent with my own vision, my beliefs and my understanding of the facts?

- Am I doing what I believe is morally and ethically right? Does it *feel* right? (If it doesn't feel right, it probably isn't.)

- And finally, would I feel comfortable telling my wife, Francie, and my children what I have done and why I have done it?

[2] Ponder this reflection from the famed playwright, Arthur Miller: "The longer I worked, the more certain I felt that as improbable as it might seem, there were moments when an individual conscience was all that could keep the world from falling."

Persistence

Persistence has been a powerful driving force in my life. I have never taken success for granted.

There's no getting around it. Hard work and persistence are essential ingredients of success. Their importance is written large in the history of our business, but often in invisible ink. As earlier chapters in this book have made clear, the development of P&G brands such as Tide and Crest, as well as our business in country after country, would never have happened if it weren't for the persistence of both individuals and groups of men and women in this Company.

> "Life takes strength and staying power."
>
> — John Gardner

It is hard to find any truly great accomplishment that has been achieved without persistence. Take the right of women to vote in the United States. The amendment to the Constitution that established that right had been proposed and rejected 57 times starting in 1868 before it was finally ratified on August 26, 1920. This, in a country founded on the principle of "justice for all." And from 1776 when Thomas Jefferson pledged the United States to the precept that "all men are created equal," it took 89 years (and a Civil War) until the institution of slavery was forbidden by law.

It's been no different at Procter & Gamble.

- It took 15 years to capture the consumer benefit and brand-building power of surfactant technology in Tide.
- We worked on fluoride technologies for more than 10 years before finding a way to commercialize them to achieve leadership on Crest.
- It will have taken us a decade to find and execute a winning strategy in the laundry business in China.
- We were in the pharmaceutical business for 20 years before achieving the breakthrough success we're experiencing today.
- It has taken many years of effort to bring diversity to the top of our Company, and we are still on the journey.

We will learn from these experiences, and we'll be able to resolve issues faster in the future. But persistence will always remain an essential ingredient for success, especially in the pursuit of significant and challenging goals.

P&G's business in Vietnam provides a recent example of this. Persisting in Vietnam in the late-1990s was not an easy choice. We were tempted to leave the country, and for good reason. We were losing money. Prospects for profit were poor. The government had asked us to make another major investment without an increase in equity. We had our hands full in China and other places, too. But we didn't want to abandon this country. Vietnam has more than 50 million people. The environment and the prospects for growth in Vietnam in the late-'90s were similar to what we'd found in the eastern provinces of China a decade earlier. So we stayed. We negotiated a fair deal with the government. We committed to getting profitable in no more than three years, and we're beating those goals. Tide, which had less than a 10 percent share, grew to a 20 percent share in fiscal year 2003-2004.

We installed a small production facility for Pampers that has the lowest-cost diaper line in the P&G world. It is teaching us a lot about the value of low-cost production units that is being applied globally. In Vietnam, this facility allowed us to cut the price of Pampers to consumers in half, tripling the brand's share quickly to market leadership at over 30 percent and significantly expanding the total diaper category. As General Manager S. Vaidyanath realistically observed at the time, "We still have a long way to go. Lever is a Goliath and will come back ... with all their might. But we're on our way. With strong foundations, our persistence will continue to pay off."

I love to tell the story about the shortest speech Winston Churchill ever gave. He was returning to his prep school shortly after having been voted out of office following World War II. Teachers, parents and students were looking forward to his talk with great anticipation. The moment arrived. Churchill came to the podium, pushed his glasses down over his nose and said: "Never, never, never, never give up." Six words. With that, he turned around and went back to his seat. The initial reaction, it is reported, was one of disappointment, disbelief. The audience had expected more. But on reflection, many felt that they had just heard the wisest speech of their lives. I wouldn't quarrel with that judgment.

"Never, never, never, never give up."

— Winston Churchill

I treasure another dimension of persistence. It's knowing when you're done that you've "left nothing on the table." You can look back and say, "I carried this out as well as I could. I finished strong." It's a wonderful feeling. I had it when I finished five glorious years of managing our International

business in 1995; when we successfully completed the Greater Cincinnati United Way Campaign, ahead of goal, in 1994; and when I retired as chairman of P&G (for the second time) in June 2002, knowing that the Company couldn't be in stronger hands than those of my successor, A.G. Lafley.

Despite all that I've just written, it is *not enough* just to persist. We must persist as leaders, *proactively, with confidence,* especially in times of difficulty. I learned this the hard way a couple of times during my career. One of the toughest was during 1981-84, when I was leading Europe. We were working to increase our meager profit position, while at the same time reorganizing to bring Europe to a more integrated, transnational operating structure. Looking back at my journal reveals this telling entry from 1983. It taught me a lesson I never forgot:

> *I have been too preoccupied by our profit situation in Europe. It has gotten me down personally to too great an extent. I have got to "manage" it and be sure it doesn't "manage" me. I have looked like I have been in too much pain to too many people. To be sure, that is how I felt, but the real answer is to be more vigorous and confident in going out to do the best possible job. I need to recognize that my attitude will have a mighty influence on the attitude and motivation of others. I must not get discouraged by short-term setbacks.*

I went on to reflect on the careers of DeGaulle, Eisenhower and Churchill. They each had major setbacks, but they didn't let those setbacks get them down — not their view of themselves, nor what they should and could achieve.

As I reread these thoughts, I recall the challenges, but I recall the satisfactions, too. How reassuring it was to look back at the end of 1983 and see what I could record as "notable accomplishments" in Europe:

- Volume up by 7 percent compared to market growth of 2-3 percent.
- Profit up significantly.
- Continued growth in working together on a European basis.
- Continued strengthening of our organization.
- Recruiting and training efforts improved.
- Continued progress on a number of important new brands.

Still, it took me more time to wrestle through this leadership issue than it should have. I came back to the United States from Europe in June 1984 and again faced a challenging situation. Shares on our leading laundry, diaper and dentifrice brands were weak, and several of our new brand launches were failing. I was under stress and was apparently letting it show, as reflected in this journal entry:

Norm Levy (the leader of our Copy operations) greeted me with a serious comment: "You've got to smile more." He's right. It came as a shocker — the fact that it's taking on such importance in his eyes that he'd feel compelled to comment on it. Need to take this to heart. Realize the impact of my attitudes and my emotion on others. (6/85)

Obviously, the right response to Levy's comment wasn't simply to start smiling more. Rather, it was to get on top of the issues firmly, confidently, personally. It was to offer my team my energy, my enthusiasm, not my anxiety. A few months later, I had faced up to the reality of the business situation. The challenges were there, but we were addressing them head on. My journal reflected this different attitude:

We have just had one of those wild and woolly, roller-coaster weeks — great ups and downs — showing once again the need and ability to hang in there; to persist. Now is the time we most need courage. In many ways we are in the toughest part of the storm. We need to go forward with confidence and commitment.

That is what leadership is all about.

Respect and Trust

When I'm asked what I believe explains my success at Procter & Gamble, I always put my respect for people (and the trust that accompanies it) close to the top of the list. I could not possibly overstate its importance. As I wrote in a journal entry in January 1986:

What has been most important to my success, and what do I need to continue to emphasize in the future? My belief in people — a genuine desire to help people achieve their potential. Great, gut conviction that our people are excellent in their talent; that they want to do a great job; that no one has a monopoly on good ideas. We have to have an environment that encourages and allows the ideas of all to impact the business.

I went on later that month to express a conviction that some may see to be overly sentimental. I don't: "My dominant feeling continues to be one of love and pride in the people of this Company. They truly inspire me. Their hearts and their capacities are enormous."

On occasion, I have allowed my belief in people's capacities and their good intentions to get ahead of reality. Much more often, I have been extraordinarily well served by my belief in people. Rarely have they let me down; far more often they have exceeded my expectations.

Respect for others isn't some "warm and fuzzy" concept. It brings a host of concrete benefits. First of all, it allows us to listen to and gain the benefit of other people's ideas. Some people have told me they believe my ability to listen is my greatest strength. I'm not sure, but I am sure there is no better way to learn.

I agree with Steven Covey that no principle determines the quality of an interpersonal relationship more than this: *Seek first to understand, then to be understood*. We can only understand another person if we listen empathetically. Yet there is even more to listening than learning and understanding. While it may not be the reason you do it, empathetic listening conveys your respect for another person like nothing else. That respect is empowering; it is a precious gift. It permits other people to be more authentic, to risk more and to express their own thoughts more creatively, clearly and bluntly.

Respect for another does something else. It sets the foundation for *mutual* respect and trust. Few things are more powerful. That's because this creates connections with others from which we can derive enormous strength and insight. Most of the relationships we have with people are relatively formalized; they're contained within prescribed boundaries. To a degree, that's all right. Life would probably be too chaotic, even unbearable, if we were constantly revealing our deepest feelings and taking in those of others. But how much of life do we lose because we fail to be open and transparent? How many things do we fail to understand because we haven't given them the chance to emerge, often unexpectedly, in ways that only authentic rapport and honest conversation can reveal? These aren't academic questions, at least not for me. They are on my mind almost every day in one relationship or another.

I am lifted as I reflect on those connected relationships that have enabled my most meaningful conversations to take place — relationships within my family, of course, but also in those closest of friendships that have come outside it — at P&G and elsewhere.

"The glory of friendship is not so much in the outstretched hand or even in the kindly smile. It is in the spiritual inspiration that comes when you discover that someone else believes in you and is willing to trust you with his friendship."

— Ralph Waldo Emerson

Those relationships in which I have felt free to talk openly without fear of embarrassment have been amazingly productive. We've been able to cut

through to the essence of issues, whether business or personal, quickly, imaginatively and honestly. Those relationships have been important to me in another way, too. They have made me feel in touch with another person whom I respect and trust and who respects and trusts me; they've made me feel alive; they've brought me joy, and with that has come creativity, energy and determination I otherwise wouldn't have had.

<p style="text-align:center">———➤●◄———</p>

What does it take to become a trusting — and trusted — person? I believe it begins with trusting yourself. Here's how I expressed it in early 1986: "I must be at peace within myself — listen to all points of view, but then have faith and confidence in the answer I reach." These words mirror those of Joshua Lieberman in his excellent book *Peace of Mind*. "He who does not have the proper regard for his own capacities, power and compassion can have no respect for others." That regard for ourselves must rest on our consistently keeping the commitments and promises that we make to ourselves.

Next, we must *choose* to trust others. It is a conscious act. Ed Artzt talked about this in a wonderful speech called "How to be a Winning Manager."

> *Trust is a character trait that does not come easily to many people. But I believe that winning managers inherently trust the judgment, competence and integrity of their subordinates, and are successful because they communicate that feeling to their people as part of the winning spirit that they ultimately create.*

> *Losing managers, on the other hand, are often inherently distrustful of the judgment, competence or integrity of their people, and they inevitably transmit that feeling much to their own detriment, and to the detriment of the enterprise.*

> *Understand that I am not talking about blind, unquestioned, hands-off, let-your-people-run-wild trust. But I am talking about developing the capacity to convey to people the trust that they have earned through their efforts and their performance.*

> *Remember just one thing: Trust your people. If you trust them, they will give it back tenfold.*

The trust we place in another person (and that others place in us) is the most powerful of motivators and the most precious of gifts.

Listen to how Herbert Schmitz, who as noted earlier led the development of P&G's business in Eastern and Central Europe, describes what enabled him to take the risks that led to his breakthrough results:

> *I felt trust and respect from those to whom I reported. They had confidence in me ... they had fun in taking the risk with me. I could see it in the sparkle of Wolfgang Berndt's eyes* [Herbert reported to Wolf]. *It gave me oxygen. I knew that he'd forgive mistakes as they occurred.*

A few mistakes were made, but there were many more victories. Respect and trust fueled these victories.

Trust is at its most powerful when it is authentic and spontaneous. Two personal encounters brought this home to me. The first occurred in 1971 during a car ride that lasted no more than 10 minutes. I was advertising manager of the Bar Soap & Household Cleaning Products Division and had been attending a presentation by a senior creative director of one of our advertising agencies. John Smale, then group vice president responsible for our Laundry & Cleaning businesses, offered me a ride back to the office. During the short trip, Smale asked me what I thought of the presentation. I told him I hadn't thought much of it. I had found it superficial. It turned out that he felt the same way. What I recall from this brief exchange was the obvious respect Smale had for my point of view and his interest in having a real interchange about our views. He was listening, really listening. As it always does, this conveyed a sense of respect that went beyond mere words.

The second incident produced an even more vivid memory. It occurred in Rome in the fall of 1974. For about three months, I had been on the job as general manager of our Italian business. It could not have been in much worse shape. Profits were virtually nil. We had just emerged from price controls. Inflation was running in double digits. The Communist Party was within a few percentage points of taking control of the government, and our sales were stagnant. What a time to have the chairman and chief executive officer of the Company coming to visit, but here he was. Thank heaven it was Ed Harness! He'd led the Company through some of its most challenging days in the post-World War II era. I can't imagine anyone doing it better or with a more human touch. Ed was arriving in Rome to meet one of his newest general managers to review a business that certainly was not one of his highlights that year.

I can't recall a single bit of what I reviewed with Ed during our meetings. Whatever it was, I'm sure I evidenced more than a little personal stress. As we came to the end of the day, Ed and I were walking down the hall as I escorted him from the building on Via Cavour, just outside Rome. We had almost reached the elevator when Ed put his arm on my shoulder. He looked at me

and with just a trace of a smile, said: "John, sometimes you just have to wait for the other shoe to fall. You're doing the right things. Everything will be all right." That was it. And that was enough. With those few words, Ed Harness lifted a huge weight off my shoulders. He made me feel valued. He allowed me to get back to work, not with any less intensity, but with an altogether higher level of confidence and assurance that I was trusted. Remember, this was 30 years ago. Ed Harness gave me a great gift that day — his respect and his trust. I'm not sure if he recalled it afterward. Sadly, I never mentioned it to him prior to his all-too-early death in 1984. I wish I had. That honest, sensitive and caring interchange, which lasted less than 30 seconds, has had an impact on me for 30 years ... and will for a lifetime. That's the power of the respect and trust we can convey to each other.

Consciously, and I'm sure unconsciously too, I've tried to reciprocate the life-changing benefits I've gained from people who conveyed their trust in me. As I was retiring, I was deeply moved to receive a letter from Johnip Cua, one of the most outstanding general managers I've ever worked with. He reminded me that in 1991, when he was still a young product supply manager, I'd observed him in a meeting and recommended to his line management that he undertake a training assignment in marketing, likely leading to general management.

Johnip recalled, "It took me two weeks to think through what I wanted to do, and what I thought I was capable of doing. To be honest, I was not sure, but because you placed so much trust in me, I decided to accept the challenge and the rest was history. ..." And what a history it has been. Johnip has led the Philippines to record after record, year after year. Countless men and women have grown under his leadership.

A former P&G leader, Chris Warmoth, once told me that he believed my unique strength is

The ability to make people feel special and responsible and enthusiastic. Over time, I have come to see that this is probably more important than anything else. P&G really does hire very good people. If they work at the top of their game, they are pretty powerful. You had that ability to make this happen.

Perhaps this is an ability, but I think of it more as an instinct, for it's not something I had to work at; indeed, for the most part it's not something I was even conscious of. It came naturally, because of the respect, the trust and the affection I had for the people with whom I worked. I identify with the words of a long-time friend, Bob McDonald, vice chairman, Global Operations:

I've never met anyone in my life who wants to fail. In every leadership class I teach, I ask, "All you who try to fail, please raise your hands." Of course, no one raises their hand. Yet, as managers, we often work harder to try to catch people failing than to try to catch people succeeding and reinforce them in that success. I believe that trust comes from a conviction that P&G people really are the best.

This is so true, and it applies to everyone. Respect and trust cannot be gifts for a few. They must be gifts for all, because everyone matters. We all need to know we count.

I can conceive of no stronger validation of what I believe matters most in business and in life than a letter I received from a P&G associate, Kathy Grogan. She understood my conviction that *everyone* in the Company has a vital role to play and should be respected and trusted to play that role.

That we counted as individuals and were not just a number are things I will never forget under your direction. I particularly remember your talking about the number of administrative and technical employees employed at P&G being larger than managers and that we have a voice and should be listened to. What awesome advice.

Awesome, perhaps; correct, absolutely.

In my experience, choosing to trust your own capabilities and then consciously choosing to take the risk of trusting others will eventually build your confidence as a trusting person. Over time, trust will become an instinctive part of you, and your life and career will benefit enormously as a result.

Part III
Three Foundations of Living

As I wrote at the beginning of this chapter, this model for living has three levels, each tightly interrelated with the others. So far, I've talked about *what* I've tried to achieve — my goals, my "Three North Stars" as I've come to refer to them. I've gone on to describe five qualities of living that I have found critical in deciding *how* to achieve these goals. In this, the third level of the model, I reflect on three values that I have come to believe describe *who* I aspire to be. They have infused everything I have tried to do up to this very day. Moreover, I have come to see these as the most foundational values, not only in my life, but in the lives of those men and women whom I most admire. They start with *integrity*, the foundation of good character.

Integrity
FOUNDATION VALUES

Integrity: The Foundation of Good Character

Integrity, for me, means always trying to do the right thing. It means being faithful in action to our most important core values, to our promises, to our words. Saying what we mean and meaning what we say, saying it plainly, and facing bad news squarely and candidly.

R.R. Deupree, the first person to lead Procter & Gamble other than a Procter or a Gamble, said it most simply: "In all we do, we should always try to do the right thing." What a wise and simple guide. I have turned to it again and again when I have tried to sort out what I should do in a complex situation.

While the guide is simple, the direction it points to often isn't. In the end, you have to rely on your judgment and do what you believe is right. No incident in P&G's history brought our commitment to do the right thing to life for me more visibly than Ed Harness's decision to withdraw the Rely Feminine Protection brand from the market in 1979. Because science did not allow a categorical separation of the disease of Toxic Shock Syndrome from Rely's product attributes, we closed the brand down. There was not then, nor is there now, evidence that Rely was directly involved. But we refused to take the chance that it might be. In today's terms, that decision cost us hundreds of millions of dollars. Ed Harness's integrity made it an easy, if punishing, decision.

One of the most difficult — but ultimately clear-cut — decisions I faced involved an incident that I wouldn't have believed could have happened in P&G. It arose from a misguided attempt by a small number of P&G employees to show that our current methods of obtaining competitive intelligence were too conservative. One of the contractors they hired retrieved sensitive documents from a trash receptacle located near one of our competitor's facilities. This might not have been illegal, but it clearly violated P&G policies. When I learned that we had competitively sensitive documents inside the Company that may have been obtained improperly, I called Niall Fitzgerald, chairman and CEO of Unilever, right away. At that point, I didn't know how we had gained access to the materials, nor how broadly they might have been distributed within the Company.

We worked with Unilever to identify how the materials had been obtained. We immediately quarantined them and returned them to Unilever. In the final analysis, I am confident that the materials were not used in any way that hurt Unilever's business. After an investigation of several months, P&G ended up making a significant monetary payment as compensation for the incident, and terminating the employment of individuals most closely associated with the competitive intelligence operations.

Many lessons were to be learned from this unfortunate experience: We had failed to penetrate the activities of our contractors; our policy itself had not been broadly enough understood. But one thing was sure. When we became aware that we might be in violation of our policy, we had only one thought in mind: "Do the right thing, and do it now!"

We model this type of behavior for one another every day. A former P&G associate of mine, Tammy Minick-Scokalo, related how she first "got religion" on P&G values. At the Mehoopany, Pennsylvania, paper plant, Manufacturing Division Manager Mac McKinnon called Tammy into his office during her orientation and asked her to sit down. His message was crystal clear:

> We have a lot of rules and policies around here. You will hear about many of them, but there is one that is more important than all the others ... so important I want you to paste it on the inside of your eyelids and if you're ever in doubt, shut your eyes and look at it. The rule: "Do what you believe is right."

> I'm paying you to think and to do what you believe is the right thing to do, considering all available information and your values and principles. Doing what's right is the only policy you have to remember.

As Tammy told me later: "The first empowerment seed had been sown; the first link of loyalty. Mac McKinnon had confirmed that I joined the right place and he walked his talk. It was not just puffy language." How liberating and uplifting it is for a young person to hear words like these. Really, for a person of any age.

Winston Churchill explained it this way in a speech in Norway in 1948. No words could more perfectly mirror my own deepest convictions:

> Human judgment may fail. You may act very wisely, you think, but it may turn out a great failure. I have seen many things happen, but the fact remains that human life is presented to us as a simple choice between right and wrong. If you obey that law, you will find that way is far safer in the long run than all calculation which can ever be made. I certainly don't want you to understand me to say that I've always done the right thing — I should be ashamed to claim that. But I do have the feeling that one must act in accordance with what one feels and believes.

Integrity
FOUNDATION VALUES

Bob Goldstein: "A Principle Isn't a Principle Until It Costs You Something"

Bob Goldstein

Gibby Carey tells a compelling story about how a spontaneous interaction with Bob Goldstein underscored a commitment to principle in a way no formal presentation ever could. Goldstein was a man of striking character and ability who led P&G's Corporate Marketing organization from 1979 to 1987. Tragically, he died in a rafting accident at the age of only 50. Accurately described by Carey as "devastatingly intelligent and truly caring," Goldstein's integrity was uncompromising. Carey tells us he was reminded of that one day when he (Carey) raised the possibility of "taking a shortcut" to solve a nagging business problem. "Goddamn it, Carey," Goldstein said, "a principle isn't a principle until it costs you something."

Carey never forgot that brief discussion, nor will I. Goldstein was drawing on his deepest instincts — a vivid reminder that all the videos and speeches in the world will not override the behavior that people can observe. This is why it is so important for us to be faithful to our best ideals at all times. We won't do that perfectly, but that's what we must try to do.

Robert A. Jackson, attorney general in President Franklin D. Roosevelt's administration and later associate justice of the U.S. Supreme Court, offered this biting perspective:

> *While I grant that results may be the best test of the wisdom of a policy, I must disagree that the moral worthiness of a policy or the mental intent of a politician is wholly irrelevant in judging the rightness or wrongness of a political course of action. The focus on results is merely a retrospective application of the doctrine that the end justifies the means. … Preoccupation with outcome may also distract attention from whether it is right and ought to succeed. And, in my view, the prognostications of a policy's ultimate results are even less reliable than are the simpler judgments of right and wrong.*

Integrity has two other important dimensions for me. One is its call for *authenticity*; the other is the crucial importance of *consistency*.

By authenticity, I mean the willingness to say what we mean and mean what we say — to avoid anything that smacks of political positioning. In simple terms, to be ourselves.

One of the most mesmerizing (indeed, chilling) stories I have ever read is Tolstoy's *The Death of Ivan Ilyich*. It revolves around Ilyich's reflections as he approaches death. All he sees is that much of his life has been a sham. He concludes, sorrowfully, that his life excluded "everything with the sap of life in it." He saw people around him carrying the "pretense he was ill and not dying" — all this "being done in the name of the very decorum he had served all his life long." In the end, Ivan concludes he did not live as he should have lived. "His life had concealed both life and death." He had fought against his most important and valuable impulses. The message emerges loud and clear: Don't live for tomorrow — live for today. Live for those to whom we owe service. Trust your instincts. Live authentically.

Living authentically earns the reputation I love to hear ascribed to someone — "What you see is what you get." No matter where they are, no matter whom they are talking to, they're the same. Why? Because they are acting in line with their basic values and feelings. They do what they believe is right, not what consensus demands and not what is safe and accepted. That's integrity. And it is powerful for the simple reason that above all else people respond to what a person *is*. This is why the biggest impact we have on others doesn't come in formal, skill-based training courses, or in prepared talks and presentations. No, it comes in those moments when we exhibit spontaneity, genuineness and conviction. "It takes great boldness to dare to be oneself," Albert Camus once said. How right he was.

Consistency is the other dimension of integrity I want to highlight. The longer I live, the more I learn that each violation of what I believe is right, even if it isn't the biggest matter in the world, can become a crack in my self-esteem and confidence. Ronald Reagan had it right in a talk he gave in 1993:

The character that takes command in moments of crucial choices has already been determined by a thousand other choices made earlier at seemingly unimportant moments. It has been determined by all of the seemingly little choices of years past, by all those times when the voice of conscience was at war with the voice of temptation, whispering, aloud or internal, it doesn't really matter.

Integrity
FOUNDATION VALUES

President Reagan's comments remind me of a story told by Norm Augustine, retired chairman and CEO of Lockheed-Martin Corporation, a close friend and valued member of P&G's board of directors. Norm dramatized the importance of our consistently trying to do what's right by examining the habits of a snake, of all things. Norm once thought, as I did, that the boa constrictor made its kill by quickly crushing its victim with its powerful body. However, a look in the encyclopedia revealed, instead, that the boa places two or three coils of its body around the chest of its prey, and each time the victim exhales the boa simply takes up the slack. After three or four breaths, there is no more slack. The prey quickly suffocates and is then swallowed by the boa.

Norm went on to note that this deadly phenomenon of the victim becoming an unwitting accomplice in its own destruction is not confined to the world of reptiles. The boa *we* have to face and overcome is following our ethical values: "Each lapse is another coil of the snake."

When it comes to integrity, a lack of consistency undermines the trust and respect others have for us and, even more, the trust and respect we have for ourselves. There is no more important determinant of character.

> "Watch your thoughts; they become words.
> Watch your words; they become actions.
> Watch your actions; they become habits.
> Watch your habits; they become character.
> Watch your character; it becomes your destiny."
>
> — Frank Outlaw

Learning: The Foundation of Growth

Learning is an irreplaceable value, especially with the world changing so rapidly around us. Years ago, I recorded what has motivated my own commitment to learn:

> *There is no secret to my drive to learn, no mystery at all. It derives from a passion and a joyful sense of purpose. That's what continues to motivate me and all of us to reach out to the future, taking risks, willing to be wrong. That's what leads us to learn.*

Yet, I've been amazed at how differently people continue to learn over time and how this has an impact on their growth and satisfaction. Some people seem

to level out in their learning. Their curiosity dissipates, and they find it hard to accept new ideas. Other people remain forever curious, forever open, seeking and receiving input, assessing it in light of their own values, and moving on to make their own decisions informed by this learning. They reach out to see how improvements can be made, to learn from others and to identify new possibilities.

Richard H. Brodhead, president of Duke University (and former dean of Yale College) said it well in a baccalaureate address delivered at Yale University in May 2004:

> *In my life, I've met people who seemed absolutely to have stopped thinking at a certain point and to be living on a stock of frozen opinions as limited and antiquated as their aging wardrobes. I cannot promise that this will not happen to you, but I pray that it won't. With luck [you] will have developed an instinctive drive to keep identifying and assimilating new sources of information and subjecting them to analysis and synthesis.*

Over the years, I've seen that the strongest leaders are those who have enough confidence to seek input from others without losing the direction provided by their own internal compass. They understand that the objective of learning is not comfortable consensus. It is to make wiser, more informed choices. It is a priceless attribute, this combination of being open to input, having the self-assurance to assess the input objectively, and being guided by your own judgment to the conclusion you believe in.

Learning is not just an attribute, however. It is a skill. I've discovered over time that there are *learnable* learning skills.

- *Learning from others.* From my earliest days, I learned an enormous amount from those I worked for. I always felt comfortable — even positively inclined — to go to my managers for advice when I was facing a tough issue. It's important to have enough confidence in yourself and enough trust in your relationship with your manager to do that. I almost always went with a point of view, but I was looking for input where I thought it would help me.

 I continue to learn an enormous amount from those I work with. The learning and insights that I've drawn from members of P&G's board of directors have been of incalculable benefit. The learning I continue to gain from working with my many associates at Yale touches on every aspect of life.

- *Learning how to ask the right questions to reveal new choices.* Too often we tend to try to resolve a problem by coming at it head on, with pre-set

assumptions. If we set those aside, and look for questions that might yield answers we've not considered, we often learn far more than we expected.

A good example was my experience in Italy, which I've mentioned earlier. Price controls were placed on our brands but not on the raw materials we purchased. At first, we simply tried to persuade the government to withdraw price controls on our national brands. They wouldn't hear of it. It was only when we sat down with government officials a second time that we thought to explore whether an unseen option might exist. The government wanted a lower-priced laundry detergent that would help consumers in the midst of runaway inflation caused by the Middle East oil embargo. We needed the flexibility to increase prices on our national brands to absorb the higher costs of raw materials. When we each clarified (and respected) our individual needs, we came up with a joint plan to market a new line of unadvertised, lower-priced brands, while the government allowed prices on our regular national brands to go free. That happened because we had asked the right question: Is there a solution that will meet needs which, on the surface, seemed entirely in conflict with one another? The answer was "Yes," but we wouldn't have discovered this if we hadn't gone back to the table with a simple, but previously unasked, question.

- *Learning by teaching.* We all learn by teaching, not only because we have to arrange our own thoughts and experiences into some semblance of order before trying to impart them to others, but because in the teaching process we learn from our students' reactions and feedback. There is no way, for example, that this chapter would be in front of you if I hadn't taught a course on personal leadership at the Yale School of Management in spring 2000, or if I hadn't shared these principles with fellow P&Gers and received valuable feedback from them. All of this is meant to encourage you to seize the opportunities to teach. You will learn as you do.

- *Learning from personal reflection.* In particular, it is valuable to learn from the disciplined sort of reflection that occurs when we commit experiences and thoughts to writing. With all their meanderings, the journals I've kept for more than 20 years have preserved learnings and experiences that otherwise may have faded or been distorted by my memory. It's provided the space to reflect on the relevance of some of the finest books I've ever read. It has been a repository for the thoughts and writings of friends and colleagues. It has also been a place where, as my daughter, Susan, observed recently, I could address the disarmingly challenging and simple questions: "What did I learn last year?" "What will I do with that learning?"

The process of learning involves more than accumulating knowledge and being stimulated by new ideas. Learning develops character. This learning can be acquired through reading, particularly stories involving individual choice and courage. It can be gained by watching a great film. But the learning that has affected me the most hasn't come from books or films. It's come from being up close and personal with others: consumers, customers, fellow employees, outside experts, members of the community. It's come from gaining new perspectives while working with people who've had different experiences and together figuring out what needs to be done. It has come from diversity.

My most important learning has come from experience borne out of difficult decisions and challenging situations. For example, learning came from the decision I made (as described earlier in this chapter) to alert Unilever's CEO to the potential breach in our competitive information-gathering system, knowing full well that if I didn't call him, he might never have discovered it. It came from the decision to go ahead to introduce Crest toothpaste into China, knowing that the odds of success were far from certain. You have to be willing to put yourself in stretching, uncomfortable situations to learn this way, but I've found it's the best way and sometimes the only way.

One of the most meaningful learning experiences of my life occurred in December 1987, at an off-site Executive Leadership Conference I convened for our U.S. business leadership team. I had been responsible for the U.S. business for about three years. Our business results were improving after several difficult years, but we still had a long way to go. We knew we weren't unified sufficiently across our line and staff functions. We were not the team we needed to be. I decided the time had come to bring together our leadership group. We brought in a facilitator and set out to better define our goals and how we should operate to achieve them.

The insight and determination flowing from this experience led to several major interventions, including a new compensation plan designed to reward and encourage bringing our profit results back to our historical trends. We also focused on how we could better unify the efforts of staff and line, and simplify our approval systems. But beyond any particulars, this experience deepened my appreciation of the value that trust-based leadership could bring to the business. Following the first day of the conference, a journal entry recorded at 3 a.m. (needless to say, not my normal waking hour) captured my feelings:

Awoke in very exhilarated state — anticipating what is to come — I feel comfortable, able to risk, just to be myself. Why? We were one. Able to express ourselves from the gut. I contrast that feeling now with what we had going in — concerned and apprehensive. The change comes down, I

Learning
FOUNDATION VALUES

think, to that common personal experience of going through something where we all risked — and found each other reinforcing each other. (12/16/87)

Much more was involved here than a warm feeling. My follow-up notes showed that we left committed to "find ways to establish one clear-cut business goal that all functions align to and measure their performance by; to eliminate elements that are not key to results — that tend to be distractions in and of themselves to the main goal."

A lot of good came from these interventions. The new compensation program helped improve our profit performance dramatically. Simplified approval procedures let us focus more time externally on building the business. And, as never before, the experience punctuated the value of establishing open, trust-based relationships with one another.

<div align="center">⟴</div>

I want to highlight one final aspect of learning, because it reinforces the concept I began this chapter with — the importance of service to others.

Just as we learn from others, we can help others learn from us. It's our *attitude* that makes all the difference. One attitude proceeds from the proposition that "I'm going to teach you how to do this particular task." The focus here is on me as teacher. But a far better attitude proceeds from the proposition that *"I'm going to do everything in my power to help you develop as far and as fast as you can."*

The focus here is on the learner. Doing that may involve teaching certain tasks and principles, but it will have the overriding purpose of helping another person be all he or she can be. This will lead to a different kind of teaching and a better form of learning. It will leave space for the student to think and react, to form his or her own view, and to search for his or her own best option.

I'm not talking about a certain style of teaching. You'll find *tough taskmasters* and you'll find *not-so-tough taskmasters*. But all great teachers have one thing in common: the desire to help those they're working with to learn and develop. And learn and develop they invariably will — and they'll look back on this as the greatest gift.

Whether we're learning ourselves, or helping others to learn from us, it all gets down to the particulars: asking the right and often unexpected questions;

being intensely curious and open to what you don't yet know; and perhaps most important of all, being a person who cares.

Caring: The Foundation for Just About Everything

I want to close on this point. How much we care determines everything we do. This was brought home to me by a talk given some years ago by Army General Melvin Cais. A veteran of Korea and Vietnam and just about to retire, Cais was giving his final address to the graduates of the Armed Forces College. He offered the students only one piece of advice, promising that it would make them better leaders, provide them with greater happiness, and advance their careers more than any other advice he could provide. He said, "It doesn't call for a special personality nor any certain chemistry. Any one of you can do it, and that advice is *You must care.*"

The general acknowledged that by this point the students were probably wondering, What is this guy talking about? After all, they had already devoted four years preparing to serve their country and now they were ready to go out and do it. But the general continued:

> *There are all kinds of caring, and there are degrees of personal sacrifice to reflect the amount of caring that you do. There is part-time caring. There is almost-excellent caring, there is even, unfortunately, pretend caring — and then there is true, deep caring.*
>
> *How can you tell whether you really care deeply? Ask yourself how you would feel if you are 15 minutes late for a meeting of your squad. Would you feel, as you should, that you have conveyed disrespect to every member of that squad? How would you react if you saw a member of your squad who was deeply troubled? Would you involve yourself just enough to satisfy yourself that you had done something and that now it's up to the person to fix it? Or would you keep digging to really understand the root cause of the issue and do your very best to help the person resolve it?*

Caring deeply has everything to do with success in P&G's business. We know we care when we pursue a product complaint to its root cause, doing everything possible to ensure it doesn't happen again. We know we care when we deal with each consumer affected by a problem as if he or she were the only consumer in the world. We know we care when we deal with our customers, one by one, knowing each deserves our very best effort. We know we care when we never stop learning how to do our jobs better, no matter what they are. We know we care when we do everything in our power to help those reporting to us to succeed.

Caring
Foundation Values

Yes, when all is said and done, it is how much we truly care about our families, about our consumers, about our customers, about our associates and about our communities. This is what determines what we will accomplish, what we will contribute and how much satisfaction we will take from life.

<p align="center">⎯⎯➤•⫷⎯⎯</p>

I've talked several times with P&G employees about the concepts I've developed in this chapter. Following one of these presentations, I received this remarkably perceptive e-mail from one of the attendees:

> *I have thought a lot about what you talked about with us yesterday as you discussed your "personal model for living," and I've come to the conclusion that what you were really talking about [in discussing] several of these concepts was "love." Perhaps love isn't a sufficiently manly word to use, but that's what I think you're really talking about.*

I was amazed that this young man made this observation. Why? Because in an earlier draft of this model, I had used the word *love* rather than *caring*. I ended up choosing *caring* not because I felt *love* unmanly, but because I thought *caring* was a better description of the deeply rooted, mission-focused commitment I had in mind.

Yet, as I've thought about it, love does sum up what really matters. It is the best possible description of the instinct and driving power that motivate us at our best. No one expressed this better than Vince Lombardi, the legendary former coach of the champion American football team, the Green Bay Packers. Speaking to the American Management Association shortly before his death, Lombardi summed it up with great clarity: "I don't necessarily have to like my associates, but as a man I must love them. Love their loyalty; love their teamwork. Love respects the dignity of the individual. Heart power is the strength of a corporation."

Still, let's be frank. Even with Vince Lombardi's reputation buttressing its legitimacy, talking about love can sound mushy. What's more, it is a tough leadership lesson to teach, because love has to come from inside, from experience. How do you teach future leaders to love the people they work with without a transformational experience that creates love in their heart? We receive this gift in different ways. Some of us received it when we were in the military. Product Supply people in P&G often received it as young supervisors on the manufacturing line in a plant. When I was growing up in P&G, our sales people often received it in distant places, far removed from Cincinnati, getting together for lunches in diners, relying on one another to build our business

town-to-town and store-to-store. Today, many receive it in transformational learning experiences.

However, no matter our location or circumstances, I believe love will come to us if we are intimate with the business, with the consumer and with one another. It will come to us as a result of our growing and innate belief in the inherent quality and goodness of P&G people and our ability to achieve something great by working together.

> "I do not believe that any man can lead who does not act ... under the impulse of a profound sympathy with those whom he leads — a sympathy flowing from an insight which is of the heart rather than of the intellect."

> — Woodrow Wilson

This reminds me of a wonderful memoir written by Katharine Meyer Graham, former publisher of the *Washington Post*. Following her husband's tragic suicide, Graham assumed responsibility for the newspaper. She never expected to do that, and she described her initial feelings as "pretty much putting one foot in front of the other and shutting my eyes, and stepping off the edge." She was tentative and filled with worry. Then as she went along, she started to throw herself into it. As she wrote years later, "My initial Girl Scout-type of resolve was turning into a passionate interest. In short, I fell in love with my job. I fell in love with the paper. I fell in love with the people."

I identify with Katharine Graham's feelings every step of the way. It is the kind of passionate love she describes that generates personal mastery and leads to inspired leadership. It's how I feel about P&G and the colleagues I've worked with for so many years. With whatever other personal qualities they have, the outstanding women and men whom I've seen operating in Procter & Gamble (and every other great institution) have this characteristic in common: They are great at their jobs because they believe in them, they care about them — yes, they love them.

That's living based on caring and love. On a commitment to service. On a determination to lead and a resolve to grow. On the belief in the capability and commitment of one another. All of which brings me to reflect on what my memory brings back most clearly as I survey the years. Not so much an individual budget or strategy meeting. Oh, I can recall those. But the memories that run deepest are those of the conversations and debates, the get-togethers, the personal relationships through which ideas were revealed, respect was

displayed, admiration was evident, and ultimately, affection was nurtured among people sharing a common purpose and set of values, and a belief that in ways large and small we were making a difference in the world. What most illuminates these memories are the faces of my associates and the conviction, the determination and the spirit they expressed. I remember, too, the pride and often the wonder I felt in what they achieved, and in what we achieved together for those we serve.

In a real sense, it is caring and love that make P&G not just a great company or a great institution, but a *thriving* community. It is caring and love that make us want to delight consumers. It is caring and love that lead us to work with others to help them be all they can be. It is caring and love that lead us to want to be of service and at our personal best.

As I said at the outset, all the concepts I've discussed in this chapter flow together as one. Perhaps the best way to summarize the sentiment that motivated me to develop my own model for living, and with which I've written this chapter, comes from the writer John Gardner, whose writing I value highly. These words will resonate with me forever:

> *All the best that humans have said and done, all that leaves us with a sense of human dignity, comes from unrelenting effort by some part of the race. The future is shaped by people who believe in the future. It is built by people who see the complexities that lie ahead, but are not deterred; people who are conscious of the flaws in humankind, but not overwhelmed by the doubts and anxieties of life; people with the vitality to gamble on the future, even their lives, on ventures of unknown outcome. If they had all looked before they leaped, we would still be crouched in caves sketching animal pictures on the wall.*

What a joy and a privilege it has been for me to live in the company of women and men who strive mightily to serve, to lead and to grow ... to be the best they can be and to help others do the same.

A Personal Model for Living

Some Questions to Consider

1. How would you describe your personal mission?

2. Whom do you serve?

3. How does your commitment to serve cause you to act?

4. What do you feel most passionate about? Do you believe you express your true passion in your interactions with others?

5. What occasion(s) are you most proud of when you pursued truth as far as you could? What did you learn from this?

6. Is there any occasion when you wish you had pursued truth more fully? What did you learn from this?

7. What are the one or two acts of moral or physical courage that you have observed that have had the most influence on you? Why?

8. On what occasion(s) has your courage been most tested? What did you learn from this?

9. What one or two accomplishments drew most heavily on your willingness to persist? What did you learn from this?

10. What challenge do you face now that will call the most on your willingness to persist?

11. To what degree do you respect and trust your associates: those you work for, who work for you, and who work with you?

12. How is your productivity affected by the respect and trust in your relationships with others? Are there important opportunities for improvement? How will you seize these opportunities?

13. Do you have a passion for helping others grow and succeed? Do you translate your experience into teachable lessons others can learn from?

14. Are you sharing your respect for and trust in others in a way that informs and strengthens them?

Chapter 10
"A Family Affair"

"There is no way I could have had my career at Procter & Gamble or
have enjoyed life the way I have if it were not for my family."

— John Pepper

I will long remember my stay in Beijing, China. It was the week of October 22,
2000. I had been having one meeting after another with government officials
and visiting local stores and consumer homes. Sunday was a day of rest. I had
been invited to a gathering of P&G families at the home of Penny and Jeff
Boucher, a few miles outside of the city center. It was raining hard that day, but
when I entered the Bouchers' home, it was as if the sun had just come out.
Everything brightened. Parents were there with their children, ranging in age
from a few months to teens. The spirit of friendship and warmth that permeated
that room was unmistakable. These families had come from all over the world
to work in China to help create a great business. They were there on that rainy
afternoon to share friendships, to exchange ideas on how to best experience
what was uniquely available to them in China and, of course, to see their
children just have fun. Being there with that wonderful group of P&G employ-
ees, their spouses and their children made it even clearer to me that what we
are engaged in is, in a real sense, "a family affair."

My family is what most people would describe as "traditional," though I
reject the label. It sounds so boring, and it's been anything but that. My wife,
Francie, suspended her professional career to raise our four children, support a
myriad of community programs and work alongside me on countless activities
connected with Procter & Gamble. That's worked superbly for us. It's been
our choice and my blessing. Each of our families is different, of course. In
many, the husband and wife both work in full-time careers; in some, the wife
builds an outside career and the husband manages the home. Other choices
include whether to have children and, if so, how many; or whether to
remain single.

The relationships of our families to our work are also unique and a matter
of personal choice. Is it a close relationship? Is it a distant one? Few things are
more personal or individual.

Despite all that is unique about our individual families, we also share a remark-
ably common experience. My sentiment is no different from what I've heard
countless other P&G people say: *There is no way I could have had my career at
Procter & Gamble or have enjoyed life the way I have if it were not for my family.*

I've read many biographies of business leaders. The presence of these leaders' families usually amounts to little more than a few paragraphs; their role little more than incidental. Sometimes it seems as if you could remove the family without changing the person's life and career. Perhaps that would have been true for some of these leaders, perhaps not. What I *am* sure of, however, is that it would *not* have been true for me, and I don't believe it would have been true for most of the business and community leaders whom I have known. So it seems appropriate to say a few words here about P&G as a family affair.

There is no way that you can be in jobs as intense and active as ours and not have your immediate family members involved. For us, this involvement has often been significant, sometimes challenging, occasionally, even humorous (at least in hindsight!). But however I characterize it, my family has been steadily and deeply involved in my career.

My wife, Francie, loves to tell the story of our first child's birth. It was only two weeks before her due date, so we were both on alert to the beginning of labor pains. One night they began. As Francie tells it, she tried to wake me up to go to the hospital, but despite vigorous prodding for 10 minutes or so (hopefully she exaggerates, but probably not!), all I did was lie there half awake, babbling about Mr. Clean, one of the brands for which I was then responsible. It was evidently an important time in the "life" of Mr. Clean, but not nearly as important as Francie's bringing a new life into the world. The story ends happily! We got to the hospital in plenty of time; our first son, John, was born and I was there. In fact, I was in the delivery room for the arrival of each of our four children. No memory will last longer.

That first son, John, was only three years old when I took him on his first airplane trip and, sure enough, it was for a store check to see P&G brands. We boarded a Boeing 707, which was *the* modern aircraft then, and flew to Kansas City where our newest brand, Bounce fabric softener, was in test market. It was the dead of winter. The snow was piled 2-3 feet high. John was excited and so was I — he, about the airplane and snow, and I, about Bounce. This was the most important new brand with which I had been associated at that point in my life. We climbed into the rented car and started to navigate the snowy streets. After visiting the third store (early in my plan to cover about 15), I could tell John was starting to get a bit tired. We had just returned to the car when he looked up at me and said rather plaintively, "Dad, I think we've seen enough. We can go home now!" Needless to say, we didn't go home right away. But we didn't get to 15 stores, either!

You can't grow up in a Procter & Gamble household without acquiring what some would describe as an obsessive commitment to our brands. Francie recalls that when we were house-hunting during one of our moves to Europe,

I wouldn't seriously consider a home if I found that the owners weren't using Procter & Gamble products. Frankly, I find that hard to believe, even for me, but Francie is seldom wrong. There were also times, I have to acknowledge, when my children's close involvement in the business got their education off on the wrong foot. Francie tells me that in a spelling bee at school one of our boys got the word "soap," and he spelled it "I-V-O-R-Y."

My children remind me of the many products that I brought home for them to try, often in unmarked packages, sometimes with languages they did not understand. They recall, too, that as they grew up, they had to put up with my constantly asking their friends what brands of toothpaste or shampoo they used. I remind them that there was a positive side to this. If their friends weren't using P&G products, they often ended up with samples to try!

As a family, we did other things in pursuit of the business. One I'll always remember occurred when I was general manager in Italy in the mid-'70s. Colgate had just entered a regional test with a new laundry detergent, putting pressure on our most important category of business. One Saturday I decided to go to the test market on the Adriatic, about two hours by car from Rome, where we lived. Francie came with me. Our main stop was Pescara. In order to cover more stores, Francie and I split up the street: She took one side and I took the other. I must say, she learned more than I did, not the least reason being her vastly superior Italian and her thoroughly Italian mannerisms and expressive speaking.

Of course, the difference Francie made in my career, not to mention in my life, isn't described by her assistance on store checks. I expressed it plainly in my personal journal the day I assumed the responsibility as president of the Company on April 1, 1986:

> *My confidence in undertaking this enormous responsibility rests, importantly, as has my total career, on Francie. For we have approached life as a partnership and that has included Procter & Gamble. Whatever the strengths I bring to this great Company, they are all underpinned by Francie's common sense, courage and sense of what is right.*

In truth, if it weren't for Francie, I probably would not have even stayed at Procter & Gamble long enough to have made that diary entry. This story takes me back to the early-'70s. I had been with the Company for just under 10 years and found myself seriously considering leaving P&G to start up a new business. Fortunately, Francie was on the scene by then since we had married five years earlier. I explained what was on my mind. She told me that she would go wherever I wanted, but before making a decision, she wanted me to answer three questions. She explained with seeming (but I suspect pretended) innocence, that they had simply grown out of what I had told her

Francie and I on our back porch (circa 1984)

about Procter & Gamble over the years.

"Do you like what you're doing?" she asked.

"Yes," I replied, "most of the time, I love it." I acknowledged some frustrating moments, but they were the exception.

Next, she asked me if the people I was working for were telling me that I was doing well. I replied that they weren't saying a lot, but from what they *did* say, I sensed they thought I was doing all right. They were encouraging. At least no one was suggesting I should leave!

Finally, Francie posed this show stopper: "If you imagine doing as well in your career as you would hope to, is there any company where you would rather be working than Procter & Gamble?"

I thought for just a few seconds and then gave her my answer: "No."

She smiled and said, with a still seemingly open mind: "Then, what are we talking about?"

I stayed at P&G, of course. And since that moment, more than 30 years ago, I have never looked back. The reason has been the work, the people, the values, the excitement and the challenge — all those things that mark P&G as a very special place. Over the years, Francie has saved me from many missteps, as she decisively points out. (If I had listened to her more carefully, she would have saved me from several more.)

Francie and I found that certain events in life bring you together as a family. One is a long-distance relocation. You can't make a move like this, especially if it involves children, without an enormous amount of planning and considerable stress and challenge. Our family has made five international moves during my career. That's a small number compared to some. I know associates who have moved with their families 10 and 12 times. Scheduling movers, packing boxes, transporting pets (I can't forget taking five gerbils to Brussels), finding new schools, getting children enrolled, moving into a new home, coping with lost and broken furniture — these are just a few of the events (and

sometimes travails) that can be part of an evolving life and career. And Francie handled them all.

John, Douglas and David ready for school outside our house in Rome

Fortunately, in the great majority of cases, many positives come from this experience. You get closer as a family. You enjoy new experiences and discover things together. We certainly did. My children lived in Rome and Brussels for seven of their pre-teen years. To say they weren't outwardly enthusiastic at the time about this being a "good thing" would be an understatement. I can still recall making confident, hopeful comments to them along the lines of, "Isn't it great that we have this chance to live here in Italy?" or, " … in Belgium?" Their response was, at best, a neutral stare.

You can imagine my joy, then, when many years later two of my children told me that they had such fond memories of Italy that they wanted to return to spend one of their college semesters there. My oldest son, John, and his bride, Maggie Tiblier, even chose to be married in Positano, Italy. (And they were, in March 2003). It's amazing (and heartening) how sometimes the things we do as families stick when we don't even know they are happening in the first place.

P&G is a family affair in another way, too, and that lies in the enjoyment we take from getting together as families. It is remarkable how social gatherings with P&G families have formed such an important part of why so many of us feel so positively about P&G.

Pomezia plant picnic (Italy)

To this day, I can vividly recall a wonderful picnic Francie and our three young sons had in 1974 with the families of our Italian organization at our Pomezia plant just south of Rome. It was a pig roast with gunnysack races and

263

volleyball games. We got to know one another better. We had a good time together. We were a family.

I also remember a celebration dinner at our Port Ivory plant on Staten Island, New York, in 1977. I met three generations of one family that evening. All of them had worked or were working at P&G. They were very proud — and I was proud to be with them.

I will never forget my pleasure in attending the tenth anniversary of the founding of our Procter & Gamble operations in Russia and Eastern Europe. What a day it was — June 29, 2001. My journal notes capture how I felt:

We concluded our formal celebrations with several hours of P&G family time: watching skits and building friendships just outside Moscow. Russians, Ukrainians and Belorussians; ex-patriates from India, the UK, the U.S., France, Italy and other countries — all P&G people who contributed mightily to our growing success in Eastern Europe — came together to share friendship and to renew their commitment to growing even more, even faster, in the years ahead.

The value of this type of event and what it produces cannot be measured in financial terms, but it's large. It provides strength that we draw on in moments of challenge. It puts trust and confidence in the "emotional" bank account. P&G has had Dividend Days that have brought together families in our different locations for more than 100 years. They mean a lot. They are symbolic and substantive. The celebration provides the opportunity to come together and enjoy each other as families.

Tenth anniversary celebration of the founding of our Russian/Eastern European operations

I run a risk here. Celebrating the role of families in a company like P&G can risk denying the very real challenge of balancing work and family responsibilities. One of the questions I'm asked most often is how I feel I've done at striking this balance.

I always acknowledge that the answer I'll give is probably different from the one Francie might offer. In fact, she once had the opportunity to tell her side of the story, and it was a decidedly different perspective.

The incident occurred following a talk I gave at Brigham Young University. I was there to receive an award and Francie had come with me. About 400-500 students were in the auditorium. One student asked me about work-family balance. I knew I was on the spot! This was the first time I'd ever been asked that question with Francie present. I said I'd answer but first wanted to invite Francie to give her side of the story.

She was reluctant, but with the students prodding, she found her way to the podium. She began by saying she hoped to write a book of her own one day, which she planned to title "Trailing Spouse" (to which I jokingly added, "Unauthorized by the CEO"). She said that I'd been very encouraging about her plans, but she was anxious about writing it, because she feared the final manuscript would hurt my feelings. Then I asked her, in front of the students, why she felt that way. Her answer brought down the house: "Because *you* won't be in it!"

Thankfully, she went on to say that I *had* been a pretty good father. All things considered, I think the students came away with a reasonably balanced sense of the truth.

I do hope and believe that I've been able to balance work and life reasonably well, *because I believe in both and I've made choices.*

Most of my choices have been very easy. I stopped playing golf the day my first son was born. Rarely scoring below 90, even on an easy course, I wouldn't call *that* a major sacrifice. But it did save me five to six hours every Saturday. (I found running two miles a day a lot less time consuming, not to mention less frustrating.) I have not been one to go off for long weekends with a bunch of guys. I'm sure I've missed something in my life because of that, but it's a choice I made in order to be with my family and to be able to spend the time I needed to at work and on a few outside activities.

Joe Pichler, a good friend and former chairman of the Kroger Company, likes to tell a story about a discussion he and his wife, Francie and I, and several other couples were having, when someone asked me the question: "Where is your favorite place to be in the world?" I thought for just a few seconds and answered, "Wherever Francie and my children are." It's true. I don't care where it is. Wherever they are, that is where I most want to be.

Still, in raising our family, Francie did so many things that I was not able to do. Without her, our children would not be who they are today. I refer not only to attending events like parent-teacher conferences and swim meets, but more importantly to the conversations she had with them, which I wasn't there to have, and perhaps may not have had the insight to have. Still, there is one terribly important point I want to make based on my own experience, as well

as the lives of countless other extraordinarily busy people whom I have known. There is no reason you can't have a demanding career and still have the joy of seeing your children grow up and be your very best friends — if you're focused and believe it can be done.

Carol Tuthill, a marvelously talented senior Human Resource leader, summed it up very simply several years ago. She was asked how women who are married and have children and also have a major job at Procter & Gamble are able to carry out their myriad responsibilities. "Can they do it?" Her reply, "If you really believe it's important, you'll do it." I have found that to be true. I believe that the most important responsibilities I have in life are to my family and to my business. I have tried to take them in that order.

I've seen this in one family after another in Procter & Gamble, probably none more compellingly than Bob Wehling's. Bob had a distinguished 39-year career at P&G, completing it as P&G's Global Marketing and External Relations officer. We had a retirement celebration for Bob on August 9, 2001. Many of us offered testimonials to Bob's contributions. But the highlight of the evening didn't come from a P&G employee. It came from Bob's daughter Karen as she reflected on the acts of caring that Bob had brought (and continues to bring) to his family. She recounted how he had spent one day every year at school in the classroom of each of his six daughters to understand "how they live." He continues to do that today for his grandchildren. She described how every year their father would personalize a note to each of his children, reviewing the events of the year, and place it on the Christmas tree.

According to Bob Wehling, family comes first

Karen talked about Bob's ever-present lectures: "Finish in four years or else"; "always look at the glass half full." There was no mistaking that, for Bob, family came first.

But there's no mistaking something else, too. Getting the right work-life balance is more challenging today than ever. Many reasons account for this. Our global reach means you can be on the phone doing business somewhere literally any time of the day or night. Global time zones stretch people. For example, we have to be mindful of what it means to our colleagues in Asia when we schedule videoconferences in North America during the day. Just add 12-plus hours and think of the impact on family life. And, wherever we are, the ever-present e-mails and cell phones are. At times, they simply need to be shut off or family and personal life suffer.

Why, you might ask, am I taking the time to highlight the importance of our understanding (and acknowledging) the role of our families in our lives — especially since this is so self-evident? Why have I devoted a chapter to this subject in what has already become a long book? Because I want to help ensure that, as a company and a community of P&G people, we continue working hard to make healthy families a part of the P&G culture.

Having reached the age of 66, after a career of almost 40 years, and with children now at the ages of 35, 33, 31 and 27, I can look back and tell you without equivocation that family really does come first. Surely you expected that statement. And I wouldn't be making it if that's all I had to say. Even if briefly, I want to reflect on what I might have done better in recognizing this reality. I do this with the hope that some of you may find it helpful. I do it by raising a few questions that I have sometimes asked myself — not always with the answer I'd like.

- *Am I listening to my spouse and to my children with the intensity that I bring to my conversations with those at work, when I'm at my best?* Coming home, often tired and, perhaps, frustrated, have I avoided the pitfall of "turning off"? Have I shown the respect that open listening and honest conversation can provide?

- *Am I showing the respect for my spouse and family that flows from keeping my commitments,* including the small ones like arriving at home for dinner when I said I would? Or when I'm going to be late, do I phone ahead to let the family know?

- *Am I taking too much for granted? Do I appreciate the life I'm living through the eyes of the members of my family?* It's inevitable that familiarity can lead us to take things for granted. That's been true in my life. You can handle this to a degree in a marriage or in any mature relationship. You don't expect perfection. You make allowances because of the underlying affection and respect that have been built up over the years. They allow some departures from the ideal, but it can go too far. We can take too much from the emotional bank account and not put enough back in.

As with anything, it comes back to our choices, our decisions and, above all, our actions. What do they say about how we really feel?

An action I will never forget is one which A.G. Lafley took the very day I had told him he was being named CEO. At the beginning of that day, he had

no idea I'd be asking him to assume this position. Still, as we met in my office that afternoon, A.G. told me there was one scheduled event he could not change: dinner that night with his wife, Margaret, to celebrate their 25th wedding anniversary. Nothing was going to get in the way of that. His decision spoke volumes. It told me and, much more importantly, I'm sure, it told Margaret how he really felt.

Nothing was going to get in the way of Margaret and A.G. Lafley celebrating their 25th wedding anniversary

The second reason I have devoted a chapter to this subject relates to the Company's policies and practices. I want to help ensure that our policies will continue to recognize and respect the importance of our families to our lives: certainly by sustaining the benefit programs that allow families to be secure in what matters most to their peace of mind — health care, life insurance and sound retirement plans. But it goes beyond that.

Understanding the importance of families in our lives also leads us to provide as much advance notice as possible when we ask a family to move, and it leads us to take every step to make that move as hassle-free as possible. It leads us to invite spouses to visit the location where we have asked them to move, so they can learn about the new location. It also leads us to provide appropriate resources to support the careers and lives of spouses. There are many examples of our doing this. When possible, we make child care available close to P&G facilities. Several years ago, we created a Jobs Bank Program in Cincinnati that brings together many companies who pool open-job positions and work to match them with spouses of P&G employees. In one way or the other, we try to do the same thing in other locations.

While it's a matter of individual choice, many spouses and partners will want to be involved with the P&G life of their partner. We should look for opportunities to do this not only socially, but, to the extent spouses choose, on a business level. At our two most recent annual management meetings, A.G. Lafley did a wonderful thing by inviting spouses and partners to attend. This was appreciated greatly by all who came, and it's not surprising — as families, most of us are "in this together."

Finally, it is important that we help enable families to network together. To be sure, families will do much of this networking on their own. The wonderful afternoon that I spent in Beijing, which I recalled at the beginning of this chapter, exemplifies this. But we should look attentively to networking that the Company can help initiate and support.

We live in a very competitive world. Every cost must be scrutinized. We must not ask the consumer to pay for things that are not justified. Still, we must not be penny-wise and pound-foolish. No matter the pressures that exist, we must never forget that the success of Procter & Gamble, indeed its fiber, rests in an important way on our strength — not just as *individuals*, but as *families*. As Rick Betsch, an associate director in Customer Business Development, wrote me on my retirement in July 2002:

> *Your leadership has assured our Company continued success not only as a global leader in its industry, but also as a "family" company. Every day I come in to work feeling confident that P&G has the best interest of its employees, their families and community in mind when making its daily decisions.*

This is a belief that we must sustain through our personal actions and our corporate policies, day after day, year after year.

We must deliberately take the time and make the investments to nurture Procter & Gamble as a family affair.

Chapter 11
A Company Built to Last

"We shall not cease from exploration, and the end of all our exploring
will be to arrive where we started and know the place for the first time."

— T. S. Eliot

"Such as we were we gave ourselves outright."

— Robert Frost

It was the week of July 1, 2002, my last week as an active employee with the Company. I was on my way to Russia. There were a lot of places I could have been that week, but there was no place in all of Procter & Gamble where I would rather have been than Russia. Why? Because over the course of more than a decade, my experience in this country had brought to life — perhaps more than any other single experience — what I've learned matters most to our success. I learned that serving consumers lies at the foundation of our success. I learned that we need to be open to major and often unexpected change, even as we remain faithful to our core Purpose and Values. I learned, irrefutably, the value of the individual and the depth of commitment P&G people bring to our business.

Imagine how impossible it would have seemed to me when I joined the Company (not long after chasing Russian submarines around the North Atlantic) that I would have the opportunity to work with so many wonderful people building a business in a part of the world that was unreachable, isolated behind the Iron Curtain. And yet, during this first week of July, I found myself celebrating heroic achievements that I knew would have an impact on generations of Russian people, and Procter & Gamble's global success.

As I began the trip, I recalled how we had been warned in 1990 that we shouldn't even think about entering Russia for years, perhaps decades. We didn't agree. We believed the country would develop into a place where we could do business; we didn't wait. And thanks to the men and women I was about to spend time with, our decision 12 years earlier had proven to be right.

I started my visit in St. Petersburg where I addressed the graduating class of St. Petersburg University's School of Management. Nine years earlier, I had addressed the first class at this newly formed school. Only 35 students were in

271

that class. Now, thanks in part to P&G's support, the school has more than 1,500 students.

I next went to P&G's plant in Novomoskovsk near Tula. I recalled our earlier need to reduce employment from 3,000 to 700 people if we were to survive. I shared the satisfaction that we did it the right way, by placing people into new careers insofar as humanly possible. Here I was visiting a plant which, in the space of just a few years, had moved from being one of the highest-cost to one of the lowest-cost operations in the entire P&G world. Here I was able to proudly announce that Novomoskovsk had achieved the longest record of accident-free operations in the entire history of Procter & Gamble.

I then went on to Moscow to participate in the annual review of the business and a year-end celebration with employees from Russia, Ukraine and Belarus. The celebration was an emotional experience for us all. I stood before the men and women who had bravely gone out a decade earlier to create P&G businesses from Minsk and Kiev in the West, to Novosibirsk and Vladivostok in the East. I was filled with pride as I explained how they had demonstrated what we have seen again and again in Procter & Gamble: Our success depends on the courage and initiative of the individuals who make it go ... from the technician in the plant, to our representative in Irkutsk, to the marketing director in Moscow. I recalled some of the many events that had brought this truth to life:

- The development of our relationship with the Russian Dental Association and its director, Dr. Leontiev, which enabled us to offer oral care educational programs that dramatically reduced tooth decay for children in schools throughout Russia. It also helped our Blend-a-Med dentifrice brand achieve market leadership, demonstrating that we do, indeed, receive good by doing good.

- The contentious decision to introduce Fairy Dishwashing Liquid. Doing this made no sense to a lot of people outside of Russia, but it made sense to our people in Russia. Thank heaven they stood by what they believed in, and that we listened to them. Fairy is far and away the leader today.

- The devastating ruble devaluation in fall 1998 and how our people courageously and effectively reacted to it as they have done so often to overcome economic crises.

I recalled, too, how our experience in Russia had reaffirmed the reality I expressed in the Preface: the different elements of doing what really matters reinforce one another in significant and unpredictable ways — often to great advantage.

- Our sensitive handling of the need to significantly reduce employment at our plant in Novomoskovsk helped fuel the loyalty of those employees who today have made this one of the highest-quality, cost-efficient plants in the P&G world.[1]

- Our work in helping create a leading Business School in St. Petersburg University provided access to many graduates who have helped make P&G Russia the Company it has become.

- Our respect for diversity helped us bring together the men and women of our Russian, Ukrainian and Belorussian organizations in a unit that gained strength from shared knowledge and its scale without losing the appreciation of what should be tailored for each population.

The thrill and satisfaction I felt at being in Russia on that July afternoon had another dimension. It was my belief that P&G had been able to play a part in creating something that could make a major difference to individual women, men and children — to society — not for a year or two, but for generations to come. This, I suspect, was no different from what the founders of Procter & Gamble felt as they created P&G's business in the 19th century. Nor was it any different from what P&G men and women felt as they created P&G's businesses in Western Europe after World War II, or made their way into Latin America, Japan, China and other countries of Asia. No different from how they felt in developing new brands and new businesses.

In all these cases, P&G people were working to create the foundations for healthy, long-term growth. Just as then, we had stayed close to consumers and customers. We had recruited outstanding people. We had built leadership brands. We had confronted difficult challenges with the determination to do what was right for the long term. We had supported the community. We had done what really matters.

My remembering this experience of building a business in Russia led me to reflect on my entire career at P&G. It's been almost 40 years — easy to say, but hard to believe, because it's gone by so quickly. It's been an adventure, a challenge, a learning experience, and an inspiration right up to this very day. Confucius said, "Choose a job you love and you will never have to work a day in your life." That's the way I felt, virtually every moment, from start to finish.

[1] Just as this book was nearing completion, I received an unforgettable letter from Giancarlo Iannelli, the manager of P&G's plant in Novomoskovsk, Russia. As noted, from its challenging and difficult beginnings, it has become one of our highest-quality, lowest-cost manufacturing plants in the world. But these facts don't begin to reveal the spirit of the leadership that produced this success and the remarkable difference this success has made in people's lives. Giancarlo's eloquent description of his experience in working with the men and women at Novomoskovsk brings these realities alive. Read it for yourself in Appendix IV.

How could I have imagined on that day I got off the train in Cincinnati in the fall of 1963 that I would:

- Be joining a company committed to a purpose and set of values worthy of (indeed demanding) a lifetime of my best effort?

- See a company with sales of little more than one billion dollars the year I joined it grow to sales approaching $50 billion the year I left?

- Gain a sense of responsibility from listening to a mother in a tiny, two-room apartment in one of the poorest sections of Bombay, India, describe how Vicks VapoRub was helping her sick baby breathe more comfortably?

- Experience the thrill of seeing Procter & Gamble scientists and technicians overcome tough technical challenges to develop revolutionary new products that really do improve — and in many cases save — the lives of women, men and children all around the world?

There was, of course, no way I could have imagined any of these developments.

I'm often asked if, in retrospect, I would have done some things differently. The answer is "Absolutely, there are many." And I've tried to identify the most important ones in this book.

I wish I had brought more informed and realistic judgment to some issues; I wish I had made more decisive choices and followed my deepest instincts more faithfully on others. Aside from this, however, I would do much the same.

Going right back to the beginning, I would again throw myself into my job at P&G as if I were sure it would be the only job I'd ever have — which, contrary to every expectation I had at the time, it turned out to be. I've found that the only way you can learn if you really love something is to immerse yourself in it fully, no holds barred.

I'd try to appreciate even earlier how talented and effective people can be in their individuality and in their diversity.

I'd continue to go for the big wins that will make a big difference for generations — like aggressively entering Eastern and Central Europe and launching our largest categories into China early.

I'd stay close to our employees at every level of the organization.

I'd do my best to make decisions based on principle, trying to determine what is right for the long-term health of Procter & Gamble as an institution

and as a community. To that end, I would maintain a habit I adopted in recent years as I faced the toughest decisions. I'd ask myself, "What would the individuals whose principles and judgment I most admire decide in this situation?" I have a picture of William Cooper Procter in my office. I've looked at it often in recent years as I pondered a tough decision, and asked myself, What would *he* have done?

As I reflect on all these things, one constant shines through: the people I've worked with and how they have lived by their values. As I recorded in my journal in January 1985, soon after returning from Europe to run the business in the United States, "I just love the people of this Company — they are so good — capable of so much; so committed." This is what I was least able to imagine when I joined P&G 40 years ago: the quality of P&G people and the inspiration they have provided me by what they've done and how they've done it. That, more than anything, is why my final trip for P&G to Russia meant so much to me.

As I reflect on that emotional moment in Russia and recall all I've experienced in my years as a P&G employee, I recognize how fortunate I have been. Fortunate in the people I've known and the achievements I've been privileged to witness and participate in, none more so than those I've experienced over the past several years.

As I conclude this book in spring 2005, P&G is successfully navigating through a period of perhaps the greatest organizational change and learning in our history. Our Purpose, Values and Principles are intact and our business is healthy and growing, thanks to the strong leadership of CEO A.G. Lafley, his top leadership team and more than 100,000 committed men and women. This performance was recognized, as it often has been in our past, by a recent poll reported by *Fortune* magazine that voted P&G one of the Global Top 10 Most-Admired Companies.

We have learned, and relearned, a lot during the past three years. We have relearned that, as A.G. Lafley so aptly puts it, the "consumer is boss." We have relearned that "value is king" and that we need to "price right or forget it."

We have been reminded of the irreplaceable role of strategic focus, operational discipline and unrelenting concentration on the fundamentals, including cost control and superb execution.

We have reaffirmed the need to set realistic *external* goals and beat them *internally*. Consistency is vital.

Finally, we have been reminded that times change, but values don't. P&G people remain the foundation of our success — their values and capability, their confidence and motivation, and their relationships with one another.

At its heart, our business is a simple business. It is changing faster than ever and we need to lead that change. But through it all, we should never forget that this business is about understanding consumers ... knowing their current needs and being able to anticipate their emerging needs. It's about meeting those needs better than competition through the performance and value of our brands. It's about being cost-competitive and having superior relationships with our customers, stakeholders and other partners — all to the end of delighting consumers and achieving leadership results. It's about being a respected corporate citizen, as well.

It may be human nature, but we have a tendency to let the pendulum swing too far from one side to another. Sometimes that leads us away from the basic objectives of our business. At a given moment, we can become too thorough (and bureaucratic) and, as a result, we end up being too slow. So in a fitful reaction, we tell the organization we want to go fast, and believe me, with the kind of people P&G has, they go fast. But if in doing this we lose the discipline needed to ensure a high success rate on our initiatives, we will fail. The answer to this all-too-human tendency is to remember why we're here and what we're about. It is to remember what our *end goals* are and not let intermediary *means* become ends in themselves.

We must lead change in order to grow, indeed even to survive, but it must be change in the name of fulfilling our Purpose, and it must be change in line with our Values. In *Good to Great*, Jim Collins cites a salient observation from Robert Burgelman, professor at the Stanford Business School: "The single, biggest danger in business and life other than outright failure is to be successful without being resolutely clear about why you were successful in the first place." Without that knowledge and conviction, registered to the point of being a deep commitment, purposeful change and renewal are unlikely.

Time doesn't stand still and it never will. While knowledge of the past and commitment to our Purpose help protect us from diversionary fads, we must avoid any reluctance to change. Change is needed to fulfill our Purpose. History walks on a knife edge. We determine which way it falls. All of the critical decisions that have made Procter & Gamble what it is today involved a significant element of change and the decision could easily have gone another way.

Sometimes we know we're at a "moment of truth" when we realize we need to change the rules or we will probably fail. But sometimes we don't know it. How large will our Pharmaceutical business be? Will loyalty remain a powerfully distinctive trait of P&G people? None of these questions has a foreordained answer. They will all be answered by the wisdom, imagination and perseverance of P&G people: by our strategies, by the quality of our execution, and by the community we build together.

Challenges P&G Faces

We face, as has every generation, the important challenges of the future.

1. Developing and marketing leadership brands that can win the loyalty of consumers who earn as much as $1,000 per day and as little as $1 per day. We need to do both in order to be the worldwide leaders in our core categories, and fulfill our Purpose of improving the lives of not just the wealthiest, but the great majority of the world's consumers.

2. Creating preferred, business-building relationships with a relatively smaller number of rapidly growing customers, who at the same time are competing with their own brands.

3. Continuing to innovate to improve our productivity and cost effectiveness while also becoming more innovative in building new businesses.

4. Achieving the right balance between standardizing what should be standard and localizing what should be local.

5. Avoiding the pitfall of bureaucracy as we grow larger, and the pitfall of complacency as we succeed.

6. Achieving the right measure of focus and discipline in our operations without giving up the creativity and experimentation needed for progress.

7. Continuing to recruit and retain the strongest, most diverse group of men and women entering business anywhere in the world.

8. Continuing to nurture that sense of personal ownership, trust and loyalty that has always represented the backbone of our success when loyalty to institutions, in general, has declined. Put simply, providing the wise and inspirational leadership that leads to (and justifies) P&G people devoting their minds and their hearts to our Company.

I hope the preceding chapters have helped address some of these challenges. In addition, I offer the following convictions:

- *We will become increasingly global in our business and more diverse in our employees and consumers.* Today, 65 percent of P&G's sales and more than that of our profit come from just five countries, which account for less than 20 percent of the world's population. It appears virtually certain that the so-called developing nations of the world — countries that today account for the great majority of the world's population, yet less than 25 percent of P&G's sales — will grow at least twice as fast as developed markets during the coming 50 years. As a result, I expect they will come to account for considerably more than half our business. For this to happen, we will need to be extraordinarily effective in creating technologies and business models that respond to the much lower incomes of consumers in the developing parts of the world. In particular, we will need to win big in China and India. They, alone, account for almost 40 percent of the world's population.

- *We will need to create and acquire new businesses in order to meet our growth objectives.* In 1963 when I joined the Company, we weren't yet in Snacks, Pharmaceuticals, Diapers, Feminine Protection, or Tissue/Towel, and we were barely in Health & Beauty Care. What a change! Today, our Health & Beauty Care business represents close to half of the Company's sales and profits. About 30 percent of our current total sales are accounted for by brands acquired or introduced just since 1985. In the end, our success in creating new brands and entering new businesses has been based on one thing above all others: bringing new benefits and superior value to consumers. This will continue to be true in the future.

- *As P&G keeps on growing, we will need to overcome the natural tendency of greater size to lead to bureaucracy.* Forty years ago, our sales were just over $1 billion per year. They now exceed $50 billion. Then, we had about 35,000 employees. Today, we have more than 100,000. A growth rate of 5 percent per year would see us reach annual sales of $100 billion per year by 2020. As we grow, we'll need to continue to redesign our organization to provide intimate contact with consumers and customers, superior innovation and cost competitiveness, and an intense feeling of personal ownership, accountability and teamwork.

- *Finally, and we can be certain of this, our success will continue to rest, above all, on the quality of P&G people:* their capability, commitment, sense of ownership and character. The only way I could imagine Procter & Gamble ever failing is if we were somehow to lose our way in being able to recruit and retain the finest men and women entering businesses anywhere in the world. And that would only happen

if, for some reason, we lost our will to perpetuate and live by our Values and Principles.

These are general points, and that's the way it needs to be. P&G's own history tells us we can never fully anticipate the specific challenges and opportunities that await us. Our plans must make room for the provisional: the new insight, the discovery, the opportunities observed and driven by inspired individuals, who are committed to learn and determined to win.

Realizing that we cannot design specific action plans for a future we cannot foretell makes it especially important that we foster the recruitment and growth of the kinds of men and women who can cope with the future as it unfolds. The Company needs individuals who can aggressively and imaginatively adapt to new realities and challenges as they emerge without foregoing the continuities in our long-standing Purpose, Values and Principles.

As I have said many times throughout this book, in the end it will be our Purpose, our Values and our Principles that will guide the ongoing renewal needed to succeed in our competitive and rapidly changing world. They will allow our organization to maintain its identity, even as we change its form. They will allow us to work freely and imaginatively, taking action in a manner that fits the situation and the moment, without losing our way toward our ultimate goals.

I don't want this to sound too simplistic. We must constantly be engaged in generating new knowledge and ideas. We will be confronted with new realities arising from changes in consumer desires, competitive capabilities and intentions, and changes in the underlying economic, technological, political and social context in which we operate. Thus, while we must have consensus on our core values and a shared sense of direction, we must be ready to revise yesterday's strategies and plans on the basis of new knowledge in order to address the ever-changing circumstances we live in.

We must beware of being overly simplistic in another sense, as well. It will never be easy to hold the right balance between

- The focus on doing what is right for the long term and hitting short-term targets.
- The strategic choices needed to have any chance of success, and the open-minded exploration of new ideas so essential to coming up with the next breakthroughs.
- The standardization needed to quickly and efficiently expand what works and the responsiveness to local needs so vital to winning in our major countries.
- Spirited individualism and selfless teamwork.

However, to say it's not an easy matter is not to say it can't be done, especially when we've done it before. This was never clearer to me than on that Russian summer day in July 2002 as I joined my colleagues to celebrate the success they had achieved in the midst of great challenge while creating the foundation for continued growth.

Procter & Gamble is not at its best every day, but when we're good, we are very good. Our history is a mixture of noble ideals never completely fulfilled, but always sought; and when lost track of for whatever reason, they are pursued again with renewed vigor. This heritage is tailor-made for the volatile world we live in today. Our respect for it, and our proven ability to act on it from one generation to another, is the foundation for my confidence in P&G's future.

I conclude by drawing from one of my favorite texts of the Talmud: *"You are not required to complete the work, but neither are you free to desist from it."*

In that spirit, I offer this thought: While we won't build a *perfect* world, we can build a *better* one. Little did I know when I joined Procter & Gamble what a wonderful opportunity awaited me to do just that. The opportunities that await you are much greater still:

- To build our business by serving the billions of consumers who cannot afford our brands.
- To create new brands that will dramatically improve the health and hygiene of people around the world.
- To be part of a diverse, global organization in daily contact with associates around the world.
- To work with our customers in new ways to improve their businesses as well as our own.
- To contribute to the financial well-being of our owners (our shareholders).
- To contribute to the healthy development of communities and, in some cases, countries around the world.

It would be hard for me to imagine a more exciting and important set of opportunities. I'd love to be able to turn back the clock and pursue them afresh. But my not being able to do this causes me no worry. I am confident of P&G's ability to take advantage of these opportunities as we continue into this new century. The challenges will always be present. But just as we've overcome them in the past ... just as we have fought for leadership, acknowledging our mistakes and working mightily to set them right ... I'm confident we'll do that in the future. I have this confidence because I know the people of this Company. I know A.G. Lafley and our senior leadership team. I know thousands more. I know that the characteristics of intelligence, character and

determination to win that have marked the people of this Company from the day I joined it are alive and well today.

We, the men and women of Procter & Gamble, know *what really matters.* This is why I believe P&G as an institution, a community is truly built to last — generation after generation — forever.

A.G. Lafley

P&G has had the good fortune throughout its history to have the right CEO for the times. Never could this have been truer than with A.G. Lafley's appointment as CEO in June 2000.

A.G. brought to this position the precise combination of talents, instincts and character that was needed. Insightful, imaginative and decisive in his strategic choices. Focused and unrelenting in delivering executional excellence. Inspirational, visionary and demanding in his leadership. A believer in the possibilities of people. Someone who is open to the ideas of others, yet firm and confident in his own judgment. A leader committed to the Purpose, Values and Principles of Procter & Gamble while enthusiastically (and happily) pursuing the constructive change needed to keep P&G successful and growing.

Business Week summed it up well in its January 12, 2004, edition, "Alan G. 'A.G.' Lafley has restored Procter & Gamble as the premiere global consumer-goods company."

People sometimes ask me, "Do you worry about anything?"

My answer is that, of course, like anyone, there are things I worry about. But one thing I don't worry about is Procter & Gamble's future. A major reason is I know A.G. Lafley is leading it.

Acknowledgements

So many people have contributed to this book, it would be impossible for me to express my gratitude to them all.

Denise Andrews, Steve Bishop, Robert Dixon, Gina Drosos, Werner Geissler, Paul Hart, Deb Henretta, Colleen Jay, Mark Ketchum, Sam Kim, Hartwig Langer, Bob McDonald, Jorge Mesquita, Jorge Montoya, Tom Muccio, Laurent Philippe, Daniela Riccardi, and Shannan Stevenson are among the many who provided insight on the history and lessons I've developed.

A special thanks to Craig Wynett, Wolfgang Berndt, Diana Shaheen and Diane Dietz (and virtually her entire Crest team). They offered me extensive thoughts and unflagging encouragement on the manuscript, not once, but many times.

Doug Price and his team assisted me in corralling key facts, as they have done for years on so much else.

Ed Rider, who has ably led the P&G Archives for decades, and his staff were of great help in providing visual material for the book.

John Smale and Ed Artzt read portions of the manuscript, broadening my perspective in many areas. No reader will miss the enormous impact they have had on my career.

I owe a special debt to Lisa Popyk. A gifted writer, she gave me encouragement and insightful and significant suggestions on the structure, substance and language of every chapter of the book.

My wife, Francie, and each of my children read parts of the manuscript. It is the better for that, especially (as you might expect!) in its clarity and candor.

My thanks to Howard Wells, my early editor, who helped me develop this book from its original form. He was patient with a process that I'm sure went longer than he anticipated. Howard was direct when he should have been, suggestive at other times and, throughout it all, tolerant of a writer who has a notorious tendency to find "one more thing" he wants to say.

Greg Icenhower has been of extraordinary help in finalizing this book. He sharpened my focus and strengthened the clarity of my writing. Greg has worked with me in preparing talks and articles for more than a decade, invariably helping me to express myself more cogently and crisply. He did it again here. This book is far better because of his input.

Charlotte Otto reviewed the manuscript in its entirety as it neared completion. I benefitted greatly from her ideas.

Jane Goedl did the final editing with great care, thoughtfulness and ability. She brought important improvements to every part of the manuscript.

Andy Ruttle and David Hess at RDG handled the design and production of the book with expertise and patience. They've been a pleasure to work with.

This book wouldn't be here at all if it weren't for my wonderful assistants, Judy Floyd, Kate Glazier and, before them, Sue Schoenberger (now retired). They prepared and corrected so many versions of this manuscript, we long ago gave up counting. This was all very much in line with my well-developed habit of making that "one last change." They did this with their unrelenting positive spirit and great competence. They encouraged me every step along the way and made it fun. That came as no surprise. They do that every day we are together!

With all these credits sincerely offered, I'll repeat what any author always properly says: Any errors of fact or incidences of unclear expression are my responsibility.

This is the first book I've written. It's been a challenge but, even more, it's been a joy — importantly, because it has allowed me to savor not only the principles that have guided Procter & Gamble, but their expression in the personal actions and accomplishments of men and women I greatly admire. It's been a joy, too, because of the continuing contact it has offered me with the many people who have helped me develop this book. Some of you are noted above. There are many others. To all of you, I say, "Thank you."

Sources & Selected Bibliography

My purpose here is to identify the key sources on which I've drawn in writing this book. I have particularly focused on those books that have most influenced me and that I believe the reader might enjoy and benefit from reading.

General Sources

I've drawn heavily on a personal journal I've kept since 1980. It has helped me recall key events and activities in which I was involved and my reaction to them at the time. It has helped me remember the many people from whom I learned so much and those speeches and books that influenced me most.

I have also drawn on P&G archival material, particularly talks given by the CEOs and other leaders of the Company prior to my joining it. Especially rich have been the talks of William Cooper Procter, Richard R. Deupree and Walter (Jake) Lingle.

Selected Bibliography

Procter & Gamble — CEO Memoirs and Talks

The Letters of William Cooper Procter with Commentary by A.C. Denison. A wonderfully candid selection of letters from William Cooper Procter starting in 1907 (when Cooper was 45) almost to his death in 1934. Written to his niece, Mary Elizabeth Johnston. Thoughtful, open commentary on business, politics and life in general. Reveals the deep moral convictions of this great leader.

The following four books contain selected talks and statements by the four CEOs who led the company during most of my career. The selections cover a wide range of subjects, including business, world affairs, the role of the Company in the community, and leadership.

Howard Morgens of Procter & Gamble (Privately Printed, 1977).

E. G. Harness Speaks to Procter & Gamble Management (Privately Printed, 1984).

John G. Smale: With All That's In Me, (Privately Printed, 1990).

A Company of Individuals: The Addresses of Edwin L. Artzt (Privately Printed, 1995).

Other Books

Argyris, Chris. *Flawed Advice and the Management Trap* (Oxford University Press, 2000) and *Knowledge for Action: A Guide to Overcoming Barriers to Organizational Change* (Jossey-Bass, 1993). Coherent and compelling illustrations of the dynamics that can lead to productive (and unproductive) conversation and dialogue within an organization. Argyris uses live case studies to illustrate his points. An important mentor of Roger Martin's, who has also been an influential instructor to many of us at Procter & Gamble. See Martin's book (below), *The Responsibility Virus.*

Augustine, Norman R. *Augustine's Travels* (AMACOM, 1998). There is no finer book addressing the principles of effective leadership and business practices than this one. Practical, experience-based advice. A joy to read. Norm was chairman and CEO of Martin Marietta and later Lockheed Martin and has been a long-term (and highly valued) member of P&G's board of directors.

Bartlett, Christopher A. and Ghoshal, Sumantra. *Managing Across Borders: The Transnational Solution* (Harvard Business School Press, 1998). I regard Bartlett and Ghoshal as leading thinkers in terms of organizational design for a company like Procter & Gamble. Bartlett has been a close student of the evolution of Procter & Gamble's design and has contributed to our own understanding of the direction we should pursue.

Bower, Marvin. *The Will to Manage* (McGraw-Hill, 1966). This is the first serious business book I ever read. Authored in 1966 by the then-managing director of McKinsey & Co. Inc., it remains a straightforward exposition of the importance of sound company values and decision making based on facts, strategy and competitive urgency. This book stands as testimony to the truth that if we practice — really well — what a few of the best writers preach, success will be ours.

Brown, Shona L. and Eisenhardt, Kathleen M. *Competing on the Edge* (Harvard Business School Press, 1998). This book proved helpful to us at P&G in understanding the different pace and character of innovation that we need to succeed in our different businesses.

Burnett, Leo. *Communications of an Advertising Man* (Privately Printed, 1961). While written over 40 years ago, for my money, this book still stands as the most plainspoken and wise collection of writings you'll find on what makes for effective advertising and company-agency relationships.

Cohen, Don and Prusak, Laurence. *In Good Company* (Harvard Business School Press, 2001). A thoughtful study of the benefits and means of achieving a strong sense of community in an organization like Procter & Gamble. It provides important insight into the value of trust and the importance of having space and time to connect.

Cohen, Eliot A. *Supreme Command* (Free Press, 2002). An excellent book on leadership, specifically examining the relationship between military and civilian leadership, but really pertinent to all kinds of leadership. Examines the lives of Lincoln, Clemenceau, Ben-Gurion and Churchill. Develops compelling insights into the strengths and weaknesses of their leadership approaches.

Collins, James C. and Porras, Jerry I. *Built to Last* (HarperBusiness, 1994). The single finest book I have ever read in outlining the characteristics of companies that have stood the test of time. While it was written in 1994, it remains a standard.

Collins, Jim (James C.). *Good to Great* (HarperBusiness, 2001). Follow-up volume by one of the authors of *Built to Last*, this book surveys the characteristics of those companies that advanced from "good to great" and how they did it. It provides new insights into the characteristics of the leaders who made this happen. Best read following *Built to Last*.

Covey, Stephen R. *The Seven Habits of Highly Effective People* (Simon & Schuster, 1989). This book had an enormous effect on me when I first read it in 1989. My experience since then has done nothing but corroborate the correctness of its principles.

DePree, Max. *Leadership Is an Art* (Michigan State University Press, 1987). A short, but thoughtful, volume on the subject perfectly described by its title. It brings to life the concept of servant leadership in very practical, experience-based and principled terms. As wise as it is plainspoken in its language.

Drucker, Peter F. *The Effective Executive* (Harper & Row, 1967); *Management Challenges for the 21st Century* (HarperBusiness, 1999); and *Managing for Results* (Harper & Row, 1964). The master of leadership and management principles. I continue to find Drucker's earlier books to be extremely on point.

Friedman, Thomas L. *From Beirut to Jerusalem* (Farrar, Straus, Giroux, 1989) and *Longitudes and Attitudes* (Farrar, Straus, Giroux, 2002). Friedman is a leading columnist for The New York Times. While neither of these books takes business as its primary subject, they both deal with world events that remain with us and that will impact all we do, including business. They also provide fascinating perspective on the dynamics of individual leadership and decision making. These are two of the many books I have read that, while not directed to business principles per se, have provided me with important perspective that I have been able to relate to business.

Gardner, John W. *Excellence* (Norton, 1984); *Morale* (Norton, 1978); *On Leadership* (Free Press, 1990); and *Self-Renewal* (Norton, 1981). As the reader will probably have surmised from the number of references I have made to Gardner in my book, he has been very influential in my thinking and development. I have found all of his books rewarding. I'd start with *Self-Renewal* which, as the title suggests, talks about what it takes for any entity — whether it be an institution or an individual — to continually renew itself in a purposeful manner. His other excellent books include *Morale, Excellence* and *On Leadership*.

Giamatti, A. Bartlett. *A Free and Ordered Space: The Real World of the University* (Norton, 1988). Bart Giamatti was a classmate of mine at Yale and later president of that university; subsequently he became commissioner of Major League Baseball. An extraordinarily thoughtful and eloquent person, his ideas have influenced me greatly. This book is a series of essays that touch on the value of a liberal education, the importance of our public educational system, the value of continued learning and, most importantly, the principles of a good life. Few readers will be disappointed by spending a couple of hours with these wonderful essays.

Gladwell, Malcolm. *The Tipping Point* (Little, Brown, 2000). A fascinating exploration of how individual events and seemingly peripheral interventions can be the tipping point for major change. The perspective provided in this book has highlighted for me the potential impact of seemingly small individual policy changes and decisions. An easy read. Very well presented.

Graham, Katharine Meyer. *Personal History* (Knopf, 1997). One of the finest autobiographies I've ever read. Deeply honest and informing. Wonderful insight into how a woman who was placed unexpectedly in charge of a major enterprise (the Washington Post) overcame her initial fear as she fell in love with her job and her people and learned to lead with courage and effectiveness. Few will fail to draw personal guidance and encouragement from Ms. Graham's account of her life.

Hamel, Gary and Prahalad, C.K. *Competing for the Future* (Harvard Business School Press, 1994). One of the finest books I've read on the strategic and conceptual approaches for competing effectively in the future.

Havel, Václav. *Disturbing the Peace*. Translated from the Czech, with an introduction by Paul Wilson. (Knopf, 1990); and *Open Letters*. Selected and edited by Paul Wilson. (Knopf, 1991). I have found the writings (and to the extent I know it, the life) of no world leader more inspirational than that of Václav Havel, Czech playwright, dissident and first president of Czechoslovakia following its newly won freedom after the Iron Curtain came down in 1989. His writing touches eloquently on many of the characteristics I feel are most important to a good life and effective leadership. The books I've noted are collections of essays. Excellent in their entirety, I particularly recommend "The Politics of Hope" in *Disturbing the Peace*, and "Dear Dr. Husák" and "Politics and Conscience" in *Open Letters*.

Kuhn, Thomas S. *The Structure of Scientific Revolutions* (University of Chicago Press, 1962). Still a standard, this book deals with the process and ways in which major technological change occurs.

Levin, Richard C. *The Work of the University* (Yale University Press, 2003). A collection of illuminating and inspiring essays and speeches that provide almost as much insight into the work of a company like P&G as a university. Written by the president of Yale University, with whom I've had the privilege of working for over a decade and one of finest leaders I've ever known.

Liebman, Joshua Loth. *Peace of Mind* (Simon & Schuster, 1946). I have read this book several times since encountering it more than a decade ago. It is as relevant today as when first published in 1946. It helped me achieve (even if not as fully as I'd like) what one reviewer captioned as the "peace of mind that can be won by knowledge, discipline and character."

Martin, Roger L. *The Responsibility Virus* (Basic Books, 2002). Written by the dean of the University of Toronto's Rotman School of Business and a valuable counselor to P&G. Extraordinarily insightful, illustrating the traps that we can fall into by undertaking too much or too little responsibility, with some very practical action steps to avoid the traps.

Novak, Michael. *Business as a Calling* (The Free Press, 1996). Persuasively makes the case for the role of business in the development of communities and society.

Osborn, Alex F. *Your Creative Power* (C. Scribner's Sons, 1948). A good, practical and easy-to-read set of tips on doing what the title suggests: expanding your creative powers.

Porter, Michael E. *Competitive Strategy* (Free Press, 1980). Perhaps the classic treatment on the development of competitive strategy. While written more than 20 years ago, it has stood the test of time.

Putnam, Robert D. *Bowling Alone* (Simon & Schuster, 2000). An extraordinarily provocative book, highly suggestive on the benefits of community, the challenges of achieving it, and steps to overcome these challenges.

Reichheld, Frederick F., with Thomas Teal. *The Loyalty Effect* (Harvard Business School Press, 1996). Excellent book that makes a powerful economic case for loyalty — of customers, employees and investors — and demonstrates how loyalty of one group goes hand-in-hand with the others.

Schisgall, Oscar. *Eyes on Tomorrow: The Evolution of Procter & Gamble* (J.G. Ferguson Pub. Co., 1981). A workmanlike presentation of the history of the Company through 1980. A new, updated history of Procter & Gamble was published June 2004. [Davis Dyer, Frederick Dalzell and Rowena Olegario. *Rising Tide: Lessons From 165 Years of Brand Building at Procter & Gamble* (Harvard Business School Press, 2004).]

Stegner, Wallace. *Crossing to Safety* (Random House, 1987). I've read few novels in recent years. However, this one provides deep insight into the nature and power of personal, family and professional relationships.

Sullivan, General Gordon R. and Harper, Michael V. *Hope Is Not a Method* (Times Business, 1996). Written by a former general of the Army, this is an extraordinarily useful book on leadership, particularly in the practicality of its advice.

Wheatley, Margaret J. *Leadership and the New Science* (Barrett-Koehler Publishers, 1992). Drawing from Wheatley's knowledge of biological science, this book stresses that in order for an individual, a company or any institution to survive and grow, it must have the ability to renew itself purposefully, adapting to changes in the environment while remaining true to its most deeply held values and principles. Very influential on my thinking.

Yankelovich, Daniel. *The Magic of Dialogue: Transforming Conflict into Cooperation* (Simon & Schuster, 1999). A lucid primer on having serious, productive conversations on tough issues. It combines practical how-to tips with a thoughtful examination of the role of civil discourse in society.

Biographical Data

John E. Pepper
Retired Chairman and CEO, The Procter & Gamble Company

Residence: Cincinnati, Ohio, USA

Date of birth: August 2, 1938

Place: Pottsville, Pennsylvania

Education:
Portsmouth Abbey, 1956
Yale University, B.A., 1960
Honorary doctorate degrees: College of Mount St. Joseph,
St. Petersburg University (Russia), Xavier University (Cincinnati),
The Ohio State University

Military service: U.S. Navy — 1960-63

Date joined P&G: September 25, 1963

Positions held and dates:
1963 — Staff assistant
1964 — Assistant brand manager
1966 — Brand manager
1968 — Copy supervisor
1969 — Brand promotion manager
1972 — Advertising manager, Bar Soap & Household Cleaning
 Products Division
1974 — General manager, Procter & Gamble Italia
1977 — Division manager, International
1978 — Vice president, Packaged Soap & Detergent Division
1980 — Group vice president, PS&D and BS&HCP Divisions
1981 — Group vice president, Europe
1984 — Member, board of directors, and executive vice president,
 U.S. business
1986 — President, with responsibility for U.S. business
1990 — President, with responsibility for International business
1995 — Chairman of the board and chief executive officer
1999 — Chairman of the board
1999 — Chairman, executive committee of the board
 (upon retirement as active employee: September 1, 1999)
2000 — Chairman of the board
 (returning as active employee: June 8, 2000)

2002 — Chairman, executive committee of the board
(upon second retirement as active employee: July 1, 2002)
2003 — Retired from the board (July 1, 2003)
2004 — Vice president, Finance & Administration, Yale University

Other business affiliations:
Director, Xerox Corporation
Director, Motorola, Inc.
Director, Boston Scientific Corporation

Local, national and international activities:
Honorary co-chair and member, board of trustees,
 National Underground Railroad Freedom Center
Co-founder and member of the executive committee,
 Cincinnati Youth Collaborative
Member, American Society of Corporate Executives (1998 chairman)
Former senior fellow, the Yale Corporation
Former member, Partnership for a Drug-Free America
General chairman, 1994 United Way Campaign
Former member, Governor's Education and Business Advisory Group,
 State of Ohio
Former member, board of directors, National Alliance of Business
 (1985-94)
Former member, board of trustees, Xavier University (1985-89)
Former vice president, American Chamber of Commerce, Brussels, Belgium
 (1981-84)
Former member, Cincinnati Symphony board (1979-81)
Former member, Cincinnati Art Museum
Former president, Commercial Club (1997-98)
Former chair, Ohio Business Roundtable (1998-99)
Former chair, United States Advisory Committee for Trade Policy and
 Negotiations (1999-2000)

Clubs:
Yale Club
Commonwealth Club
Commercial Club

Appendices

A View From P&G Alumni:
(From the Sublime to the Ridiculous)

Have you ever wondered how P&G alumni look back on their P&G experience, and what they believe is most important to assure P&G's success in the future? Well, I did, and I took the opportunity to find out during the P&G Alumni Network weekend in April 2003. I asked each person to fill out a card during lunch. The following comments, which were gathered that day, represent their responses to this request. As you'll see, they range from the sublime to the ridiculous.

Describe your most memorable recollection of your experience at Procter & Gamble.

"The wonderful, principled people and the integrity they have."

"The willingness of my management to put up with my inexperience as they allowed me the chance to learn and develop. After over 40 years in business, I continue to look upon my days at P&G as the most rewarding and most enjoyable. To me, P&G will always be the finest company in the world."

"The first memo — the niggles filled more space than the original text, and my brand manager held it over his lighter to demonstrate his low opinion of it."

"Playing touch football on Saturday with the division football team, including John Pepper, Bob Morrison (former CEO Quaker), and Ted Cutler (EVP Time Warner). Who says competition stops when you leave P&G headquarters?"

"We were trying to improve Liquid Cascade and most of our R&D were considering a minor change that would not address enough consumer frustration. By using the consumer's passionate feedback, I was able to get management agreement to shift to a riskier technology. It resulted in Cascade LiquiGel, which reversed the profit decline of many years. It taught me the power of the consumer making a decision!"

"Getting stuck in an elevator in Taiwan with John Pepper and senior management team. After prying open the door, which was stuck halfway below the floor level, we scrambled up and out the half-opened elevator. So much for all that pre-planning to ensure a smooth management visit!"

"Right after Liquid Tide launched, we analyzed the impact of Wisk's huge defense in our launch plan. We determined we could not achieve our trial objectives with our launch plan ... even though we had just launched and it was highly politically incorrect to ask for more money, we did (a lot more!). A.G. Lafley was the associate ad manager, who approved the plan first; Bruce Byrnes as VP and Steve Donovan as group VP also approved. Finally, we took the plan to John Pepper (the division manager), who did not want to approve it at first. He asked as many questions as the other four combined but let facts win over instinct (a powerful lesson). Liquid Tide went on to category leadership."

"Being constantly challenged to find the best model of success and take what works, fit it to your business, and be a champion for the business ... and the people — the unbelievable, stellar people."

"Listening and learning from so many talented and experienced business-men and women, not only business lessons, but so many life lessons."

"Learning the importance of consumer focus in any successful business enterprise."

"As a 'lowly' brand assistant seeing my first packaging change on shelf and feeling as if I could really have an impact in the marketplace."

"The immense amount of trust and respect placed on the individuals while coming to love and believe what the company stands for. There was a sense of working for something much bigger than a paycheck, which I haven't seen ... [since]."

"Mostly the feeling of pride of being part of such a wonderful organization."

"Sliding down a hill from Mt. Adams on my P&G briefcase in an ice storm so I could get to the office."

"Home visits in China to learn about how families did laundry. They were mystified by why a group of Americans would want to watch them do their laundry."

"The level of support the Company provided me in a personal crisis when my wife was Med-i-vac'd from Japan to a hospital in Hawaii and then to the East Coast. It was family first, and their support never failed to amaze me."

"Working in Spain, finding a culture where under-the-table payments and more than one set of books were kept and knowing that P&G would never do anything like that."

What do you believe to be most important to assuring Procter & Gamble's success in the future?

"Continuous innovation, less bureaucracy, willingness to change the old ways of doing things, better process for bringing ideas in from outside at levels that can make a change."

"Humility, knowledge and lack of arrogance."

"Recruit and hire the highest-quality young people; then take time to train them in the P&G way of ethical business."

"Being open to new ideas from outside resources."

"Instilling in new employees the values that we espouse and the importance of doing things right."

"Staying focused on true consumer needs and desires and using disciplined P&G approaches to deliver on them."

"Continue to put strong programs in place to develop strong leaders."

"Fostering innovation and challenging the organization to take risks."

"Maintenance of ethical standards"

"Continued focus on recruiting the best talent combined with intensive on-the-job training."

"Continued focus on the consumer's needs and on innovation."

"An unyielding desire to continue to understand and respond to legitimate consumer needs in all of its markets ... and never again give up on making the very best products."

"Hire, train and retain the best leaders and thinkers in the world."

"Learning how to challenge conventional wisdom. Continue to innovate by partnering and going outside of P&G in a dedicated way."

"Willingness to change — challenge success — expose itself to non-traditional thinking of people."

"Make sure you keep reinventing yourself (organization and products) while ensuring you don't get 'cocky' on how you're doing. You can still learn tons from the outside world."

"Maintaining the culture of success (that feeling that P&G is the No. 1 team), ... combined with a bit of running scared (believing competition is right behind us)."

"Tapping the ideas of innovation and unorthodox thinking of new hires."

"Eyes wide open to new ways and ideas, while maintaining commitment to ... enlightened, inspiring leadership."

"Maintaining values of character and ethical behavior within the Company. Training managers to bring out the best in each individual, whether they fit the classic mold or not."

"Believing in global diversity is the only way P&G will always prevail."

"Continuing to develop an 'externally focused' company. It is great to see the renewed consumer focus. It needs to be sustained."

"Attracting the best talent globally and developing the best."

"Smart innovation in developing products that meet known consumer needs, not products that are looking for a home."

"Continued stress on character and principles."

"Continue to focus on understanding consumers, both their functional needs and their emotional needs, and connecting those two in the marketing programs, and especially the advertising."

"Maintaining value and integrity of the Company while keeping an external focus."

"A deeply held belief in your own fallibility, ignorance and competitive vulnerability. Ensuring a stream of breakthrough innovations"

"Unleashing the full potential of its employees while maintaining everyone's commitment to P&G's core values."

"Continued focus on the values that make the experience of working at P&G 'special' and 'different.'"

William Cooper Procter:
A Fervent Believer in the
Importance of the Individual

William Cooper Procter was at the helm of the Company as president, CEO and finally chairman for over 40 years — from 1890 until 1934. Even before that, in 1885, he led the way among U.S. companies to give workers a half-day off on Saturday. This was a very revolutionary idea at the time, but far less revolutionary than what was to come two years later — his introduction of Profit Sharing.

William Cooper Procter

It was 1887 and Grover Cleveland was the president of the United States. The Statue of Liberty had just been erected and the U.S. flag had only 38 stars. P&G was celebrating its 50th anniversary and eight-year-old Ivory had just introduced the first Ivory baby. However, little that was baby-friendly was in the air when it came to employee relations. The year before had witnessed the Haymarket riot in Chicago; 11 police officers and laborers had been killed. The American Federation of Labor was formed in the same year. Labor unrest was prevalent and P&G was not immune to it: the Company had experienced 14 walkouts in two years.

William Cooper Procter, the 25-year-old grandson of the founder, was worried. He had been working at the plant since graduating from college in 1883, and he was trying to find a way to improve relations with his fellow employees. An idea from the Guilds of Europe in the Middle Ages suggested itself to Cooper. Why not let the employees share in the earnings? Why not give them an incentive to increase earnings? It is not hard to imagine the consternation of Cooper's father. He and others thought that young Cooper had taken leave of his senses. This was surely boyish enthusiasm. After all, weren't the men and women of P&G already being paid for what they were hired to do? Still, after much discussion and planning, the announcement was made in a letter to Procter & Gamble employees on April 12, 1887: "We have, for some time, had under consideration the subject of investing certain of our employees with an interest in the declared profits of our business and at length matured the plan which is set forth below."

Six months later, P&G held its first Dividend Day, a day to celebrate P&G's profits. A German band led off the celebration. Skeptics in the crowd suspected the Company had hired the band in order to lift people's spirits before they discovered how little profit sharing meant. The band stopped, and James Norris Gamble, then president of the Company, stepped up to the podium and gave a short speech. He talked about the mutuality of interest of P&G and its employees. He finished, and the moment of truth had arrived. He invited the workers to come forward and receive their profit sharing checks. The workers tore open their envelopes and suddenly the room buzzed with astonishment. Profit sharing was not a pittance. Each worker was richer by 13 percent of his or her annual wages. Interestingly, this profit sharing was granted only to the daily workers, not senior management. Indeed, qualification was cut off at an annual salary of $3,000. It was not until 1944 that the Company extended profit sharing to non-hourly employees.

How successful was the first profit sharing plan? Did P&G see an immediate benefit? To a degree, yes. Following the first distribution of profits, the strikes ended and the employee turnover rate dropped by two-thirds. However, it would be a dangerous misreading of history to leave the impression that everyone lived happily ever after. No, as with so many innovations at P&G, whether developing our brands or redesigning our organizational structure, we didn't get it right the first time. We had to remain open to experience as it unfolded. We had to adapt and make changes in order to achieve our objective. Our first profit sharing plan proved no exception. The result was not what Cooper Procter had hoped for. As he said later:

> We tried this plan for a number of years, and without satisfaction. Employees took the profit sharing as a bonus to which they were entitled; and, in many cases, anticipated its payments by running up bills. We were ready to give the plan up, but after consideration decided to modify it.

Modify it he did, turning it into a savings plan or pension plan with the Company matching employees' contributions on a four-to-one basis, up to a total potential contribution equal to 25 percent of the employee's salary.

It is very important for us to know where William Cooper Procter was coming from as he launched these benefit programs. It's important to know what was in his mind, what he thought *really mattered*, particularly as we draw lessons for the future. I have come to see that there was a finely balanced equilibrium in Procter's conviction that initiatives such as giving half-days off on Saturday and reducing the workday from 10 to eight hours were right to do. His view was principled and pragmatic. *He saw these initiatives as being morally right for our employees and financially right for the business.* Here was an equilibrium anchored in Procter's twin beliefs that it was the Company's duty

to serve the public and its employees, yet, at the same time, the employee's duty to earn that service by his or her hard work. As he remarked in 1918:

I've never given one moment's consideration to any scheme of profit sharing, shortening hours of labor, old-age pension or any other line that did not, in my judgment, lead to the increase in efficiency and production of the Procter & Gamble organization. It would be silly, no matter how sentimental you might be, or what your sympathies, to consider it upon any other basis.

Procter constantly looked for improved productivity from the actions he took. In March 1918, not too long after moving from a 10-hour to an eight-hour workday, Procter was pleased to report that "although we only went to the eight-hour day on the 1st of March, in the majority of departments more work is being turned out than was ever turned out of a 10-hour day." There was no mistaking the competitive drive of this leader. He made no bones about this as these words, from a talk he gave in 1919, attest:

Neither this Company nor any other company has made business, gained reputation, rendered service, except in one way, and that is by an aggressive, offensive fighting policy. When we made our greatest progress, we were most aggressive.

He went on to observe that our employees "want nothing that savors of something just being given to them." Procter's view of the responsibility carried by every individual, including himself, could not have been clearer:

When the board of directors places a man at the head of the Company, he is responsible for the success of the Company. No failure or mistake of subordinate relieves him ... and so down to the individual worker: The responsibility of the job to which he is charged is his, and no person can relieve him from it.

There was never a question where Cooper Procter stood on the matter of holding people accountable for their performance. He emphasized "the necessity for a prompt and firm decision when a subordinate is showing himself incompetent," and as a general rule he said "he should be ... discharged from the Company."

Cooper returned often to these underlying values of the Company, which have played such a vital role in our strength as an institution and community over the years. The Company, he said, has "standards higher than mere money-making." At the same time, every employee must "recognize their obligation to service; of fair dealings; of truthfulness; and responsibility."

Again and again, we hear this finely balanced expression of Procter's convictions on each individual's accountability and the Company's responsibility to serve. "The keynote to success must be fairness and justice on both sides," Procter said.

When all is said and done, there is no question that among all the changes he initiated, William Cooper Procter regarded profit sharing as the "most important ... more important than all the others put together. More important to the Company. More important to you (the employees) and, as an example, more important to the nation than any other plan in effect in the Procter & Gamble Company."

Why did he feel this way? Because profit sharing gave proof to the conviction that every single employee matters in P&G's success. It gave substance to employees' special feelings of ownership for the Company. I first felt that sense of personal ownership from our employees as I walked to the front of an auditorium filled by 300-400 women and men, who were attending a business presentation at our Ivorydale plant in Cincinnati in the mid-'60s. I could sense that these people knew this was their Company and they were committed to its success.

I have never forgotten that feeling and I never will. It was on my mind as I embarked on my first assignment with P&G outside the United States in 1974 as general manager of our Italian subsidiary. I pledged to myself that I would find ways to bring that same reality of ownership to our International employees who, having their own national pension plans, typically didn't own P&G stock. This is what led us years later to introduce a savings plan offering non-U.S. employees a free share of stock and a Company contribution to match a portion of their income used to purchase P&G stock. In country after country, we were the very first company to enable our employees to own stock in a non-national corporation. This desire to provide the reality of stock ownership to all our employees is also what led me to recommend to our board of directors that we make a one-time grant of stock options to all employees in the late-'90s. Today, almost *90 percent* of P&G employees worldwide own P&G stock. That makes me very proud. Above all, it gives substance to what William Cooper Procter believed: Every one of us matters to P&G's success, and every one of us ought to share in that success.

Redesigning Your Organizational Structure to Achieve Your Purpose

We have seen that developing and maintaining a strong community requires many things: a purpose worthy of a lifetime's effort, leadership results, values that define our character and guide our actions, and the ability to constantly renew our strategies and priorities in the light of new knowledge and the changes around us, all while preserving our core Purpose and Values.

A particular requirement in all of this is rarely recognized in a book like this. That is, the need to periodically redesign our organizational structure. Given its importance, and because it is commented on so rarely, I want to reflect on that need here.

I've often said that a company is a lot more than lines and boxes on a piece of paper; much more than a formal listing of roles and responsibilities. I've said that the quality and effectiveness of an organization cannot be gleaned from an organization chart. All that is true. It would be a mistake, however, to conclude that the structure and design of an organization are not matters of great importance. Indeed, when well conceived and executed (as has often been the case in Procter & Gamble's history), changes in organization design are a source of enormous competitive advantage. James Collins and Jerry Porras, whose book *Built To Last* I mentioned earlier, were more accurate than even they might have imagined in saying:

> *William Procter's and James Gamble's most significant contribution was not hog fat soap, lamp oils or candles, for these would eventually become obsolete; their primary contribution was something that can never become obsolete: a highly adaptable organization with a "spiritual inheritance" of deeply ingrained core values, transferred to generation after generation of P&G people.*

Procter & Gamble has distinguished itself throughout its history by its ability to continue to adapt its organization design to achieve the core imperatives of leadership and growth. Company leaders have been avid students of organization design, and the results of their efforts have brought lasting competitive advantage. Before surveying some of the most important changes in Procter & Gamble's organization structure (and the lessons to be derived from them), I'll first address the key principles that have guided these changes. I'll also indicate the points of tension, which have made many of these changes challenging both in concept and in execution.

Basic Purpose and Principles

The standards we should use to evaluate any organization change in P&G were stated with remarkable simplicity by Neil McElroy over half a century ago:

1. Its effectiveness in enabling us to build leadership brands.

2. Its ability to make Procter & Gamble a place where the finest men and women will want to come to spend their careers and be able to grow and perform at their best.

Within those two broad parameters, I've seen four imperatives drive our organization changes:

1. We believe our total business will grow faster by providing to discreet business units focused responsibility and accountability for our brands, categories of brands, and country operations.

2. We take advantage of the economies of scale and the opportunity to transfer knowledge and capabilities across our business units in order to maximize innovation and value creation.

3. We increasingly operate on a regional and global scale while keeping our ability to innovate and execute better than any competitor to meet the needs of consumers in the most important countries of the world.

4. We work with our customers as a single company to take advantage of our corporate scale and capabilities, while at the same time delivering superior strategies and execution in each of our major businesses so we win versus our competitors, many of whom are focused on much narrower lines of business than we are.

The inherent tension between some of these imperatives is apparent. As just one example: How do we take advantage of the scale and knowledge transfer to be gained by operating regionally and globally without losing our ability to meet *individual* consumer needs in *individual* countries?

Resolving these tensions in a way that delivers on our purpose and business objectives has been at the heart of the successful evolution of P&G's organizational design. As we'll see, this has been challenging. Rarely have we managed to get the big changes right the first time. But as we'll also see, we've been fast learners. We've adapted and more often than not we've been ahead of our competitors.

1. Focused Responsibility and Accountability
The conviction that our business would grow faster if responsibility and accountability for discreet business units were assigned to separate organizations was brought to a new level by Neil McElroy, when he helped create the brand management system in the 1930s. And it worked. This same belief was at the heart of the major organization changes that followed in the mid-'40s and mid-'50s as the Company, under Howard Morgens' leadership, first established a separate drug product division. Then in 1955, following the addition of several new brands, three separate divisions were formed: one for our soap and detergent brands, one for our toilet goods brands, and a third for our food brands. Each division had its own Product Development, Advertising, Manufacturing and Sales organizations with a small corporate staff providing linkage across the three divisions. This defined the basic structure of the Company when I walked in the front door in fall 1963.

2. Managing Geographic Expansion and Regionalization
The next phases in the evolution of the Company's organization structure drew their primary impetus from geographic expansion as we spread throughout continental Europe in the late-'50s and '60s. In doing this, we managed the business on a geographic basis, almost as if each country was a mini-United States. When I went to Italy as general manager in 1974, for example, we had our own manufacturing and product development organizations; and we had our own advertising, finance and accounting departments. We also had our own suppliers for just about everything, and we didn't want to let go of those relationships. Each of us had an ever-so-slightly different laundry detergent formula, and each of us was convinced *we* had exactly the right one. We were pretty much worlds unto ourselves — all nine European countries. The word "standardization" was not in our vocabulary. To say we were separate fiefdoms would be a little overstated, but not much.

This started to change in the mid-'70s and, as is often the case, the change was driven by crisis. We faced enormous economic challenges flowing from the Middle East oil embargo. We faced the inescapable reality that while our European business continued to mature, its profitability remained well below that of the United States. Perhaps most important in driving the change, however, was Ed Artzt's arrival as head of the European business. It was very clear to Ed that the "every-country-on-its-own" days had to be brought to an end. We could see our strength being dissipated by fractionalization. We weren't benefiting from each other's ideas. We were inefficient and we were moving too slowly. We were increasingly seeing that we needed to operate much more on a regional basis. The development of this perception, and even more its actualization, came slowly over the course of the following decade. But, in retrospect, it's probably fair to say we were moving faster than our competitors.

Regionalization started in Research & Development under Wahib Zaki's (and later Gordon Brunner's) able leadership, and then moved to Manufacturing and Purchases. Overall profit responsibility (as well as most marketing activity and customer contacts), remained the province of each country's general manager. However, we created teams for each of our major European brands led by a general manager to coordinate the development of key brand strategies and initiatives, and to share learnings across the countries of Europe.

As modest and logical as these changes sound today, they were *very controversial* at the time. I know, because I was leading these changes in Europe from 1981 to 1984. Some general managers felt we were moving too quickly to regionalize, thereby risking the value of each country's being able to bring resources against its own particular objectives. Others felt we were moving too slowly to gain the benefit of scale. In retrospect, I believe we had the pace of change about right, but it is also clear that we were in transition, laying the foundation for a much bolder evolution in organizational design. That bolder evolution came in 1984-85.

Just as it had earlier, yet this time even more so, change came out of a fight for survival. Our European disposable diaper business, the second largest (only laundry being bigger) was going nowhere. Our market shares were declining. We were losing money and more of it every year. We knew "more of the same" was not the answer. We concluded we needed to operate on a pan-European basis, not only for key product and strategic decisions, *but for profit and cash management, as well.* Ed Artzt, by then leading all of P&G's International business, placed one executive, Michael Allen, in charge of the entire European disposable diaper business. Allen reported to Harald Einsmann, an outstanding leader who succeeded me (and achieved great results) as head of Europe when I returned to the U.S. in mid-1984.

The new organizational design worked wonders. The speed and quality of innovation increased dramatically. Costs came down. In a period of less than five years, our share of the diaper market doubled to over 50 percent; profits increased manyfold. Buoyed by this success, and with strong leadership from Bruce Byrnes, who had come to Europe from the U.S., we adopted the same regional organizational structure for our Feminine Protection business, as we introduced Always into Europe in the late-'80s. It, too, was a great success.

This organizational transformation, the regionalization of our European business, evolved over more than a decade. It was a difficult and challenging change. To a degree, we were finding our way. But it was right, and through it all, we tried to stay focused on what we were about: achieving leadership through the growth of leadership brands.

Much the same process took place in Latin America starting in 1985 as Jorge Montoya took responsibility for our business in this region, which then consisted of just four countries: Mexico, Venezuela, Peru and Puerto Rico. Communication among those countries was similar to what I had found in Europe when I had arrived there 10 years earlier — *almost none*. Just as in Europe, the decision to regionalize our operations in Latin America came out of necessity. Jorge saw clearly that the Company did not *have* to be in Latin America to meets its goals. He knew that if Latin America didn't get its act together, it would not receive priority attention. Informed by his experience in Europe (Jorge had run our business in Spain), he moved to regionalize our operations. In addition to managing the operations in a country, each general manager took responsibility for a category across all of Latin America. This was a turning point in our Latin American business. Improvement in results came quickly; we were on our way to almost a tenfold increase in sales over the next 18 years.

3. Managing an Increasingly Diverse Brand Portfolio

At about the same time that we were regionalizing our operations in Latin America, we moved to once again redesign our organizational structure in the United States. We had been adding major brands in more and more categories during the 1960s, '70s and '80s including Folgers, Pringles, Pampers, Charmin and Bounty. As we did this, we increased the number of divisions in the United States to a total of seven, with each division having its own functional departments. Some of these divisions were larger than the entire Company was when divisionalization started in 1955. Still, we were uncomfortable. We didn't believe we were bringing sufficient focus to some of our existing major categories (for example, Oral Care), or to some of our still-small, but high-potential categories (for example, Pharmaceuticals). We didn't feel we were close enough to the consumer. So in 1986, John Smale and I (he the CEO, and I, president of the Company) changed our structure again. We broke our seven U.S. divisions into 26 categories placed within four major business units. Our purpose was to bring *greater focus* to our specific categories of business in order to serve consumers better and build our brands faster. Each category team was staffed with the people needed to accomplish this, including Marketing, Product Development, Finance, Sales and Product Supply.

In the months following this change, we found (as we usually have) that we had not gotten it right the first time. We had put too many functional resources in the individual categories. We had created too much infrastructure and added too much cost. We found that we could provide support for many of our functions across several categories and that's what we did. However, we had achieved our aim of getting closer to the consumer with greater cross-functional capability. And we began to see the business benefit from a faster flow of product and marketing initiatives.

4. P&G Goes Global

The organization changes that have occurred over the last 15 years have been driven by two factors: the continued *diversification* and, particularly, the increased *globalization* of our business.

- In 1985, P&G was on the ground doing business in 26 countries having a combined population of approximately one billion people.

- Today we are on the ground doing business in more than 60 countries having a combined population of about five billion people.

- In the course of less than 20 years, we increased by fivefold the size of the population we serve.

A great deal has happened over these years: the acquisition of Richardson-Vicks in 1985 and the greatly increased presence it gave us in Asia; our entry into China in 1988; the fall of the Berlin Wall and the opening up of Eastern and Central Europe; and P&G's entry into the Southern Cone of Latin America in the early-'90s. During this same period, we also added several new major categories, including Cosmetics and Fine Fragrances, and we greatly expanded our presence in Pharmaceuticals.

These two factors — diversification and especially the globalization of our business — made it increasingly apparent that in order to achieve our goals we needed to look at our strategies, technologies, product initiatives and sourcing plans on not only a national and a regional basis, but on a global basis. Our search for and implementation of the best way to do this globally have played out now for more than a decade.

In 1989, much as we had done in Europe about a decade earlier, we began by putting in place a new position filled by a senior line officer with responsibility for providing *worldwide coordination* of our key categories. Bob Blanchard led the way on this, taking responsibility for our Health & Beauty Care business. His job was to lead the global development and implementation of key strategic plans and activities, including product design, manufacturing sourcing and marketing strategy. However, his office did not carry profit responsibility; that remained with our geographic units. Not surprisingly, this proved to be a transitional structure. It was a necessary step, but not an end point, because it led to significant negotiations and considerable tension between the geographic and product coordination units, particularly on matters that had an impact on profit and cash flow. Still, this transition carried the Company forward for the better part of the 1990s, during which we expanded Pantene, Always and Pringles, and regenerated growth on some of our most important established brands, including Pampers and Head & Shoulders.

"Organization 2005"

As I assumed the position of CEO and Durk Jager COO in July 1995, the need for still-greater speed of innovation and still-lower costs became clear. We began to realize we needed to take another major step in the evolution of our organizational structure if we were to remain the leader we intended to be. That brought us to Organization 2005.

The need for this change was irrefutable. We found ourselves operating within an organizational structure that had, as I said at the time, "become too complex to meet the needs of today's and tomorrow's business." We had arrived where we were thoughtfully, but sort of "brick by brick." Our regional operations were strong, carrying profit-and-loss responsibility. We overlaid this with global category teams having responsibility for product design, marketing strategy and manufacturing sourcing. Corporate staff functions played powerful leadership roles to drive improvement across all of our businesses, in areas such as manufacturing reliability. And a strong corporate governance group exercised responsibility, in most ways, just as we had in the past. In a way, we had a four-way matrix.

We were spending too much time on internal transactions and not enough on achieving faster speed and bigger breakthroughs. These weren't just my observations. The same concerns were expressed loudly and clearly throughout the organization. Hard-number facts also signaled it was time for change. Annual sales growth was running at only about 4 percent, well below our historical pace. Of even greater concern, we were building market share in categories representing less than half our volume, well below our goal of building share on 80 percent of our volume.

So, by 1997, we had concluded that we needed to once again evolve our organization design to allow our leadership brands to grow faster. We established a study team led by our senior leaders, which developed the set of changes we described as Organization 2005. *(Figure 11 describes its key components.)*

More than six years have passed since we launched Organization 2005. Despite its challenges, it is proving to be a correct and productive change. We made a number of mistakes, the most important of which I have tried to identify in this book to capture learnings for the future. Among them was the establishment of unrealistically aggressive growth goals during the transition itself. (This led to several unintended negatives, particularly overly aggressive pricing.) We failed to move quickly enough to put common goals into place across our Global Business Units (GBUs) and our Market Development Organizations (MDOs). We also failed to build a working relationship between them that was able to reach the best possible decisions on such key matters as

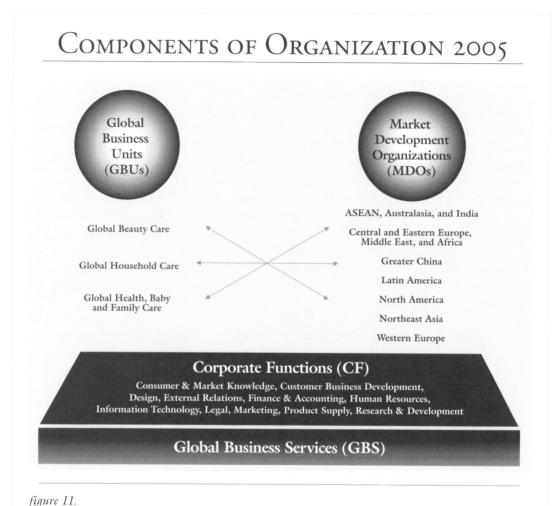

COMPONENTS OF ORGANIZATION 2005

Global Business Units (GBUs)

Global Beauty Care

Global Household Care

Global Health, Baby and Family Care

Market Development Organizations (MDOs)

ASEAN, Australasia, and India

Central and Eastern Europe, Middle East, and Africa

Greater China

Latin America

North America

Northeast Asia

Western Europe

Corporate Functions (CF)

Consumer & Market Knowledge, Customer Business Development, Design, External Relations, Finance & Accounting, Human Resources, Information Technology, Legal, Marketing, Product Supply, Research & Development

Global Business Services (GBS)

figure 11.

pricing. At a time of major change, we were insufficiently focused on our strategic choices, and we took on too many major initiatives at once. Finally, as discussed earlier, we confused our people with an all-too-vague call to "change our culture."

Still, just as we've done on other organization changes, we learned. We adapted and corrected outages as we discovered them. We aligned our goals across our business units based on the renewed objectives, goals and strategies that A.G. Lafley established for the corporation after becoming CEO in June 2000. We returned to focus on the fundamentals: winning with consumers and with our customers, winning on our largest brands, winning in our largest countries. We did those few things we knew we must do to have a healthy business: get our prices right and our costs down; lead on innovation and

commercialize it effectively; build strong partnerships with our customers; and work together across all our business units focusing on building leadership brands. We affirmed that all we were doing was centered on achieving our Purpose and living our Principles and Values.

We are now realizing the promise of Organization 2005, which I expressed in announcing the change in September 1998:

> *We intend to accelerate sales and profit growth and returns to our shareholders by increasing our capability to create and build large, profitable leadership brands globally. The key to operating globally is to be global and local at the same time. By marrying the strategies and innovation capability of Global Business Units with the superior market-place understanding and capability of the Market Development Organizations, we will accomplish this. We will deliver bigger innovations to consumers faster, better serve our global and local customers, and build stronger partnerships in our markets.*

To do this has taken longer than I had hoped and involved more pain than I expected. But we're well down the road now to making Organization 2005 a source of major competitive advantage. I believe it is the very challenge we found in implementing this change, given its enormous dependence on communicating effectively and decisively across organizational units, which will make it such an important source of competitive advantage. I say this because mastering this communication challenge has depended so heavily on P&G's sense of community, which will make this organizational design hardest for others to duplicate.

Organization 2005 and every other change I've seen us make reminds me of what Neil McElroy said decades ago. We are seeking an organization design that best builds leadership brands and makes P&G a company where the finest men and women will come to spend their careers, grow, perform at their best, and be glad they found this place.

"I Love My Job ... I Love the People I Work With ... We Are Making a Difference"

Giancarlo Iannelli, P&G Plant Manager
Novomoskovsk, Russia

I was born in one of the nicest places in Italy, very close to the beautiful coast and places like Capri, Pompeii, Amalfi and Sorrento. The climate is wonderful, the food is delicious, lemon trees grow spontaneously, people are always in the streets and everybody is a singer. Most of the most famous Italian and Neapolitan love songs have been inspired and written in this place. Beauty is all around you in terms of nature, art, history, monuments, music, and people are smiling all the time.

It is really a dreamland and I strongly advise you to visit in case you have not been there yet.

Now I live in Novo and that is quite different. How is it possible that I wake up in the morning here and often there is not hot water, the temperature outside is minus 20 Celsius, I have to fight with a mouse ... but still I am happy, and I shave with water heated on the burners while singing one of my favorite opera's arias.

How is that possible?

It is possible because I love my job and I love the people I work with. I know I am in charge, and I know that my job — my decisions — will make a difference in the development of the plant, in the life of my people, and in the life of the city.

Seeing how the plant grows and how your people develop, knowing that you make a difference in your people's growth and in the improvement of their lives, what can be more rewarding than that? And you have seen they are very nice people and they really deserve that.

First time I worked in Novo, most of the people had never been abroad or owned a car. They lived in very small and very bad apartments shared with other families. Now all the people you meet have their own decent and clean apartments; they do not have to share them. They own a good-quality car.

And I know that I am contributing to that change. This, in itself, would be more than enough to explain why I am happy to work here.

But that's not all.

On Thursday I visited the city's children's hospital and the maternity hospital within our charity program, and what I have seen there has really touched me. You cannot imagine the dramatic conditions in which the doctors are working and in which the patients are kept. And knowing that we as P&G are doing so much to help them is an incredible feeling.

Reading the gratitude in the eyes of doctors, mothers and children for what P&G is doing for them ... there is nothing worth more than such a feeling. I also met in this hospital abandoned children who are kept there ... their big, beautiful, sad eyes staring at me. Why do all children left by their parents have such big eyes? We are helping these people, we are really making a difference for them, and sometimes the difference we are making is between life or death for those big eyes.

I work for a company that allows and wants me to make that difference, and I have a job that puts me in a position to make that difference. I have been blessed to be born where I was born and to have all the opportunities that I had and to work for such a Company in such a job. It's time for me to give back some of that luck to the people who were not as lucky. I am doing it now and I know I can do it even more.

This is why I am happy.

I wish all the Western World people could go through such an experience. It changes your life forever, it puts everything in the right perspective, it makes you a better human being in addition to a better P&G manager. But you have to go through it, you can't learn it in a book or in training.

Many among my Western colleagues think I am unlucky to be here. They make fun and say jokes about Novo and the expats of Novo.

I wish they could experience what a rich gift it is to live here for a while; to work with people like Yuri, Elena, Evgeny, Ludmilla, Natasha, Alexey ... and to see the big eyes of an abandoned child and think: I am doing something important, even for him, every day.

Giancarlo Iannelli

As this book was nearing completion, Greg Icenhower, who has played such an important role in its development, shared a poem with me that he felt summed up a great deal of the essence of what I intended to express. I read the poem and agreed wholeheartedly. With the permission of and with gratitude to its author, I reprint it below.

What Will Matter

By Michael Josephson

Ready or not, some day it will all come to an end.
There will be no more sunrises, no minutes, hours or days.
All the things you have collected, whether treasured or forgotten, will pass to someone else.
Your wealth, fame and temporal power will shrivel to irrelevance.
It will not matter what you owned or what you were owed.
Your grudges, resentments, frustrations and jealousies will finally disappear.
So too, your hopes, ambitions, plans and to-do lists will expire.
The wins and losses that once seemed so important will fade away.
It won't matter where you came from or what side of the tracks you lived on at the end.
It won't matter whether you were beautiful or brilliant.
Even your gender and skin color will be irrelevant.

So what *will* matter? How will the value of your days be measured?

What will matter is not what you bought but what you built,
not what you got but what you gave.
What will matter is not your success but your significance.
What will matter is not what you learned but what you taught.
What will matter is every act of integrity, compassion, courage or sacrifice that enriched,
empowered or encouraged others to emulate your example.

What will matter is not your competence but your character.
What will matter is not how many people you knew,
but how many people will feel a lasting loss when you're gone.
What will matter is not your memories but the memories of those who loved you.
What will matter is how long you will be remembered, by whom and for what.

Living a life that matters doesn't happen by accident.
It's not a matter of circumstance but of choice.
Choose to live a life that matters.

Index

References to illustrations and Color Plate (CP) photographs are printed in *italics*.